CUBISM and TWENTIETH-CENTURY ART

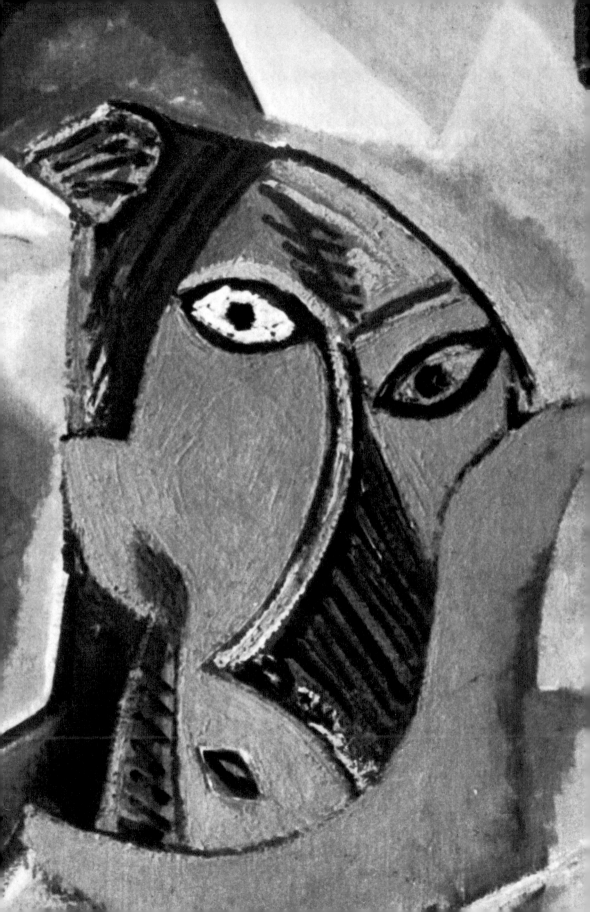

CUBISM and TWENTIETH-CENTURY ART

Robert Rosenblum *Professor of Fine Arts, New York University*

Harry N. Abrams, Inc., Publishers, New York

Standard Book Number: 8109-0767-4
Library of Congress Catalogue Card Number: 61-7155
All rights reserved. No part of the contents of this book may be
reproduced without the written permission
of the publishers, Harry N. Abrams, Incorporated, New York
Picture reproduction rights reserved by S.P.A.D.E.M. and A.D.A.G.P., Paris

Printed and bound in Japan

Foreword to the Present Edition

Rereading a book written some years earlier inevitably gives an author pause, and I am no exception. Were I to write this book today, it would be considerably different, emphasizing far more, I suspect, the subject matter of the great Cubists—Picasso, Braque, Gris—and their awareness of a new kind of urban realism, especially in the light of their increasingly apparent connections with the commercial imagery of the early twentieth century: posters, newspapers, packaging. It would seem that, from the post-Pop vantage point of the 1970s, Cubism may be moving out of its formalist and cerebral ivory tower. Moreover, as decades pass, Cubism seems to look as much backward as forward, and can often be interpreted as the culminating statement of nineteenth-century traditions of still life, landscape, and figural compositions rather than as a radical rejection of the past. There are more and more moments, that is, when Picasso's Analytic Cubism feels as close to, say, Corot as to a revolutionary modernism, or when the *Demoiselles d'Avignon* seems to have as much to do with Delacroix and Ingres as with a destruction of Western perspective. I should also today have considered at greater length the historically telling efforts of painters like Gleizes, Metzinger, and Delaunay to create a heroic new art from the fusion of Cubist style and inherited allegories. And I should certainly have included many artists whose work has come into greater prominence in recent years— among others, the incisively original British painter David Bomberg; the innovative Czech sculptor Otto Gutfreund; the brilliant American in Purist Paris Gerald Murphy.

Rather than write a new book, however, I have contented myself with tampering slightly with the old one, improving, I hope, its precision of fact and interpretation (several dates and some identifications of objects in Cubist pictures have been changed) and adding, sadly, an occasional death date. Furthermore, there is a brief supplement to the earlier bibliographies, which considers relevant publications since the last edition.

R. R.
New York, 1976

Foreword to the Revised Edition

The author who has the chance to make revisions not only before, but after his book has been printed is fortunate indeed. This new edition of *Cubism and Twentieth-Century Art* has afforded me just such an agreeable occasion. Although there have been no major alterations in the text, many minor corrections of fact, word, and interpretation have been made that I hope will increase the accuracy of this study as both history and analysis. In addition, the bibliography has been brought up to date.

In accumulating a list of possible emendations, I am indebted to the helpful comments of many people. Of these, I should like to thank most particularly my friend and colleague, Edward F. Fry, who, though involved with the final preparation of his own documentary study of Cubism, was generous and patient enough to provide unerringly precise answers to my countless queries about matters of dating and bibliography.

<div align="right">

Robert Rosenblum
New York, 1966

</div>

Acknowledgments

In preparing this study, I have accumulated many debts of gratitude to people, to institutions, and to books. Most of the time and support required for a period of uninterrupted writing was generously provided by Princeton University through a Procter and Gamble Fellowship in the fall semester, 1958. My research was constantly facilitated by Bernard Karpel and the members of his staff, who made the unsurpassed resources of the Museum of Modern Art Library a pleasure to use; and it was no less constantly inspired by Alfred H. Barr's *Cubism and Abstract Art* (1936) and *Picasso: Fifty Years of His Art* (1946), two books that still offer the firmest general foundations for the student of Cubism. Many technical problems could not have been solved had it not been for the help of Ralph Colin, Daniel Henry Kahnweiler, Sidney Janis, Maurice Jardot, and Hermann Rupf; and it need hardly be said that this book would not exist at all were it not for the kindness of the many collectors who permitted their paintings and sculptures to be reproduced in these pages and who so often opened the doors of their homes to me. Of these collectors, I owe a particularly heavy debt to Douglas Cooper, who not only allowed me to see his unrivaled group of Cubist masterpieces, but who, in his capacity as a scholar of Cubism, was good enough to read my manuscript and to sharpen its accuracy of fact and interpretation. It is difficult to acknowledge specifically the many friends whose casual conversations engendered ideas that found their way into my text. It would be less than honest, however, not to mention how much of my thinking about Cubism, in particular, and modern art, in general, has been molded by the brilliant lectures and seminars of Professor George Heard Hamilton which I was privileged to attend at Yale University between 1948 and 1950. I must also offer my warmest thanks for the unfailingly intelligent and efficient practical support of Ursula Krauss, who, for a period of over two years, was involved in countless transatlantic complexities that ranged from photograph hunting to polyglot correspondence. Lastly, I wish to thank my editor, Irene Gordon, whose tireless interest and high standards improved this book in a multitude of large and small ways.

Robert Rosenblum
Princeton, 1959

Contents

Part One THE FOUNDATIONS OF CUBISM

1. *Picasso and Braque, 1905–1908* 13

2. *Picasso and Braque, 1909–1911* 31

3. *Picasso and Braque, 1912–1924* 67

Part Two THE EXPANSION OF CUBISM
IN PARIS

4. *Juan Gris* 111

5. *Léger and Purism* 133

6. *The Parisian Satellites* 157

Part Three CUBISM
AND TWENTIETH-CENTURY ART

7. *Cubism and the Italian Futurists* 203

8. *Cubism and the German Romantic Tradition* 217

9. *Cubism in England and America* 222

10. *Cubism and Abstract Art: Malevich and Mondrian* 245

11. *Cubism and Fantastic Art: Chagall, Klee, Miró* 259

12. *Cubism and Twentieth-Century Sculpture* 295

13. *The Later Work of Picasso and Braque, 1925–1939* 315

Chronology 1906–1925 330

Bibliography 333

List of Illustrations 339

Index of Names 345

Photographic Sources 347

THE FOUNDATIONS OF CUBISM

1 *Picasso and Braque, 1905–1908*

There are moments in the history of art when the genesis of a new and major style becomes so important that it appears temporarily to dictate the careers of the most individual artists. So it was around 1510, when the diverse geniuses of Michelangelo, Raphael, and Bramante rapidly coalesced to create the monumental style of the High Renaissance; and around 1870, when painters as unlike as Monet, Renoir, and Pissarro approached a common goal in their evolution toward Impressionism. And so it was again around 1910, when two artists of dissimilar backgrounds and personalities, Picasso and Braque, invented the new viewpoint that has come to be known as *Cubism*.

From our position in the second half of the twentieth century, Cubism emerges clearly as one of the major transformations in Western art. As revolutionary as the discoveries of Einstein or Freud, the discoveries of Cubism controverted principles that had prevailed for centuries. For the traditional distinction between solid form and the space around it, Cubism substituted a radically new fusion of mass and void. In place of earlier perspective systems that determined the precise location of discrete objects in illusory depth, Cubism offered an unstable structure of dismembered planes in indeterminate spatial positions. Instead of assuming that the work of art was an illusion of a reality that lay beyond it, Cubism proposed that the work of art was itself a reality that represented the very process by which nature is transformed into art.

In the new world of Cubism, no fact of vision remained absolute. A dense, opaque shape could suddenly become a weightless transparency;

13

a sharp, firm outline could abruptly dissolve into a vibrant texture; a plane that defined the remoteness of the background could be perceived simultaneously in the immediate foreground. Even the identity of objects was not exempt from these visual contradictions. In a Cubist work, a book could be metamorphosed into a table, a hand into a musical instrument. For a century that questioned the very concept of absolute truth or value, Cubism created an artistic language of intentional ambiguity. In front of a Cubist work of art, the spectator was to realize that no single interpretation of the fluctuating shapes, textures, spaces, and objects could be complete in itself. And, in expressing this awareness of the paradoxical nature of reality and the need for describing it in multiple and even contradictory ways, Cubism offered a visual equivalent of a fundamental aspect of twentieth-century experience.

The genesis of this new style, which was to alter the entire course of Western painting, sculpture, and even architecture, produced one of the most exhilarating moments in the history of art. Born within six months of each other, the two parents of Cubism, the Spaniard Pablo Picasso (1881–1973) and the Frenchman Georges Braque (1882–1963), could hardly have stemmed from more unlike artistic roots. Yet, by 1910, with the strange destiny of history, their viewpoints had converged so closely that their respective works of this time can be distinguished by connoisseurs alone.

The unfolding of the Cubist adventure might begin conveniently in 1905, the year after Picasso left Barcelona to establish himself in Paris. While Braque became fascinated with the problems raised by the coloristic outburst of Matisse, Derain, and Vlaminck at the Salon d'Automne, Picasso was less involved with these currents. Still steeped in compassion for humanity and concern with morality and emotion, Picasso at the time remained remote from Braque's characteristically French interest in the sensuous and intellectual aspects of painting. The *Girl on a Ball* of 1905 is 1 a case in point. Here, in an arid plain, are the lonely, wistful figures who people the strange world of beggars, circus performers, and other pariahs that preoccupied Picasso until the first tremors of Cubism. Continuing the allegorical intention of so many of his early works, Picasso contrasts the youthful innocence of the frail fledgling with the world-wearied sobriety of the older acrobat by opposing her precarious equilibrium on the ball with his ponderous position upon the block. Yet, given the hindsight of history, there are portents of the Cubist world even here. The parallelism of the sphere and cube with the human forms may symbolize the theme of youth and maturity, but its very presence is also prophetic of the interaction between organic and geometric form that, stripped of symbolic implications, will dominate the early evolution of Cubism. Moreover, this painting, like others of the time, presents a curiously flattened and ambiguous space. Although the radical diminution of figures from foreground to middleground and background suggests a deep recession, all these forms defy such spatial inferences by hovering close to the picture plane. Here, too, there is a foreshadowing of the Cubist dialectic between the representation of objects in space and the assertion of the reality of the flat picture surface.

By the following year, 1906, the withdrawn, introspective mood so prominent in Picasso's early work vanished rapidly, to be replaced by a

2, 3 new sense of creation and energy. In two self-portraits, of 1901 and 1906, this transformation is immediately apparent. Paradoxically, the brooding, tragically isolated twenty-year-old artist of 1901 looks older and more somber than the twenty-five-year-old artist of 1906. In the later portrait the feeling of youthful, potential energies is apparent not only in the lighter, more optimistic color, but above all in the lunging arcs that define such areas as the jaw, eyebrows, neckline, and sleeve, and in the tensions of the face and the muscular compactness of the forearm.

The gathering power of this self-portrait is equally evident in the

4, 5 many female nudes that Picasso painted in the same year. In two characteristic studies, the human figure is compressed in order to explore now the qualities of welling physical force rather than to achieve the pathos and asceticism created by the distorted anatomies of the earlier Blue and Circus periods. In details like the stumpy, muscular forearms or the mighty break of the wrists, these grotesquely compacted limbs and torsos arouse a sense of harnessed, superhuman strength rivaled only in the figures of Michelangelo. So heroic, in fact, is the torsion of Picasso's figures that every movement—even the turning of a head away from the picture plane —seems the product of titanic energies. In color and texture, too, these almost prehistoric women evoke the birth throes that precede Picasso's

1 first full statement of this new world, *Les Demoiselles d'Avignon*. They are painted, for the most part, in earthy, terracotta tones that, especially in the frequently unfinished areas, suggest a primordial soil from which this radical vision will soon grow to maturity and fruition. Like the first sculptor of prehistory, Picasso molds and shapes figures who stand, solemn and silent, on the threshold of an unpredictable new world.

This new world began with an explosion, for *Les Demoiselles d'Avignon,* projected in 1906 but worked on mostly in the spring of 1907, appears to be the thunderous outburst that released the latent forces of the preceding year. If it might be said that Picasso's hallucinatory masterpiece

6 of 1905, the *Family of Saltimbanques,* is the last picture of the nineteenth century, then certainly *Les Demoiselles* is the first of the twentieth. Like most major pictorial revolutions, *Les Demoiselles d'Avignon* (whose title, a reference to a Barcelona red-light district, was given it later) mirrors the past and proclaims the future, for it both resumes an earlier tradition and begins a new one. Yet no masterpiece of Western painting has reverberated so far back into time as Picasso's five heroic nudes, who carry us across centuries and millenniums. To begin, we sense the immediate heritage of Cézanne's studies of bathers, and, through them, the whole Renaissance tradition of the monumental nude, whether the noble structural order of Poussin and Raphael or—in the extraordinary anatomical compression of the two central figures—the anguish of Michelangelo's slaves. But *Les Demoiselles* can take us even further back in time, and in civilization, to ancient, pre-Christian worlds. The three nudes at the left, who twist so vigorously from their draperies, evoke first the Venuses and Victories of the Hellenistic world, and then, cruder and more distant, the squat, sharp-

planed figures of the pagan art of Iberia. And in the two figures at the right, this atavism reaches a fearsome remoteness in something still more primitive—the ritual masks of African Negro art.

The most immediate quality of *Les Demoiselles* is a barbaric, dissonant power whose excitement and savagery were paralleled not only by such eruptions of vital energy as Matisse's art of 1905–10, but by music of the following decade—witness the titles alone of such works as Bartók's *Allegro barbaro* (1910), Stravinsky's *Le Sacre du printemps* (1912–13), and Prokofiev's *Scythian Suite* (1914–16). *Les Demoiselles* marks, as well, a shrill climax to the nineteenth century's growing veneration of the primitive—whether Ingres' enthusiasm for the linear stylizations of Greek vase painters and Italian primitives or Gauguin's rejection of Western society in favor of the simple truths of art and life in the South Seas. In *Les Demoiselles,* this fascination with the primitive is revealed not only in explicit references to Iberian sculpture in the three nudes at the left and to African Negro sculpture in the two figures at the right but in the savagery that dominates the painting. The anatomies themselves are defined by jagged planes that lacerate torsos and limbs in violent, unpredictable patterns. So contagious, in fact, are the furious energies of these collisive, cutting angles that even the still life in the foreground is charged with the same electric vitality that animates the figures. The scimitarlike wedge of melon, contrasted with the tumbling grapes and pears, seems to generate the ascending spirals of pink flesh; and, similarly, other inanimate forms, such as the curtain at the left, seem to echo the harsh junctures of the human anatomies.

This primitive power of form is fully complemented by the magnetic expression of the heads. Here, one senses above all the hypnotic presence of staring eyes that have a ritualistic fixity amid all this splintering animation. One moves from the single eye of the figure at the extreme left, placed frontally on a profile head as in Egyptian painting, to the more demonic pair of eyes, in different shades of blue and on different levels, that invests the squatting figure in the right foreground with magical force. Viewed as prophecy, this emphasis on the mysterious psychological intensity of a staring eye was to be a constant element in Picasso's later work, even in some of his most cerebral Cubist paintings.

Les Demoiselles d'Avignon has often been criticized for its stylistic incoherence, especially apparent in the shift from the Iberian stylizations of the three women at the left to the more sinister and grotesque look of the heads of the two women at the right, presumably repainted under the influence of African Negro sculpture. Yet this very inconsistency is an integral part of *Les Demoiselles.* The irrepressible energy behind its creation demanded a vocabulary of change and impulse rather than of measured statement in a style already articulated. The breathless tempo of this pregnant historical moment virtually obligated its first masterpiece to carry within itself the very process of artistic evolution. In fact, the velocity of stylistic change from left to right in this single painting foreshadows, in contracted form, the comparably swift creation of a more disciplined Cubist vocabulary in the years that follow.

8

10

16

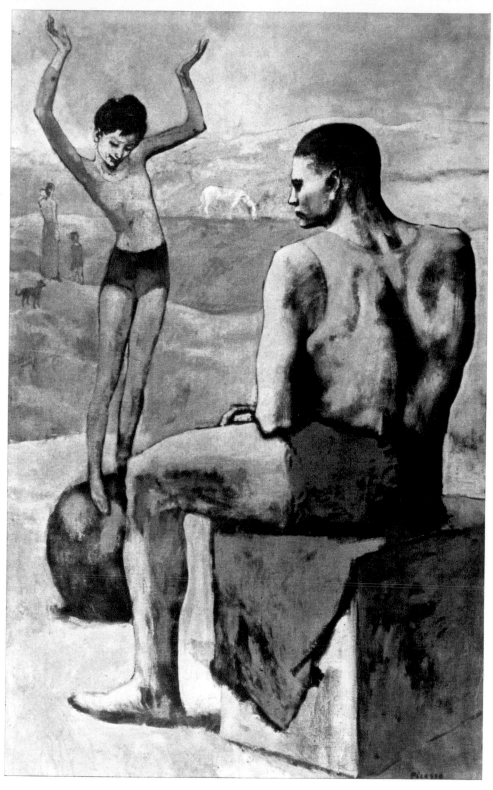

1. Pablo Picasso. *Girl on a Ball*. 1905

2. Pablo Picasso. *Self-Portrait*. 1901

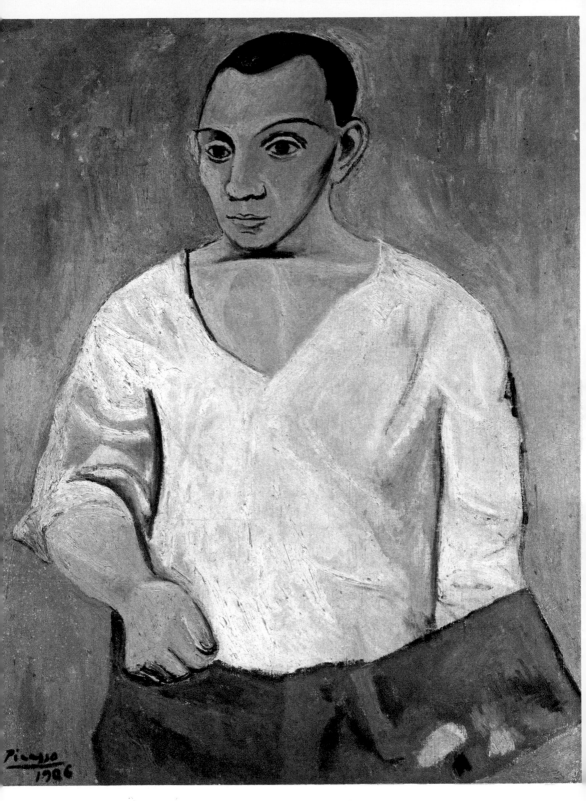

3. Pablo Picasso. *Self-Portrait*. 1906

4. Pablo Picasso. *Two Nudes*. 1906

5. Pablo Picasso. *Two Nudes*. 1906

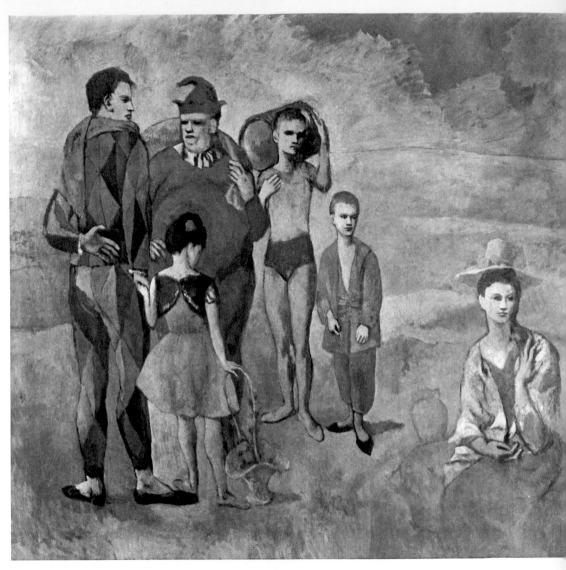

6. Pablo Picasso.
Family of Saltimbanques. 1905

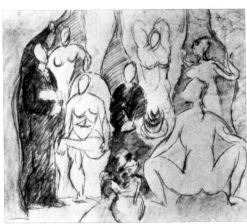

7. Pablo Picasso. *Study for "Les Démoiselles d'Avignon."* 1907

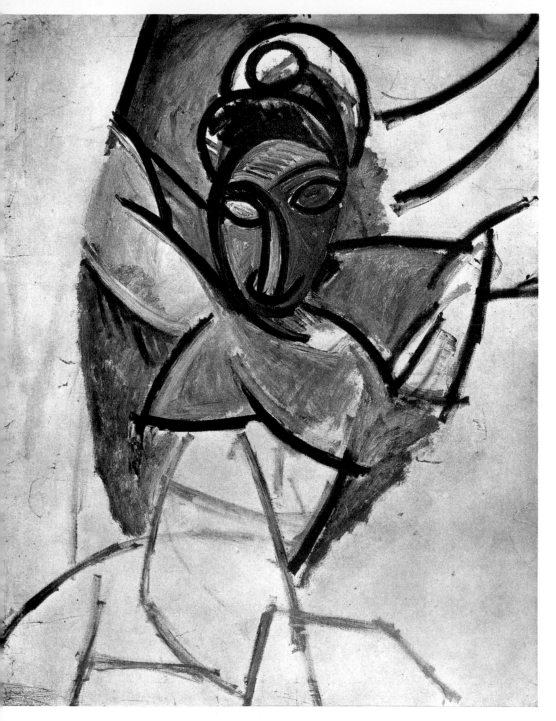

8. Pablo Picasso. *Woman* (study for *Les Demoiselles d'Avignon*). 1906–7

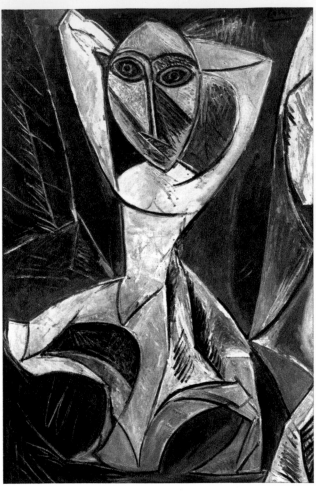

9. Pablo Picasso. *Dancer*. 1907

10. African Sculpture (Bakota).
Funerary Fetish

What are the pictorial problems that *Les Demoiselles d'Avignon,* with its still molten vocabulary, had posed but not yet solved? The radical quality of *Les Demoiselles* lies, above all, in its threat to the integrity of mass as distinct from space. In the three nudes at the left, the arcs and planes that dissect the anatomies begin to shatter the traditional sense of bulk; and in the later figures at the right, this fragmentation of mass is even more explicit. The nudes' contours now merge ambiguously with the icy-blue planes beside them, and the concavities of the noses tend to disrupt the sense of a continuous solid. The square plane that describes the breast of the figure at the left still adheres to her torso, whereas the square plane that describes the breast of the figure at the upper right suddenly becomes detached from the body to assert its independent existence. Just as the impulse to explore the autonomous life of linear and planar rhythms seems almost to dominate Picasso's contact with perceived reality, the colors, too, have become more abstract. The blues and pinks used earlier in the Blue and Rose periods to convey moods of depression and frailty are now almost independent from expressive or representational ends. Most remarkably, the brilliant and varied pinks of the nudes exist first as autonomous means of fracturing these bodies into their agitated planar components and only second as means of representing flesh. And it is exactly this new freedom in the exploration of mass and void, line and plane, color and value—independent from representational ends—that makes *Les Demoiselles* so crucial for the still more radical liberties of the mature years of Cubism.

Les Demoiselles d'Avignon contained within its orbit any number of preparatory studies and postludes which, though works of lesser magnitude, investigated the problems of that moment. A study of a nude, for one, focuses on the savage, slashing arcs that appear sporadically in *Les Demoiselles.* Here the concave sweep of the nose between the almond-shaped eyes generates the expansive, arced rhythms that fragment the form into a tangle of energies. Moreover, the savagery is intensified by the incompleteness of the study. In the larger, more fully realized *Dancer,* also of 1907, the dominant motif is again the broad arcs whose force not only cuts wildly into the figure as well as into the tropical density of the background, but even seems to threaten the balance of the figure, whose only factor of equilibrium, as in *Les Demoiselles,* is the haunting stare of the masklike eyes.

Again, as in *Les Demoiselles,* the influence of African Negro art is evident. In comparing the *Dancer* with an African funerary figure from Bakota, the dual nature of this influence soon becomes clear. For one thing, primitive sculpture apparently exemplified, for Picasso, the freedom to distort anatomy for the sake of creating a rhythmic structure that can merge solids and voids and invent new shapes. For another, its terrifying power and suggestion of a supernatural presence seem to have been equally stimulating. Looked at in the context of the Western artistic tradition of the nude, the African sculpture, like Picasso's *Dancer,* is unbearably ugly. As such, it provided Picasso with an artistic stimulus of man-made grotesquerie that could, perhaps, surpass even the God-made grotesquerie

of his earlier *Dwarf Dancer* of 1901. In this fascination with the deformed and the morbid, Picasso reflects a recurrent strain in Spanish art, which he will perpetuate in his own later work. 11

The violence of 1907 can be felt in the still lifes of that year. The emotional neutrality that we might expect in a still life is upset, for example, in the *Still Life with Skull,* not only by the way in which Picasso has adapted the jagged, twisting rhythms of *Les Demoiselles* but by his use of a riotous, almost Expressionist palette, whose searing reds, blues, and lavenders add to the dissonance. The very choice of still-life objects contributes to the surprising drama of a table top, for, amid the sensuous and intellectual pleasures of artist's palette, framed painting, pipe, and books, Picasso has introduced the traditional still-life theme of vanity and human transience by including a skull. In so doing, he recalls the original allegorical intention of *Les Demoiselles*—in which a figure carrying a skull was to enter the hedonistic environment of five nudes, a sailor, and an arrangement of flowers and fruit—and foreshadows, as well, the impassioned expressive qualities with which he will so often invest his later still lifes, even without the help of such traditional symbolism. This is already apparent, in fact, in another still life of the same year, *Flowers,* in which a comparably dramatic import is achieved by more explicitly formal means, without depending upon such an emotive object as a skull. Here the bristling, spiky shapes of leaves and flowers, opposed by the rectilinear, stable shape of the black fireplace at the left, reverberate in the impetuous hatchings that describe the curtain, vase, and table top and transform the whole picture into a pulsating jungle of coarse energies, as compellingly savage as those which inform the figure studies of the same time. 11 7 17

In the following year, Picasso temporarily purged himself of these barbaric impulses in order to concentrate on the more measured and systematic study of the formal problems created so violently in *Les Demoiselles d'Avignon*. The less impassioned, more resolute qualities of the works of 1908 may be explained, in part, by the almost inevitable calm and control that might be expected to follow the cathartic vehemence of 1907. It may also be explained by the disciplining influence of the French tradition, which confronted Picasso in historical retrospect at the famous Cézanne memorial exhibition held at the Salon d'Automne in 1907 and in living actuality in the person of Georges Braque, whom he met at about the same time through the poet Guillaume Apollinaire and the dealer—and, later, historian of Cubism—Daniel Henry Kahnweiler. In his work of 1908, Picasso seems more and more to suppress the pathos and fury of his earlier art, substituting the rigorous control of eye and intellect recurrent in the French pictorial tradition.

A picture like the *Nude in the Forest (La Grande dryade)* continues something of the constructive fantasies of the nudes of 1906 and 1907, but it also offers a new sense of order and rational exploration that replaces the more impulsive approach of the earlier works. The figure now seems to be studied in a manner that, for Picasso, is relatively dispassionate, for the artist here quietly examines the elementary building blocks of three-dimensional form. The colors, too, change from the surprising III

outbursts of 1907 to a cautious and restricted palette of dark blues and ochers. Yet, even here, Picasso's penchant for the grotesque is hardly absent. So abstract does the analysis of volumes become that the relation between the nude figure and external reality is unexpectedly fantastic. The scale, in particular, appears bizarre and irrational, for there is no way of judging whether this figure, clumsily moving through the forest like the creation of a twentieth-century Frankenstein, is pygmy or giantess.

More conspicuous in Picasso's *oeuvre* of 1908, however, were still lifes and landscapes. Though he had painted these subjects before, and often with vigor and drama, their new predominance in his work of 1908 indicates a turning from his earlier preoccupation with the human figure as a vehicle of feeling. Just as Cézanne in the 1870s, under the impact of Impressionism, was to reject or, rather, to harness the human passions that animated his early work, so, too, did Picasso abandon subjects that evoked human compassion in order to focus on the emotionally more neutral themes that are provided by still life and landscape.

IV A still life of 1908, *Fruit and Wineglass,* continues and transforms the study of the pictorial problems that had preoccupied Cézanne in his great table arrangements of the 1880s and 1890s. What Cézanne had explored in his still lifes was in good part the difficult and precarious reconciliation of the demands of nature with the demands of art. How was one to establish the illusion of volume and solidity without destroying the two-dimensional fabric of paint that constitutes the flat truth of the picture surface? How could one record both the specific textural qualities of an object and its more fundamental structural components? How could one describe the fugitive passage of light as well as the enduring massiveness of objects beneath such transient surfaces? How could one seize the perceptions of a moment as well as present a stable, timeless order?

For Picasso, after the freedom gained in *Les Demoiselles d' Avignon,* the balance between the reality of nature and the reality of art was not so tenuous as it had been for Cézanne. In comparing Picasso's *Fruit*
13 *and Wineglass* with Cézanne's *Still Life: Jug of Milk and Fruit* of 1888–90, we realize that art has won the battle. For one thing, Picasso's textures are far more neutral than Cézanne's. Indeed, they have become so abstract that the identity of the fruit is even more conjectural than in the Cézanne. Likewise, Cézanne's famous tilted table tops are tilted more acutely by Picasso, so that the objects are tightly compressed forward and the puncturing of the picture plane—a consequence of traditional perspective—is avoided less arduously than in Cézanne's work. Furthermore, the tremulous, complex color planes that define Cézanne's surfaces are replaced by forms that vary more simply in color and value. These variations clarify the surfaces and edges more precisely, and suggest a light that is far more abstract than the still natural light that floods Cézanne's table tops. And Picasso's scale, too, is far less familiar than Cézanne's. As in the *Nude in the Forest,* we are confronted with shapes that might be the strange, constructive toys of either titans or Lilliputians.

In such still-life painting, the elements of a Cubist vocabulary are more fully developed. The interplay between organic and inorganic forms,

which often occurs in Picasso's early work for symbolic reasons or for evocation of pathos, now becomes a means of equating the irregularities of nature with the disciplined control of geometry. The pure conical forms of the goblet are so closely confounded with the like geometry of the pears that the object in the background is no longer decipherable as either man-made or natural. And, in the same way, the illusion of volume achieved by the strong chiaroscuro is never consistent and is always contradicted by the asserted reality of the picture plane. The separate objects merge at their points of maximum distance from the surface, so that ultimately the fruit and wineglass become an interlocking network of broadly defined planes that never complete the illusion of fully rounded, independent masses.

This homage to and transformation of Cézanne is again evident in the many landscapes of the same year, a subject whose new importance in Picasso's art marked a temporary rejection not only of the prominent role that the human figure had played in his earlier work but also of the Spanish tradition, which minimized the art of landscape painting. A characteristic example, painted in 1908, once more focuses on pictorial rather than emotive issues. Trees, soil, and clouds are stripped of surface detail and are energetically compressed into a primitive pictorial architecture that seems, like the objects in the still life, at once monumental and diminutive. Indeed, the curiously unreal, almost doll-like quality of these rudimentary shapes recalls the work of Henri Rousseau, who was admired at this time not only by Picasso but by the Parisian *avant-garde* in general. Unlike Rousseau's paintings, however, Picasso's landscape achieves its simplicity by a conscious reduction of means whose underlying sophistication is easily disclosed. Picasso's palette, for instance, demonstrates an extraordinary virtuosity in the nuanced, yet vigorous variety of ruddy, earth-colored hues. Moreover, the balancing of the unstable patterns of earth and arching tree trunks against the emphatic vertical contours to the left of the center is no less masterful. Again Picasso asserts the flat continuity of the picture plane, for, despite the seeming bulk of earth and tree, such solids are ultimately subordinated to an interweaving of planes that never perforate the surface. Recalling Cézanne, even the voids of the distant, slate-gray clouds are locked into this two-dimensional fabric. This is accomplished not only by their flat, scalloped patterns, which continue similar motifs in the contours of the mountain and the trees, but by the forceful textural manipulation of the paint—in this case, watercolor—which asserts the palpability of the picture surface.

From 1907 on, Picasso's development cannot be understood without also considering the evolution of the Frenchman Georges Braque. From the time of their first meeting in 1907 until about 1914, the art of the two men followed a closely interrelated course that for several years attained a disciplined vocabulary that subordinated individual eccentricities to a comparatively objective standard. As a Frenchman who had come to Paris from Le Havre in 1900, Braque could hardly have been less like Picasso in background. While Picasso was painting scenes of allegory and human despair, Braque worked within the confines of the Im-

pressionist viewpoint, painting candidly observed landscapes and still lifes. By 1906, he had given his temporary allegiance to the coloristic exuberance of the Fauves, producing such works as the landscape at L'Estaque. Yet here, in historical retrospect, we can already perceive a certain insistence on the analysis of solids that distinguishes Braque from his fellow Fauves and allies him more closely to the structural bent of Cézanne, who had earlier scrutinized this same Provençal landscape in terms of its volumetric fundamentals. And in the following year, 1907, Braque painted another of Cézanne's sites, the *Viaduct at L'Estaque,* in which the angular definition of planes in the central vista of earth, bridge, and houses grows even more emphatic, especially by contrast with the looser definition of the trees that frame the view.

Perhaps the first explicit statement of the mutual influence of Braque and Picasso may be seen in Braque's *Large Nude* of 1907–8, which reflects the world of *Les Demoiselles d'Avignon.* Braque's is a curiously unconvincing work, but its failings help us to understand the basic distinctions between the two masters that are temporarily, though never completely, obscured by the common excitement of the Cubist adventure. Presumably an echo of Picasso's barbarism, the *Large Nude* lacks both the formal and the expressive energy of Picasso's primitive women. The face is bland by contrast with the magical fierceness of *Les Demoiselles.* The coarse and blocky planes, as well as the heavily defined contours, appear tentative and timid. The energy and violence of the Spaniard Picasso are clearly foreign to the Frenchman Braque, who stems from a countertradition of elegance and intellectuality.

Such a painting, however, was exceptional in Braque's *oeuvre.* Wisely, he concentrated on those subjects which corresponded to his French heritage; and, in 1908, he continued to explore landscape and still life as a means to pictorial rather than emotive ends. The *Houses at L'Estaque* of that year is perhaps even more advanced than any of Picasso's contemporary work. Again, a comparison with Cézanne is inevitable and demonstrates once more that Braque, like Picasso in 1908, had resolved the precarious tension of Cézanne's dual homage to optically perceived nature and intellectually conceived art in favor of art. Next to a Cézanne landscape like the *Turning Road at Montgeroult* of 1899, Braque's canvas consciously disregards the data of vision. His Provençal houses, boldly defined by the most rudimentary planes, have so thoroughly lost contact with the realities of surface texture or even fenestration that at places— as in the background and the lower right foreground—they are subtly confounded with the green areas of vegetation. And, just as the description of surfaces becomes remote from reality, so, too, do the colors take leave of perceived nature and tend toward an ever more severe monochrome that permits the study of a new spatial structure without the interference of a complex chromatic organization. In the same way, the light follows the dictates of pictorial rather than natural laws. Though multiple sources of light are often implied in Cézanne's work, his painting never violates so completely the physical laws of nature. In Braque's painting, however, the houses are illuminated from contrary sources—from above, from the

front, from both sides—in order to define most distinctly the planar constituents of architecture and landscape. And spatially, too, no painting of Cézanne's is so congestedly two-dimensional; for Braque's houses, despite their ostensible bulk and suggestions of perspective diminution, are so tightly compressed in a shallow space that they appear to ascend the picture plane rather than to recede into depth.

Yet, within this apparently rudimentary vocabulary, there are the most sophisticated and disconcerting complexities. It may be noticed, for example, that whereas the planar simplifications suggest the most primary of solid geometries, the contrary light sources that strongly shadow and illumine these planes permit, at the same time, unexpected variations in the spatial organization. Suddenly a convex passage becomes concave, or the sharply defined terminal plane of a house slides into an adjacent plane to produce a denial of illusionistic depth more explicit than Cézanne's.

Both Matisse and Louis Vauxcelles, the critic who had unwittingly given the Fauves their name, referred to Braque's work of the time and to this painting in particular as being composed of cubes—remarks that were destined to name the Cubist movement for history. Yet their observation was only partially right. For all the seeming solidity of this new world of building blocks, there is something strangely unstable and shifting in its appearance. The ostensible cubes of *Houses at L'Estaque* were to evolve into a pictorial language that rapidly discarded this preliminary reference to solid geometry and turned rather to a further exploration of an ever more ambiguous and fluctuating world.

2 *Picasso and Braque, 1909–1911*

Just as Impressionism emerged in the 1860s and 1870s as a logical sequence that seemed generated by the epoch rather than by the will of any single master, so, too, did Cubism evolve with an inevitability that almost appeared to shape, rather than to be shaped by, the individual directions taken by Braque and Picasso between 1909 and 1912. Given the premises of *Les Demoiselles* of 1907 and the more intellectualized and measured still lifes and landscapes of 1908, both Braque and Picasso were compelled, as it were, to disclose, one after the other, the adventurous deductions that followed their first statements. To say this is not to minimize the genius of these two masters, for between 1908 and 1910 two other artists, Raoul Dufy and André Derain, momentarily allied themselves to an early phase of Cubism, but, lacking Braque's and Picasso's courage and creative insight, soon retraced their steps. It is to emphasize rather how, in retrospect, Braque's and Picasso's works of these years seem to grow, one from the other, with an exhilarating logic and almost organic necessity.

 Some measure of the tempo and direction of Cubism in 1909 may be indicated by comparing a Braque landscape of the summer of that year with his *Houses at L'Estaque* executed during the previous summer. Like the earlier work, the view of La Roche-Guyon (a picturesque village on the Seine near Mantes, where Cézanne also painted) is still partially dependent upon the Impressionists' commitment to a specific view in nature, yet clearly, it goes much further in yielding to the demands of a pictorial order independent from the data of vision. Whereas the blocky planes of the *Houses at L'Estaque* conveyed, for all their instability, the illusion of

19

bulk and solidity, the later canvas now announces decisively the destruction of the illusion of mass. The planar rhythms are more rapid and nervous, producing a shifting, lambent surface that parallels the loose planes and brushwork in the late work of Cézanne. Indeed, it seems that the broad, clearly defined planes of 1908 have finally become unhinged and that the earlier structure was only a house of cards that now flutters and floats in complete disregard of gravity. Furthermore, the balance between the particular reality of the scene represented and the very unreal vocabulary of glistening planes and facets is even more precarious than before. As in the mature phase of Impressionism, with its increasingly homogeneous vocabulary of "commas" of light, the narrowing restriction here to a pattern of herringbone brushwork and sharp angles threatens to conceal the identity of the subject. It becomes more and more difficult, especially in comparison with the 1908 landscape, to distinguish precisely the boundaries between the planes that describe the earth and the planes that define the tree or the houses. And, in another view of La Roche-Guyon of the same time, 20 this confounding of architecture and landscape in a shimmering fabric of dismembered planes becomes even more pronounced.

The same phenomena are observable in Picasso's work of 1909. In the *Still Life with Gourd,* the ponderous solidity of the 1908 *Fruit and* VII, IV *Wineglass* is challenged by the extreme shallowness of the space and the greater frequency of sudden contrasts of light and dark, so that the two protagonists of the still-life arrangement, the vase and the gourd, can be read almost as concave molds cut into the table top rather than as convex solids. Likewise, the quickened tempo of the interlocking conical rhythms of the cloth and the pears in the lower right produces the same agitated flicker and weightlessness found in Braque's work. The vocabulary, too, is increasingly austere, approaching an ascetic reduction to straight lines and clean-cut arcs and reasserting that interplay between the organic and inorganic—the parallelism of vase and gourd—which, by 1910, will result in an almost completely geometric representation of that irregular and mysterious organic form, the human body.

The colors, too, move in this austere direction. By contrast with the Cézannesque variety of yellows, oranges, and reds that, in Picasso's 1908 still life, define solid forms in space, the 1909 work is restricted to two fundamental colors, brown and green. The variety of color possible in an array of cloth, fruit, vegetable, vase, table, chair, and wallpaper is now reduced, and is limited as severely as the variety of shape and texture. In the same way that it evolved an almost homogeneous vocabulary of fragmented planes to describe the structure of the world, Cubism produced a comparably narrow chromatic range. Earlier, Picasso had used such a monochrome palette, but, in the tinted Blue and Rose pictures of 1901–6, the color spread, as it were, an enshrouding veil of emotion. Now, in Cubism, the monochrome lens begins to focus on unreal, neutral hues of tan, gray, and brown that pervade the subject with an aura which is equally mysterious, but which substitutes for the mood of despair and spirituality the recondite atmosphere of cerebration and analysis.

The impulse toward increasing fragmentation of mass seen in the

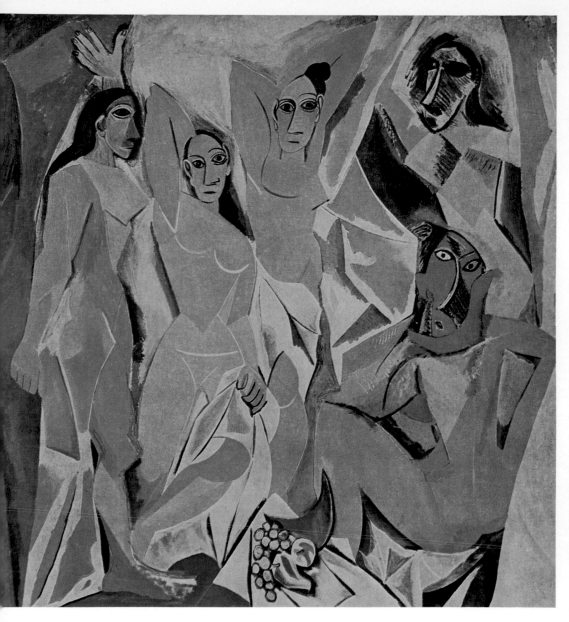

I. Pablo Picasso. *Les Demoiselles d'Avignon*. 1907

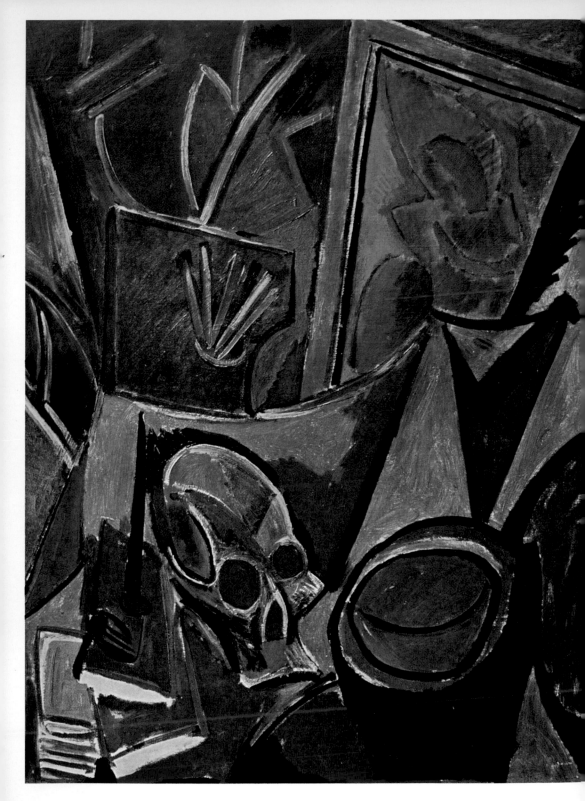

II. Pablo Picasso. *Still Life with Skull*. 1907

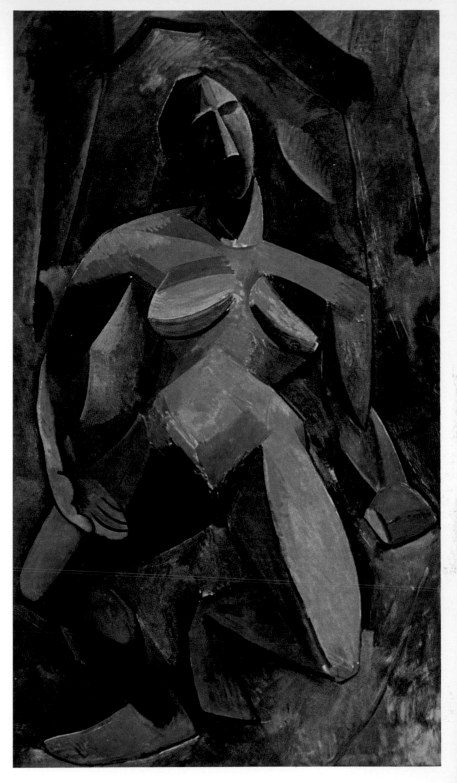

III. Pablo Picasso. *Nude in the Forest (La Grande dryade)*. 1908

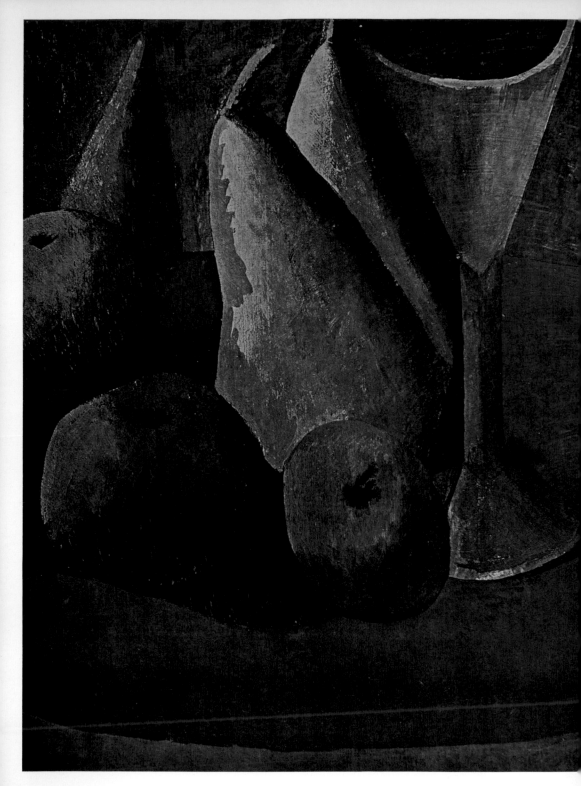

IV. Pablo Picasso. *Fruit and Wineglass*. 1908

V. Pablo Picasso. *Landscape*. 1908

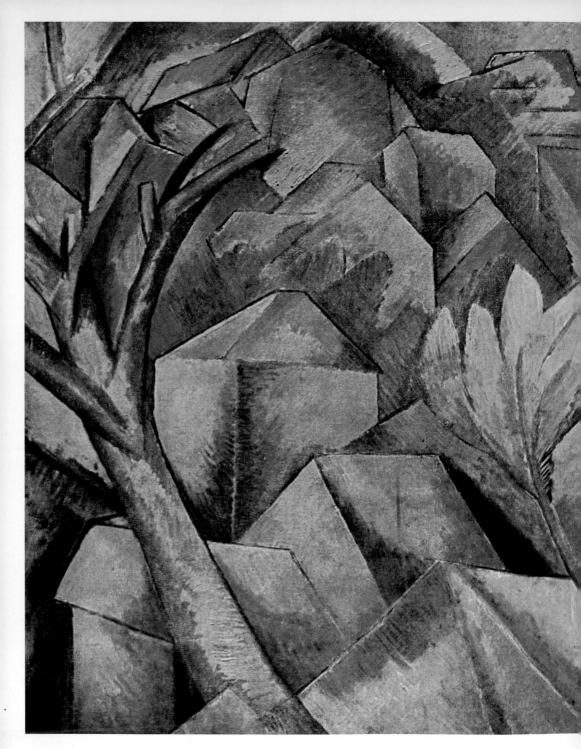

VI. Georges Braque. *Houses at L'Estaque*. 1908

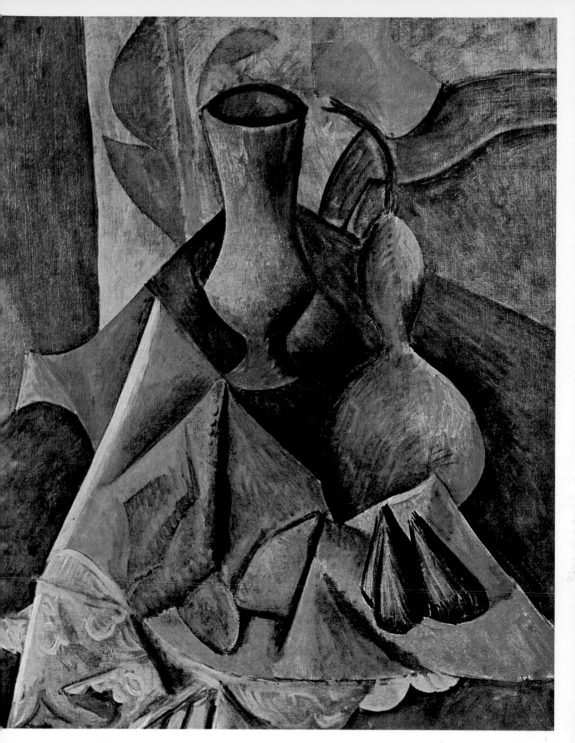

VII. Pablo Picasso. *Still Life with Gourd*. 1909

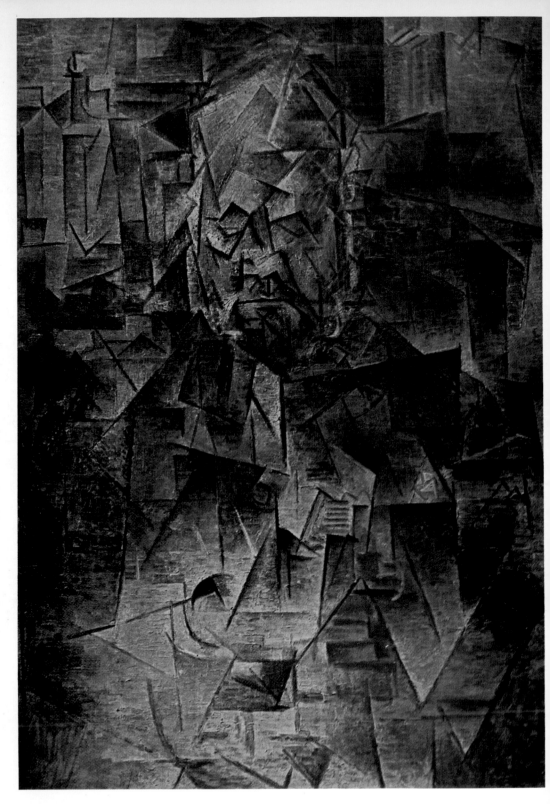

VIII. Pablo Picasso. *Portrait of Ambroise Vollard.* 1909–10

Still Life with Gourd is perhaps even clearer in Picasso's landscapes of the

21 same year. The view of the reservoir at Horta de Ebro (Horta de San Juan), a Spanish town where Picasso spent the summer of 1909, depends, like Braque's views of La Roche-Guyon, upon a very particular site but similarly transforms it into a kaleidoscopic surface of crystalline planes. Again, the rapid and arbitrary changes of shadowed and illumined surfaces destroy any consistent illusion of mass. Even the highest rooftops are subtly woven into the sky in a manner that, paradoxically, denies the evident tangibility of this picturesque pile of stucco houses. But, above all, this assault upon mass and gravity is effected by the prominence of the so-called reservoir (actually a trough for animals) in the lower center of the canvas. As in so many of Monet's later paintings, the usual relationship of load and support, illusion and reality, is inverted; for here a palpable architectural structure above is supported and re-created by its watery reflection below. More and more, Picasso's seemingly objective translation of the planar irregularities of a Spanish hill town into a disciplined geometric structure takes on a curious evanescence and mystery that look backward to the frail, spectral people of his Blue and Rose periods and forward to the fragile, enigmatic labyrinths of line and plane still to be created.

However much Braque and Picasso in these years appear to approach an impersonal style, it should not be forgotten that their personal temperaments can still be perceived beneath the growing common denominator of the Cubist vocabulary. Even in the emotionally neutral territory of the 1909 landscape and still life discussed above, Picasso asserts a degree of vigor and energy foreign to Braque. In the *Still Life with Gourd,* the greater excitement and unpredictability of Picasso's works are affirmed by the tenuous stability of the rigidly upright vase and gourd amid a torrent of erratic countermovements and by the vigorous pressure of the three pears against the spiky facets of the tablecloth. Even the more delicate view of Horta de Ebro is nearly as forceful in the bold, elliptical thrust of the walls of the reservoir against the vertical plane to the right or in the jostling, irregular rhythms created by the unexpected patterns of the hill houses. By contrast, Braque offers a more lucidly predetermined structure. The views of La Roche-Guyon almost fit comfortably into a diagonal network of diamond-shaped patterns, and their transitions of light and of plane are far less abrupt and jagged than Picasso's. But, beyond this, Picasso seems to be more unwilling to give up the representation of a specific reality. Whereas the individuality of Braque's subjects seems subordinate to the artfulness of his picture-making, Picasso's still lifes and landscapes have, in keeping with the heritage of Velázquez, Zurbarán, and Goya, the flavor of unique facts that are recorded by the artist with a fervent respect that triumphs over pictorial artifice. In the views of La Roche-Guyon, a predetermined order is imposed upon the singular data of reality; in the view of Horta de Ebro, the unique irregularities of the topography determine the unique irregularities of the work of art. Or consider a Picasso

18 still life of 1909, the *Fishes*. Here, in a spare, ascetic painting reminiscent of a seventeenth-century Spanish still life, one senses the Spanish painter's profound humility before the singular identity of objects, making the spec-

tator aware primarily of the presence of three individual fish and a cut lemon rather than of the generic array of table paraphernalia found in the Dutch or French still-life tradition.

Some of the qualities that differentiate Picasso from Braque—a greater sense of the concreteness and particularity of objects and a greater tension and energy—can be perceived as well in the figure studies of 1909. In the *Seated Woman (Woman in Green),* perhaps a portrait of Fernande Olivier, Picasso's companion during these years, the shimmering facets are not handled methodically and consistently enough to deny the sense of a particular human presence who fully dominates the painting. Neither are they intricate enough to diffuse the tremendous sense of energy created by the muscular tension of the arm (so reminiscent of certain nude studies of 1906) and by the vigorous sweep and thrust of the neckline. Less committed to an emotional response to the human form or to the Spanish interest in particular things and people, Braque's contemporary figure studies offer a more consistent vocabulary than Picasso's. The *Head of a Woman* of 1909, like the *Large Nude* of 1907–8, is psychologically tepid, without the tension and alertness of Picasso's woman, and is more coherently fused with its background. In Picasso's work there is still a reluctance to deny the distinction between the human form and the inanimate trappings of wall and furniture that surround it. His woman, in fact, has as much psychic and physical presence as the more literally realistic 1906 portrait of Gertrude Stein.

In a more advanced work of 1909, *Seated Woman,* the fracturing of mass into ever smaller facets has gone much further toward annihilating the integrity of the human form and especially of the human face. Yet even here, Picasso sharply distinguishes the figure from its setting. By contrast with the broad planes of the background and the pliant spiral of the chair arm at the right, the seated woman is invested with an intense physical energy that is revealed not only in the acute torsion of the twisting neckline but in the bristling planes that define her body.

By the beginning of 1910, impelled to an ever greater fragmentation of mass and to a more consistently regularized vocabulary of arcs and angles, Picasso treated even the human figure with a coherence that finally confounded the organic and the inorganic. The unfinished *Girl with Mandolin,* a Corot-like studio portrait of a model named Fanny Tellier, takes us far beyond the 1909 figure paintings into a world that seems to follow the glistening transparencies of *The Reservoir, Horta* rather than the more ruggedly sculptural figure studies of 1909. With its paradoxes of plane, light, and texture, the *Girl with Mandolin* introduces the strangely elusive and fluctuating world of the mature years of Cubism, a world in which the fixed and the absolute are replaced by the indeterminate and the relative.

As in the aesthetic and structural innovations of contemporary architecture, in which transparent glass planes and free-standing walls both define a volume and belie that definition by implying a fusion with the space around it, the precise boundaries of the contours that describe the model and her mandolin cannot be located with visual certainty. In

this unstable world of bodiless yet palpable shapes, the integrity of matter undergoes an assault comparable to that made on the once indivisible atom. The contours of the hair, for example, destroy the solidity of the head by merging with the planes that describe the adjacent space, just as the bent elbows seem to dematerialize in their translucent ambiance.

Similarly, spatial positions must now be defined relatively rather than absolutely. Unlike the fixed positions determined by Renaissance perspective systems, planes here are in a state of constant flux, shifting their relative locations according to a changing context. Is the cylinder of the upper arm in back or in front of the incomplete cubes at the left? Are these same cubes concave or convex? Do they move toward us or away from us? Even the texture of the painting shares such ambiguity. The shaded planes evoke the illusion, on the one hand, of modeled, opaque solids, and on the other, of a curiously translucent substance whose complex structural order is as visually puzzling as the spatial relations in a house of mirrors.

If fixed spatial relations are rejected by the continual shifting and rearrangement of planes, so, too, are fixed temporal relations. In observing how the profile of the head is repeated or how the upper arm shifts to a plane different from the plane of the shoulder, the spectator is obliged to assume that the figure is pieced together of fragments taken from multiple and discontinuous viewpoints. The ambiguous quality of time in a Cubist painting derives from this very phenomenon, for one senses neither duration nor instantaneity, but rather a composite time of fragmentary moments without permanence or sequential continuity.

In so creating a many-leveled world of dismemberment and discontinuity, Picasso and Braque are paralleled in the other arts. For example, their almost exact contemporary, Igor Stravinsky, demonstrates a new approach to musical structure that might well be called "Cubist." Often his melodic line—especially in *Le Sacre du printemps* (1912–13)—is splintered into fragmentary motifs by rhythmic patterns as jagged and shifting as the angular planes of Cubist painting and equally destructive of a traditional sense of fluid sequence. Similarly, Stravinsky's experiments in polytonality, as in *Petrouchka* (1911), where two different tonalities (C and F # major in the most often cited example) are sounded simultaneously, provide close analogies to the multiple images of Cubism, which destroy the possibility of an absolute reading of the work of art. In literature as well, James Joyce and Virginia Woolf (both born within a year of Picasso and Braque) were to introduce "Cubist" techniques in novels like *Ulysses* (composed between 1914 and 1921) and *Mrs. Dalloway* (1925). In both these works the narrative sequence is limited in time to the events of one day; and, as in a Cubist painting, these events are recomposed in a complexity of multiple experiences and interpretations that evoke the simultaneous and contradictory fabric of reality itself.

Despite the fact that the more consistent vocabulary and radical disintegrations of *Girl with Mandolin* introduce a more advanced and abstruse stage of Cubism, Picasso somehow preserves much of the physical and emotional integrity of his model. Her feminine form, with its rounded patterns of breasts and coiffure echoing the arc of the mandolin, is by no

means obscured totally in the Cubist network of planes; and there even emerges something of a quiet, introspective melancholy (not unlike that of the Circus period) from a style that has so often been narrow-mindedly interpreted as coldly antagonistic to so-called "humanistic" values.

Indeed, Picasso's ability to present the peculiar data of a human being's personality and appearance in the abstract language of Cubism is even more conspicuous in other portraits of this time, most notably that of the German art critic Wilhelm Uhde, painted in the spring of 1910. 29 Here, almost miraculously, the coruscating web of lines and planes, so much more broken and insubstantial than in the earlier *Girl with Mandolin,* unveils a sitter whose presence is as immediate as in any Goya or Velázquez. Behind the high forehead, the arched eyebrows, the tightly pursed lips, and the impeccable attire, one senses an incisive, elegant personality whose punctiliousness is almost caricatured. The awareness of a specific human presence is equally acute in the portrait of Ambroise VIII Vollard, the Parisian art dealer, done earlier in 1909–10. Emerging from the muted monochromes of this angular maze, Vollard's powerful head coalesces with an extraordinary concreteness in which are perceptible not only the facial structure of domed head and broad, protruding jawbones, but also the color and texture of ruddy flesh and light-brown hair, beard, and mustache. Even the portrait situation itself is surprisingly precise, for the famous dealer seems to be gazing downward at a rectangular shape, which, judging from his expression of shrewd critical discernment, may well be a work of art.

Braque's exploration of the ever more complex language of Cubism closely paralleled Picasso's, although portraiture, which attracted Picasso throughout his career, was foreign to Braque, who generally preferred landscapes, still lifes, and anonymous figures. In one of the epoch-making canvases of Cubism, the *Still Life with Violin and Pitcher* of 1909–10, IX Braque's decomposition of solids into air-borne, twinkling facets is as fully advanced as in any of Picasso's work of the time and creates perhaps even richer visual and intellectual paradoxes. Transparent and opaque forms are confounded wittily: the pitcher, which might well be made of glass, appears more opaque than the violin, whose fragile transparencies belie its wooden substance. Space, too, is fascinatingly ambiguous: the illusion of depth inferred from the sharp cut of the wall and triple molding at the right is contradicted by the continuous oscillation of planes that seem to cling to the picture surface as if magnetized. But most brilliant is the *trompe-l'oeil* nail that projects obliquely from the very top center of the canvas, a device that Braque uses in a comparable work of this time, the *Violin and Palette,* in which the nail projects through the hole of the artist's 30 palette. Here we have an essential key to the complex interchanges of art and reality that were later to be explored in collage, for the illusionistic nail helps to establish one of the basic meanings of Cubism—that a work of art depends upon both the external reality of nature and the internal reality of art.

This proposition may seem a truism in the sense that almost all art of the past reveals this dual responsibility toward nature and toward

its own language, but it was Braque and Picasso who first made this quality explicit in demonstrating, as it were, the very process by which nature becomes art. In these terms, the nail shatters the deception that Renaissance perspective would sustain in its attempt to transform the surface of the picture into a transparent window through which we see an illusion of reality. By appearing to cast a shadow upon the flat surface of the canvas, the *trompe-l'oeil* nail also casts doubts upon the illusions around it. If the painter's medium is now so irrevocably proved to be two-dimensional, then the dog-eared corner and the oblique thrust of wall and molding in the upper right of the *Still Life with Violin and Pitcher* are patently deceptions, as are the tilted, overlapping sheets of music below the nail in the *Violin and Palette*. But the implications go still further. The *trompe-l'oeil* nail is, after all, no more and no less real than the ostensibly unreal Cubist still life below, just as the almost palpable scroll of the violin in both pictures is actually no more and no less real than the body of the violin, which slips out of its material skin like a specter. The inevitable conclusion is that a work of art presents a complex interchange between artifice and reality. A picture depends upon external reality, but the Cubist means of recording this reality—unlike the means devised by the Renaissance—are not absolute but relative. One pictorial language is no more "real" than another, for the nail, conceived as external reality, is just as false as any of the less illusionistic passages in the canvas—or conversely, conceived as art, is just as true.

Again, this demonstration of the tension between the two realities, nature and art, can be paralleled outside the realm of painting. Two major modern novels, André Gide's *The Counterfeiters* (1925) and Aldous Huxley's *Point Counter Point* (1928), concern writers who transform the real events around them into the art of literature. Like these paintings, such novels posit an extra level of experience by articulating the relation between art and reality within the work of art itself. And, in so doing, they destroy that sense of transparency whereby a novel or a painting deceives its public into forgetting that the work of art has an artistic reality of its own.

It is therefore essential to realize that, no matter how remote from literal appearances Cubist art may at times become, it always has an ultimate reference to external reality, without which it could not express the fundamental tension between the demands of nature and the demands of art. Even the color, texture, and light of Braque's *Still Life with Violin and Pitcher* testify to this dual responsibility. Although it has often been pointed out that the ascetic ochers, silvers, and grays of 1910 and 1911 move far from the variegated colors of reality into a more abstract realm, the artificial colors of this painting are nevertheless partially relevant to the world of appearances. The browns of the violin and the table top at its right are directly appropriate to the colors of wood, just as the milky white planes of the tablecloth and the pitcher can allude, not implausibly, to the folds of a fabric and to the crystalline facets of what is perhaps a transparent pitcher. In the same way, the light in this painting, for all the arbitrariness of the contradictory patterns of highlight and shadow, conveys

a luminosity that refers to the laws of physics and visual perception as well as to the laws of art.

So it was that even during the years 1910–11, when Cubism moved furthest from a literal description of reality, there were occasional ventures into the recording of specific sites. For example, Braque's 1910 *View of* 23 *Sacré-Coeur from the Artist's Studio* offers, within this new vocabulary of dismembered planes, a partial reprise of the Impressionists' characteristic window view, which paid full homage to particular data of vision. Picasso, as well, in the previous year, 1909, executed a similar window view of Sacré-Coeur, which, though it demonstrates his typically more agitated 22 and irregular design, nevertheless reveals a similar dependence on non-artistic fact as the raw material of art.

Generally, however, the works of 1910–11 grow progressively more distant from a legible transcription of visual reality and increasingly difficult to decipher in their extraordinary degree of transformation from nature to art. A Picasso drawing of 1910, a study of a nude, can indicate 34 perhaps even more clearly than the paintings of the time the extreme purity that the Cubist vocabulary had attained by 1910. The impulse toward fragmentation of surfaces into component planes is now so strong that the very core of matter seems finally to be disclosed as a delicately open struc-ture of interlocking arcs and angles. Yet paradoxically, if this form appears to dissolve outward into the openness of the surrounding void, it also ap-pears to coalesce inward into a strangely crystalline substance.

Ironically, this advanced moment of Cubism is at once simpler and more complex than the earlier phases. On the one hand, the vocabulary, in its almost complete restriction to flattened arcs and straight lines and its abstention from irrelevant literal detail, has reached a pristine simplic-ity. On the other hand, the syntax has achieved an infinite sophistication revealed, for example, in the endlessly intricate shifting of planes within a hairbreadth, or in the equally rich variations of light and dark that make this gossamer scaffolding quiver in unpredictable ways upon the white surface of the paper. To accuse such a drawing of being a dry exercise in geometry is to ignore, for one thing, the extraordinarily subtle deviations from an absolute geometric purity in both the irregularities of touch and the irregularities of shape of these slightly imperfect curves and straight lines. In addition, it is to overlook the intellectual exhilaration with which the human form has been translated magically into a spider web of mys-terious spatial relations. Not since the century of Donatello, Uccello, and Piero della Francesca has there been so exalted a union of art, nature, and geometry.

In the summer of 1911, both Picasso and Braque vacationed at Céret, a village in the French Pyrenees, where they executed a group of paintings that articulates the culminating statement of the more difficult and rarefied style of 1910 and presents the climax of the preliminary adventure of Cubism. But, even here, nature is by no means rejected, for the very topography of the Pyrenean hill towns, with their ascending, complex clusters of stucco houses, must have been a partial stimulus to the analogous structure and color of this phase of Cubist painting. At this

very time, in fact, Braque recorded a window view of the zigzagging roof-tops and chimneys of Céret, which, though demonstrating the remoteness from literal appearance that Cubism had attained by 1911, still proceeds from the same attachment to an actual site that can be found in the earlier Cubist views of Sacré-Coeur, La Roche-Guyon, Horta de Ebro, or L'Es-taque.

The figure paintings of the summer of 1911, exemplified by Braque's *Man with a Guitar* and Picasso's *Accordionist*, likewise attest to the Cubists' increasingly enigmatic image of reality. As in the 1910 draw-ing of the nude, the space in these paintings has now become so shallow that at times the dissected planes appear almost to hover in front of the pic-ture plane, rather than behind it. The vocabulary, too, has been regularized to almost exclusively rectilinear and curvilinear elements. Together with this development, the degree of fragmentation has progressed so far that, at first glance, the reference to reality is barely possible to ascertain. Again there is a parallel with the later work of Monet, where the impulse to at-omize the world into ever more independent particles of colored light often conceals the identity of cloud and water, tree and earth under a superficially abstract veil. Yet, as with Impressionism, one can partially decode the obscure pictorial language of Cubism; and both Braque and Picasso often provide realistic clues to carry us into the more arcane passages, where lines and planes seem to refer to nothing but themselves. In both these works, for example, a scroll form at the lower left (repeated in the Picasso at lower right and in the Braque at upper and lower right) locates an ex-tremity of the chair in which the musician is seated. Suddenly, in the Braque, the cylinders of sleeves, the half-circles of buttons, the parallels of fingers may be discerned, and with them, the approximate location of torso, shoulders, neck, and head. And, further to relate the forms to reality, the upper left-hand corner shows a curl of curtain cord on a nail that functions like the *trompe-l'oeil* nails in the 1909–10 *Still Life with Violin and Pitcher* and *Violin and Palette*. In the Picasso, too, the figure is slowly disclosed as being in approximately the same position as the figure in the Braque—one glimpses a fragment of eyelids and mustache and, in the center, the saw-edged bellows of the small accordion merged with circular keys and pipelike fingers. It would be a mistake to assume, however, that every passage in these paintings can be decoded with respect to na-ture; for an essential aspect of Cubism is to deny a single definition of reality and to replace it with a multiple interpretation. Just as it is impos-sible to determine absolutely the location of any plane or line in these works, the identities of objects, too, are intentionally confounded in a way that recalls the multiple identities of Leopold Bloom, the hero of Joyce's *Ulysses,* who is not only a Jewish business man in Dublin but, at the same time, a Homeric hero, Jesus, Hamlet, and many other persons of fact and fiction. Having reduced the infinite appearances of the world to an ele-mentary vocabulary of arcs and angles, Braque and Picasso reveal analo-gies that challenge the once separate existences of objects. Thus, in the Braque, the arc of a shoulder is confounded with the arc of a collar or the scroll of an armchair; and, in the Picasso, the zigzag silhouette of the accordion reverberates in the stepped pyramid of planes in the background.

47

The artist need no longer accept the data of reality as fixed and irrevocable. And the spectator himself, like the artist, becomes a creator who reconstructs this new world in infinite ways. Again a Joycean analogy may be apt. Not the least remarkable thing about *Ulysses* is that it has been subject to an infinite number of interpretations, all partial, some contradictory, and none absolute. And on a more prosaic level, the complex, concealed identities of Cubist art found a surprising parallel in the military art of camouflage, developed largely by the French during the First World War. Gertrude Stein, in fact, recounts in her biography of Picasso how amazed he was to see the first camouflaged truck pass down the Boulevard Raspail and how he cried out, "Yes, it is we who made it; that is Cubism."

In these two canvases, Braque's *Man with a Guitar* and Picasso's *Accordionist*, it is astonishing to see how closely Braque's art and Picasso's have converged in the pursuit of this new pictorial world. Once more, there are reminders of paintings by Monet, Renoir, and Pissarro in the 1870s that, at times, are almost indistinguishable from one another. But, for all the ostensible anonymity of the Cubist style of 1911, differences between the two masters are still discernible. Typically, the rhythms of the Picasso are sharper and more strident (especially in the tense, unstable form of the narrow central triangle); and the alternations of light and dark are comparably more sudden and nervous. Braque, by contrast, retains a greater suppleness in his transitions and a more obvious equilibrium of structure, as in the lucid network of perpendiculars countered by the more predictable repetitions of a diagonal.

In two other masterpieces of this climactic year of Cubism— Braque's *Portuguese,* painted in the spring of 1911, and Picasso's *Ma Jolie,* x, xi painted in the winter of 1911–12—we are again confronted with a figure playing a stringed instrument. Although the attraction of Picasso and Braque to this subject and to musical instruments in general has often been interpreted in rather speculative terms (such as the analogies between the abstract nature of Cubism and that of music), the frequency of violins, guitars, and mandolins may perhaps be explained better by the fact that these instruments provided a convenient and easily manipulated example in reality of the purified pictorial forms of early Cubism. Indeed, a stringed instrument, with its clear oppositions of curved and rectilinear shape, solid and void, line and plane, is almost a dictionary of the Cubist language of 1910–12. Moreover, the specific juxtaposition of human figure and stringed instrument presented an opportunity to confound the anatomy of man and guitar in the kind of punning between the animate and the inanimate which was seen in earlier Cubist works and which now becomes more explicit. Again, both these canvases, for all the remoteness from the everyday world implied by their fantastic geometries, depend upon what is essentially a commonplace situation. Braque's point of departure is a Portuguese musician in a Marseilles bar; Picasso's is a woman—probably an allusion to his new love, Eva (Marcelle Humbert)—who plays a stringed instrument (probably a guitar). But, within these almost trivial scenes,

11. Pablo Picasso. *Dwarf Dancer*. 1901

12. Georges Braque. *Large Nude*. 1907–8

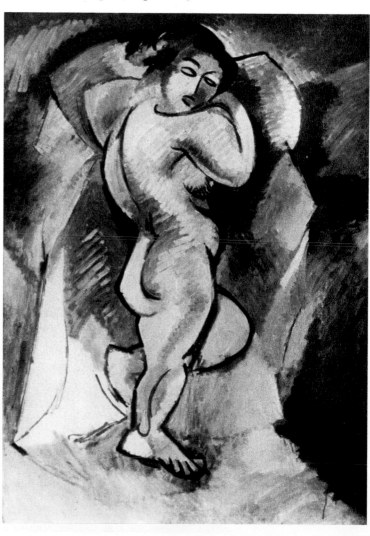

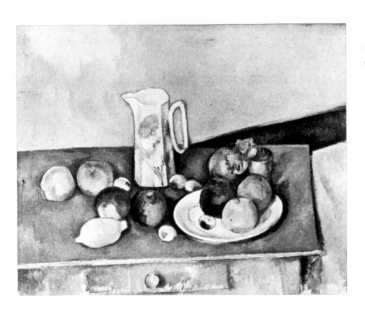

13. Paul Cézanne.
*Still Life: Jug of Milk
and Fruit*. 1888–90

14. Paul Cézanne.
Turning Road at Montgeroult.
1899

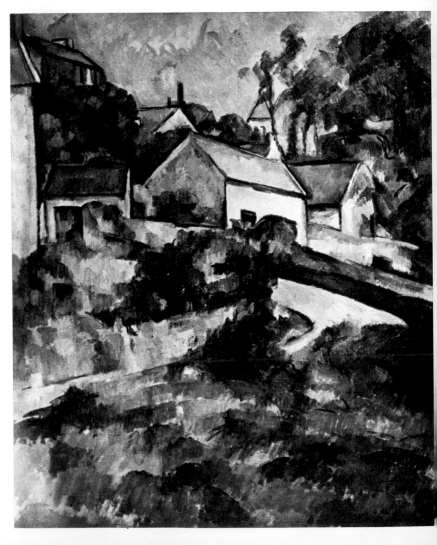

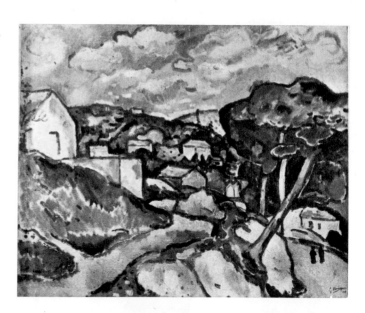

15. Georges Braque.
L'Estaque. 1906

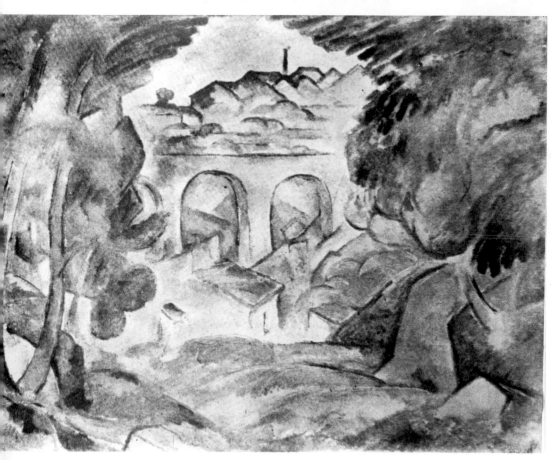

16. Georges Braque. *Viaduct at L'Estaque*. 1907

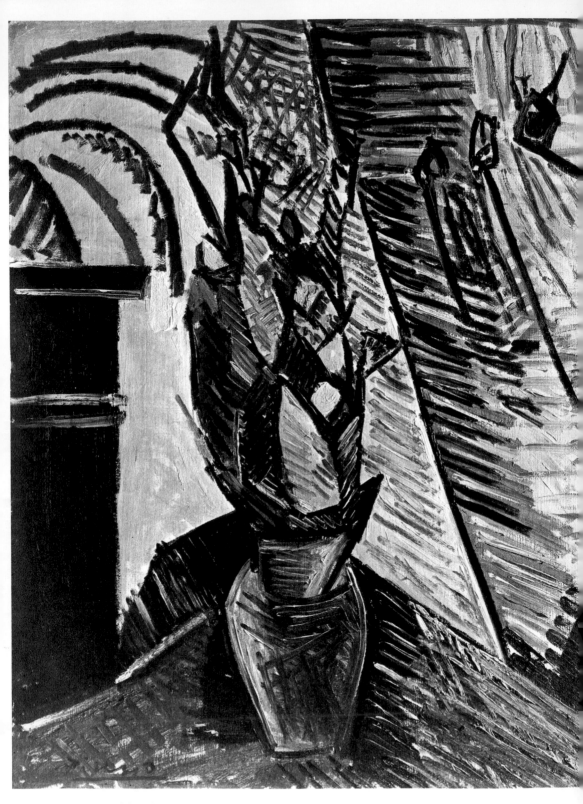

17. Pablo Picasso. *Flowers*. 1907

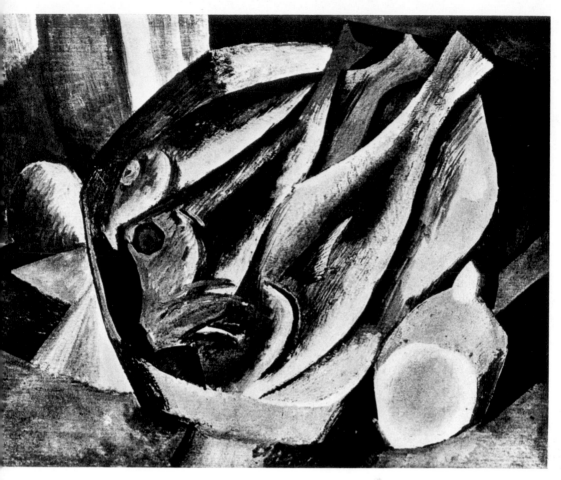

18. Pablo Picasso. *The Fishes*. 1909

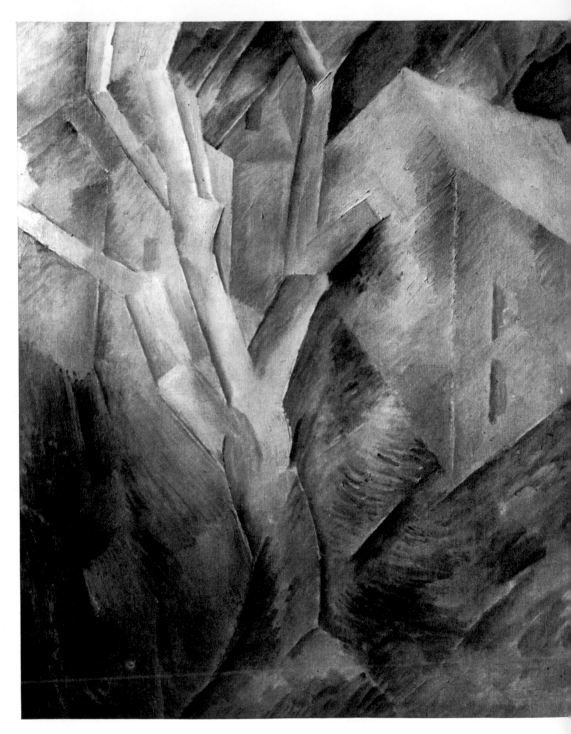

19. Georges Braque. *View of La Roche-Guyon.* 1909

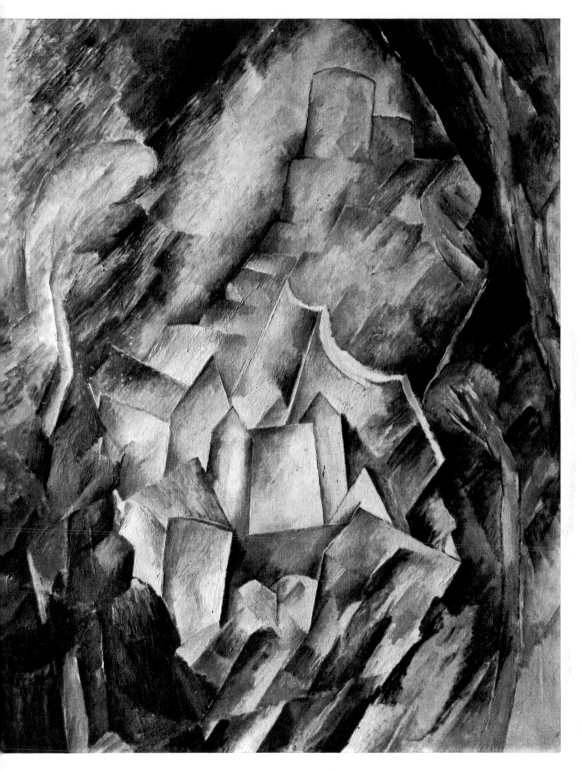

20. Georges Braque. *View of La Roche-Guyon*. 1909

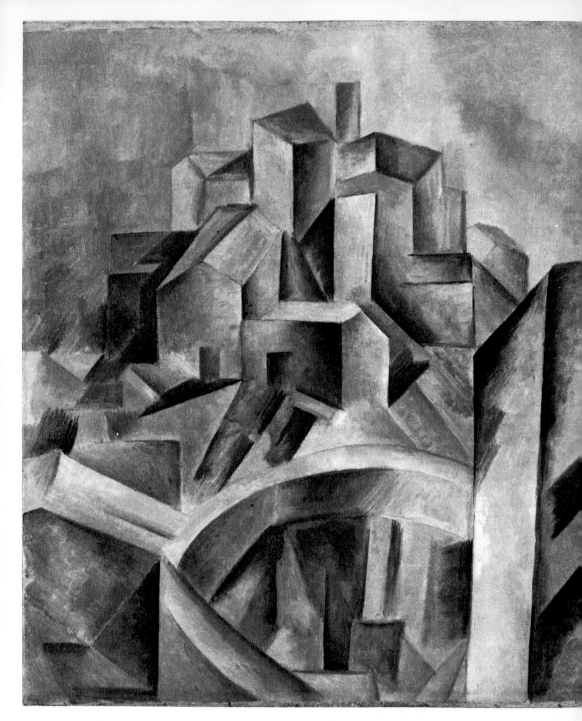

21. Pablo Picasso. *The Reservoir, Horta.* Summer 1909

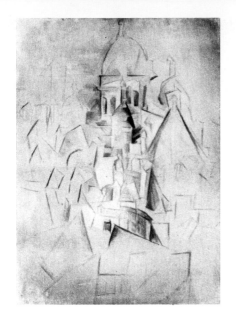

22. Pablo Picasso. *Sacré-Coeur*. 1909

23. Georges Braque.
*View of Sacré-Coeur from the
Artist's Studio*. Summer 1910

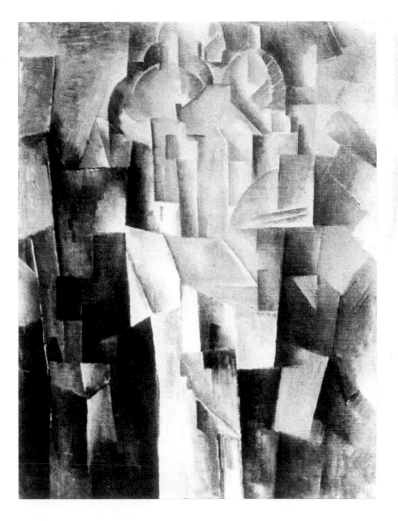

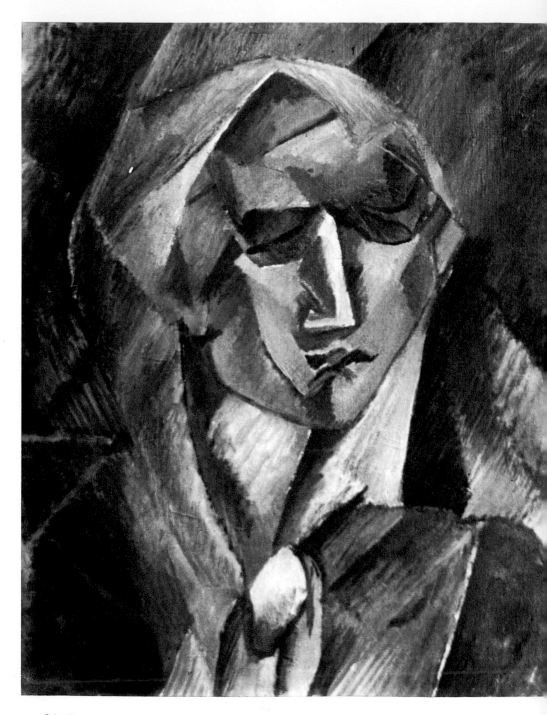

24. Georges Braque. *Head of a Woman.* 1909

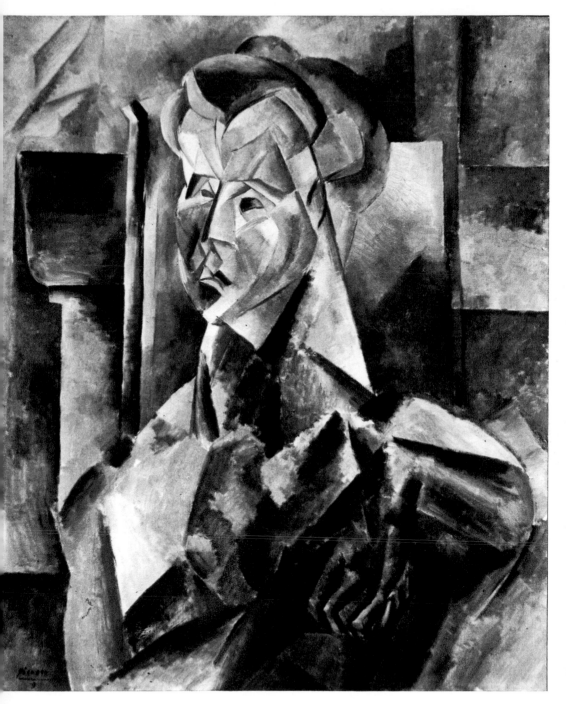

25. Pablo Picasso. *Seated Woman (Woman in Green)*. 1909

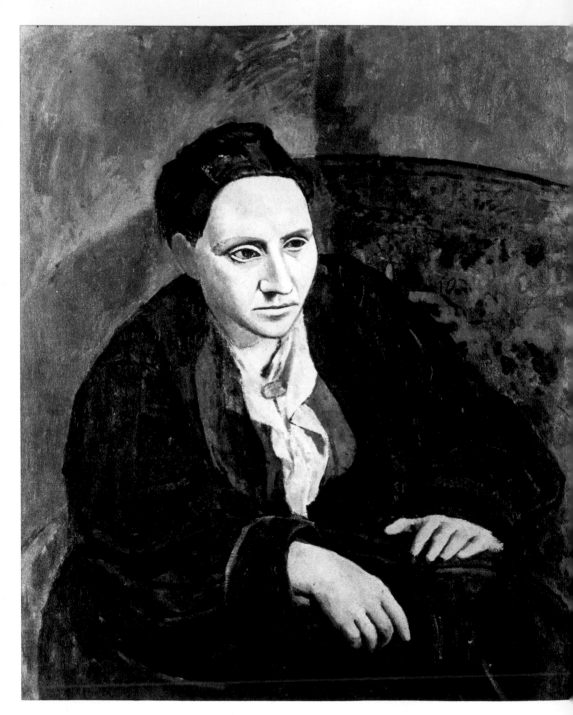

26. Pablo Picasso. *Gertrude Stein*. 1906

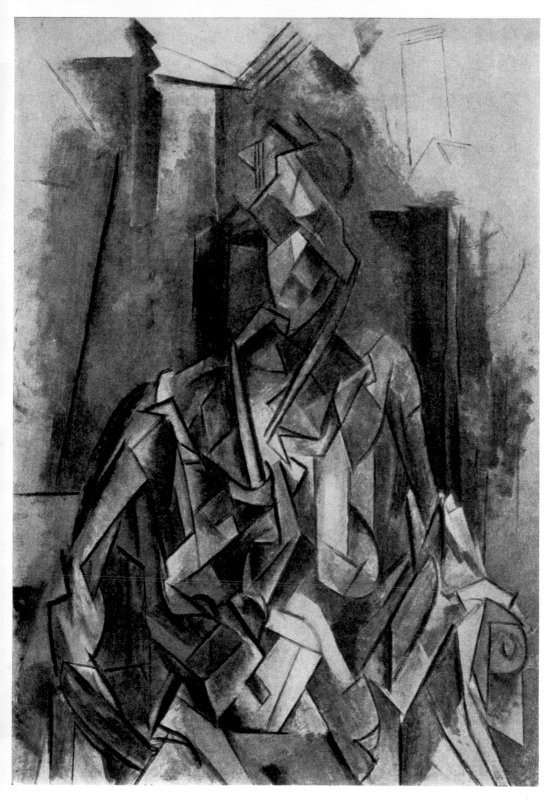

27. Pablo Picasso. *Seated Woman*. 1909

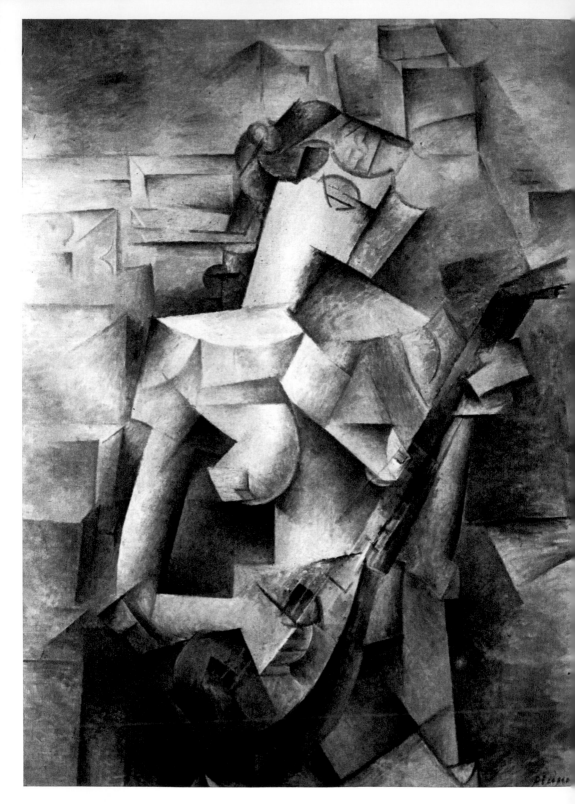

28. Pablo Picasso. *Girl with Mandolin (Fanny Tellier)*. 1910

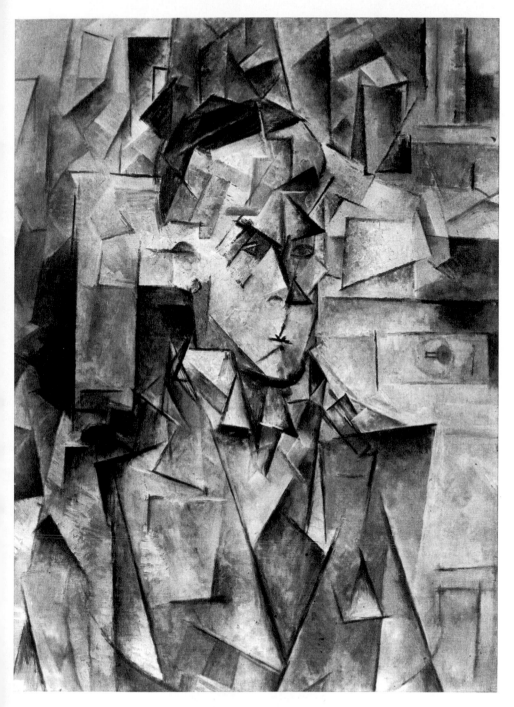

29. Pablo Picasso. *Wilhelm Uhde*. Spring 1910

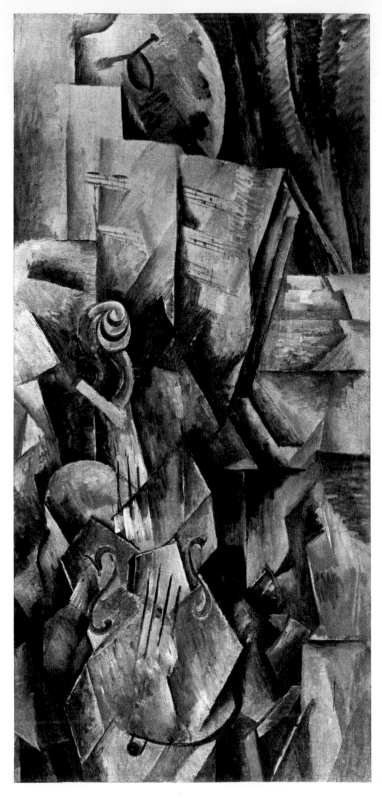

30. Georges Braque. *Violin and Palette*. 1909–10

there appear strangely disconcerting elements—letters, numbers, and symbols. In the Braque, the D BAL, D CO, &, and 10, 40 can be explained in literal terms as fragments from posters that one would expect to find on the wall of a bar (the D BAL, for example, is undoubtedly the latter half of GRAND BAL); and in the Picasso, the MA JOLIE, the 𝄞, and the four-lined music staff are explicit descriptions of the music being played and sung, a piece whose apparent title, "Ma Jolie," refers, with Cubist *double-entendre,* both to the refrain of a popular tune of the time ("O Manon, ma jolie, mon coeur te dit bonjour") and to Picasso's affectionate name for Eva. Yet, in the context of the unliteral vocabulary of Cubism, these letters, numbers, and symbols offer another major innovation in the history of Western painting.

Confronted with these various alphabetical, numerical, and musical symbols, one realizes that the arcs and planes that surround them are also to be read as symbols, and that they are no more to be considered the visual facsimile of reality than a word is to be considered identical with the thing to which it refers. The parallelism of these traditional symbols and Braque's and Picasso's newly invented geometric symbols is insisted upon through the way in which both are subjected to the same fragmentation. In a world of shifting and partial appearances, these old-fashioned signs, too, are first dismembered and then reintegrated with the dense visual and intellectual fabric of the painting. Thus, the title "Ma Jolie" slips into two different levels and the D BAL hovers in space and fades at the edges. Or, similarly, in the Picasso the four-lined music staff becomes an analogue of the four fingerlike parallels (perhaps the chair's tassels) in the lower right and the strings of the musical instrument (slightly below center). By this fusion of the traditional symbols for words, numbers, and music with the newly created geometric symbols of Cubism, Braque and Picasso offer a decisive rejection of one of the fundamentals of Western painting since the Renaissance, namely, that a picture presents an illusion of perceived reality. In its place, we have almost a reversion to a medieval viewpoint in which a pictorial image is a symbol and its relation to reality is conceptual. It is tempting to say that the medieval manuscript page suggests the closest parallel to the Cubist mixture of conventional symbols and extremely stylized images of reality. Nevertheless, it would be a gross simplification to consider Cubism a simple reassertion of the symbolic viewpoint that had prevailed in the art of the Middle Ages or of early periods of antiquity. Cubism obviously expresses a much more complex and ambiguous relation to reality than does any art of the past.

Though we may stress the symbolic nature of the Cubist vocabulary, it is also true that, by contrast with the abstract quality of letters and numbers, Braque's and Picasso's geometric description of perceived reality still has the immediacy of pictorial illusion, containing, as it does, fragments of light and texture, of strings, clothing, wood. Once more, then, as with the *trompe-l'oeil* nail, the implication is that a painting is neither a replica nor a symbol of reality, but that it has a life of its own in a precarious, fluctuating balance between the two extremes of illusion and symbol.

In a sense, what Picasso and Braque discovered was the independent reality of the pictorial means by which nature is transformed into art upon the flat surface of a canvas.

With this growing awareness of a painting as a physical fact in itself, it was inevitable that Cubism would evolve an increasingly acute consciousness of the two-dimensional reality of the picture surface that Renaissance perspective had succeeded in disguising. In the *Portuguese* and *Ma Jolie,* space has been so contracted that a new kind of pictorial syntax is created. The overlapping planes and their complicated light and shadow imply relationships in an illusory depth, yet each plane is committed to a contact with the picture surface. The printed symbols appear to shift and fade in space, yet, at the same time, they rest as flatly upon the opaque plane of the canvas as printed letters on a page. Once again, the constant rearrangement and shuffling of spatial layers in these pictures call explicit attention to the paradoxical process of picture making. The traditional illusionistic devices of textural variation and chiaroscuro are simultaneously contradicted by the subordination of each pictorial element to the sovereignty of the flat picture surface.

It is precisely such willfully ambiguous descriptions of phenomena that make the *Portuguese* and *Ma Jolie* the masterpieces that they are. Their language, like the language of modern poetry, is multileveled, and conforms to the twentieth century's refusal to accept a single, absolute interpretation of reality. The contradictions in these works are endless. A prosaic subject is transformed into a fantastic structure of the highest conceptual complexity; a taut, architectonic design dissolves into the shimmering vibrations of delicately stippled textures and flickering light; a rigorously restricted and impersonal vocabulary of simple geometric shapes is executed with a keen sense of the artist's individual and irregular brushwork; a monkishly somber palette of ochers, grays, and browns is treated with a sumptuous subtlety that rivals the dark chromatic modulations of the late Titian or Rembrandt; a fabric of bewildering translucence and density asserts the opacity of the canvas underneath; an unfamiliar world of hieroglyphs is punctuated by vivid fragments of reality. Yet, if these paintings illumine those complex paradoxes that pertain so specifically to our century's destruction of absolutes, it should not be forgotten that they also stand securely in the great tradition of Western painting that stems from the Renaissance. Like the masterpieces of the past—whether by a Giotto or a Cézanne—these canvases present a tense and vital equilibrium between the reality of nature and the reality of art.

3 *Picasso and Braque, 1912–1924*

If Cubism wished to make explicit the means by which nature becomes art, then the growing complication of Cubist syntax in 1911 must have threatened the balance between dependence upon nature and autonomy of art. For example, in Braque's circular *Soda* of 1911 the teeming fragments of still-life objects (which appear to include a wineglass, a pipe, a sheet of music, and the label SODA) have become so intricate that not only the composition itself but its references to the external world are dangerously obscured. Although Picasso never reached as complex a degree of analysis as this, both he and Braque apparently began to feel a strong urge toward clarifying their ever more diffuse and labyrinthine pictorial structure and their increasingly illegible constructs of reality. With the same intellectual exhilaration that characterized the successive revolutions of 1907–11, first Picasso and then Braque resolved the crisis of 1911 by revitalizing their contact with the external world in a way that was as unexpected as it was disarmingly logical.

35

This revolution in picture making was inaugurated by Picasso's *Still Life with Chair Caning,* which had traditionally been dated winter 1911–12, but which is now generally dated, according to the artist's recollections, May 1912. Here, within this small and unpretentious assemblage of the letters JOU (from *Le Journal*), a pipe, glass, knife, lemon, and scallop shell, another fundamental tradition of Western painting has been destroyed. Instead of using paint alone to achieve the appearance of reality, Picasso has pasted a strip of oilcloth on the canvas. This pasting or, to use the now familiar French term, *collage,* is perhaps

36

even more probing in its commentary on the relation between art and reality than any of such earlier Cubist devices as *trompe-l'oeil* or printed symbols, since the result now involves an even more complex paradox between "true" and "false." The oilcloth is demonstrably more "real" than the illusory Cubist still-life objects, for it is not a fiction created by the artist but an actual machine-made fragment from the external world. Yet, in its own terms, it is as false as the painted objects around it, for it purports to be chair caning but is only oilcloth. To enrich this irony, the most unreal Cubist objects seem to have a quality of true depth, especially the *trompe-l'oeil* pipe stem, which is rendered even more vivid by juxtaposition with the flatness of the *trompe-l'oeil* chair caning below. And, as a final assault on our suddenly outmoded conceptions about fact and illusion in art and reality, Picasso has added a rope to the oval periphery of the canvas, a feature that first functions as a conventional frame to enclose a pictorial illusion and then contradicts this function by creating the illusion of decorative woodcarving on the edge of a flat surface like that of an oval table top, from which these still-life objects seem to project.

Perhaps the greatest heresy introduced in this collage concerns Western painting's convention that the artist achieve his illusion of reality with paint or pencil alone. Now Picasso extends his creative domain to materials that had previously been excluded from the world of canvas or paper and obliges these real fragments from a nonartistic world to play surprisingly unreal roles in a new artistic world. Moreover, this destruction of the traditional mimetic relationship between art and reality becomes even more emphatic by the very choice of a material that in itself offers a deception. For here Picasso mocks the illusions painstakingly created by the artist's hand by rivaling them with the perhaps more skillful illusions impersonally stamped out by a machine. If the reality of art is a relative matter, so, too, is the reality of this seemingly real chair caning, which is actually oilcloth.

The close interchange of ideas between Picasso and Braque and the still very disputable dates traditionally assigned to many works of this period make it difficult to establish any secure chronological priority in the various innovations of collage. Generally, however, it is claimed that in his drawn and pasted *Fruit Dish* of September 1912, Braque was the first to initiate *papier collé* (pasted paper), a term that refers specifically to the use of paper fragments as opposed to the more inclusive term *collage*. In any case, Braque's *Fruit Dish* continues that complex juggling of fact and illusion which makes Picasso's earlier *Still Life with Chair Caning* so compelling to the eye and the intellect. Again, as in Picasso's collage, the true elements pasted into the picture are even falser than the drawn fiction of the Cubist still life, for they are strips of wallpaper simulating the grain of oak. Once more, these fragments of reality are made to perform roles even more unreal than those implied by their simple function as decorative facsimiles of wood, of the kind Braque had long been familiar with through his early training as a house painter *(peintre-décorateur)*. Thus, Braque uses the same artificial wood to suggest, in the horizontal strip below, the drawer of the table upon which are placed the cen-

37

tral fruit bowl (with a bunch of grapes and an apple) and the goblet at the right; and, in the vertical strips above, to suggest the wall of the café whose milieu is evoked by the letters BAR and ALE. Nor does this Cubist confounding of identities stop here, for we may go on to still another ambiguity and question whether the illusory café wall created by the pasted wallpaper is supposed to be covered with real or artificial wood paneling.

Exactly the same kind of paradoxical sequence obtains in a comparable collage still life (or, to be precise, *papier collé*) executed by Picasso in the winter of 1912–13. Here the cut-up fragments of the daily newspaper are magically revitalized in the unexpected environment of a Cubist drawing. The presence of the newspaper in the still-life arrangement is explicitly stated by the word JOURNAL, which rests on the table, but the other clippings proceed to still more surprising adventures. The siphon on the left, for example, which we would expect to be transparent, is made of the opaque newspaper, whereas the violin at the right, which we would expect to be opaque, seems so incorporeal that the newspaper can be read right through the scroll and pegs. And if the goblet in the center at first appears to share the violin's transparency, it might well, by analogy with the siphon, be made of the same opaque newspaper. In the same way, the laws of gravity are turned topsy-turvy. The glass objects—the siphon and goblet—would in reality appear less weighty than the wooden violin, yet, in the context of this new aesthetic realm, their newsprint substance makes them seem much heavier. And, by the same token, the most earthbound object in the picture, the table, is rendered as the most air-borne ghost of an outline, whose wooden texture, like the violin's, is symbolized only by a small brown pasting on its periphery. So pervasive are these transformations that no detail is left unambiguous. Thus, the two sound holes are not only radically different in size and shape but appear to be solids floating in a void rather than voids cut through a solid. Moreover, the four strings of the violin emerge as five on the other side of the bridge, conforming to the general, though hardly unbroken, rule in most Cubist representations of stringed instruments: that in the Cubist re-creation the number of strings of the real instrument changes. Thus, the six strings of a guitar are generally reduced to four or five, and the four strings of a mandolin to three. Similarly, the five lines of the music staff are almost invariably transformed to three or four. Indeed, a neglect of such thoroughgoing mutations can often be considered a telling indication of a lesser Cubist artist.

If collage, with its material references to nonartistic realities, acted as an antidote to the growing illegibility of so many Cubist works of 1911, it nevertheless enriched considerably the paradoxes involved in the Cubist dialectic between art and reality. It effected, moreover, a profound reorganization of the very structure of Cubist pictures. In the first place, the size of these clippings is now larger than those increasingly small and diffuse pictorial units of 1911, and therefore begins to establish a simpler and more readily grasped pattern of fewer and bolder shapes. Thus, in opposition to the painted works preceding them, these early collages are compositionally lucid and extremely restricted in the number of their pictorial

elements. But, more important still, the technique of pasting so strongly emphasizes the two-dimensional reality of the picture surface that even the few vestiges of traditional illusionism clinging to earlier Cubist painting—the vibrant modeling in light and dark, the fragmentary diagonals that create a deceptive space—could not survive for long. Rapidly, the luminous shimmer and the oblique disposition of planes in earlier Cubism were to be replaced by a new syntax in which largely unshaded planes were to be placed parallel to the picture surface. In the case of actual collage, the placement was quite literally on top of the opaque picture surface, thereby controverting another fundamental principle of Western painting since the *quattrocento,* if not earlier—namely, that the picture plane was an imaginary transparency through which an illusion was seen.

This reorientation of Cubist structure can be suggested in comparing, for example, the two previously discussed collages by Picasso and Braque. The still complex fragmentation into overlapping, shaded planes in the Braque of September 1912 yields in the Picasso of winter 1912–13 to a much simpler analysis. Thus, the goblet in the Picasso, while retaining a remnant of shading at its right, is composed of few and easily legible shapes. The rim of the goblet is no longer seen as a structure of many interpenetrating oblique arcs but rather as a complete and flattened circle. Its clear, pure geometry is elegantly balanced by the printed rectangle in the newspaper above; by the drawn parallelogram intersecting it directly below; by the floating trapezoid capping the siphon at the upper left; and by the delicately drawn arc defining the lower contour of the violin at the bottom right.

Besides contributing such stylistic clarifications, collage stimulated an even greater consciousness of the independent reality of pictorial means than had been achieved in earlier Cubism. In these drawn and pasted pictures there is a new and radical dissociation of the outlines defining an object and the textured or colored area (represented by the pasted papers) traditionally filling these shapes. Now the contours of objects seem to function in counterpoint, as it were, to their textured or colored substance, so that the previously inseparable elements of line, texture, and color suddenly have independent existences. This phenomenon, although adumbrated in paintings of 1910–11, had never reached the autonomy of separate pictorial means so explicitly defined in collage.

This examination of the aesthetic substance itself, which heretofore had been disguised in order to produce the illusion of reality, is not unique to Cubist art. Choosing analogies from the theater, one is reminded of such a play as Luigi Pirandello's *Six Characters in Search of an Author* (1921), in which the startling objectification of characters, stage manager, and scenery offers a comparable insistence on the means that produce a dramatic illusion rather than on the illusion itself. And in an earlier example, a similar shuffling of dramatic fiction and the humdrum realities of dramatic production is found in Hugo von Hofmannsthal's and Richard Strauss's opera *Ariadne auf Naxos* (1912; revised 1916).

The crucial transformations of Cubist style that occurred in 1912 make it necessary to draw a distinction between works that precede and

works that follow this year. The most familiar terms for the earlier and the later phases—*Analytic Cubism* and *Synthetic Cubism*—are so commonly accepted today that, even if one were to cavil at their precision, they are no more likely to be abandoned or replaced than the far more imprecise name of Cubism itself.

The term *Analytic Cubism* is perhaps the more accurately descriptive of the two. It refers explicitly to the quality of analysis that dominates the searching dissections of light, line, and plane in the works of 1909–12. Indeed, no matter how remote from appearances these works may become, they nevertheless depend quite clearly on a scrutiny of the external world that, at times, is almost as intense as that of the Impressionists. By contrast, the works that follow have a considerably less objective character, and suggest far more arbitrary and imaginative symbols of the external world. In this they parallel the change from the Impressionists' fidelity to objective visual fact in the 1870s to the Post-Impressionists' more subjective and symbolic constructs of reality in the late 1880s. Ostensibly, Synthetic Cubism is no longer so concerned with exploring the anatomy of nature, but turns rather to the creation of a new anatomy that is far less dependent upon the data of perception. Instead of reducing real objects to their abstract components, the works following 1912 appear to invent objects from such very real components as pasted paper, flat patches of color, and clearly outlined planar fragments. The process now seems to be one of construction rather than analysis; hence the term *synthetic*.

Although this convenient classification of the creative processes before and after 1912 may be applicable to many works, it can also be somewhat misleading in its implication that after 1912 there is an about-face in the Cubists' relation to nature. It is certainly true that many Synthetic Cubist drawings and paintings after 1912 offer a capricious rearrangement of reality that would be impossible in the Analytic phase. However, it must be stressed that this presumed independence of nature is more often of degree than of kind. As will be shown, the post-1912 works of Picasso, Braque, and other Cubists often depend on as close a scrutiny of the data of perception as did the pre-1912 works, however different the results may seem. Without this contact with the external world, Cubism's fundamental assertion that a work of art is related to but different from nature could not be made; for there would be no means of measuring the distance traversed between the stimulus in reality and its pictorial re-creation.

It is probably more to the point, then, to think of Synthetic Cubism, not primarily in terms of a dubious reversal of the Cubists' relation to nature, but, rather, in terms of a demonstrable reorganization of Cubist pictorial structure. Now illusionistic depth is obliterated by placing the newly enlarged and clarified pictorial elements—line, plane, color, texture—parallel to and, by implication, imposed upon the two-dimensional fact of the canvas or paper. Beginning in 1912, the work of Picasso and Braque—and ultimately, most major painting of our century—is based on the radically new principle that the pictorial illusion takes place upon

the physical reality of an opaque surface rather than behind the illusion of a transparent plane. As will be indicated later, even Picasso's most overtly sculptural paintings from his Neo-classic period are not exempt from this generalization.

The pictorial reorientations introduced by collage affected as well the wholly painted pictures of 1912, although it may be conjectured that a comparable change in Cubist structure would have occurred even without the flattening influence of the technique of pasting paper fragments. Be that as it may, two of Picasso's works of 1912, *Spanish Still Life* and *Dead Birds,* already indicate a clarification and broadening of shape and structure—as well as an increased two-dimensionality—analogous to contemporary developments in collage. Indeed, the prominence of the printed word here suggests, with typical Cubist paradox, that these letters might be confounded with actual paper collages.

Apart from such stylistic redirections, these works are also significant as prophecy of the way in which the art of Picasso and Braque, after the moment of convergence in 1911, will diverge again to viewpoints almost as far apart as those which separated them in 1906, before their joint creation of Cubism. Between 1908 and 1911, Picasso's subject matter—except for his attraction to portraiture—was almost identical with Braque's in its usual restriction to still life, landscape, and music-making figures; but in these two works there are hints of deviation from such relatively dispassionate themes.

The *Spanish Still Life* reasserts the artist's nationality not only in the use of fragmented Spanish words and the vivid red and yellow Spanish flag at the lower right, but also in a more subtle and unconscious way. The letters SOL and SOMB, taken from the title of a periodical about bullfighting, refer to the Spanish words *sol* and *sombra* (sun and shadow), words that, although innocuous in this inanimate context, nevertheless anticipate much of the violence and tragedy of Picasso's later work. For *sol* and *sombra* allude not only to an essential visual contrast in the Spanish environment, but also to the designation of tickets sold for sunny and shaded locations at the bull ring. And, ultimately, this opposition of light and dark, with its symbolic connotations of life and death, good and evil, will reach a climax in the complex symbolism of *Guernica.*

In a far more explicit way, the *Dead Birds* presents a surprising iconographic intrusion in the prevailing cerebral environment of Cubism. Here, again, the theme of the dead bird on a table, in itself morbid, foreshadows the harsher treatment, in *Guernica* and in many later works by Picasso, of the theme of the bird as a sacrificial victim to a bestial force.

Nevertheless, such prophecies of the moral and tragic nature of much of Picasso's later work were exceptional around 1912, although, even within the conventional repertory of Cubist iconography, Picasso's personality asserts itself with increasing vigor. In comparing two paintings of violins, one of 1912 and one of 1913, we can see not only the evolution of Synthetic Cubism toward greater flatness and a simplification of planes, but also how Picasso's art moves from the relatively impersonal realm that he and Braque had mapped out together toward a more personal

39
40

228

42, XII

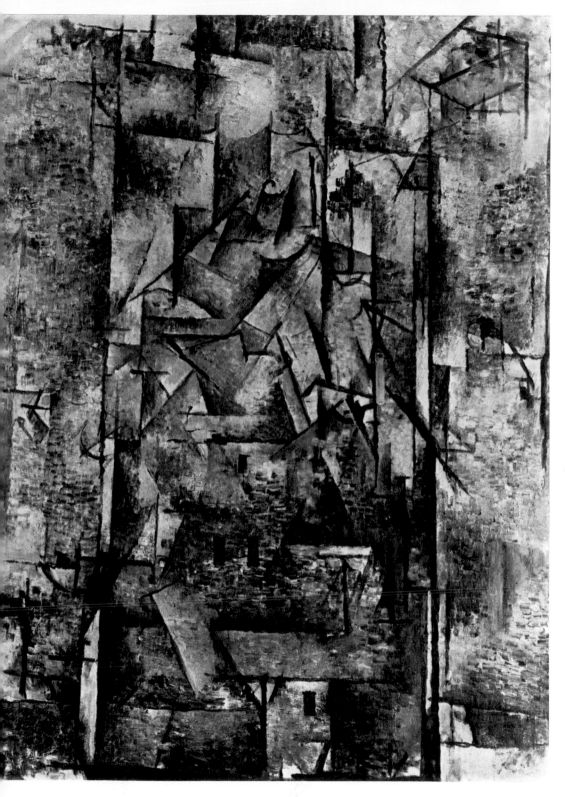

31. Georges Braque. *Céret: The Rooftops*. Summer 1911

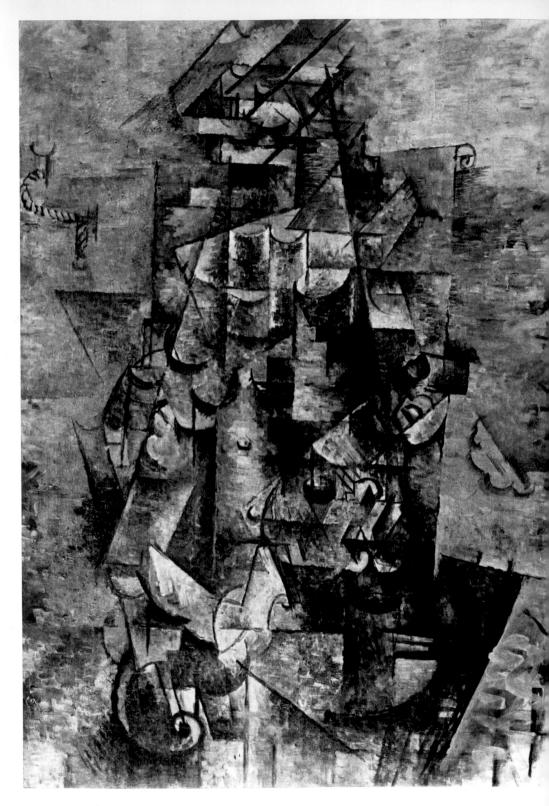

32. Georges Braque. *Man with a Guitar*. Summer 1911

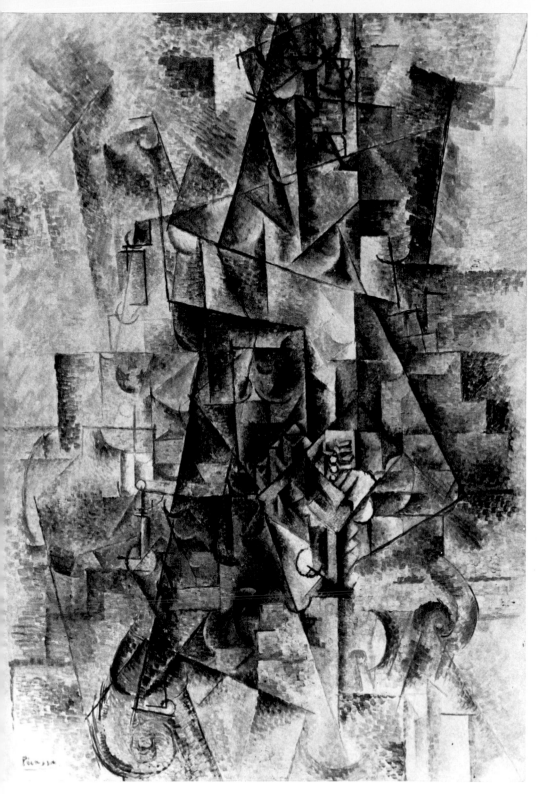

33. Pablo Picasso. *The Accordionist*. Summer 1911

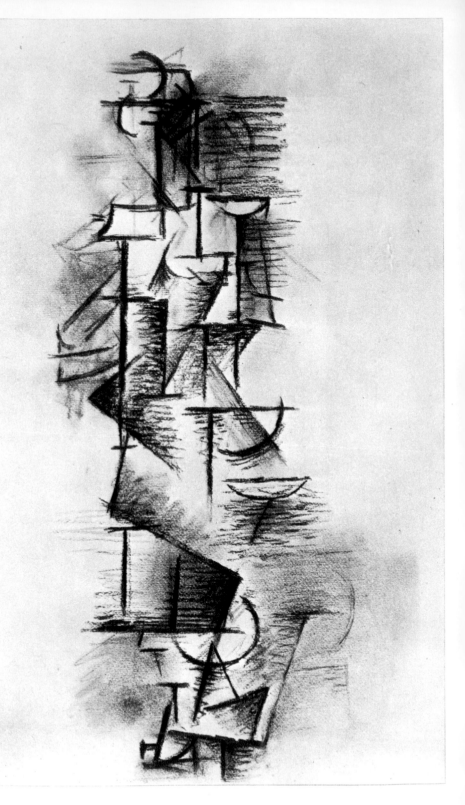

34. Pablo Picasso. *Nude*. 1910

35. Georges Braque. *Soda*. 1911

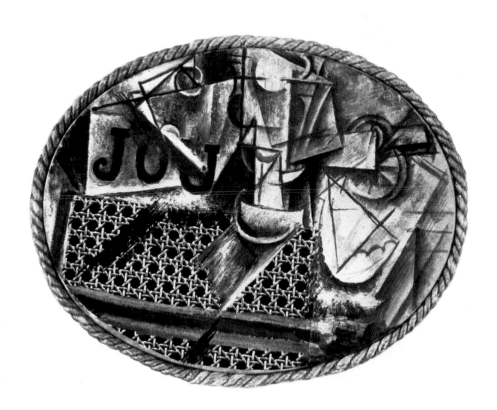

36. Pablo Picasso. *Still Life with Chair Caning*. May 1912

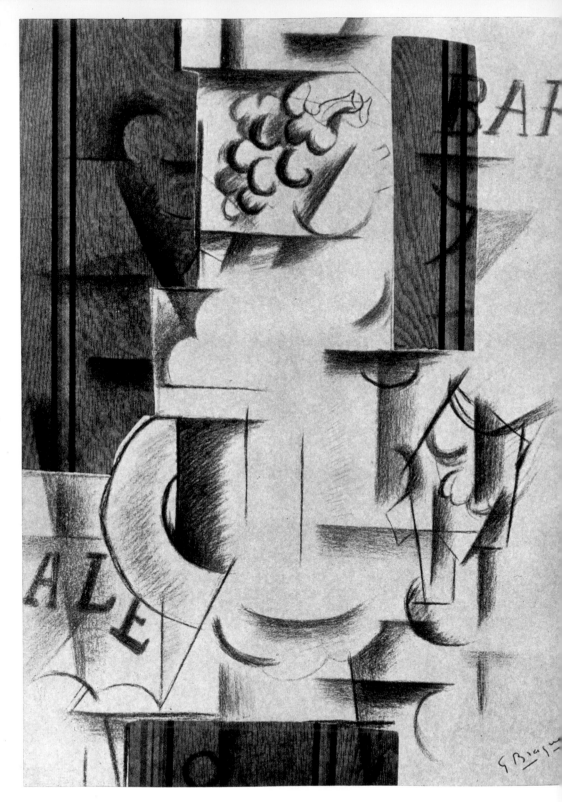

37. Georges Braque. *The Fruit Dish*. 1912

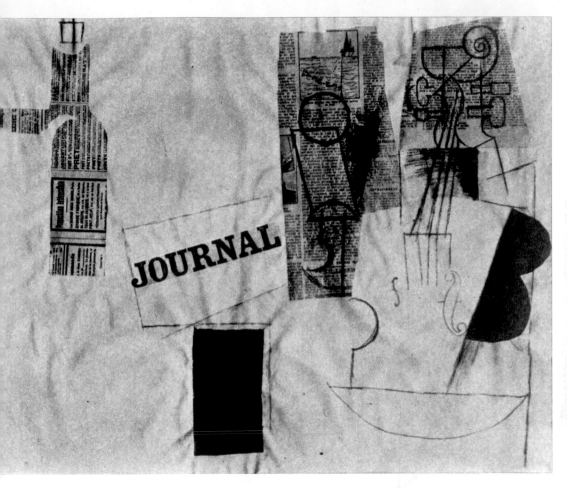

38. Pablo Picasso. *Bottle, Glass, Violin*. 1912–13

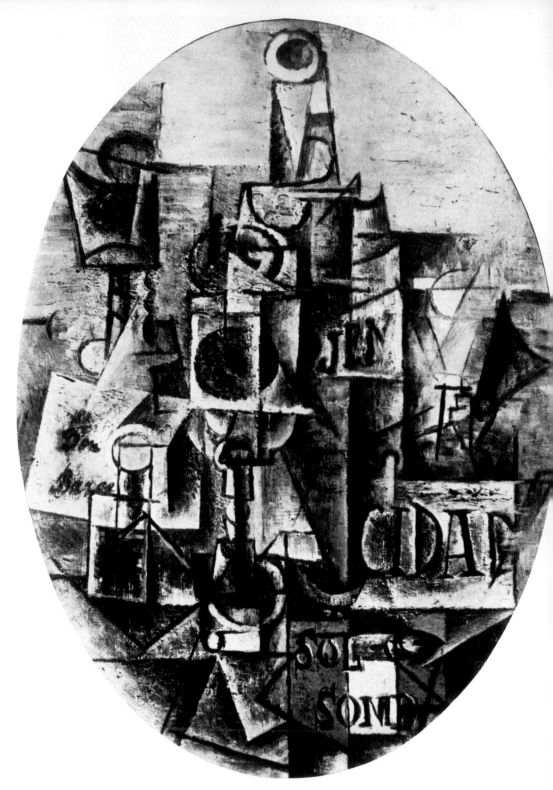

39. Pablo Picasso. *Spanish Still Life*. 1912

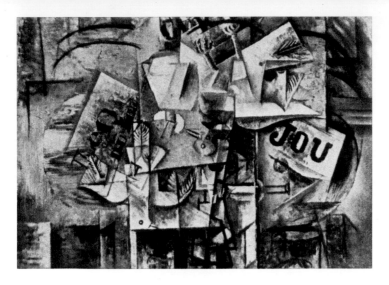

40. Pablo Picasso. *Dead Birds*. 1912

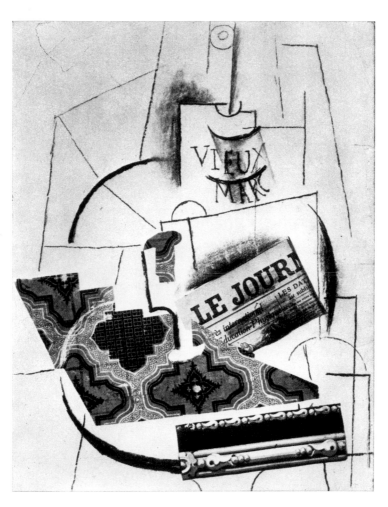

41. Pablo Picasso.
Bottle of Vieux Marc, Glass, Newspaper. Spring 1913

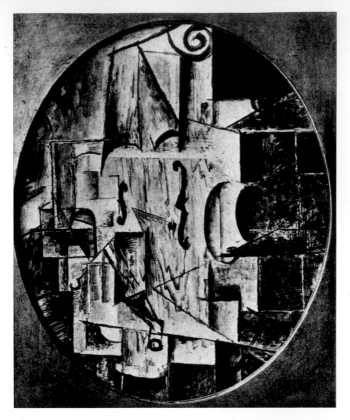

42. Pablo Picasso. *Violin*. 1912

43. Georges Braque.
*Qval Still Life
(Le Violon)*. Spring 1914

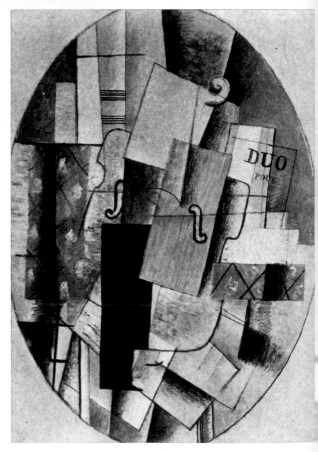

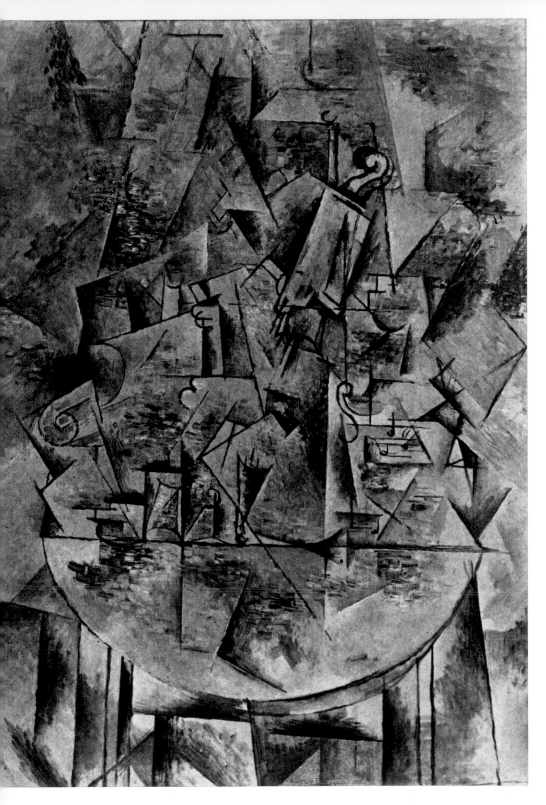

44. Georges Braque. *Le Guéridon*. Spring 1912

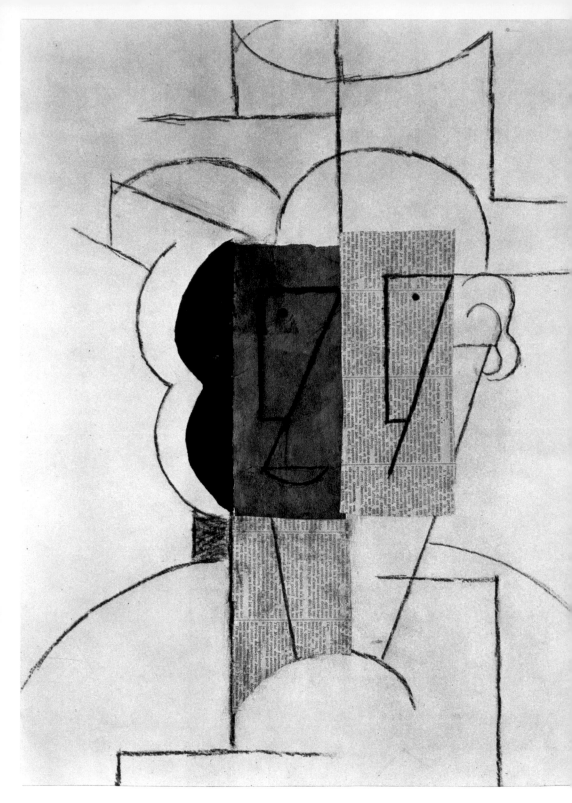

45. Pablo Picasso. *Man with a Hat*. December 1912

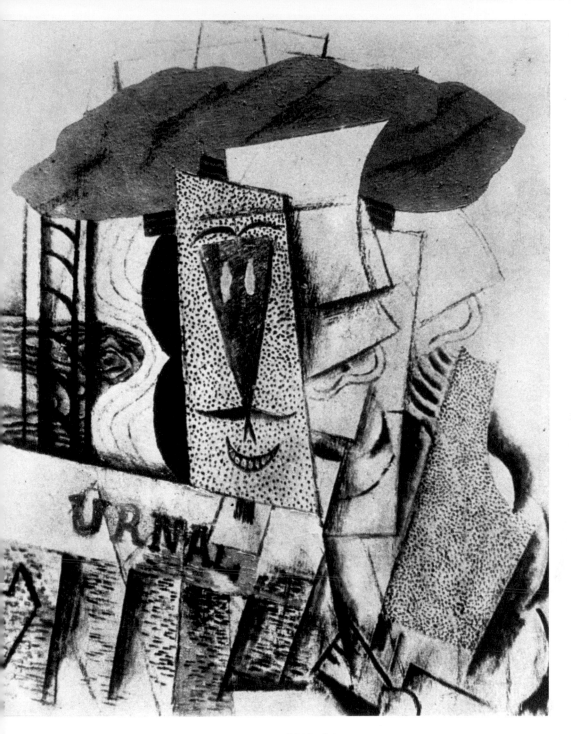

46. Pablo Picasso. *Student with a Newspaper.* 1913–14

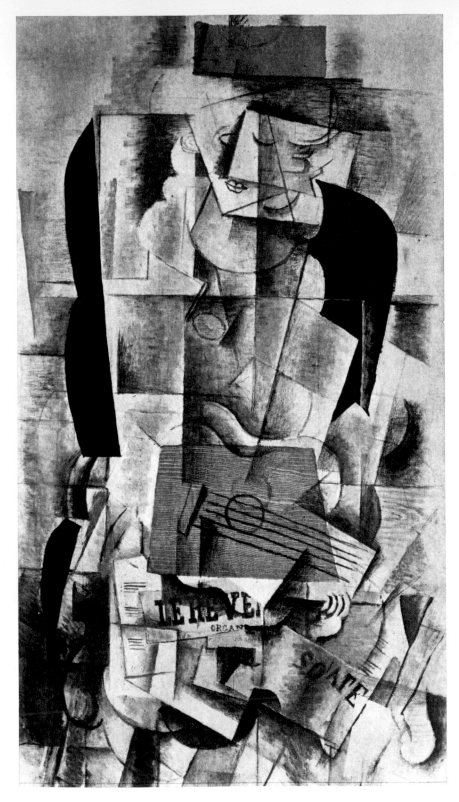

47. Georges Braque. *Woman with Guitar*. 1913

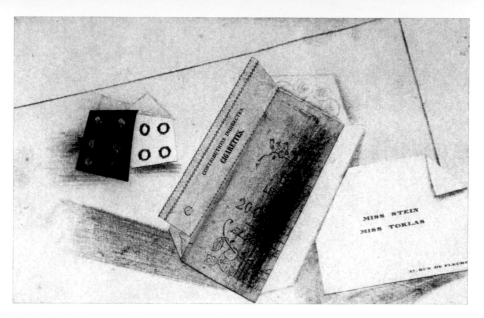

48. Pablo Picasso. *Still Life with Calling Card*. 1914

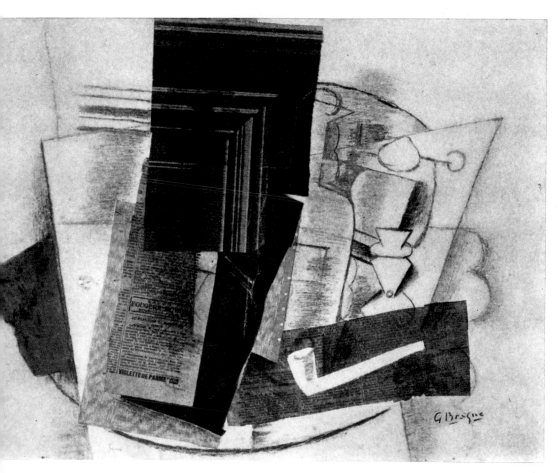

49. Georges Braque. *Bottle, Glass, and Pipe (Violette de Parme)*. 1913

50. Pablo Picasso. *Plate with Wafers*. 1914

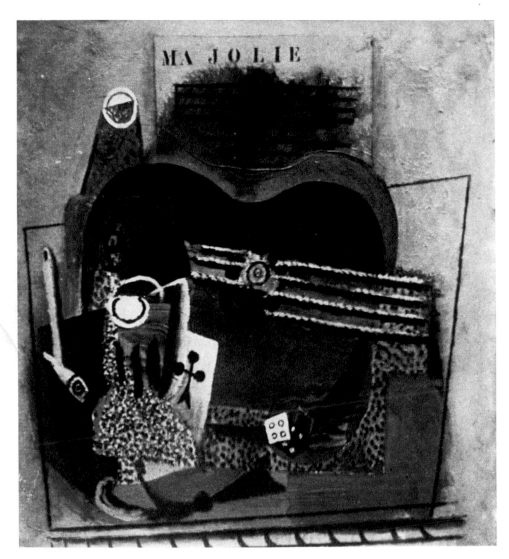

51. Pablo Picasso. *Still Life, "Ma Jolie."* 1914

statement that leaves no doubt about the identity of its creator. Not the least remarkable feature of the 1913 *Violin* is the strident eruption of color and texture, as in the sudden contrasts among blue, black, brown, and the vivid yellows and reds at the left, and in the use of sand in the paint, whose resulting coarseness of surface gives the picture an abrasive quality. The composition, too, has a nervous excitement, not only in the jagged dislocation of the vertical planes that trace the anatomy of the violin from the scroll at the top to the arc at the bottom, but in such details as the different sizes of the sound holes against planes of the same blue color and spatial location—a device that introduces an energetic tension between forward and backward movement on what is too easily described as a flat surface.

Continuing the collage metamorphoses of reality, Picasso here presents imitation wood-grain surfaces, which, however, are not pasted but painted. In so doing, he adds still another level of interpretation to the imitation wood-grain papers used in collage; for here he is imitating the appearance of something that is already an imitation of something else. Again, these wood-grain passages function as external reality, evoking here the wood paneling (real? or paper?) of the wall in the background and the wooden table of the left foreground.

About 1912, Braque's style, like Picasso's, followed the common evolution toward Synthetic Cubism, a transformation that becomes apparent in comparing two of his violin-and-table studies, one of spring 1912 and one of spring 1914. In the 1914 picture the splintered, oblique lines and planes of the earlier one are ironed out, so to speak, into a flattened space (although not totally without such vestiges of illusionism as the occasional passages of shading that separate the planes); and the more diffuse structure of the earlier work is lucidly controlled by a simple organization of verticals and horizontals countered by the slightly tilted diagonals of the violin and the musical score—a duo—on the table.

The oval format is also worth mentioning. Earlier, Picasso and Braque had used the oval for primarily pictorial reasons. For one thing, its elliptical pattern provided a foil for the growing austerity of Cubism's geometric vocabulary; for another, its shape underlined the new weightlessness of Cubist forms, whose clustering toward the center of pictorial space tended to contradict the traditional function of the bottom of the picture as a support for the pictorial weight above. In this 1914 painting, however, the oval is also involved in a complex interplay of realities. By analogy to the oval table represented in a rectangular space in the 1912 canvas, the oval of the 1914 picture becomes a synonym of the table top itself upon which the musical paraphernalia rests, just as, in Picasso's first collage, the oval shape and rope frame suggested simultaneously the boundaries of the picture and the boundaries of the surface on which the objects rest. By contrast to Picasso's 1913 *Violin,* Braque's work of 1914 offers a far more explicit definition of his artistic personality than could be discerned in the subtle differentiations between the two masters in 1910–12. Quite evidently now, the Frenchman's violin is reorganized in a far less harsh and erratic arrangement of planes, colors, and textures than

the Spaniard's. The composition has an ordered predictability absent from Picasso's work; and the ligation of planes and the modulation of textures are supple and elegant, with none of the dramatic and jarring abruptness of Picasso's transitions.

The same can be said of one of Braque's finest collages, the *Clarinet* of 1913. Here the familiar oval (which again functions ambiguously as a frame within the frame and as the edge of the table top) is aligned horizontally, with the ample movement of its curve echoed in the graining of the long expanse of imitation oak that symbolizes the table surface. If these gentle oscillations of texture and color are foreign to Picasso, so, too, is the delicacy of the muted drawing, which lends mystery and intangibility to these once prosaic objects. Even the disjunctions of form are less apparent than in Picasso. This so-called clarinet (which looks much more like an oboe with a projecting reed) emerges from beneath the oak grain on a most subtle shift of axis, just as the arc of the goblet's base merges almost imperceptibly with the newspaper clipping L'ECHO D'A *(L'Écho d'Alger),* whose bisected form enlivens verbal commonplaces and recalls the typographical freedom to rearrange words and punctuation marks in poems by Apollinaire, Marinetti, and E. E. Cummings.

Braque's nuanced manipulation of plane, line, and texture may again be set into clearer relief by comparison with a collage still life by Picasso, the *Bottle of Vieux Marc, Glass, Newspaper* of spring 1913. To be sure, Picasso's realm of intellectual discourse is still the same as Braque's —the hand-lettered label of the liquor bottle is confounded with the machine-printed title and headlines of the newspaper; the shape of the goblet is echoed in the pattern of the wallpaper; and the strips of artificial molding and wallpaper pattern exist, like the strip of imitation oak grain in Braque's *Clarinet,* simultaneously on the levels of fact, symbol, and illusion. Yet these shuffled realities are now arranged with sharp angles and brusquely textured patterns remote from Braque's unruffled order. This increasingly obvious stylistic divergence between Picasso and Braque also offers *ex post facto* visual evidence that the date traditionally ascribed to this collage—spring 1912—is incorrect. A search through the front pages of *Le Journal* proves that Picasso's headlines are clipped from the issue of March 15, 1913, and may suggest to future historians of collage a research technique that, if tedious, at least offers irrefutable results.

Picasso's greater unpredictability of style was complemented by a greater fantasy in his treatment of subject. For example, in *Man with a Hat,* a collage of December 1912, there is something distinctly bizarre in the way in which the lean geometric pattern of eye and nose is repeated to create an almost grotesque image of the human face, and in the way in which the entire configuration, especially the repeated earlike curve at the left and right, transforms the head into a pun on the violin shapes that Picasso was inventing at the time.

The same combination of humor and grotesquerie is even more evident in another figure of Picasso's, the *Student with a Newspaper* of 1913–14. Here again, the human head is assembled from a strange assortment of arcs and planes that recall, in part, the contours and the bridge of

a stringed instrument. But the sinister implications of this scarecrow head, with its blank and vertical eyes, inverted nose, crescent eyebrows and mustache, speckled skin, and grinning mouth, are countered by the lighthearted wit of the broad and clumsy student's hat (the so-called *faluche*), as well as by the slightly indecent pun that Picasso makes by omitting the JO of JOURNAL.

The imaginative enrichment of such a work is reinforced by the decorative enrichment apparent in the great variety of painted textures, which include the stippled strokes of the pleated newspaper in the foreground, the wood-grain patterns of the wall at the left, and the spotted surfaces of paint mixed with sand in the face and in the form (a bottle?) at the right. The shapes, too, are more varied, not only in the meandering contours of the *faluche* but in the pliant, earlike curves at the left and right of the student's head.

47 Braque's figures of the same time, as his 1913 *Woman with Guitar* may indicate, have none of these disquieting implications, which were to become so explicit in Picasso's later treatment of the human form. Although the visual pun on navel and sound hole in the five-stringed guitar and the intrusion of a realistically drawn mouth in an abstract environment produce a certain whimsy that might have been excluded from, say, a 1911 study of the same subject, the humor is more prosaic than Picasso's and without Picasso's disturbing overtones.

Even Picasso's choice of collage objects tends to be more evocative than Braque's, foreshadowing, at times, the unrelated miscellany of a Dada
48 collage by Kurt Schwitters. For instance, the 1914 *Still Life with Calling Card* juxtaposes such diverse items as a die (whose flattened planes offer a simple demonstration of Synthetic Cubist dissection), the wrapping from a package of cigarettes, and the calling card of Gertrude Stein and Alice B. Toklas. In front of a collage like this, the spectator is piqued by such extrapictorial associations as the surprising reference to the two brilliant women who then lived on the Rue de Fleurus. In a collage of Braque's
49 such as the *Bottle, Glass, and Pipe (Violette de Parme)* of 1913, the spectator is asked only to consider the pictorial magic that interrelates the separate identities of wall molding, table, and still-life objects in a delicate fusion of phantom shapes and textures that hover, vanish, and reappear on a sheet of white paper.

The richness of shape and texture suggested by Picasso's *Student with a Newspaper* reached a luxurious and elegant climax in 1914–15, in a series of works that Alfred H. Barr has aptly labeled Rococo Cubism.
51 The 1914 *Still Life, "Ma Jolie"* is characteristic in its seductive variety of forms and surfaces. Against a background whose flatness and opacity are made explicit by the stenciled letters of the song title MA JOLIE, Picasso presents an easily legible array of table objects—a sheet of music, a guitar, a bottle of Bass ale, a pipe, a goblet, a playing card with a club, and a die. The increasing independence of textures, instigated by the tendency of collage to isolate pictorial means, is predominant throughout the picture, whether one turns to the speckled passages that suggest some decorative fabric beneath the goblet and guitar; to the bravura definition of

the three flutings on the goblet; or to the spreading, rough-edged areas of color that flow across the sharp boundaries of the four-lined music staffs and the diverging lines of the table top. And, in keeping with this growing sensuousness, the shapes themselves have a fluidity that contrasts with the geometric severity of Analytic Cubism.

An even greater abundance and animation are found in the cool-colored *Still Life in a Landscape* of the following year, 1915, a work whose sputtering vitality and compact fitting of angular shapes contrast with the more relaxed, rococo handling of composition and texture in the 1914 *Still Life, "Ma Jolie."* With a typically Cubist confounding of fore-ground and background, Picasso here merges a table still life before a win-dow with a landscape view beyond. The vibrant, mottled greens of the foliage invade the interior so thoroughly that they are visible even through the sound hole of the guitar; the billowing, scalloped edges of the clouds are repeated in the white contours that swell above a bunch of purple grapes in a fruit bowl; and the patches of the summery blue sky reverber-ate through the foreground in the salt-and-pepper patterns at the left, the sheet of music under the guitar, and, at the right, the table edge that interesects the wineglass.

Picasso's Rococo Cubism was paralleled by Braque on a charac-teristically more muted level. A case in point is *Music* of 1914, executed just before Braque's career was interrupted for three years by his induc-tion into the army and his subsequent war injuries. Although the discretion and quiet here are remote from the buoyant vigor of Picasso's Rococo Cubist still lifes, the work, nevertheless, shares Picasso's new elaboration of shape and texture. Sawdust and gesso enliven surfaces that seem to be sprinkled rather than painted around the grouping of violin, wineglass, and pipe. Even more unusual, the enclosing frame introduces a paramecium-like shape whose flaccid contours belie the more geometric vocabulary they contain and presage the irregular, fluid shapes that will come to dom-inate both Cubist and Surrealist art of the 1920s and 1930s. As a final touch of Cubist wit, Braque has added his name in printed letters at the bottom of the canvas in a *trompe-l'oeil* nameplate. The confounding of the proper physical boundaries of the work of art by means of this device was duplicated in the same year not only in Picasso's work but in the printed title included inside instead of outside the picture space of Marcel Duchamp's *Chocolate Grinder No. 2* (Philadelphia Museum of Art).

During Braque's three-year period of enforced inactivity, Picasso embarked on a new pictorial adventure almost as startling as that an-nounced by *Les Demoiselles d'Avignon.* In 1914 he began to make draw-ings whose most literal descriptions of reality now seemed as heretical as the invented Cubist geometries they appeared to contradict. Picasso's *Plate with Wafers,* executed in Avignon in the summer of 1914 while he was also painting Rococo Cubist still lifes, is astonishingly radical, within a Cubist context, by virtue of the meticulous rendering of such details as the honeycombed surface of the biscuits and the crumpled shapes of the wrapping. A comparably traditional, Ingres-like technique of nuanced modeling and literal description again surprises us in the great series of

XIV

52

50

portrait drawings of his friends that begins in 1915 with such notable sit-
ters as the poet Max Jacob and the dealer Ambroise Vollard. Given the
chronological precedent of Cubism, a questioning of the very existence of
these scrupulously realistic drawings is inevitable. How, indeed, could
Picasso work in so conventional a style when, at the same time, he was
painting pictures like the 1915 *Harlequin,* whose heraldic, playing-card
imagery of flat, austere rectangles presumably had obliterated the tradi-
tional style of the drawings?

Yet were these styles really incompatible? An essential discovery
of Cubism was that pictorial styles, in their claims to truth, do not exclude
other claims: each style is a singular visual phenomenon with an independ-
ent aesthetic justification. Often before, Braque and Picasso had used
illusionistic passages in a Cubist environment by way of stressing the plu-
rality of the styles and techniques available to the artist. Now, beginning
in 1914, Picasso could logically extend these principles to enable him to
create pictures that used a realistic vocabulary quite unlike that of ortho-
dox Cubism, just as the contemporary spectator can find equal and inde-
pendent values in styles as different as those of Jan van Eyck and Manet,
or even in the arts of cultures as different as those of primitive Africa and
medieval France.

Yet the crucial experience of Cubism left its mark on all these pre-
sumably non-Cubist works. The longer we examine the 1914 drawing
Plate with Wafers, the clearer it becomes that we are looking at a decep-
tive fragment on a flat white background—one that has neither more nor
less reality than, say, a collage fragment with the trademark LA SUL-
TANE printed on it. Given the principles of Cubism, the question must
be raised: is this illusionistic description of a plate and wafers any more or
less real than a Cubist description? And, given the same principles, the
answer must be no.

Just as this plate of wafers becomes, as it were, an independent
visual entity applied to a flat surface like a collage, so, too, do the portrait
drawings take on the structural attributes of Synthetic Cubism. The por-
trait of Vollard, for example, is organized according to the same principles
as the 1915 *Harlequin;* both pictures assert a flat, unbroken background
before which an assemblage of loose fragments hovers weightlessly. Like
the Cubist *Harlequin,* Vollard's body is pinpointed in space by a zigzag-
ging framework, which happens, here, to describe chair legs and wall
moldings. Pictorial density, as in the *Harlequin,* clusters toward the center
and so thins out at the edges that the left shoe and chair leg seem only
slightly less flat than the rectangular extremities of the harlequin. And if
this portrait of Vollard provides more details of clothing and environment
(if not of psychology and physiognomy) than the 1909–10 portrait of the

dealer, it is also far more insistent upon the fact that its illusions of light,
space, and texture are deceptions on an opaque surface.

In the same way, the portrait of Max Jacob asserts the truth of its
white background and the falsity of its illusionistic means by bleeding out
the modeling in the sleeves and trouser legs and, even more, in the room
around him. Thus, the spectator is made aware of the explicit technique

of illusionism just as he is made aware of the objective fact of other pictorial means in Cubist works. Again, the figure seems to be tautly suspended, as in the *Harlequin,* in a flat, almost Synthetic Cubist network of planes that also describe a door, a picture frame, the chair seat and chair leg, and the planks of the floor.

The relativity of pictorial styles, as disclosed by Cubism, is even more explicit in such a later portrait (1919; also dated 1917) as that of the great Russian impresario Serge Diaghilev and the lawyer Selisburg. Here 53 Picasso has abandoned the interior modeling so prominent in the earlier portrait drawings and has left us with only a pure white surface upon which he has created an outline as abstract (or as real) as any in, say, the 1912–13 collage of a siphon, goblet, and violin. The shapes of the top 38 hat and derby, for instance, might be compared with the cap of the siphon, the rim of the goblet, or the scroll of the violin in the earlier collage; in both of these works, such shapes become objective visual facts as well as arbitrary means of describing a nonartistic reality.

Similarly, in the wistful portrait of his new wife, Olga Koklova, a 54 dancer in the Ballets Russes, Picasso leaves exposed a rough, unfinished paint passage that prevents the spectator from succumbing to the illusion of the exquisitely modeled head and arms or of the painstakingly delineated textures of the gown and embroidered floral patterns. Given this insistent flatness and opacity, such a painted portrait begins to resemble a composite of detached pictorial fragments applied to the canvas, like a butterfly pinned to a page. Just as Picasso and Braque had earlier confounded pasted imitation wood graining with hand-painted imitation wood graining, so the floral patterns here might be machine-made illusions pasted to the canvas rather than handmade illusions painted on the canvas. Once raised, the questions asked by Cubism cannot be retracted.

The objective attitude toward diverse styles created by the Cubist destruction of absolutes was also paralleled in the other arts. Stravinsky, who had first met Picasso in Rome in 1917, often shows a comparable detachment in his ability to re-create, within the framework of his own art, the musical techniques of such disparate composers as Machaut, Pergolesi, Weber, and Tchaikovsky; in the same way, Joyce in *Ulysses* demonstrates a relativist attitude toward literary history and techniques by using, within one book, forms as unlike as stream of consciousness drama, narrative, and catechism, as well as by alluding on multiple levels to authors as historically remote from one another as Homer, Dante, Sterne, and Dickens.

The familiar critical accusation that Picasso, with Joyce and Stravinsky, has no style of his own then becomes irrelevant, since an essential aspect of the work of all three is to re-examine our preconceptions about the nature of style. Picasso not only could work simultaneously in different styles but could combine different styles in one work. This stylistic diversity within one picture was already suggested by the frequent intrusion of illusionistic passages in the abstract milieu of Analytic and early Synthetic Cubism, but it becomes even more pronounced toward the year 1920. In

59 a page of sketches drawn in 1919, Picasso juxtaposes an unmodeled realistic outline drawing of a human hand, two very unrealistic geometric shapes, whose modeling nevertheless makes them more palpable than the unmodeled hand, and, as intermediaries between these paradoxical extremes, two Synthetic Cubist arrangements of a bowl and guitar, neither so real nor so abstract as the hand at the left or the faceted forms below.

 Combination of multiple styles in one work can be seen again in
58 a small gouache of the same year, 1919, the *Window,* which at first seems to be an almost illusionistic picture of a table with still-life objects and a view of Mediterranean sea and sky behind the grillwork of a balcony. Yet suddenly, such literal passages as the shading of the tablecloth, the oblique perspective lines of the French window, and the shadows cast by the balcony are negated by the curiously flat treatment of the table legs and table edges, by the surprisingly unreal geometric stylization of the most palpable guitar, and, ultimately, by the suspicion that the alluring sea and clouds beyond are nothing more than an opaque, painted backdrop.

 This characteristically Cubist awareness of the interplay between pictorial illusion and pictorial fact is evident even in the so-called "Neoclassic" works of 1920–23, which Picasso executed at the same time as more conventionally Cubist pictures. In one such work, the serene and
61 monumental idyl, the *Pipes of Pan* of 1923, the ponderous figures may at first suggest that Picasso has willfully rejected the flat vocabulary of Synthetic Cubism; yet, on further consideration, it becomes clear that nothing of the sort has happened. The back planes of sea and sky and the two almost theatrical side wings so clearly establish the two-dimensionality of the canvas that even the ground plane tilts forward to preserve its continuity. Against this opaque expanse, the figures and the geometric blocks are patently illusions, and are not even consistently modeled. The sturdy feet, for instance, are welded solidly into the flat background, contradicting the shadow cast by the foot at the right; and even the heavy blocks merge weightlessly and ambiguously with the flat patterns of the sea and the side wing, recalling the comparable denial of mass and depth
1. 54 in the treatment of the foreground block in the 1905 *Girl on a Ball.* Like the *Portrait of Olga in an Armchair,* such a work can be thought of as a collage in which some component fragments happen to contain illusionistic modeling.

 The secure, resolute quality of the *Pipes of Pan* was paralleled in other, more specifically Cubist works of the early 1920s, especially 1921, a year in which Picasso achieved an almost classical equilibrium and
60 breadth in his handling of Cubist vocabulary. The *Guitar, Bottle, and Fruit Dish,* for one, offers a poised and perfect summary of some of the problems that attended the beginnings of Synthetic Cubism, notably the contrapuntal balance between a descriptive outline and the color planes no longer contained within it. Such a still life is retrospective in its knowing manipulation of earlier discoveries; but it also presages the growing linear irregularities of the later 1920s and 1930s, irregularities that were doubtlessly inspired, in part, by the enriched vocabulary of outline derived from the portrait drawings.

95

The lean and elegant calm of this still life is countered in the same year by the crowded and savage activity of the *Dog and Cock,* a work xv whose brutal theme is as unexpected in the milieu of Neoclassicism and Synthetic Cubist still lifes as had been the far less explicitly morbid *Dead Birds* of 1912 at the climax of Analytic Cubism. The lavender tongue of 40 a ferocious, wolflike dog threatens a helpless, twitchingly animate cock that is secured to the kitchen table upside down and with wings outspread. This drama is not only underlined by the five eggs on the table at the right, which complete this life cycle of death and regeneration, but by the uncomfortably narrow and compressed structure and the sharp and vivid color. Above all, the jagged red cockscomb that emphasizes the single, staring eye provides a shrill dramatic accent in what is otherwise a cool chromatic range. This conjunction of red, yellow, white, and black constitutes a frequent color combination in Picasso's work evocative not only of the Spanish national colors, yellow and red, but of the Spanish luminary drama of white and black, sun and shadow, that reaches a climax in *Guernica.* Not least brilliant in this barbed patchwork quilt of a painting is the way in which Picasso has used the abstract vocabulary of Synthetic Cubism to describe the most literal details of reality. Textures, in particular, are fully as real as they are in the portrait drawing of Vollard; witness 56 only how Picasso has rendered the coarse and bristling quality of the black dog's hair, or how he has distinguished between the feathers that cover the cock's body and those of the tail and wings.

Like the *Guitar, Bottle, and Fruit Dish,* the *Dog and Cock* looks backward to the achievements of Synthetic Cubism and forward to new aspects of Picasso's art—in this case to the frequent outbursts of brutality to be seen in his later work. This same combination of old and new is exemplified by one of the two versions of the *Three Musicians,* both of which 62 were painted at Fontainebleau in the summer of 1921. In this, probably the most imposing statement of the earlier, more geometric phase of Synthetic Cubism, Picasso offers a résumé of previous achievements, creating a monumental canvas whose physical grandeur and magnificent pictorial discipline are perhaps even intended as a conscious (and, one might add, successful) rival to the masterpieces of the past. The classical, tripartite simplicity of the music-making figures—a Pierrot playing a recorder, a Harlequin with a guitar, and a monk singing from a sheet of music—is countered by the dazzling complexities of the jigsaw-puzzle fragments. These include the superb geometric variations of triangle and circle in the headdress; the dramatic light contrasts that run from the brilliant, milky whites of the Pierrot to the somber, shadowy blacks of the monk; the equilibrium of solid-colored planes among the more intricate patterns of the dog's bristling hair, the Harlequin's diamond costume, and the meshed veils of the two masks at the right; the circular motifs of solid and void in the recorder's finger holes, the music notation, and the seeing but unseen eyes of these phantom minstrels; and the poetic Cubist analogy made between the three strings of the guitar and the three-lined staffs of the music.

If the pictorial mastery of this work marks, in its way, a resonant,

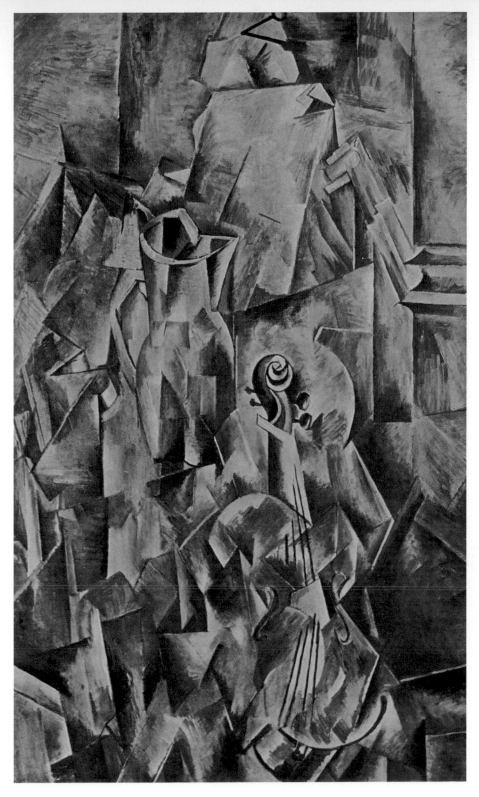

IX. Georges Braque. *Still Life with Violin and Pitcher*. 1909–10

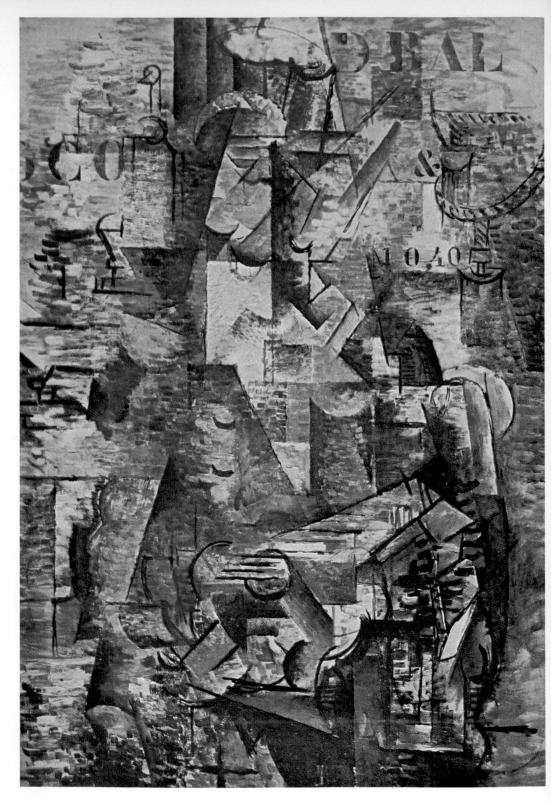

X. Georges Braque. *The Portuguese*. Spring 1911

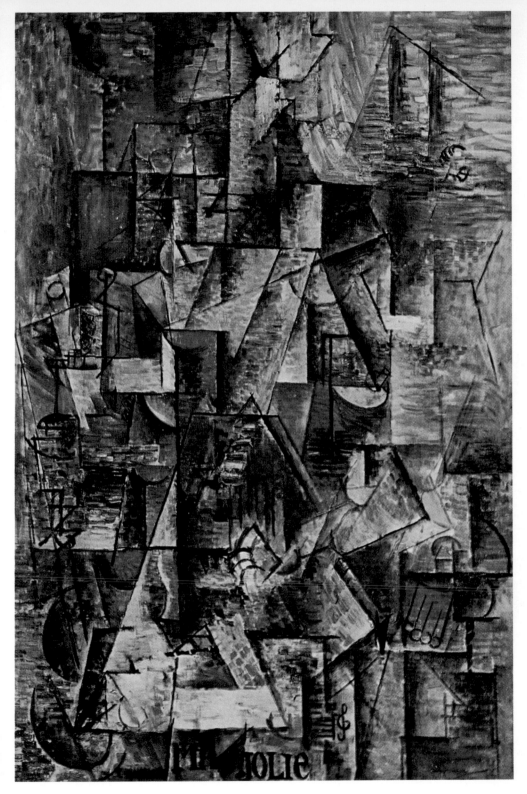

XI. Pablo Picasso. *Ma Jolie (Woman with Guitar)*. Winter 1911–12

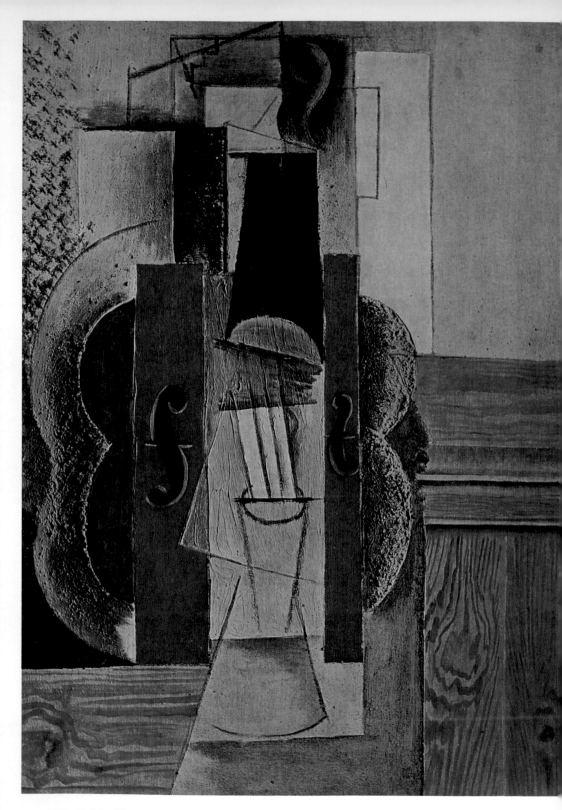

XII. Pablo Picasso. *Violin*. 1913

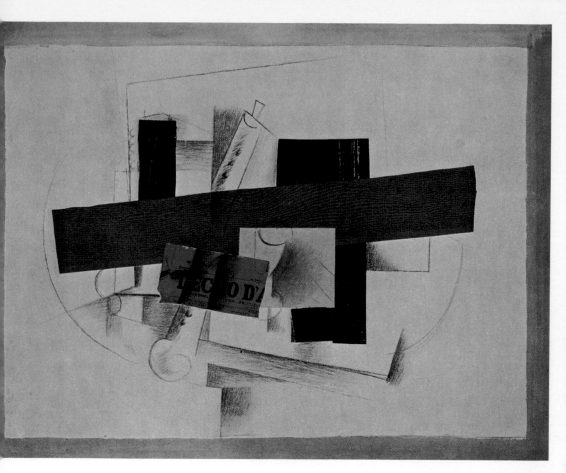

XIII. Georges Braque. *The Clarinet*. 1913

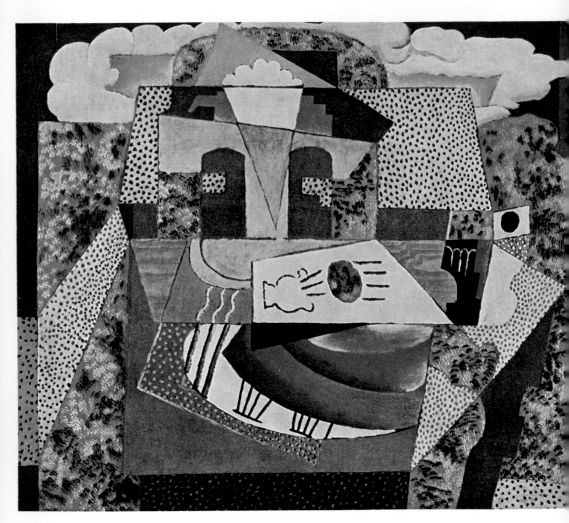

XIV. Pablo Picasso. *Still Life in a Landscape*. 1915

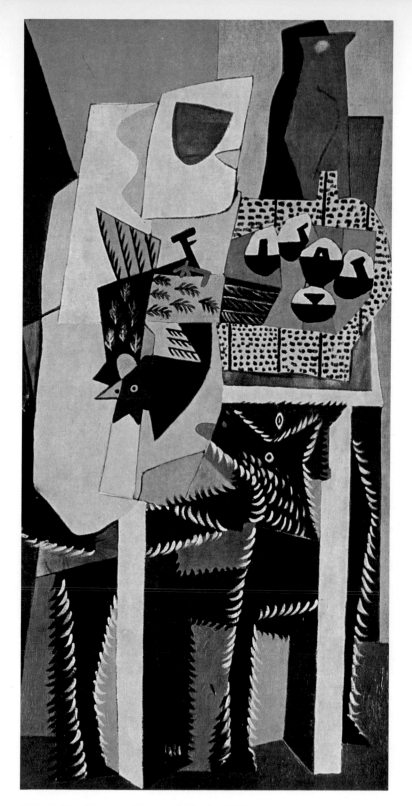

XV. Pablo Picasso. *Dog and Cock*. 1921

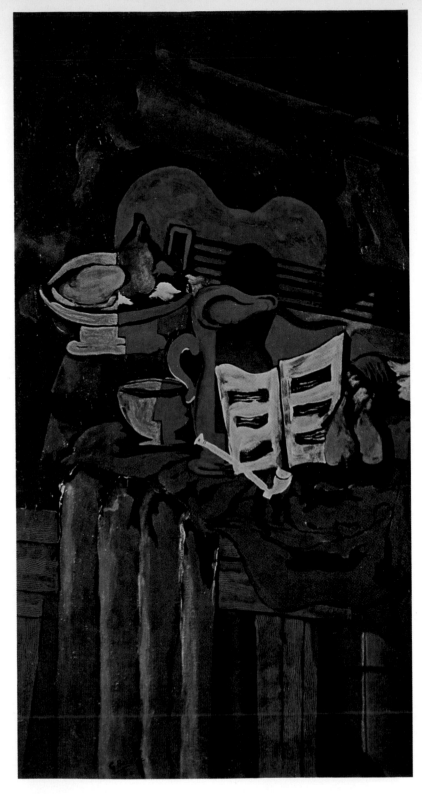

XVI. Georges Braque. *Still Life with Guitar and Fruit*. 1924

stable conclusion to the dissonant, erratic beginnings of Cubism announced in *Les Demoiselles d'Avignon,* its weird, nocturnal magic looks ahead to the Surrealist-oriented adventures of Picasso's later work. So hypnotic is this Spanish serenade, whose eerie sounds pierce a hushed, midnight silence, that it tames even the savage beast that once lurked beneath a kitchen table and now sits solemnly in the shadows at the left. The enchanted flavor of these disguised, fairy-tale musicians (whose bodiless presences are emphasized by contrast with the perspective-box space in which they are placed) is enhanced by the quality of the light, which, in contrast with the black-and-brown setting, has a ghostly, lunar quality further evoked by the crescent shape of the Harlequin's hat. Rejecting the more earthbound world of earlier Cubism, with its dependence on empirical observation, the *Three Musicians* introduces the strange realm of moonlit fantasy that was soon to dominate not only much of Picasso's own art in the next decade but also that of his Catalan compatriot, Joan Miró.

Only to mention Braque's name in the context of this haunting masterpiece is to realize how wide a gulf now separates the two masters who, ten years earlier, had shared a common point of view. Resuming work in 1917, Braque was to remain relatively faithful to the circumscribed thematic range of early Cubism, never venturing into the realms of humor and fantasy, horror and violence that began to preoccupy Picasso. The large *Musician,* begun in 1917 but not completed until the following year, offers a reprise of Braque's prewar painting, not only in the familiarity of its music-making subject but in its restriction to the more austere and flattened rectilinear fragments of early Synthetic Cubism, alleviated only by the patterns of wood grain and stippled textures. Yet Braque's style was soon to digress from this rather dry recapitulation of his prewar achievements toward the more relaxed style suggested by the oddly irregular frame in the 1914 *Music.*

In the collage *Musical Forms (Guitar and Clarinet)* of 1918 (a work often misdated 1913), Braque offers a partial restatement of the 1913 *Clarinet* in the balancing of the diagonal of a musical instrument (which again seems more properly identified as an oboe) against a more stable assemblage of near-horizontal axes. Yet the differences between the prewar and postwar collages are revealing. By contrast with the predominantly rectilinear 1913 work, the later example emphasizes the intrusion of swelling, unpredictable curves, which expand into the black shadow of the guitar and then ebb quietly in the edge of the tablecloth at the left and right. Nevertheless, the lean asceticism of this collage still pertains more to Braque's prewar than to his postwar style. Even the striking use of corrugated paper in the oboe can hardly counter the elegant spareness of surface and design revealed in the few and calculated dualities of shadow and substance, angle and curve, patterned texture and flat paint.

After 1918, however, Braque largely abandoned both the technique of collage and its accompanying stylistic austerity for a growing sumptuousness whose hedonistic intention contrasts with the pictorial and intellectual rigors of Cubism's earlier years. Already in the *Café-Bar* of 1919, Braque transforms the cerebral geography of a table top and still-

life objects into a seductive profusion of painted textures and varied shapes that catch the eye like an attractive window display. With Picasso's *Still Life, "Ma Jolie"* of 1914, the coloratura elaborations of this work add a new and less serious inflection to Cubism. The textural complexity, in its variations of diamond, stippled, and wood-grain patterns, is matched by the increased irregularity of shape, especially prominent in the legs of the table, the *guéridon* that was to become a recurrent motif in Braque's later work.

If the enriched sensuousness of the *Café-Bar* suggests a *détente* from the more tough-minded, generative years of Cubism, it should not be overlooked that, beneath its palatable surface, such a painting continues to depend fully upon the subtle intellectual structure of Cubist paradox. Thus the space still offers a typically Cubist inversion of foreground and background; for the enclosing margin appears to be the frame of a café window across which are written the words CAFE-BAR, whereas the *guéridon* and its still life seem to be located both in front of and behind this imaginary plane, judging from the contradictory overlappings with the letters and the margin. Even the diamond floor pattern participates in this ambiguity, defining as it does both a checkered floor seen in perspective and a flat plane of diamonds that merges with the diamond pattern of the margin. Similarly, the Cubist confounding of identities is continued here; witness only the analogy between the four strings of the guitar and the four lines of the music staffs and the molding at the table edge.

By the early 1920s the brittle, angular agitation still present in the *Café-Bar* had all but disappeared, to be replaced, in works like the 1924 *Still Life with Guitar and Fruit,* by grave and resolute rhythms that recall XVI the structural genius of the French pictorial tradition. Yet, as in Chardin's noble arrangements of humble objects or Renoir's monumental nudes, the painter's intuitive sense of order is balanced by a sensuous richness of texture and shape. The drapery, for instance, suggests this twofold function of structure and decoration. The four heavy folds that hang from the table are not only sumptuous in the creamy density of their paint handling, but create as well a sturdy vertical accent, like a fluted column, to support the more intricate shapes and rhythms above; and, in the background, the same drapery offers a structural echo to the measured curves of the guitar as well as providing a decorative arabesque that softens the austere rectilinearity of the foreground. Similarly, the table top and the five strings of the guitar create a lucid horizontal framework for the swelling, pliant shapes between them; yet their striped and wood-grain patterns also enrich the flat adjacent areas. This suave manipulation of structure and surface embellishment is borne out by the understatement of Braque's color, which, unlike Picasso's, remains within the undramatic confines of browns, grays, and creams, tempered by muted greens and yellows.

The classical restraint of such a work is almost matched at times by Picasso in the same year. In the *Still Life with a Cake,* the large, fluent 66 rhythms and the spatial amplitude afforded by the wide table and the expansive window view suggest analogies with the quiet equilibrium of

Braque's work of this period. Yet, even here, there are elements that would disturb the serene harmonies of Braque's ordered pictorial world. Picasso's incised linear patterns, in particular, have a capriciousness that opposes Braque's rational predictability; and, in the wriggling animation of what is probably a bunch of grapes in the fruit bowl, these lines take on a quality of doodling and of automatic fantasy that begins to transcend the prosaic, inanimate context.

XVII In another work of the same year, the *Still Life with Guitar,* these mysterious murmurs become still louder. In forceful contrast to Braque's 1924 *Still Life with Guitar and Fruit,* Picasso's work is almost savage in its collisive junctures of bold rectilinear fragments. The colors, too, with their startling transition from the quiet blues, browns, and grays of the periphery to the shrill reds, greens, and yellows of the cloth beneath the guitar, could hardly be more unlike the discreetly varied colors of Braque's warm and earthy palette. Even the decorative patterns are harsh and jagged, whether in the saw-toothed edges of the table or the raw, insistent intensity of the stars of what is probably a panel of wallpaper behind the table. But, above all, the still life is given an uncanny vitality by the sound hole of the guitar. Isolated by a stone-shaped halo of white in a sea of brilliant colors and patterns, it takes on a magical potency that recalls the primitive stare of eyes in the barbaric nudes of 1907.

As the *Dog and Cock* and the *Three Musicians* have already suggested, the Cubist world of vision and intellect could no longer encompass the whole of Picasso's experience. In his later work, Picasso, unlike Braque, was to preserve only the pictorial conventions of Cubism, but not its cerebral temperament and dispassionate subject matter.

Part Two

THE EXPANSION OF CUBISM IN PARIS

4 *Juan Gris*

About 1910, a number of young artists working in Paris began to examine closely the astonishing pictorial discoveries that had just been made. Of these artists, two emerged quickly as masters who could create and sustain a personal Cubist world whose richness might at times even rival the best of Picasso and Braque. They were another Spaniard and another Frenchman, Juan Gris (1887–1927) and Fernand Léger (1881–1955); and, in a sense, their art complemented their compatriots'. Next to Picasso's quixotic adventures in the worlds of comedy and tragedy, fantasy and reality, Juan Gris disclosed still another aspect of the Spanish character—an intense and ascetic mysticism. Next to Braque's French hedonism and elegance, Fernand Léger offered the rigorous and heroic monumentality of the classical French tradition as exemplified in Poussin, David, and Seurat.

José Victoriano González was born and raised in Madrid, a city artistically provincial by comparison with the Barcelona that nurtured Gaudí, Picasso, Miró, and Dalí. He decided to move to Paris and, shortly before leaving Spain, changed his name to Juan Gris. Arriving in the artistic capital of Europe in 1906, he moved into the *bateau-lavoir,* the famous "floating laundry" of Montmartre where Picasso and other *avant-garde* painters and poets lived. By 1908 he had made the acquaintance of Kahnweiler, who was to be his biographer. It was not until 1910, however, that he began to turn from his work as a graphic artist for Parisian newspapers to painting.

His initial exploration of Cubism was made with the same rapidity and brilliance that characterized the unfolding of so many artistic careers

around 1910. Already in a still life of 1911, the essentials of Gris's style 70 are defined. In comparison with Braque's and Picasso's contemporary Analytic Cubist work, Gris's canvas is more severe and more lucid. Four objects—a bottle, a humidor, a wineglass, and a bowl—are aligned in a grid of diagonals, verticals, and horizontals, and take their places with an immobility that belies the weightless, glistening planes of which they are composed. The measured solemnity of the structure is matched by the intense and mysterious light that illumines the objects with a whiteness as absolute as the blackness of the shadows where no light falls.

In her biography of Picasso, Gertrude Stein wrote that "the seduction of flowers and of landscapes, of still lifes was inevitably more seductive to Frenchmen than to Spaniards; Juan Gris always made still lifes but to him a still life was not a seduction it was a religion. . . . " With these words, she might have been describing this *Still Life* of 1911, whose religious quality recalls the seventeenth-century Spanish still lifes of such masters as Francisco de Zurbarán, with whom Gris's art has often been linked. In one of Zurbarán's still lifes the analogy becomes clear. As in 68 the Gris, the objects are arranged with a simple geometric strictness that locates each object—lemon, orange, leaf, rose, cup—with the ritualistic necessity of sacred vessels on an altar. Zurbarán's light, like Gris's, contributes to this sharp and dry intensity. Reflecting the strong contrasts of sunlight and shadow so familiar to the Spanish scene, its probing, steady rays silently metamorphose an array of mundane still-life objects into a hushed world of almost supernatural clarity and order.

In *Still Life with Bottles* of the following year, 1912, Gris sustains XVIII his Spanish asceticism. Again, the prosaic paraphernalia of a table top— a carafe, a bottle of wine, a wineglass, and a knife and plate—are magically ennobled by the geometry that elucidates their structure and the uncannily brilliant light that strikes their crystalline surfaces. The colors, too, contribute to this grave dignity. Here, even more self-denying than Picasso and Braque in their contemporary work, Gris keeps within a monkish olive monochrome alleviated only by the brown ring in the bottle that defines the upper surface of what almost becomes, in Gris's hands, sacramental wine.

Despite the Cubist disjunction of planes, the vivid luminary description of edges gives the objects in Gris's early still lifes a strange concreteness and precision that evoke the characteristically Spanish respect for the palpable facts of the material world. This may be seen in the *Portrait of Picasso,* also of 1912, in which Gris follows the example of his 67 sitter's great Cubist portraits by using the most abstract Cubist language to record particular facts of physiognomy. Yet Gris's attraction to a preordained geometric structure is far more inflexible than Picasso's and imposes itself more strongly upon the sitter; hence, the portrait presents a curious tension between an *a priori* concept of pictorial order and the concrete data of Picasso's appearance. The abstract regularity of Gris's structural grids extends from the right-angled prisms of the background to the predictable triangular patterns of the buttons on the jacket;

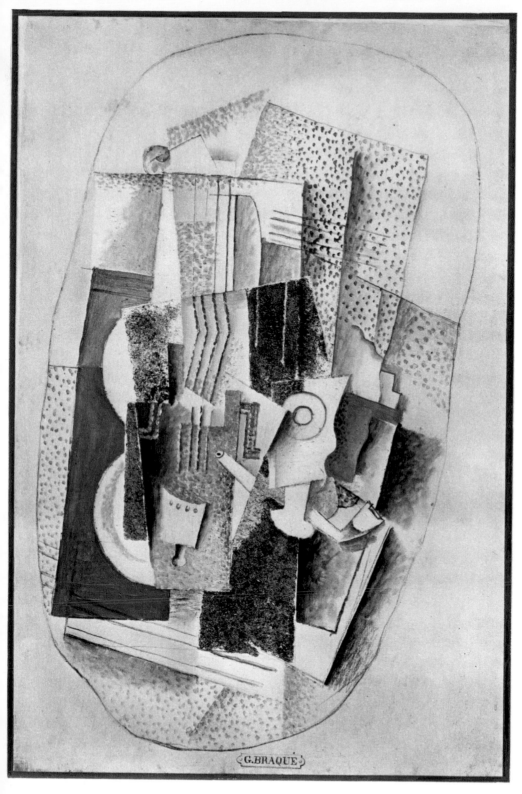

52. Georges Braque. *Music*. 1914

53. Pablo Picasso.
Diaghilev and Selisburg. 1919 (1917?)

54. Pablo Picasso. *Portrait of Olga in an Armchair*. 1919 (1917?)

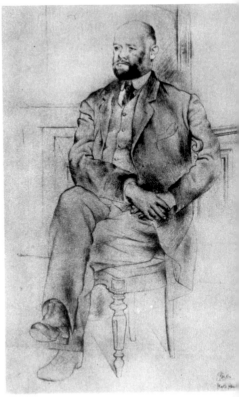

55. Pablo Picasso. *Max Jacob*. 1915

56. Pablo Picasso.
Ambroise Vollard. 1915

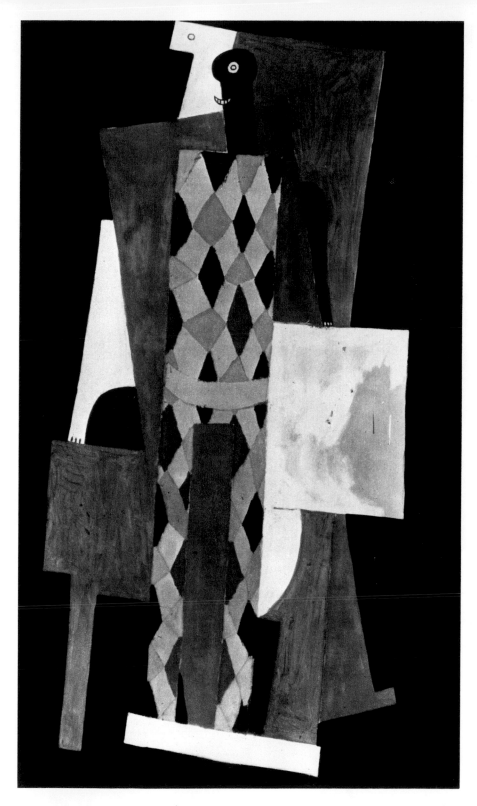

57. Pablo Picasso. *Harlequin*. 1915

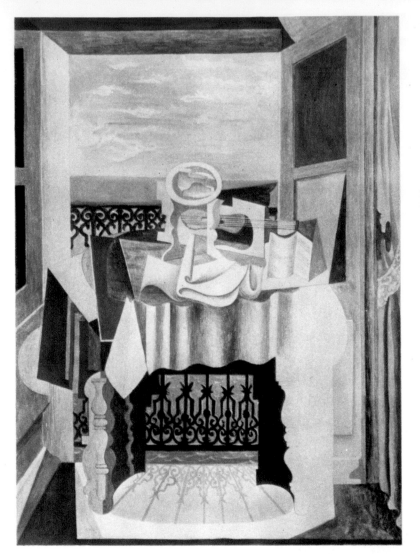

58. Pablo Picasso.
The Window. 1919

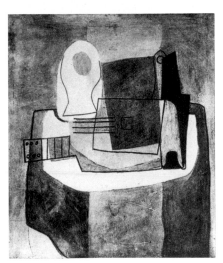

59. Pablo Picasso.
Page of Sketches. 1919

60. Pablo Picasso.
Guitar, Bottle, and Fruit Dish. 1921

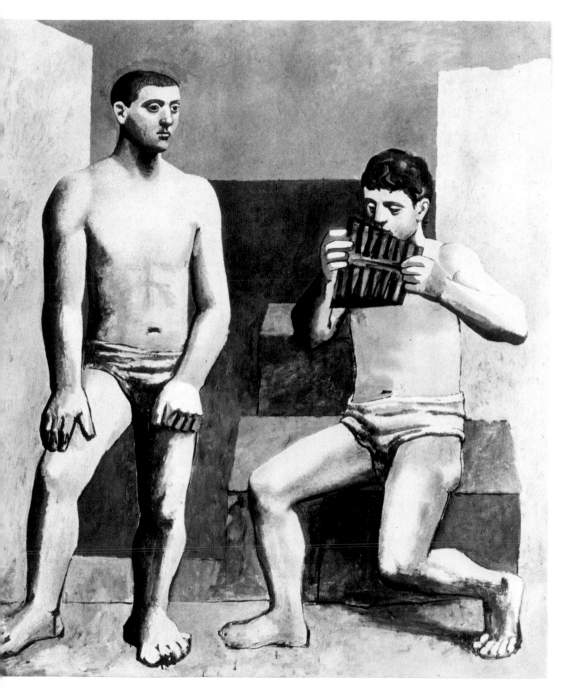

61. Pablo Picasso. *The Pipes of Pan.* 1923

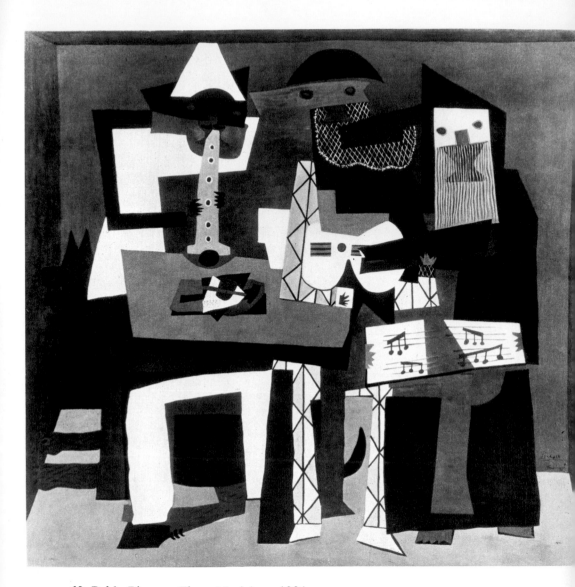

62. Pablo Picasso. *Three Musicians*. 1921

63. Georges Braque. *Musician.* 1917–18 64. Georges Braque. *Café-Bar.* 1919

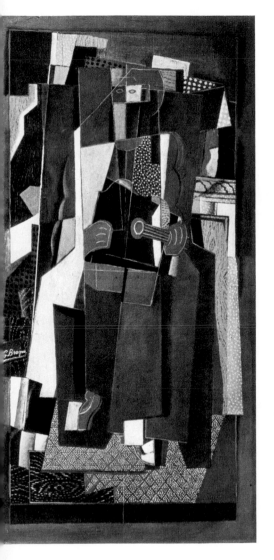

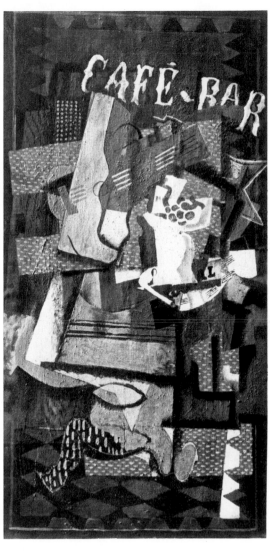

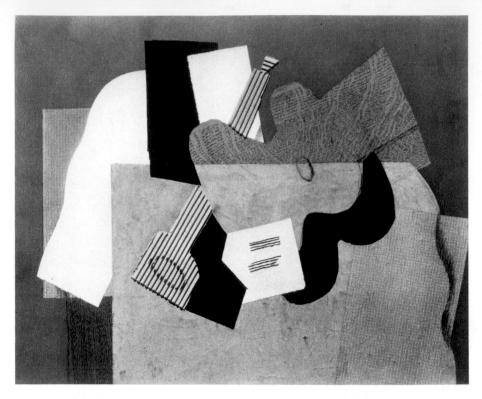

65. Georges Braque. *Musical Forms (Guitar and Clarinet)*. 1918

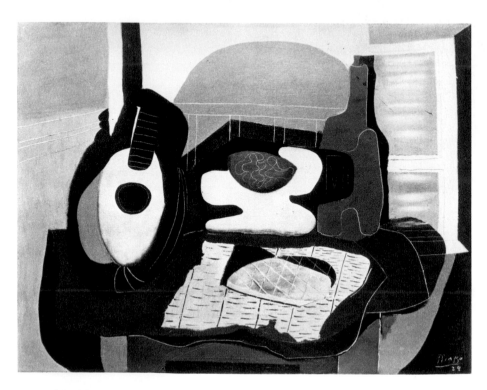

66. Pablo Picasso. *Still Life with a Cake*. 1924

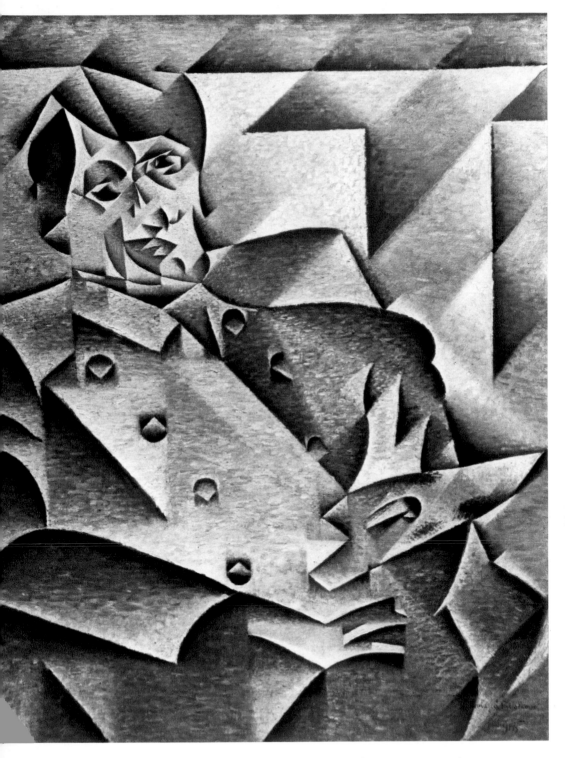

67. Juan Gris. *Portrait of Picasso*. 1912

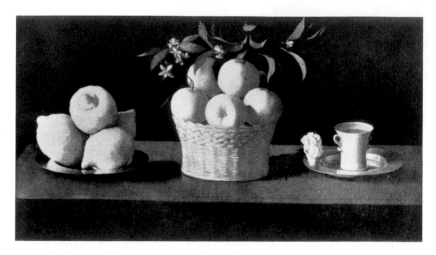

68. Francisco de Zurbarán. *Still Life with Oranges*. 1633

69. Paul Cézanne. *The Black Clock*. About 1870

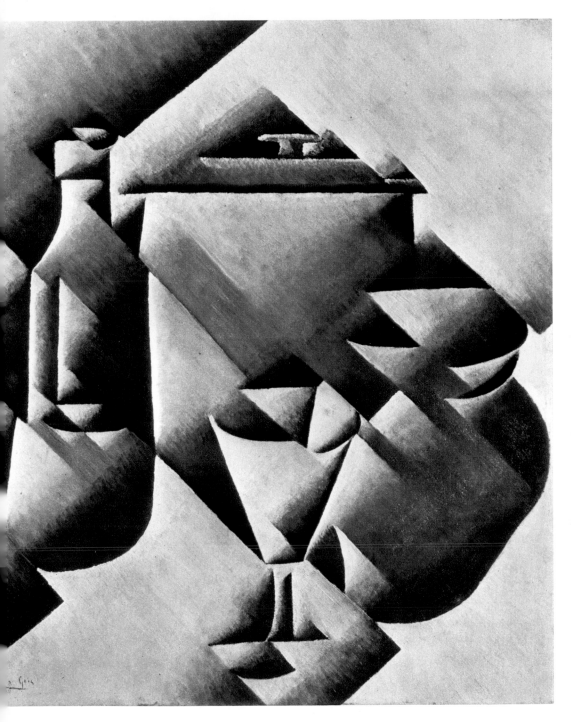

70. Juan Gris. *Still Life*. 1911

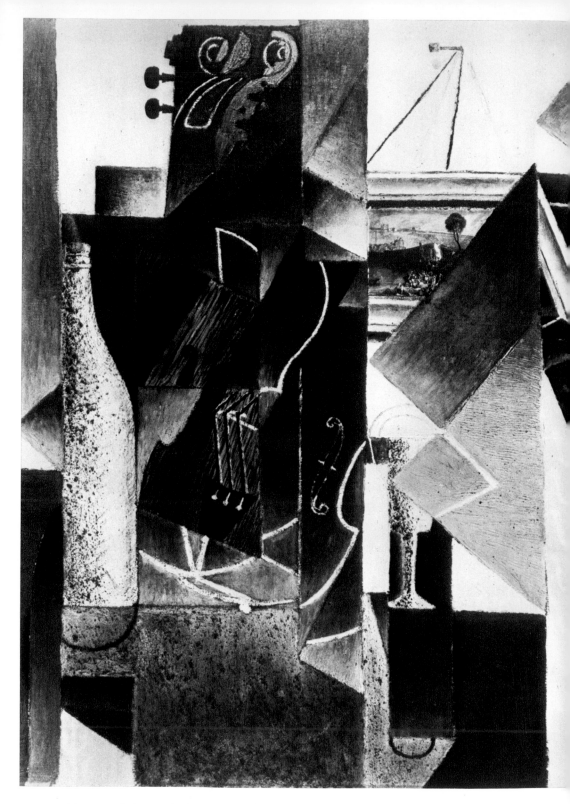

71. Juan Gris. *Violin and Engraving.* 1913

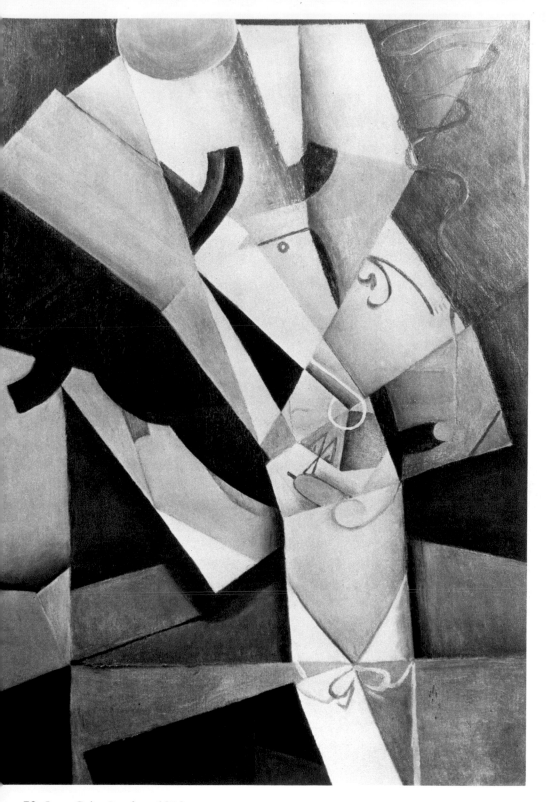

72. Juan Gris. *Smoker*. 1913

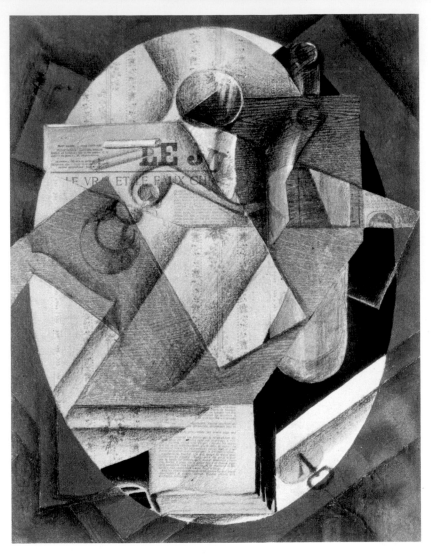

73. Juan Gris. *The Table*. 1914

74. Pablo Picasso. *La Table de Toilette*. 1910

75. Juan Gris. *Portrait of Max Jacob*. 1919

76. Juan Gris. *Harlequin*. 1919

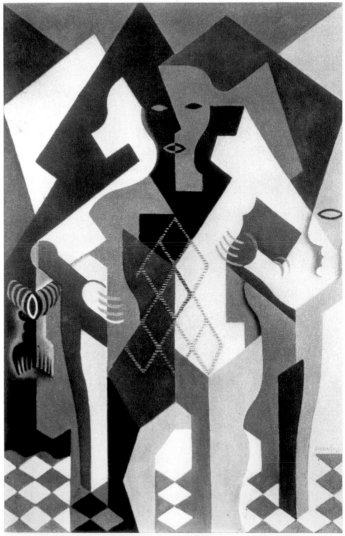

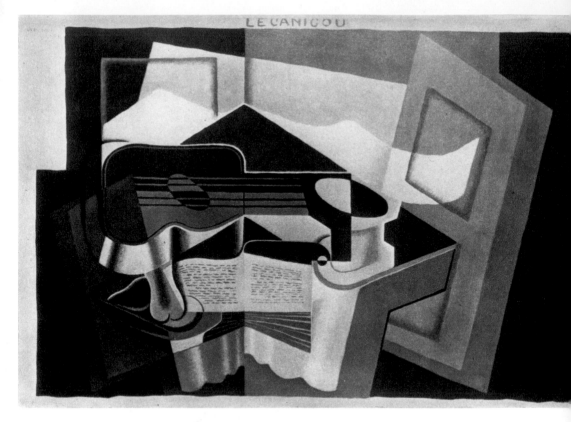

77. Juan Gris. *Le Canigou*. 1921

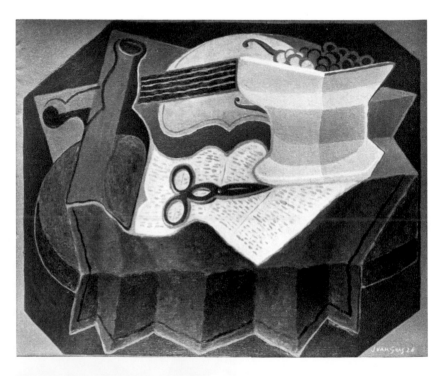

78. Juan Gris. *The Scissors*. 1926

but the head, with its strong features and great sweep of hair, rebelliously asserts its uniqueness in the context of this rigid geometric system.

Gris's search for the most lucid and fundamental forms (echoed by the three primary colors—red, yellow, blue—that he places on Picasso's palette) established in his best work a rich interplay between a predetermined vocabulary of perfect parallels, perpendiculars, and diagonals and the imperfect objects described. In the *Watch* of 1912, a group of still-life objects on a table top—including a bottle of sherry, a goblet, a bowl, and a book—is aligned against a vertical grid of blue-and-white wallpaper stripes with the precision of the mechanism that ticks away inside the watch. Yet this knife-edged perfection of shape and structure, which recalls Gris's famous statement, "Cézanne turns a bottle into a cylinder, but I . . . make a bottle—a particular bottle—out of a cylinder," is countered throughout by the intrusion of those very particular realities that both Picasso and Braque had begun to use to indicate the ultimate connection of their work with the external world. Unlike the 1912 *Still Life with Bottles,* with its Spartan leanness, this work is enriched not only by a more varied, if still somber, palette but by such concrete data as the collage (just visible under and to the upper right of the watch chain); the label on the sherry bottle (which, quite literally, makes "a bottle—a particular bottle—out of a cylinder"); the *trompe-l'oeil* effect of the curtain and tassels at the left (a device inspired by the illusionistic curtain cords in Braque's *Portuguese* or Picasso's *Ma Jolie*); and, not least, the extraordinary watch, which offers a brilliant metaphor of the Cubist time experience.

Just as Cézanne, in the famous *Black Clock* of about 1870, had chosen to paint a handless clock and thereby substituted a strange new sense of duration for the Impressionist experience of a pinpointed moment of time, so Gris paints, as it were, a Cubist watch. Although its hour hand (pointing to XI) and two numbered quarter-faces suggest a precise moment of perception, the missing minute hand and the two obscured quarter-faces make an exact reading of the time quite as impossible as an unambiguous reading of the objects and their spatial relations. Like the circles of the bottle, goblet, and bowl, time is fragmented into discontinuous quadrants that cannot be reconstructed with any finality.

As the *Watch* indicates, Gris's intellectual temperament attracted him particularly to the witty confounding of art and reality that Braque and Picasso had been exploring around 1912. In the 1913 collage *Violin and Engraving,* Gris rivals the pictorial authority and perhaps even surpasses the metaphysical complexity of Picasso's 1913 *Violin*. Here a *trompe-l'oeil* nail and wire (recalling Braque's 1909–10 *Still Life with Violin and Pitcher*) support an equally illusionistic molding of a picture frame within which Gris has pasted a very real engraving. But these two kinds of illusion—one painted by Gris himself, one engraved by an anonymous artist—are no more and no less real than the rest of the painting, for Gris has irrevocably interrelated them with their Cubist environment. The engraving and the frame are subjected to the same angular dislocation as the violin and the goblet, and the picture wire seems to metamorphose

XIX

X, XI

69

71

XII

IX

into one of the three strings of the violin, so that the *trompe-l'oeil* nail becomes more of a violin peg than the actual pegs at the left.

In making a Cubist figure, Gris, like Picasso, occasionally moved from the cerebral wit of his still lifes to a more earthbound humor. In the *Smoker* of 1913, the head of the gentleman, like the cylinder of the top hat he wears, swings back and forth with the restless motion of a pendulum. The almost caricatural effect this produces is further underlined by Gris's confounding of the scroll-like shapes of ear, chin, and necktie, so that the figure becomes a quizzical automaton made of modular parts. And, as a final humorous touch, Gris opposes the flat, Cubist reality of the smoker with the *trompe-l'oeil* reality of the smoke, which rises from his cigar in a hazy, serpentine path completely indifferent to the rectilinear disciplines that lie behind it.

In general, however, Gris worked within the austerely intellectual confines of the world of still-life objects, which he would examine again and again with almost monastic dedication. The taut and immaculate order that he so often attained is suggested by the *Table* of 1914, a still life that achieves an unerring, yet never obvious, equilibrium of intersecting diagonals, verticals, and horizontals within a perfect oval. Again, Gris explores the fascinatingly multiple lives of these humble objects. The *trompe-l'oeil* key of the table drawer (a device used earlier by Picasso in his 1910 *Table de Toilette)* is contrasted with the flatness of the table itself; the two-dimensional newspaper collage is more palpable than the ghost of a pipe that hovers over it; and the lower half of the book at the bottom is transformed at the top into the upper half of the daily newspaper, only to be reincarnated in the glassy transparency of the bottle. Even the newspaper text is no innocent bystander in this intricate series of metamorphoses; the headline LE VRAI ET LE FAUX (the true and the false) verbally announces the Cubist theme of ambiguous identities that Gris so brilliantly realizes in visual terms.

At times, the dry, cerebral drama of these collage still lifes is replaced by a strange and somber quality that had already appeared in Gris's work of 1911–12. In the *Still Life Before an Open Window: Place Ravignan* of 1915, the prismatic planes of Cubism and the Zurbaranesque contrast of crystalline light and black shadow lend a complex arrangement of table objects and a Montmartre window view an otherworldly mystery. Here an unseen distorting lens transforms the tangible realities of a book, a bottle of Médoc, a fruit bowl, a goblet, a newspaper, and a carafe into a fanlike sequence of anamorphoses, whose magical rays then encompass the grillwork of the balcony and the upper fringe of leaves and branches and finally disappear in the more literally described tree trunks and shutters of the street scene beyond. The colors, too, participate in the sorcery that Gris exercises upon the everyday world. Temporarily departing from the monochrome of his early palette, Gris offers here such startlingly original color contrasts as the unearthly blue of the Place Ravignan with the earthy brown of the wooden table or the inky blue-black of the bottle of Médoc with the luminous pastels of the fruit bowl and the mottled pink and green triangles that refer to the book's decorative binding.

72

73

74

xx

The vestiges of traditional pictorial depth maintained in such a work by the almost illusionistic passages of light and shadow or the oblique foreshortening of the book often distinguish Gris's art of these years from the more consistently flat and airless space of Picasso's and Braque's contemporary Synthetic Cubist work. Yet Gris profoundly understood the Cubist lesson that pictorial style is a relative and not an absolute matter; and, like Picasso, he could vary his style, even within one picture, from two-dimensionality to sculptural roundness.

76
75

55

In 1919, following the example of his compatriot, he could produce, on the one hand, a work like the *Harlequin,* as flat and impersonal as a playing card, and, on the other, the pencil portrait of Max Jacob, whose literal description of observed fact recalls Picasso's Ingres-like drawings, which also included portraits of Jacob. Yet, even within one work, Gris insists that the validity of two seemingly absolute and mutually exclusive styles is actually a relative matter. In the painted *Harlequin,* the patterned, emblematic flatness is interrupted by the rounded, luminous contours of the goblet at the right and the tassel at the left; conversely, the ostensible three-dimensionality of the rounded, twisting contours in the portrait of Jacob is sharply contradicted by repeating in Jacob's vest pocket the shape of the flat, right-angled molding of the background. In the same way, the rigidly geometric patterns of the *Harlequin* are surprisingly opposed by such irregular shapes as the legs of the figure and the table, whereas the seemingly unpredictable shapes of reality, as recorded in the portrait, are transformed into such rigidly repetitive patterns as the parallel fingers and the parallel folds of the sleeve.

77

Both the greater leanness of surface and the greater irregularity of contour apparent in these works were to dominate what remained of Gris's short career. In *Le Canigou* of 1921, he poses the same problem of a still life against a window view that concerned him in the 1915 *Still Life Before an Open Window: Place Ravignan,* but now the atmosphere has a chilly bareness that is appropriate to the view of the snow-capped Pyrenean mountain of the background. Again, Gris's austere geometric analogies confound the absolute identities of objects and their spatial positions; here he carries the mountain range indoors and the still life outdoors by duplicating the angle of the mountain peak in the upper corners of the book and table and by mirroring the descent of the mountain range in the lower contour of the guitar. Nor does this Cubist shuffling of realities stop with such echoes as the elliptical apertures of the guitar and the goblet. The irregular margin, with its painted title above, even confuses,

XXXVIII

as in Picasso's *Studio* of 1927–28, the identity of the painted illusion and the abstract frame that encloses it.

78

In the *Scissors* of 1926, Gris continues to develop that increasing fluidity of shape so evident in Picasso's and Braque's still lifes of the 1920s. The pair of scissors, an object that must have been so familiar to a master of collage like Gris, introduces, together with the newspaper, a pattern of complex, irregular curves which are then reborn in the flaccid shape of the violin above, with its scissorlike sound holes, and the almost animate contours of the bottle on the left. But with characteristic austerity,

Gris also creates in the fruit bowl and tablecloth an angular enclosure of dry, pleated forms that oppose the freer, more pliant shapes that threaten the ordered purity of his pictorial world.

In another still life of 1926, *Guitar with Sheet of Music,* this fun- XXI damental asceticism remains unchallenged. Here the number of objects on the table top is reduced to two—the guitar and the sheet of music— and the window view beyond is equally stark. Within an almost painfully spare pattern of acute and obtuse angles and a palette so somber that even the brilliant red of the tablecloth seems unsensuous, Gris unites and confounds these separate objects with each other and with their setting. The edge of the table, presumably convex, emerges on the left side of the tablecloth as the concave frame of the window; the olive plane of the table top becomes the barren landscape beyond; and the four strings of what, in reality, would be a six-stringed guitar are re-created in the three lines of what, in reality, would be the five-lined staffs of music.

Gris died in the spring of the following year, 1927. As such a still life may indicate, he had remained faithful to the original principles of Cubism until the end. For him, if not for his compatriot Picasso, the intellectual drama evoked by inanimate objects on a table top could express the entirety of his solemn pictorial world.

5 *Léger and Purism*

The mystic, secluded atmosphere of Juan Gris's Cubism could hardly be more remote from the world of the fourth major Cubist, Fernand Léger (1881–1955). Léger, the son of a Norman farmer, is antithetical to Gris in viewpoint. For the activities of the intellect he substitutes the physical activities of the human body and the machine; for the privacy of the artist's world of still-life objects, the public experience of the contemporary industrial world; for the intimacy of a refined pictorial language, the impersonality of a classic, monumental style. Léger, in fact, offers the most sustained twentieth-century statement of vigorous, optimistic acceptance of the often lamented realities of our mechanized environment. To him, Cubism was a means of transforming the equation of the human and the mechanical, whose implications could be so frightening to many modern observers, into something positive and even beautiful.

Léger's early evolution is somewhat conjectural, for he destroyed most of the work he executed between 1905 and 1910. By 1910, however, he had seen the work of Picasso and Braque at Kahnweiler's gallery, though, stimulated as he was by Cézanne and Delaunay, he may well have been moving independently in the direction of Cubism. In any case, the *Woman Sewing* of 1909–10 parallels the blocky, regularized forms of Picasso's work of 1908 and 1909, so that the figure takes on the curiously powerful and elemental quality of such work as Picasso's *Nude in the Forest*. But already one can discern Léger's distinct personality, for his treatment of the genre theme of a woman sewing is aggressively contemporary. Not only has the woman herself been joined together out of simple

blocks and cylinders, as one would construct a machine, but her implied movements of hand and arm have a comparably regular and automatic quality. Recalling earlier versions of this theme, which extend back to the drawings of Seurat and ultimately to Vermeer's famous *Lacemaker* in the Louvre, one is tempted to retitle Léger's painting "Sewing Machine."

In the same year, 1910, Léger completed a major canvas, *Nudes in the Forest,* which explored these attitudes still further. Here Picasso's childlike forests and subhuman block figures of 1908 have been transformed into an even stranger environment in which three gigantic and animated figures are densely compressed in a landscape crowded with hills, bushes, and trees. If this expansive trinity of nudes in a natural setting resumes a great French classical motif popular at the turn of the century in masters like Cézanne, Matisse, and Derain, the interpretation of this theme is distinctly new and distinctly Léger's. The figures, who resemble art students' anatomical manikins, are composed of chunky, regularized parts that extend even to the flattened rows of fingers and toes and the helmetlike crowns of hair. So oddly inhuman are these contorted, sexless robots that they begin to be confounded with a natural environment that, in turn, seems constructed of mechanized parts. Cylinders of tree trunks are confused with cylinders of arms; pleated rotundities of the earth merge with faceted curves of shoulders and buttocks. Moreover, the scene is pervaded with a sense of vigorous activity, like the jerky movements of a huge, churning machine. Indeed, the very colors transform the Cubist ascetic palette of beige, gray and dull green into something glistening and mechanical. Characteristically, Léger has translated Braque's and Picasso's movement of the mind into a movement of the body, their geometry of the intellect into the geometry of the machine.

Despite such fantastic excursions as the *Nudes in the Forest,* Léger's art, like Braque's and Picasso's, was generally wedded to empirical observation. In the 1912 *Paris Seen Through a Window,* Léger once again refreshes his contact with reality by confronting himself with an Impressionist theme like Braque's window view of Céret painted in the previous year. Léger, like Braque, had begun his career within the orbit of late Impressionism, and such a window view, continuing the tradition of Monet, Pissarro, and the Fauves, should hardly be unexpected in his *oeuvre.* But, unlike his nineteenth- and twentieth-century predecessors and unlike Braque and Picasso, Léger interprets this fugitive scene with a concreteness and structural firmness that recall his early training as an architect. The vertical and horizontal regularity of the window frame rigidly disciplines the complexity and agitation of the objects before and behind the glass. Léger sees the world in terms of elementary, architectonic shapes, whether he is describing the simple diagonal thrusts of the bridge and the latch or extracting the spherical patterns from the arches, smoke, and curtain.

Gradually, Léger's contact with a specifically observed reality grew more oblique. In 1913, the year following this Parisian window view, he began a series of paintings under the over-all title "Contrasts of Forms," in which the relentless reduction of the diverse phenomena of

XXII

V, III

80

31

visual experience led to a totally abstract pictorial vocabulary whose simple, homogeneous shapes could almost be mass-produced.

XXIII
101

Related to these abstract Contrasts is the *Stairway* of 1913, in which two monumental figures descend an intricate network of steps. Paying homage, consciously or not, to Duchamp's *Nude Descending a Staircase* of 1912, Léger again chooses a theme involving physical activity and again equates human movement with the predictable, regularized motion of a machine. But here the trees and robot nudes have been even more thoroughly dismembered into their fundamental components. With the simplicity of an architectural primer, Léger presents and contrasts the basic building blocks of the world as rounded and angular shapes, not excepting the two figures whose structure and pose are as identical as the steps of the stairway between them. Similarly, all the colors of perception have been distilled to an analogous purity, for Léger uses in this painting only the three primary colors—yellow, red, and blue. In a picture like this, Léger arrives at a stage of evolution comparable to the high point of Analytic Cubism in 1911. Like Braque and Picasso, he has carried the process of reduction and regularization to a dangerous but exhilarating extreme, which at the same time is contradicted by the invigorating irregularity of the drawing and brushwork that describe these deceptively simple geometries. But typically, Léger, unlike Braque and Picasso, retains his grasp of palpable matter. However dismembered his forms may be, they never lose their physical substance or their ability to function in a physical way. If Analytic Cubism takes us to the mysterious core of a dialectic between art and reality, solid and void, line and plane, Léger's *Stairway* takes us rather to the center of a very corporeal universe whose shapes and movements are ultimately as intelligible as the inner workings of a machine.

It is not surprising that, during these years, Léger was as uninterested in the metaphysical realities of collage as he was interested in the physical realities of the First World War. Whereas a search for explicit evidence of this international conflict in the art of Picasso, Braque, or Gris would challenge the most determined Marxist critic, Léger's work and thinking responded directly and enthusiastically to the world of human and mechanized battle. A member of the artillery between 1914 and 1916, Léger made many drawings of soldiers and military equipment at the time. In his own words, "I was dazzled by the breech of a 75-millimeter gun which was standing uncovered in the sunlight: the magic of light on white metal. This was enough to make me forget the abstract art of 1912–13. A complete revelation to me, both as a man and as a painter."

XXIV

In 1916 Léger was the victim of a gas attack near Verdun and was discharged from the army. In the following year, 1917, he was able to sum up his war experiences in the *Cardplayers,* a scene of two soldiers engaged in a lively card game while, at the right, a third soldier, who quietly smokes his pipe, appears to watch. As in the *Woman Sewing,* Léger has taken a genre theme from the Western tradition (which extends back from Cézanne's grave and immobile cardplayers to the sprightlier chicanery of Caravaggio's card game) and transformed it into explicitly twentieth-

century terms. Decorated with chevrons, stripes, and medals, Léger's protagonists are depersonalized machines playing, in a moment of leisure, a game less dangerous than the game of war for which they are so eminently suited. Their bodies, in fact, are identical in shape and texture with the smooth, clean geometries of gun metal, helmets, and armored tanks; and their steel-cylinder fingers seem better adapted to handling bullets than to holding paper cards. Yet this equation of the human and the mechanical, so frequent in this period, is not bitter or satirical, as with the Dadaists, or belligerent and fascistic, as with the Futurists. For Léger, this reduction of the visible world to a state of polished, regular shapes and well-oiled mechanical functions becomes a goal of aesthetic order whose lucidity and precision are classical in flavor. The very smoke from the pipes has been given a clear linear definition, recalling Ingres' earlier dictum that "even smoke should be expressed by line." Indeed, Léger's transformation of the multiple data of reality into a style that emulates the serene and unerring perfection of the machine suggests a reassertion of the viewpoint of French Classicism in terms of the unique experiences of our century. The color, too, as in the *Stairway,* conforms to the aesthetic of Ingres, David, and Poussin in its subordination to a pre-existent sculptural form and its predilection for the purest hues.

By 1919, Léger's style had changed in a manner that paralleled, in the context of his own vocabulary, the transformation from Analytic to Synthetic Cubism. The cardplayers of 1917 are still represented by the pictorial illusion of solid, rounded shapes, whose tactile reality is affirmed by the strong modeling in light and dark. Although these tangible forms may be compressed forward in a two-dimensional pattern whose almost suffocating physical density is reminiscent of certain sixteenth-century Mannerist paintings, they nevertheless maintain a traditional illusion of solids behind an imaginary picture plane. In a work of 1919 like the *City,* however, Léger's style has altered radically in the direction of a far greater awareness of the opaque reality of the picture surface. Here, in analogy with Synthetic Cubism, most forms have been flattened; they seem to exist in front of the plane of the canvas rather than behind it. Even where suggestions of the earlier modeling are retained, as in the figures of the central foreground or in the large smokestack to the right, the modeling no longer implies a total sculptural roundness, but, rather, a partial protrusion, like a bas-relief, from the flat surface. Furthermore, the forms themselves, as in Synthetic Cubism, are broader and more discontinuous, now offering large fragments of incomplete objects rather than small fragments of complete objects.

In subject, Léger's canvas re-creates brilliantly both the complexity and the unity of urban experience. Using the flat, fragmentary planes of Synthetic Cubism, Léger evokes the rapidly shifting visual environment of the contemporary world, with its continuum of abrupt and vivid sensations only fractionally observed. Here is the smoothly churning labyrinth of the modern city, infinitely extendible; and here are its human inhabitants, who become only impersonal elements in the functioning of the vast urban machine. Yet Léger's interpretation of this phenomenon is

81

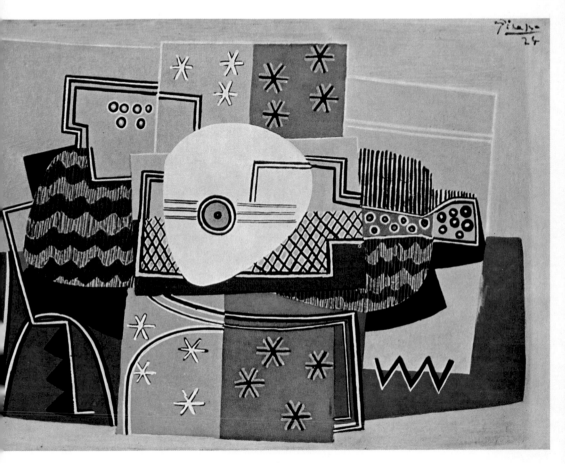

XVII. Pablo Picasso. *Still Life with Guitar*. 1924

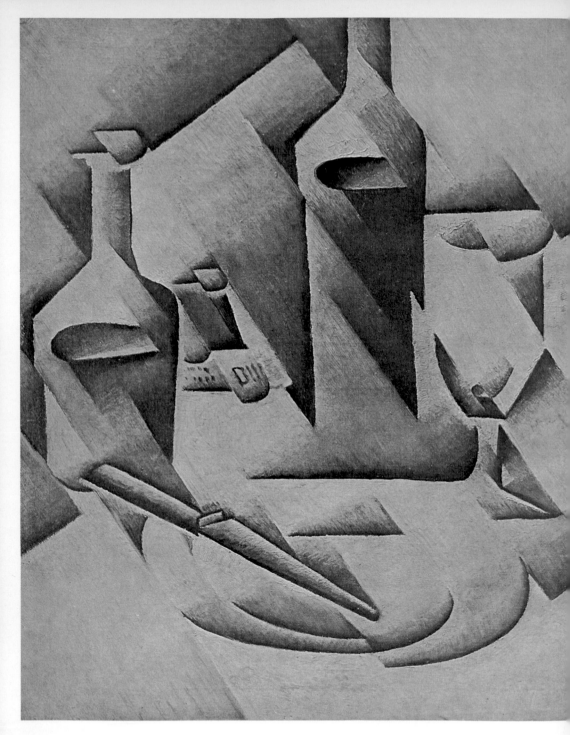

XVIII. Juan Gris. *Still Life with Bottles*. 1912

XIX. Juan Gris. *The Watch (The Sherry Bottle)*. 1912

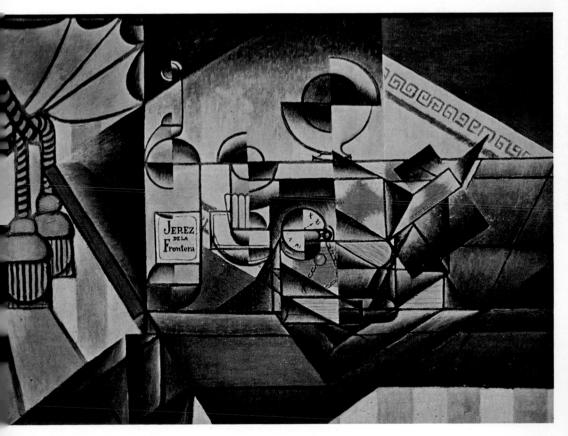

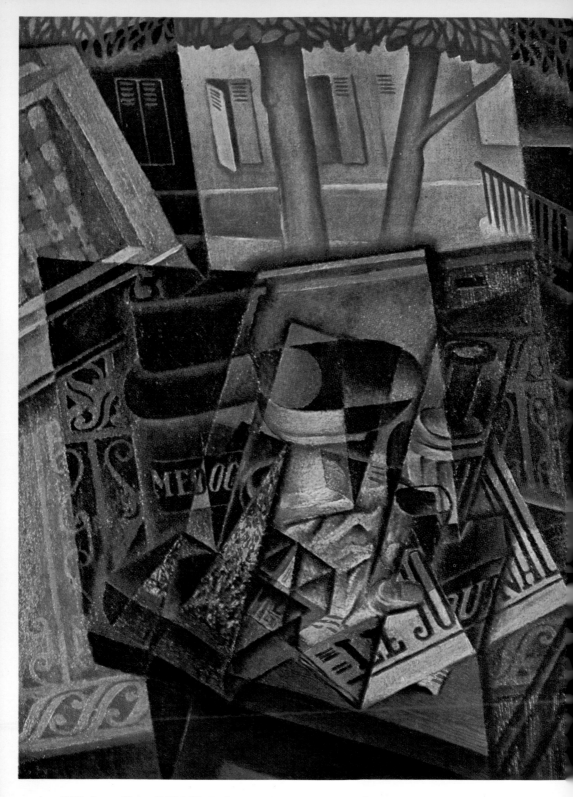

XX. Juan Gris. *Still Life Before an Open Window: Place Ravignan.* 1915

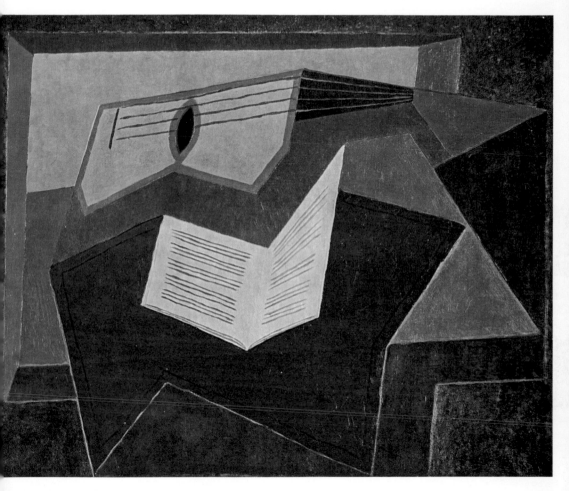

XXI. Juan Gris. *Guitar with Sheet of Music*. 1926

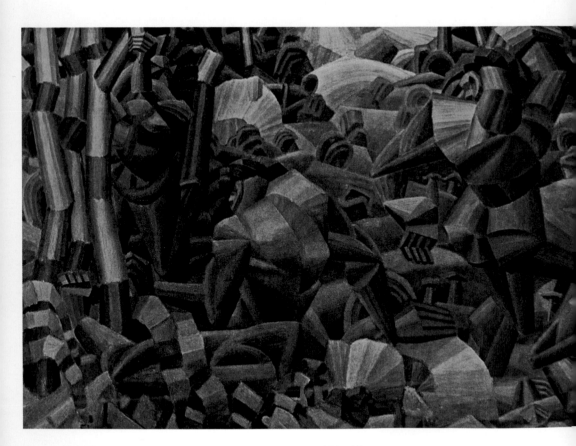

XXII. Fernand Léger. *Nudes in the Forest*. 1909–10

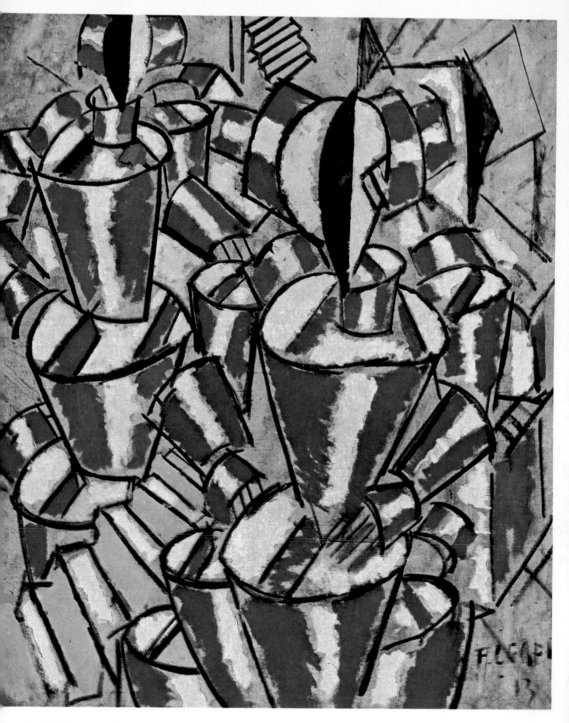

XXIII. Fernand Léger. *The Stairway*. 1913

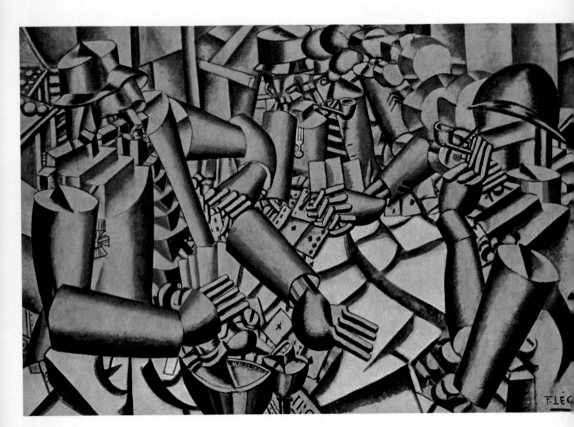

XXIV. Fernand Léger. *The Cardplayers*. 1917

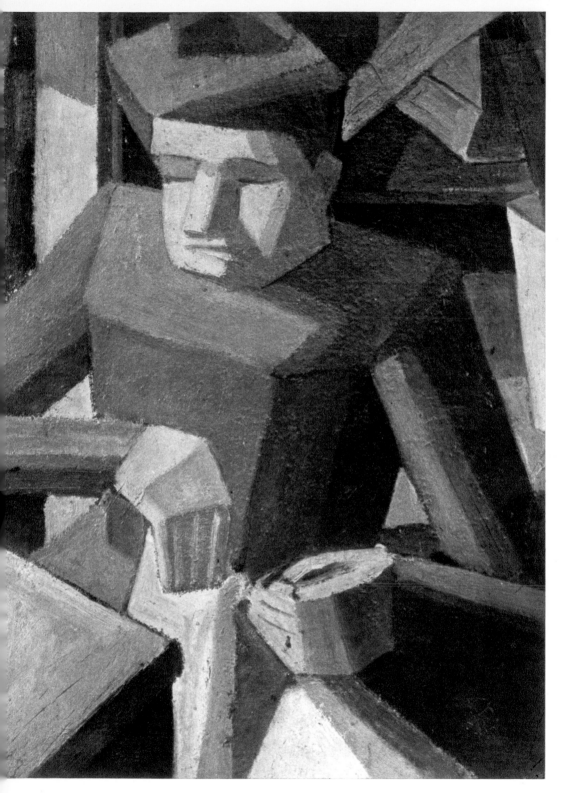

79. Fernand Léger. *Woman Sewing*. 1909–10

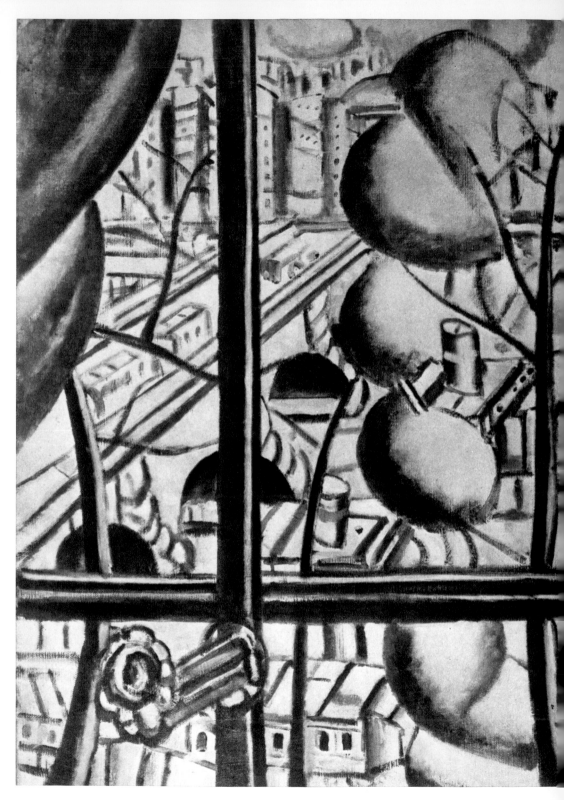

80. Fernand Léger. *Paris Seen Through a Window*. 1912

81. Fernand Léger. *The City*. 1919

82. Nicolas Poussin. *Holy Family*. 1651

83. Fernand Léger. *Three Women (Le Grand déjeuner)*. 1921

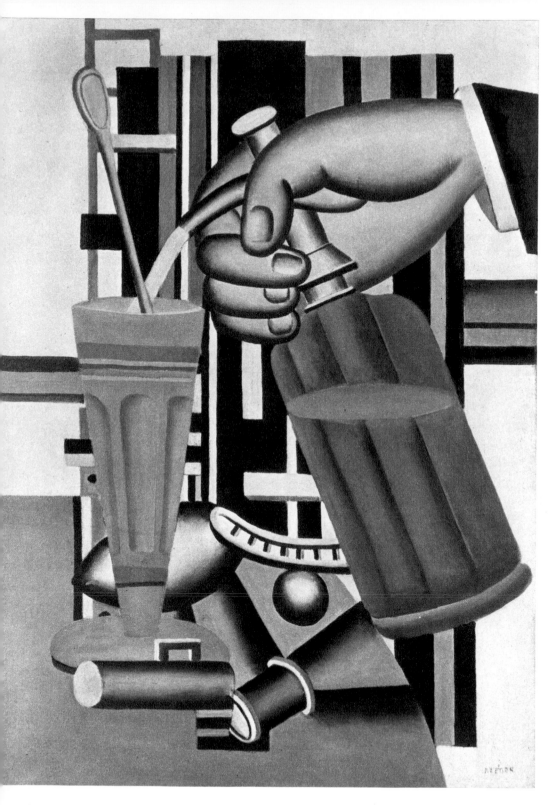

84. Fernand Léger. *The Siphon*. 1924

85. Le Corbusier (Charles-Edouard Jeanneret).
View of the Pavillon de l'Esprit Nouveau, Paris. 1925

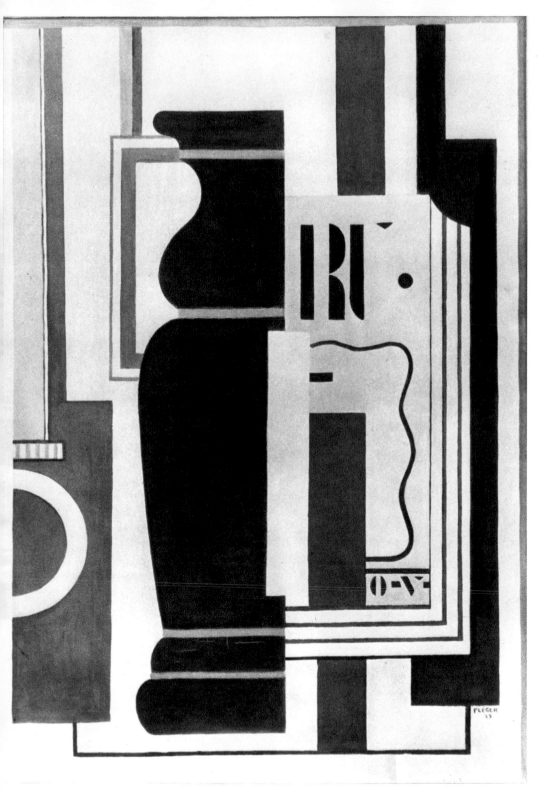

86. Fernand Léger. *Composition No.* 7. 1925

87. Amédée Ozenfant. *Fugue*. 1925

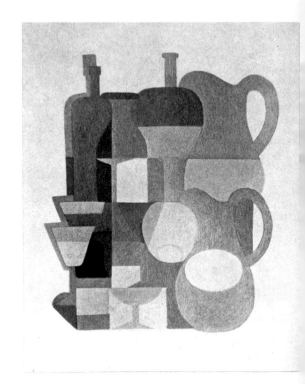

88. Amédée Ozenfant. *Theme and Variations*. 19

optimistic, for he has emphasized the modern city's potentialities of order and beauty rather than its confusion and ugliness. With his purified shapes, flat poster colors, and impersonal smoothness of brushwork, Léger has found a rich harmony in the very aspects of mass production and anonymity that are the targets of many critics of the contemporary industrial society.

The architectural subject of the *City* conformed to Léger's increasing imposition of a vertical and horizontal structural order upon the dismembered planes of his postwar style. This tendency toward an explicitly classical stability reaches its resonant climax in 1921 in the *Three Women (Le Grand déjeuner).* Like Picasso's *Three Musicians* of the same year, Léger's work offers a resolute, ordered statement of Cubism's past achievement and one that rests confidently among the masterpieces of the past. Indeed, the imposing size and serene dignity of the *Three Women* pertain specifically to the great classical tradition in French painting.

Just as Poussin and David presented idealizations of the world of classical history and mythology, and Seurat created an Arcadian idyl of the world of the nineteenth-century bourgeoisie, so Léger constructs a myth of monumental discipline and lucidity to correspond to the age of the machine. Within a domestic interior, whose geometric patternings echo the Utopian purism and simplicity of the *avant-garde* architecture and design of the period and most particularly of the Dutch group, De Stijl, Léger's three nude machine goddesses, together with their black cat (borrowed from Manet's equally imperturbable Olympia?), reign over a new era. Now the atmosphere of warmth and sensuality so often associated in the French tradition with a nude in an interior setting is replaced by a dispassionate, almost Neo-Classic geometry that orders kneecaps, breasts, and buttocks as rigorously as tables, pottery, and fruit. In this, Léger again reveals himself a master in the French classical tradition of Poussin, David, and Seurat, for here even aspects of sensuousness and emotion have been severely repressed in order to achieve a permanent and impersonal harmony between the human figure and an abstract concept of pictorial discipline. Like the protagonists of Poussin's *Holy Family,* Léger's figures are crystallized into an immutable structural order whose minimal distinction between the animate and the inanimate can tolerate few irregularities of form or emotion.

This conception of the human figure as an emotionally neutral object to be manipulated for aesthetic ends alone is revealed in some of Léger's landscapes with figures of the same year, 1921—the so-called *paysages animés* (animated landscapes). In a typical example, *Man and Dog,* Léger again recalls Poussin's rigorous structures of man, architecture, and landscape, although the classical dignity accorded the peasant subject also recalls the work of Poussin's contemporaries, the brothers Le Nain, and reminds one of Léger's own rural origin. As in the *Three Women,* the seeming complexity of limpid color and geometric pattern, which embraces everything from the faceless farmers and animals to the low clouds that echo the regulated roll of the hills, is ultimately resolved into a stable, impassive order that clarifies the distinction between major and

minor pictorial elements without sacrificing the sense of inevitability in each detail.

Although the greater emphasis in *Man and Dog* upon the more irregular, organic shapes of earth, tree, and cloud prophesied Léger's work of the 1930s, the paintings that followed it in the mid-1920s turned to reconsider the problem of the machine aesthetic with a new austerity and precision. A case in point is the *Siphon* of 1924, in which the identification of the human with the mechanical is so pronounced that Léger can disembody a human hand, as it were, only to demonstrate the operative function of a siphon. Similarly, in his film of the same period, *Ballet mécanique* (1923–24), fragments of the human body are made to move like machine parts. In the *Siphon,* the organic aspires to the perfection of geometry, so that the irregular cylinders of the fingers approximate the machine-made grooves of the glass and siphon.

84

The pictorial magnification of separate objects and their component geometric purities often led Léger to paintings that appear to have little if any reference to the real world. In *Composition No.* 7 of 1925, Léger presents a spare and monumental contrast of curved and straight silhouettes in which the barely identifiable objects—half of a baluster at the left and half of a book at the right—are related by the analogies of geometry alone rather than by the more literal context of a group of still-life objects. Even the fragmented letters on the book seem divorced from any but a geometric function, echoing in miniature, as they do, the bold opposition of curvilinear and rectilinear shapes that is the solemn theme of this lean but majestic painting.

86

The architectural clarity and ascetic exactitude of such a work suggest the impact of the movement known as Purism upon Léger's art. The two leaders of the movement, Amédée Ozenfant (1886–1966) and the great architect Le Corbusier (Charles-Edouard Jeanneret, 1887–1965), had announced the death of Cubism, at least in its initial definition, in the title of their first publication, *Après le cubisme* (1918), and offered a reform program based on a reassertion of the integrity of individual objects as opposed to Cubist dissection, and on an exactitude of pictorial style that would conform to the mechanized precision of the industrial world. In a drawing and a painting by Ozenfant, both of 1925, the characteristic detachment and almost sterile perfection of Purism are exemplified. Although these still-life objects follow the Purist doctrine in their continuity of shape, which is more clearly preserved than in earlier Cubism, they are nevertheless far more unreal than the objects of Braque, Picasso, and Gris. As in contemporary canvases by Léger, the value of these objects is totally divorced from any associative, sensuous context, but is to be found rather in the machinelike economy and regularity with which curved and straight silhouettes are measured and interrelated.

87, 88

In Le Corbusier's paintings, simple or complex, there is this same insistence on lucid, elementary shapes that appear capable of being reproduced mechanically. And, as in the Légers of the mid-1920s, diagonal accents are avoided in order to assert an architectural interlocking of strict verticals and horizontals. The architectural implications of these works

89, 90

were carried out in Le Corbusier's own buildings, whose formal relationship to Léger's art can be most explicitly demonstrated by a view of the Pavillon de l'Esprit Nouveau at the 1925 Paris Exposition Internationale des Arts Décoratifs. Here, in the context of the machinelike perfection of Le Corbusier's organization of immaculate surfaces, clean-edged volumes, and austerely elegant furniture, Léger's *Composition* of 1925 (hanging to the left of one of the architect's own paintings) presides like an authoritative dictionary of the forms and relationships realized three-dimensionally in the room itself.

By the 1930s, Léger, paralleling the evolution of Le Corbusier's architecture, began to move away from the Utopian purities of the mid-1920s and to relax his vocabulary sufficiently to introduce the unmechanical forms of nature. The *Landscape with Cows* of 1937 attests to his growing involvement with the so-called biomorphic style that dominated so much painting and sculpture in the 1930s. A severe counterpart of the fluid forms and spaces of Miró's canvases of the same decade, Léger's landscape substitutes the free shapes of organic objects created by nature for the rational shapes of mechanical objects made by man. In place of keys and balusters, books and vases, metal and glass, Léger now offers cows and hills, trees and clouds, sky and earth. But, not unexpectedly, he paints and arranges these irregular, pliant forms with the same precision and detachment that characterize his machine compositions, so that ultimately his art alludes only to the objective appearance of the organic world and not to those subjective associations of sexuality and subconscious fantasy evoked by Picasso, Moore, and Miró in their interpretations of biological form.

Given Léger's intuitive discipline, the introduction of freer contours and looser spaces meant primarily a new pictorial problem to master. By the next decade, the 1940s, he had achieved this mastery, particularly in his many studies of female divers and acrobats. Here the theme reflects not only his recurrent interest in vigorous physical activity, but, even more, the almost baroque freedom of shape and movement fostered by his explorations into organic form. Yet, predictably for Léger, this liberty is more apparent than real. The greater suppleness and irregularity of the human contours, especially irregular by contrast with the glacial rigidity and perfection of the figures in the 1921 *Three Women,* are as precisely ordered into abstractly interrelated patterns as the ruler-and-compass geometries of the earlier works. The over-all composition, which expands centrifugally and seems to be almost equally telling from any of the four sides, is a tightly locked network that reveals Léger's long contact with a more orthodox Cubist syntax. And even his new independence of line and color, which sets these two pictorial elements into a free contrapuntal relationship, depends ultimately on the structural discipline of early Cubism, especially the collages of Picasso and Braque that first established the independent existences of a contour and the colored area it enclosed.

In 1950, Léger executed a large painting, the *Builders,* inspired by the activities of the European postwar scene. The theme, with its homage to simple laborers and its optimistic acceptance of the activities of a

mechanized world, retains Léger's earlier viewpoint; but the style, paralleling the evolution of later Cubism, restores the integrity of objects that would earlier have been seen as fragmented parts. Yet even here the structural heritage of early Cubism is vital; for in such a work Léger literally transforms the mazelike intellectual structure of 1910 Cubism into a complex material structure of ladders, cranes, and steel girders that rigorously controls the new spatial amplitude and twisting shapes of his late style. And, in this identification of the language of Cubism with the forms and functions of the modern industrial era, the *Builders* may well summarize the principal theme of Léger's career.

6 *The Parisian Satellites*

Working in Paris between 1907 and 1909, Picasso and Braque had evolved Cubism in relative isolation, but by 1910 the style had begun to attract the attention of an increasing number of Parisian artists of both French and foreign origin. Between 1910 and 1914, the Parisian milieu created, in addition to the art of Léger and Gris, a virtual school of Cubist painters whose members varied widely both in the quality and in the fidelity of their interpretation of the Cubist viewpoint. And even so great an older master as Matisse, whose style had already been decisively determined by Fauvism, paused in these same years to consider, if not to absorb entirely, the new structural techniques of Cubism. The phenomenon of such a group movement was to be expected in Paris, whose public orientation to art dated back to the first salons of the seventeenth century, and whose tradition of modern art, in particular, offered the continuing spectacle of movements (such as Romanticism, Realism, Impressionism, and Fauvism) that gathered leaders and followers among the artists, and supporters and detractors among the critics and the public. By 1910 the two major Parisian salons—the Salon des Indépendants and the Salon d'Automne—began to exhibit works by young artists just won over to the Cubist point of view (although ironically Picasso and Braque, between 1909 and 1919, had important exhibitions only outside France). By 1912 the Section d'Or group, or-

ganized for the expression of Cubist ideals, held its renowned Salon and published a review. By 1913 a large body of critical writing had accumulated, including not only heated articles in such Parisian journals as *L'Intransigeant, Le Journal, La Revue de France et des pays français, Montjoie!,* and *Gil Blas,* but even two books on Cubism: Albert Gleizes and Jean Metzinger's theoretical interpretation, *Du Cubisme* (1912), and the poet Guillaume Apollinaire's less reasoned, more intuitive account of the movement, *Les Peintres cubistes; méditations esthétiques* (1913). Finally, by 1914 Cubism as a group movement in Paris had been disbanded by the outbreak of the First World War, which interrupted the careers of most of the youthful Cubists.

The Parisian satellites of Cubism, like those of Impressionism, produced a wide variety of works ranging from the rebellious to the academic, from the intensely original to the dryly imitative. Of the Parisian masters whose intense originality led to a viewpoint ultimately antagonistic to Cubism, Robert Delaunay (1885–1941) and Marcel Duchamp (1887–1968) are conspicuous. Delaunay, a consistent exhibitor in the Paris salons of 1910–14, began his Cubist career with studies of two Parisian architectural landmarks, the late Gothic church of Saint-Séverin and the late nineteenth-century monument to technology, the Eiffel Tower, whose soaring silhouette and once brilliant color had become, beginning with Seurat, a symbol of modernity to many French artists and writers. The parallel between these medieval and modern structural triumphs was made explicit by Delaunay, who, in fact, once represented them on the front and back of the same picture. Indeed, both the Gothic stone ribs and the modern metal cage presented, according to their respective centuries, a technical mastery that converted static, earthbound mass into a dynamic, ascending web of interacting forces. For this architectural experience, Gothic or modern, of the disintegration of matter to create a seemingly weightless structural network, the vocabulary of Cubism was singularly appropriate. Comparison of a 1909 version of Saint-Séverin with a 1910–11 version of the Eiffel Tower shows, in the later work, how rapidly Delaunay seized upon the fragmentation of mass evident in Picasso's and Braque's most advanced work of 1910. Imposing and proud, the great metal tower appears air-borne, as its jagged, splintered form rises far above the rooftops, past the top storeys of the highest apartment houses, and ultimately, at its very summit, moves out of sight among the bubbling clouds that accompany its vertiginous ascent.

By 1912 the vigorous, almost shattering energy of this paean to modern Paris was channeled into a more disciplined style exemplified by the regularized grids of Cubist planes that form the fabric of the monumental *City of Paris.* Consciously incorporating themes and ideas of the previous two years (hence the inscribed date, 1910–11–12), Delaunay produces in this canvas a kind of Cubist museum piece, which was, in fact, exhibited at the 1912 Salon des Indépendants. The urgency and excitement of the 1910–11 *Eiffel Tower* are here replaced by a French classi-

94, 95

96

cal lucidity, apparent not only in the tripartite structure and securely ordered detail but in the allegorical subject. Here the city of Paris is represented in terms of the famous classical group of the three Graces, whose Mannerist attenuation aspires to the weightless elegance of the Eiffel Tower at the right and whose rectilinear Cubist patternings merge firmly with the architectural vista of bridge and houses at the left.

97 The rational tendency of the *City of Paris* was continued in Delaunay's studies of the problem of color completely divorced from objects in nature; and in the same year, 1912, he produced his first *disque simultané* (simultaneous disk). In this pioneering work, Delaunay presses the Cubist's liberty to reconstruct nature to an extreme that ends by opposing the Cubist's ultimate dependence upon an external reference. For here, Delaunay offers us only an arrangement of concentric circles, whose brilliant opposition of colors is in itself intended to be the subject of the painting. Apollinaire, in *Les Peintres cubistes,* quickly recognized the radical viewpoint of such a work, and referred to it as "Orphic Cubism" and "pure art." If only for its colors, Delaunay's work would have suggested an important break with the monochromes of most Cubist painting of the time; and the influence of his Orphism can be seen in many other painters, especially in Germany.

XXVI Delaunay, however, did not adhere to a "pure art" so faithfully as such other pioneers as Mondrian, Kandinsky, and Kupka, and most often his work moved from the realm of pure color and geometry to that recording of an external reality so essential to the Cubist aesthetic. The *Homage to Blériot* of 1914 is a case in point, for its spinning complexity of prismatic *disques simultanés* here evokes the aeronautical experiences of our new century. Now, even the Eiffel Tower is left far below, as Delaunay takes the spectator high into a rainbow-colored world of whirling suns, wheels, propellers, newly conquered by such men as Blériot, who, five years earlier, in 1909, had been the first to fly across the English Channel. Delaunay's combination of the uniquely modern subject of aeronautics with the uniquely modern style of Cubism was reflected in Apollinaire, who, in *Les Peintres cubistes,* conveys an equally enthusiastic commitment to modern experience by comparing the way in which a painting by Cimabue was paraded through the streets of thirteenth-century Florence with the way in which Blériot's airplane was triumphantly carried through the streets of twentieth-century Paris when it was taken to the Conservatoire des Arts et Métiers.

 Apollinaire's analogy between the medieval and the modern world, however, referred not to Delaunay but to Marcel Duchamp, who, he felt, might revive that medieval rapport between art and the masses revealed in the public rejoicing over the completion of the Cimabue altarpiece. That Apollinaire was mistaken is not surprising, for Duchamp's career followed a course that lay beyond the prophetic capacities of even the most extraordinary critic. As one of the most intensely modern intellects of our century, Duchamp inevitably paused to examine Cubism, though

from the start his approach was heretical. In contrasting two studies of 98, 99 chess players, one of 1910 and another, unfinished, of 1911, something may be savored of his interpretation. Both scenes show Marcel's two illustrious brothers (the Cubist painter Jacques Villon and the Cubist sculptor Raymond Duchamp-Villon) concentrating intensely on a chess game, but the later version moves abruptly from an optically perceived garden to an arcane mental realm of intellect and fantasy. Freed from the restrictions of perceived reality, Duchamp's battle of logic now dissolves its two confronted protagonists into multiple, transparent images of taut brows, hand-supported chins, and pensive profiles, whose reverberation through time and space is like a projected move in the mind of a chess player. For Duchamp, Cubism opened the doors to an adventure in logic and imagination rivaled only by *Alice's Adventures in Wonderland*.

The same kind of psychological fantasy inspired by the multiple views of Cubism can be seen in another picture of 1911, *Yvonne and* 100 *Magdeleine Torn in Tatters,* the very title of which suggests a poetic metaphor for the Cubist technique of fragmentation. Again Duchamp transports a family group, this time two of his three sisters, into an imaginary world of fluid time and space, by representing each sister in both youth and maturity.

The distinctly literary intention of these four disembodied female profiles is maintained in Duchamp's most famous painting, the *Nude* 101 *Descending a Staircase, No. 2.* Once more Duchamp uses Cubist means to transfer what might be an observed situation into a strange and esoteric environment, so that even the restricted tans and browns of the Cubist palette contribute to the creation of a bizarre world that transcends ordinary color perception. In the first version of the painting, dated 1911, XXVII this famous staircase descent is relatively explicit. Regulated by the ordered, predictable sequence of steps on a spiral staircase, the nude's motion is dissected as one might analyze the moving parts of a machine. Yet, unlike Léger's contemporary figures, Duchamp's nude is no simple robot in structure or in function. Rather it is a poetic machine whose mechanical parts are indeterminate in shape and behavior and whose ultimate mysteries are as unfathomable as those of the human mind and body that it parallels.

In the second version of the *Nude Descending a Staircase,* that of 1912, the fantastic qualities of this human machine are even richer, for the figure is more extravagantly multiplied in space and its moving parts are rendered more complex. In this, Duchamp follows the increasing dismemberment and diffuseness of Analytic Cubism, although the explicit interest in sequential movement also implies connections with motion photography and the Italian Futurists. But again, the bizarre inflection Duchamp gives to his analysis of structure and motion leads to realms of private myth and imagination that, by contrast, emphasize the relative realism of the Cubist work of Picasso and Braque. In 1912, Duchamp's growing opposition to the Cubist viewpoint was symbolized by his with-

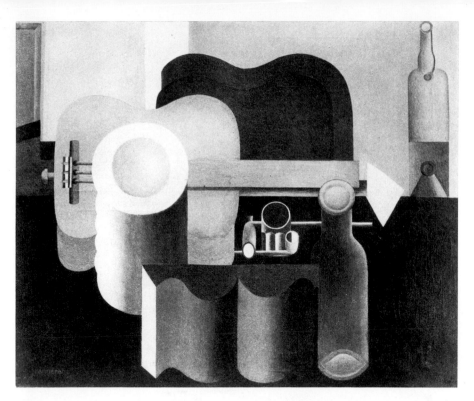

89. Le Corbusier (Charles-Edouard Jenneret). *Still Life*. 1920

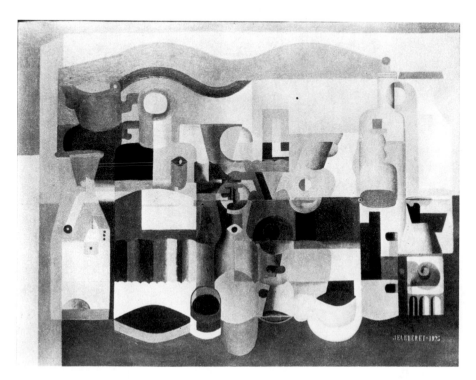

90. Le Corbusier (Charles-Edouard Jenneret).
Still Life with Many Objects. 1923

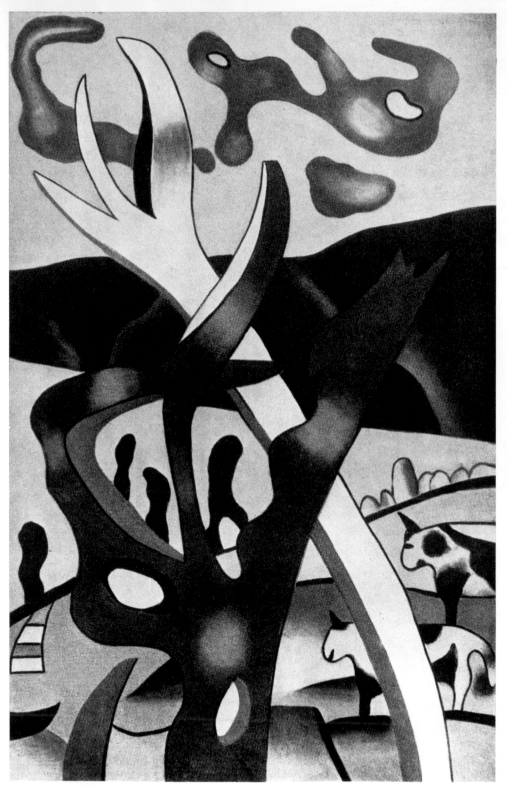

91. Fernand Léger. *Landscape with Cows.* 1937

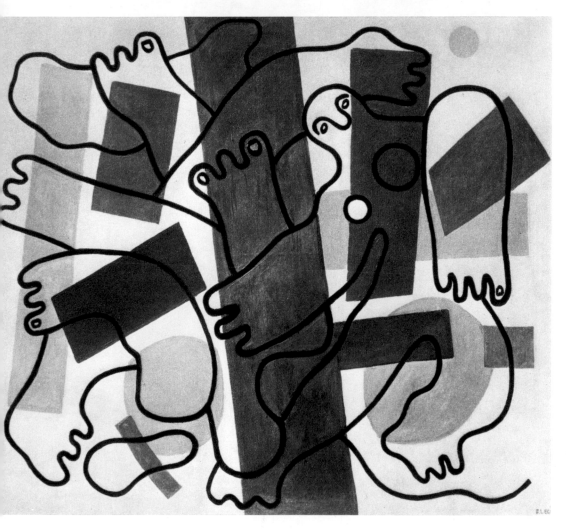

92. Fernand Léger. *Two Acrobats*. 1942–43

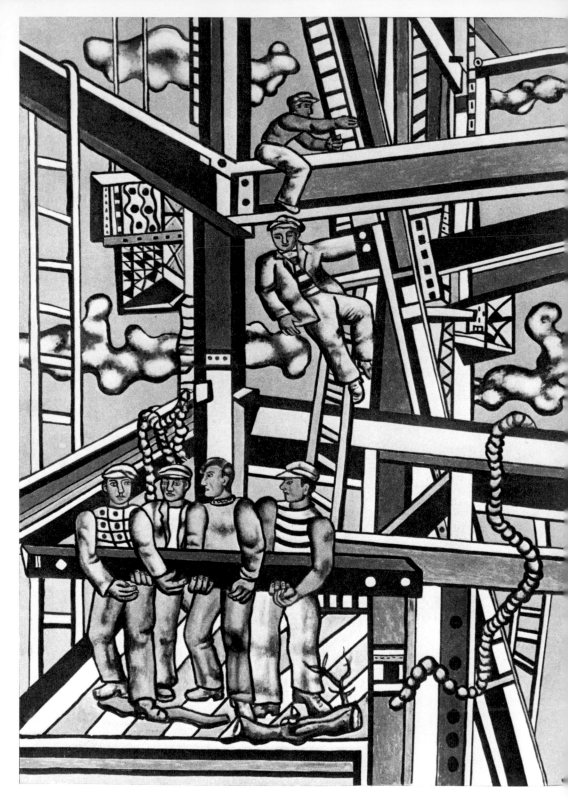

93. Fernand Léger. *The Builders*. 1950

94. Robert Delaunay. *Saint-Séverin*. 1909

95. Robert Delaunay. *The Eiffel Tower*. 1910–11.

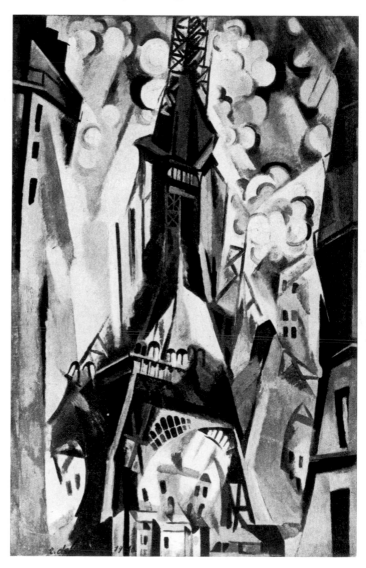

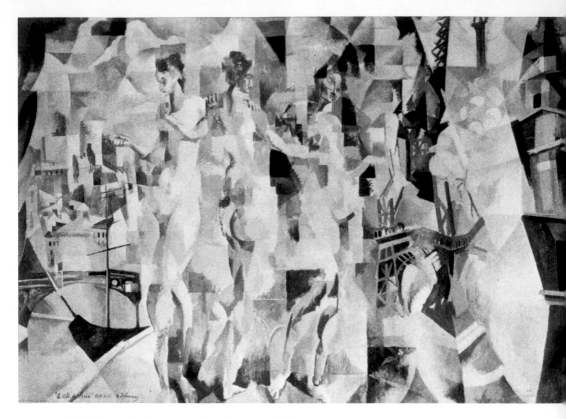

96. Robert Delaunay. *City of Paris*. 1912

97. Robert Delaunay. *Simultaneous Disk*. 1912

98. Marcel Duchamp. *The Chess Players*. 1910

99. Marcel Duchamp. *Portrait of Chess Players*. 1911

100. Marcel Duchamp. *Yvonne and Magdeleine Torn in Tatters (The Sisters)*. 1911

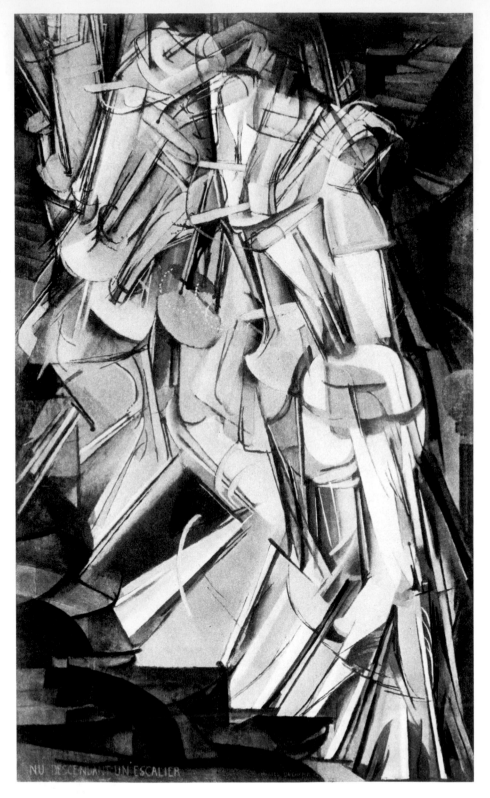

NU DESCENDANT UN ESCALIER

101. Marcel Duchamp. *Nude Descending a Staircase, No. 2.* 1912

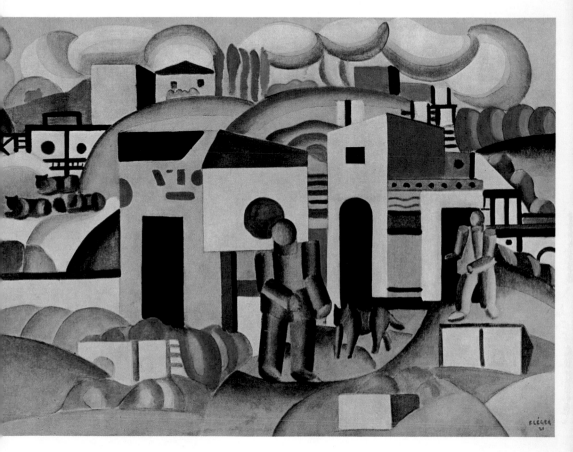

XXV. Fernand Léger. *Animated Landscape: Man and Dog.* 1921

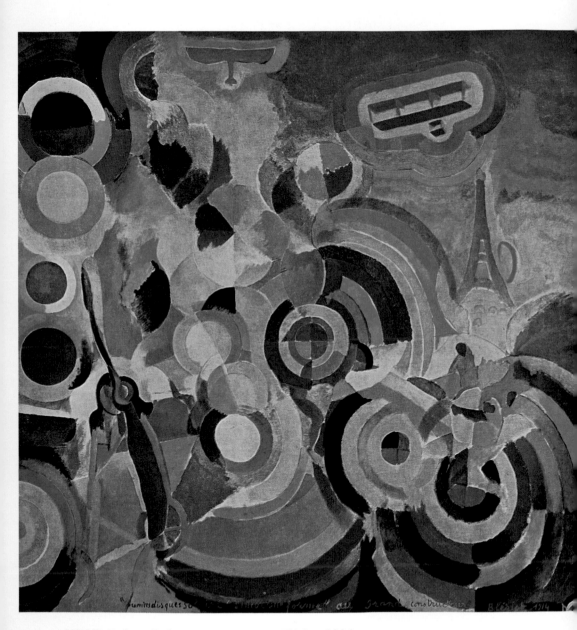

XXVI. Robert Delaunay. *Homage to Blériot*. 1914

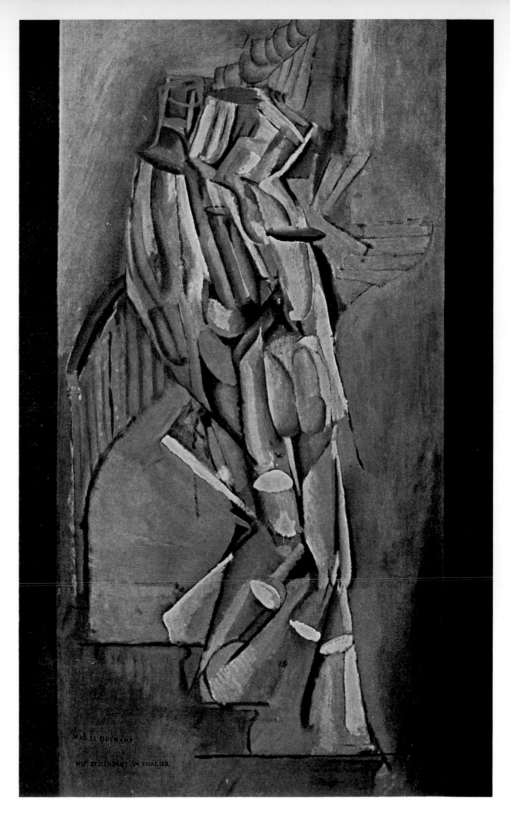

XXVII. Marcel Duchamp. *Nude Descending a Staircase, No. 1*. 1911

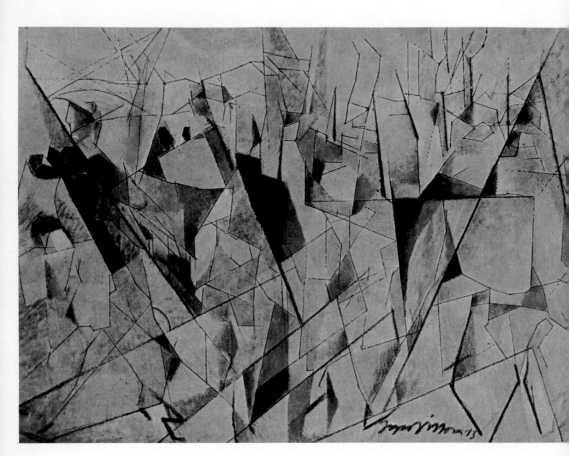

XXVIII. Jacques Villon. *Marching Soldiers*. 1913

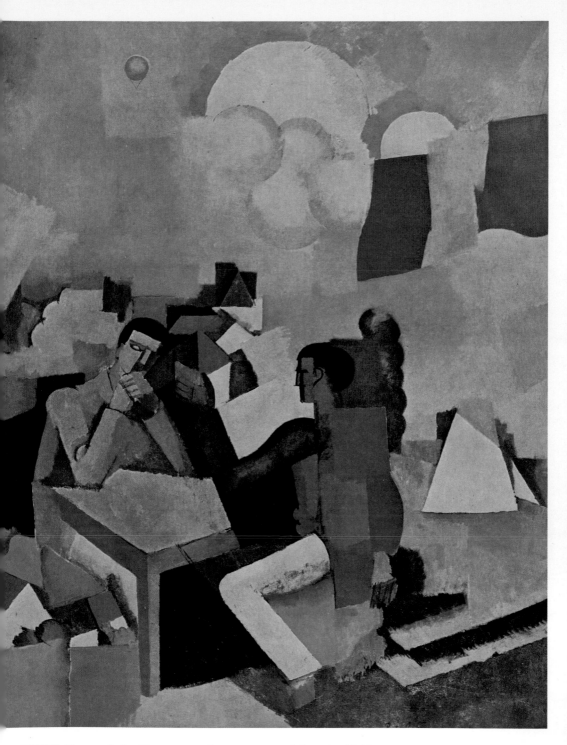

XXIX. Roger de La Fresnaye. *The Conquest of the Air*. 1913

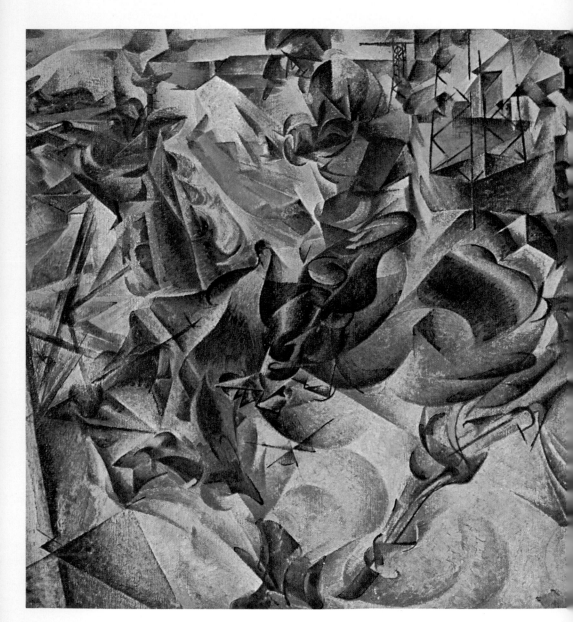

XXX. Umberto Boccioni. *Elasticity.* 1912

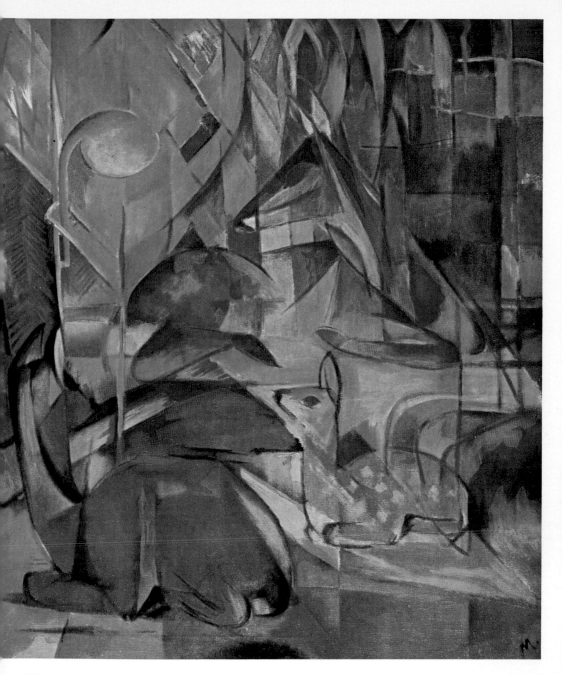

XXXI. Franz Marc. *Deer in a Forest, II.* 1913–14

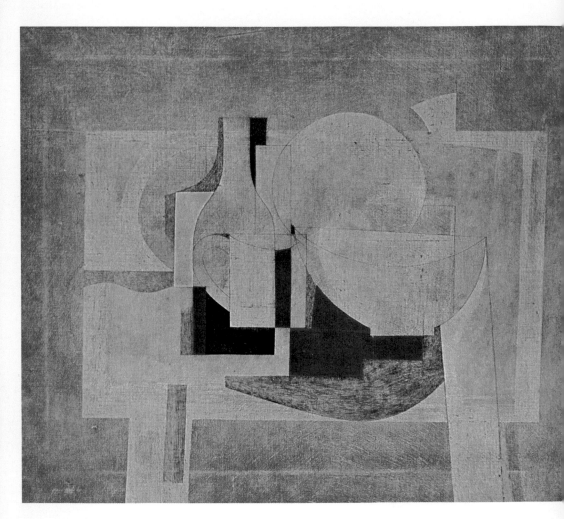

XXXII. Ben Nicholson. *Still Life*. 1929–35

drawal of the *Nude Descending a Staircase* from the Salon des Indépendants after the more conservative Cubists had objected to its literary title.

Duchamp's ultimate rejection of Cubism was made with the same brilliance and rapidity as his initial assimilation of it. In 1912 he had begun to create machine creatures whose inventiveness and iconoclasm far transcended the better-known *Nude Descending a Staircase.* In the *Bride,* for example, the Cubist machinery of the *Nude,* with its rotating disks, diagrammatically dotted paths of motion, and splintered planes, evolves into something strangely organic but unrecognizable among textbook anatomies. The shapes now move from Cubist geometries to bulbous, pliant forms connected by curious pipes and tendons. The title, always so important in Duchamp's work, makes the observer aware that he is being confronted with a heresy as astonishing as the appearance of the creature itself. For Duchamp has taken a bride, the epitome of romantic love and one of the sacrosanct symbols of Western civilization, and has cynically transformed her into a complex, impersonal apparatus for sexual activity.

Duchamp's subsequent career in Dada, with its assaults upon all preconceptions and its unbalancing discoveries about the illogical nature of logic, moved far beyond the circumscribed world of Cubism and even of easel painting; and Duchamp's greatest and most cryptic work, *The Bride Stripped Bare by Her Bachelors, Even* (Philadelphia Museum of Art), can still make even the most radical Cubist painting look conservative. Yet it should not be forgotten that the protagonist of its title is the bride of 1912 and that she, in turn, grew out of the Cubist orthodoxy that Duchamp was so quick to reject. If Cubism became only another convention for Duchamp to destroy, it nevertheless was the essential key that unlocked the first of the infinite sequence of doors that his endlessly inquiring intellect was to open.

Duchamp's interpretation of Cubism was not wholly unique, for it was shared in part by another major Dadaist, Francis Picabia (1879–1953). A Cuban born in France, Picabia was also to begin his career as a modern artist with Cubist paintings of a strong literary bias; and, like Duchamp, he frequently exhibited with the Cubists. In *Dances at the Spring* of 1912, Picabia's characteristic departure from the studio world of most Parisian Cubists is apparent. Hidden among the blocky, Légeresque fragments is a pair of figures dancing before a landscape, a subject inspired by Picabia's actual witnessing of peasant dancers near Naples. A similarly surprising and piquant combination of a tourist's souvenir with the intellectually rarefied vocabulary of Cubism is found in *Procession in Seville,* also of 1912, in which a bulky mountain of Cubist forms represents a procession of Spanish flagellants, whose black, hooded robes contrast dramatically with the brilliant blue of the Mediterranean sky.

If the rather picturesque themes of these works are remote from Duchamp's imaginative subjects, they nevertheless reveal a comparable unwillingness to consider Cubism as an exclusively formal discipline. By 1913, however, Picabia had already moved to the fantastic, myth-making

world of Duchamp, and his experience with Cubism provided the necessary catalyst for this inventive freedom. In *I See Again in Memory My Dear Udnie* of 1914, Picabia enters the strange realm of Duchamp's organic machines. Having constructed a mythical machine creature, the "fille née sans mère" (girl not of woman born), whose miraculous parentage is sacrilegiously analogous to Christ's, Picabia sets her into the churning sexual activity that is the subject of this painting. But, as with Duchamp, the complex interplay between sexual and mechanical form and creativity moves far from the Cubists' restricted world of perceived objects recorded at the artist's easel; and, after 1914, Picabia neglected painting temporarily to devote himself to the more iconoclastic activities of Dada.

105

Among the Cubists who exhibited in the Paris salons around 1910, Duchamp and Picabia were exceptional in their fundamental infidelity to the movement. In general, the others retained a loyalty to Cubist principles that soon ran the risk of mannerism and codification. There were a few, however, who could impose a sufficiently vital and personal viewpoint on Cubism to establish the basis for an entire artistic career. Duchamp's brother, Jacques Villon (1875–1963), was one of these. In *Marching Soldiers* of 1913, a distinctive personality is already apparent. Here Villon translates the plodding, mechanized regularity of soldiers and bayonets filing past one's eyes into a gossamer web whose threaded delicacy and precision are matched only by two other dedicated masters of Cubism, Lyonel Feininger and Ben Nicholson. Such a work seems an even subtler and more probing analysis of linear structure, if possible, than the skeletal networks created by Picasso and Braque in 1910 and 1911; the color, too, reaches a comparable extreme of nuance in its fragile pastel tones.

XXVIII

Villon's pictorial refinement was to be maintained throughout a long career. In an etching of 1920, the *Chessboard,* he strips his brother Marcel's 1911 *Chess Players* of its complex psychological overtones and presents the chessboard alone. Yet, the chessboard as a still-life object creates, as in many canvases of Juan Gris, an aura of tonic intellectuality, which is here paralleled by the strictness and discipline of the formal structure. With characteristic sensibility, Villon weaves together the smaller and larger patterns of chess squares and table top into a resonant interlocking of the most subtly varied shapes and luminary values.

106

98

In the early 1920s, Villon's work ventured beyond the narrow, if perfect, boundaries suggested by the *Chessboard.* Often he explored the syntax of Synthetic Cubism, at times without any reference at all to subject matter. For example, in *Color Perspective* of 1921, Villon studies the new problem of creating a pictorial space, as Picasso had done in his *Three Musicians* of the same year, by the manipulation of flat, angular planes of solid, contrasting colors aligned parallel to the picture surface. Yet, as with Delaunay, this excursion into nonobjective painting was only temporary. In another work of the early 1920s, the *Jockey* of 1924, Villon turns again to a literal subject. If this arrangement of colored planes may seem as independent of the data of perception as the 1921 *Color Perspec-*

109

62

108

tive, nevertheless its final form was achieved only after the most detailed
studies of horse and rider, whose firm basis in reality may be indicated by
one of the preparatory drawings. In so close a record of perception, Villon
suggests, too, his unwillingness to remain in the realm of nonobjective
painting without the invigorating contact of reality; and in this he reveals
his fundamental loyalty to the Cubist viewpoint, which always sought an
equilibrium between the given order of nature and the invented order of
art.

 The vitality of this balance in Villon's art continued late into his
career, as in a painting of 1950, *Large Mowing Machine with Horses.*
Here Villon achieves a fusion of Analytic and Synthetic Cubism by wed-
ding the flat, broad planes of the wide, abstract margin with the small,
crystalline facets and the oblique movement of the central area of farmer,
horses, and mowing machine. If this translation of the particularities of
observation into an ordered world of precisely measured patterns recalls
the French tradition, so, too, does Villon's attitude toward his subject.
Like Millet and the brothers Le Nain, Villon approaches the lower classes
with respect and dignity; and, like Léger, he ennobles them with the
rigorous discipline of Cubism.

 The classical flavor of Villon's art is also apparent in the work of
the short-lived Cubist master Roger de La Fresnaye (1885–1925). Already
in 1910–11, when he was attempting his first Cubist studies, La Fresnaye,
in the *Cuirassier,* stood firmly upon an earlier pictorial tradition. Here he
repaints, as it were, the famous *Wounded Cuirassier* of Géricault, recap-
turing the declamatory gestures and heroic drama of the Romantic master's
canvas; but his style has undergone the austere reductions of a preliminary
phase of Cubism. In pursuing further Cézanne's arduous search for the
solid geometry that underlies the vacillating surfaces of nature, La Fresnaye
achieves an elementary vocabulary of blocky masses that parallels Léger's
contemporary *Woman Sewing.*

 A still more personal viewpoint can be seen in a work of 1911,
the *Artillery,* which, like the *Cuirassier,* was inspired by Claudel's drama
Tête d'or. As in Villon's *Marching Soldiers,* the military subject, with its
regularized, angular disciplines, is especially suited to the painter's ordered
style. Here the field gun, caisson, and artillerymen on horseback are rig-
orously aligned on diagonal axes, recalling a robust version of Villon's
late *Mowing Machine,* and the forms are reduced to even more simplified
planes and arcs than those in the *Cuirassier.* But, if La Fresnaye prefers
the bulky, squarish forms of Léger to the crystalline attenuations of Villon,
his joining of these elements is curiously insubstantial. Characteristically,
his geometric descriptions are incomplete, presenting only a fragment of
the arc that describes a rotating wheel or of the plane that suggests a
soldier's snare drum. As a result, his structures have a fragile, disjointed
quality that belies ironically their ostensible firmness and obedience to
gravity.

 This intriguing contrast between the architectural clarity of sturdy,

107

110

111
112

79

113

179

earthbound masses and the floating incompleteness of their component parts is even more evident in the 1912 view of Meulan. Unlike Picasso 114 and Braque in their Cubist landscapes, La Fresnaye here retains a Cézannesque sense of horizontal stability combined with an expansive vista that recedes from foreground to background; yet his imperfect definition of cubic houses and spherical clouds threatens a dissolution of mass to be realized in his next works.

In 1913, after a series of preparatory studies characteristic of the classical tendency of his art, La Fresnaye painted an enormous canvas, the *Conquest of the Air,* which takes its place with Delaunay's *Homage to* XXIX, XXVI *Blériot* as a major expression of our new air-borne world. The scene shows Roger and his brother Henri seated at a table on a terrace overlooking Meulan, whose topography of church steeple and rooftops is repeated from the 1912 landscape. The two men would meet here on Sundays and discuss their common enthusiasm for sailing and aviation. Their interest in the conquest of the air was more than casual, for Roger was born in Le Mans, where, in 1908, Wilbur Wright had flown in a biplane for 140 minutes, and Henri was director of the Nieuport plant, which manufactured airplanes. In keeping with the subject, Roger's style here becomes less weighty and earthbound than usual. All the planar fragments, whether they describe the sailboat on the blue water, the rooftops and the green earth below, or the tricolor, balloon, and clouds in the blue sky, appear to hover and soar with the exhilarating freedom of a take-off. Yet, for all its suspension and openness, La Fresnaye's airscape is also conquered pictorially. The balanced contrasts of square and spherical forms, the spatial breadth and amplitude, the purity and clarity of its colors all pay homage to the rigorous serenity of the French classical landscape tradition as first defined by Poussin.

Of the many Parisian artists who adhered to the Cubist viewpoint (a list that would include Auguste Herbin, Alfred Reth, Léopold Survage, Henri Le Fauconnier, Marie Laurencin, Georges Valmier, Jean Crotti, and André Mare), it is almost as difficult to single out a few for consideration as it would be to choose a few minor followers of David's Neo-Classicism or Monet's Impressionism. Nevertheless, until a more thorough study of Parisian Cubism of these years is written, which may bring to light unsuspected achievements, certain little masters have obtained a somewhat greater prominence than other of their Cubist contemporaries.

Among these are Albert Gleizes (1881–1953) and Jean Metzinger (1883–1956), whose works may have received more attention than those of, say, Reth or Herbin, because of the renown of their theoretical book, *Du Cubisme,* which not only appeared in French in 1912, but was translated into English in 1913. In this book, Gleizes and Metzinger articulated fully for the first time a philosophical basis for Cubism, deriving intellectual generalizations *a posteriori* from the very untheoretical pictorial intuitions of Braque and Picasso. Their rationalizations about the nature of Cubism as an art that reflects such modern concepts as relativity, simultaneity, and four-dimensionality soon became, in fact, commonplaces

in many pseudo-scientific explanations of Cubism, which often echoed the following quotations from their book: "If we wished to refer the space of the painters [Cubists] to geometry, we should have to refer it to the non-Euclidean scientists; we should have to study at some length, certain theorems of Rieman's [sic]." "If so many eyes contemplate an object, there are so many images of that object; if so many minds comprehend it, there are so many essential images." " . . . the fact of moving around an object to seize several successive appearances, which, fused in a single image, reconstitute it in time, will no longer make thoughtful people indignant."

Something of the didactic, theoretical quality of Gleizes and Metzinger's writing may also be felt in their paintings. Metzinger's *Tea Time (Le Goûter),* exhibited at the Salon d'Automne of 1911, disciplines rationally the erratic dissections of Picasso's 1910 *Girl with Mandolin* into a tidy grid of right angles and diagonals, just as a minor Neo-Impressionist painter might clarify the ostensible disorder of Claude Monet's Impressionism.

More vital, because less codified, is Metzinger's *Dancer* of 1912, which rejects the restricted subject interest of the single figure, from which Braque and Picasso at that time seldom deviated, and moves to a more complex theme, that of the Parisian café world so popular in French painting from the Impressionists on. Paralleling or perhaps influenced by the Italian Severini's Futurist café paintings of the same year, Metzinger puts on Cubist glasses, so to speak, to record a scene out of Toulouse-Lautrec—at the right a dancer; at the left, two ladies and a gentleman seated before a table containing a goblet, a wine decanter, a beer mug, and a box of matches; and, behind them, a top-hatted gentleman. If the somewhat rigid quality of Metzinger's stylizations might not in itself sustain the picture's interest, the rich diversity of descriptive details does, whether one looks at the splintered, artificial café light, the seated ladies' plumed hats and fringed collars, the dancer's sumptuous bouquet, or the very un-Cubist shapes of the Art Nouveau gaslights, whose surprising intrusion, especially in the upper right-hand corner, almost paraphrases the *trompe-l'oeil* effects of the ropes and nails in Picasso's and Braque's work of 1910–11.

Like Metzinger, Gleizes tended to be more literal-minded than the major Cubists. His 1913 portrait of the publisher Eugène Figuière, for example, follows the great Cubist portraits of Vollard, Uhde, and Kahnweiler but, unlike Picasso's work, diverts attention from matters of formal and psychological analysis by wittily using the Cubist device of printed letters to compile a floating catalogue of Figuière's editions (including Apollinaire's, as well as Gleizes's and Metzinger's, study of Cubism). And, in the upper left-hand corner, Gleizes has placed a clock whose fragmented surface is almost a literal demonstration of Gleizes's and Metzinger's ideas about the discontinuous time experience of Cubism. Yet here again, Gleizes's idea is not wholly original, for in 1912 Gris had painted a Cubist timepiece, whose quartered surface and missing minute hand fragment time even more complexly than Gleizes's clock, in which

the hands provide only two readings, 2:35 or 7:10.

In 1915, Gleizes traveled to New York, where the experience of the great metropolis evoked responses that were more impulsive than calculated. Following the cue of such earlier Cubist hymns to modern technology as those by Delaunay and La Fresnaye, he painted the Brooklyn 121 Bridge with a rawness and energy matched only by the American Cubists themselves. Here Gleizes puts his lucid structural grids to vigorous use, for they offer analogies to the real structural tensions of cables and sweeping arches in the great suspension bridge.

In general, however, Gleizes's art, like Metzinger's, ran the risk of sterile codification. Already in 1914, in his *Woman at the Piano,* one 118 senses that Cubism has almost become a formula to be learned and applied to any subject, including a domestic interior with a woman playing the piano. After the First World War, Gleizes's numerous treatises and paintings provided a telling demonstration of the extinction of a marked talent under the academic weight of an all-too-rational doctrine; as a result, his work began to look less like paintings than like geometric diagrams of paintings.

An even greater aridity is apparent in the work of André Lhote (1885–1962), who in his teaching and writing established himself as the official academician of Cubism. In *Rugby* of 1917, Synthetic Cubism is 119 subjected to a measure and control that are ultimately fatal. Flat color areas are balanced by decorative dots; abstruse passages of geometric severity are relieved by such casual details as the running figures at the right; the opposed movement of the two teams is clarified by the neat grid of diagonal squares, and so on. Like Charles Le Brun's academic codification of Poussin, Lhote's transformation of the intuitive classicism of Cubism into a system of stringent rules produced works whose obvious lucidity of structure and color were eminently suitable to the expansion of their style into the realm of decorative arts.

There were other minor Cubists, however, whose work avoided the systematized geometries of Lhote or Gleizes in favor of a more personal, erratic style. One of these was Louis Marcoussis (1883–1941), who had come to Paris from his native Warsaw in 1903 and who exhibited frequently in the Cubist salons. In his 1912 *Still Life with Chessboard,* 122 Marcoussis offers a rich compendium of familiar Cubist still-life objects. In the center, the tidy checkered grid of a chessboard, an object especially favored by Villon and Gris, provides a stable structural core for the more loosely ordered objects that hover above the semitransparent table top. Decanter and wineglass, pipe and matches, pen and inkstand flutter with the same delicacy as the flurry of flat paper objects—the letter, the playing cards, the package of tobacco, the fragment from *Gil Blas* (the newspaper that, in the same year, 1912, had printed Louis Vauxcelles' assertion that Cubism was only a short-lived crisis that would have no issue)—objects, though actually painted, that parallel the collage elements then being used by Picasso and Braque. Like these two masters, Marcoussis, in his brush-

work and linear definitions, avoids the hardening of surface and edge that so often yields a mechanical quality in the work of a minor Cubist. Even the chessboard squares are painted with a vibrant irregularity which extends to the somewhat scratchy, imprecise diagonal network that locates the contours of the table top in front of the equally inexact geometric patterns of the wall plane in the background.

The same sensibility to nervously animate variation of line, texture, and luminosity is evident in an etching by Marcoussis, a posthumous portrait, completed in 1920, of his friend Apollinaire. Here the poet's rounded, heavy-set head, complete with the bandages he was obliged to wear after his war injury in 1916, emerges distinctly from the overlapping transparencies and intricate hatchings that describe the military uniform below and the more abstract background above. Following Gleizes's portrait of Eugène Figuière, Marcoussis presents, with the Cubist technique of disembodied words, an air-borne selected bibliography of the poet's work, ranging from the novel *L'Enchanteur pourrissant* (published by Kahnweiler in 1909) to the volume of verse *Alcools* (published in 1913); and on top, he inscribes his compatriot's original name, Kostrowitsky. (In fact, it was at the suggestion of Apollinaire in 1911 that Marcoussis had changed his own Polish name, Markus, to the name of a village near Paris.) As in the *Still Life with Chessboard,* Marcoussis' tremulous style counters the severe arcs and angles of his Cubist vocabulary, a contrast especially apparent in the technique of etching, where the barbed line of the needle sensitively records the slightest irregularities of texture and shape.

A comparable reaction against the mechanical severities potential to Cubism is seen in the work of Henry Hayden (1883–1970), who, like his exact contemporary Marcoussis, was born in Warsaw but moved to Paris. In 1919, at the time of his one-man show at Léonce Rosenberg's Galerie de l'Effort Moderne (which in the same year held the first Picasso and Braque exhibitions in Paris since 1909), Hayden began his best-known work, the *Three Musicians* of 1919–20. Historically remarkable as a minor prophecy of Picasso's major treatment of the same theme in 1921, this painting, like Picasso's, summarizes the achievements of Cubism in a complex and monumental group of figures that is meant, one feels, to bear comparison with the traditional masterpieces of the past. Like Marcoussis, Hayden avoids the geometric rigors of Lhote's or Gleizes's codification of Cubism; he prefers more flexible shapes and less predictable patterns that here, in particular, soften the rigidity of the three Cubist harlequins in modern clothing who perform on modern jazz instruments: banjo, saxophone, and guitar. And, in this relaxation of style, Hayden reflects the over-all postwar evolution of the major Cubists, who similarly developed an antigeometric vocabulary of ever greater fluidity.

In the early 1920s Hayden turned from Cubism to a more literally descriptive style, but in general the minor Cubists remained faithful to the discipline that had originally established their artistic identities. This

fidelity, in the hands of artists of minor stature, usually meant fidelity to a memory rather than to an actuality, and produced works that ran the risks of blandness and of a growing irrelevance to the rapidly changing conditions of contemporary art. Often in the history of nineteenth- and twentieth-century art, the characteristically short-lived artistic movements accumulated satellite figures who lacked the major masters' capacity for creative change. By the 1920s, the contagious vitality of Cubism had waned considerably, and, by the 1930s, even its greatest practitioners could only rival, and seldom, if ever, surpass their finest work of the early years.

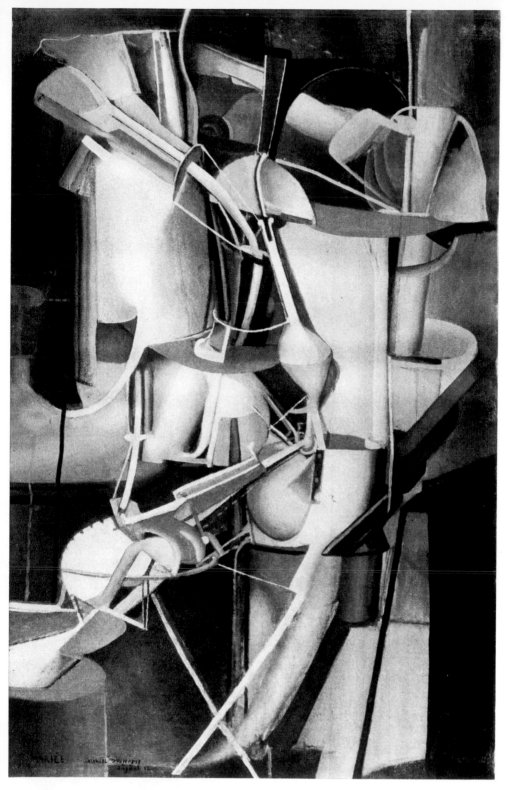

102. Marcel Duchamp. *The Bride*. 1912

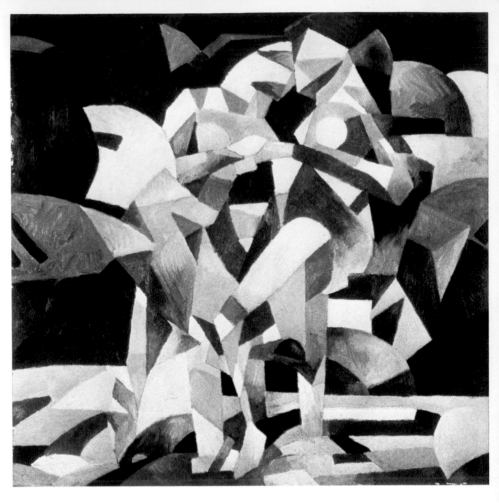

103. Francis Picabia. *Dances at the Spring*. 1912

104. Francis Picabia.
Procession in Seville. 1912

105. Francis Picabia. *I See Again in Memory My Dear Udnie*. 1914

106. Jacques Villon. *Chessboard*. 1920

107. Jacques Villon. *Study for "The Jockey."* 1921

108. Jacques Villon. *The Jockey.* 1924

109. Jacques Villon. *Color Perspective.* 1921

110. Jacques Villon. *Large Mowing Machine with Horses.* 1950

111. Roger de La Fresnaye.
The Cuirassier. 1910–11

112. Théodore Géricault.
Wounded Cuirassier. 1814

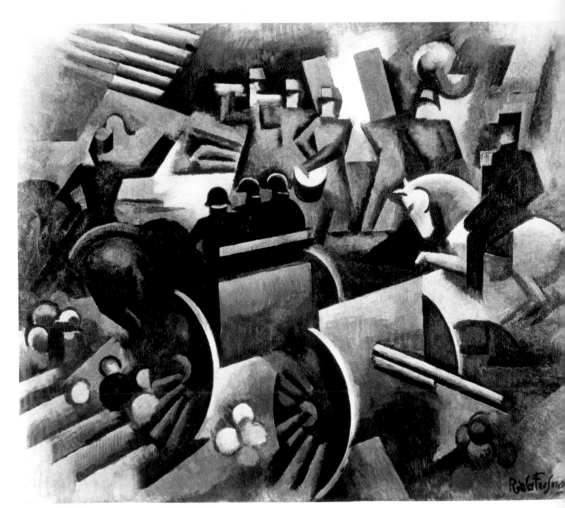

113. Roger de La Fresnaye. *Artillery.* 1911

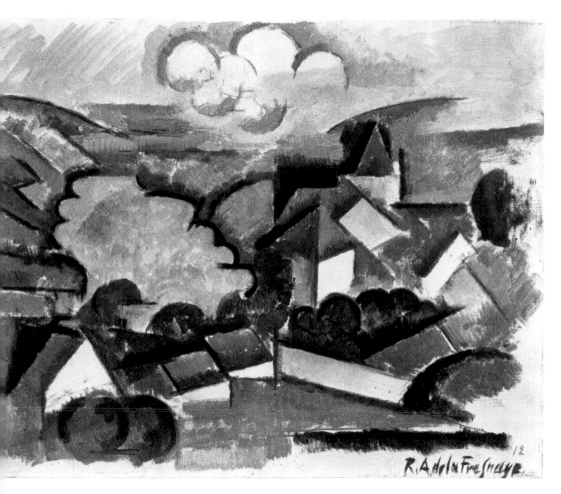

114. Roger de La Fresnaye. *Landscape (The Village of Meulan).* 1912

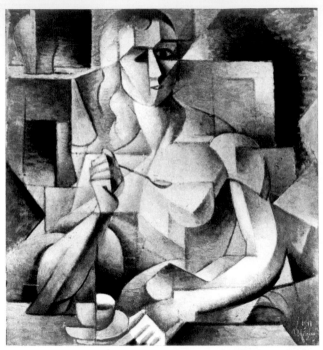

115. Jean Metzinger. *Tea Time
(Le Goûter)*. 1911

116. Jean Metzinger. *Dancer*. 1912

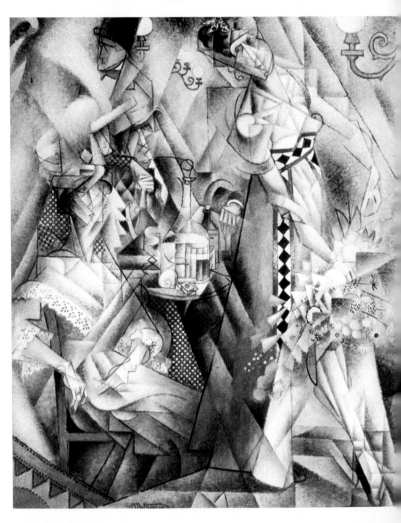

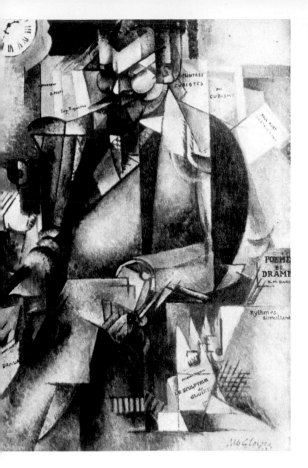

117. Albert Gleizes. *Eugène Figuière*. 1913

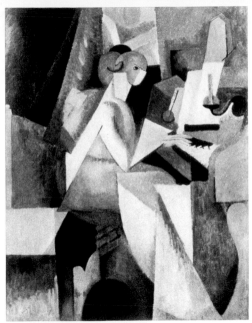

118. Albert Gleizes.
Woman at the Piano. 1914.

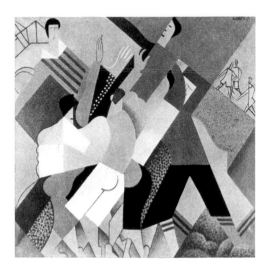

119. André Lhote. *Rugby*. 1917

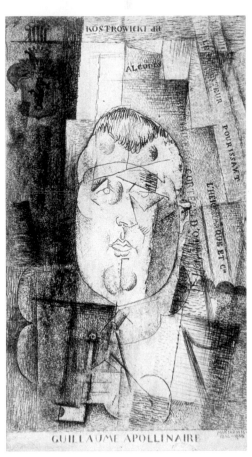

120. Louis Marcoussis. *Portrait of Guillaume Apollinaire*. 1912–20

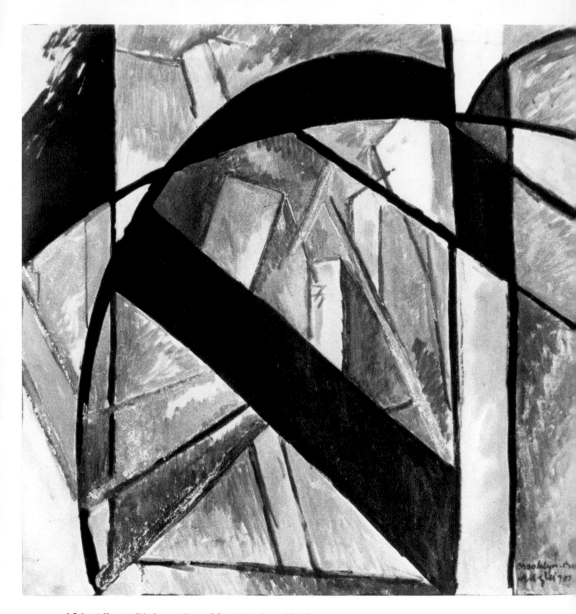

121. Albert Gleizes. *Brooklyn Bridge*. 1915

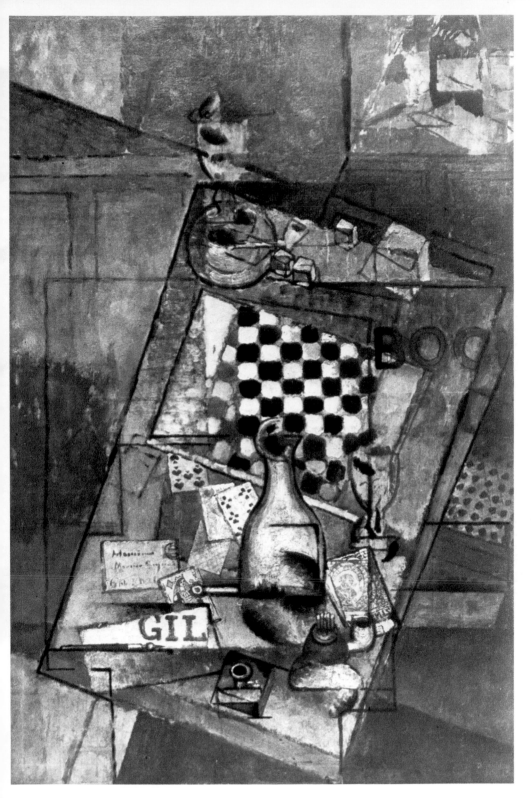

122. Louis Marcoussis. *Still Life With Chessboard*. 1912

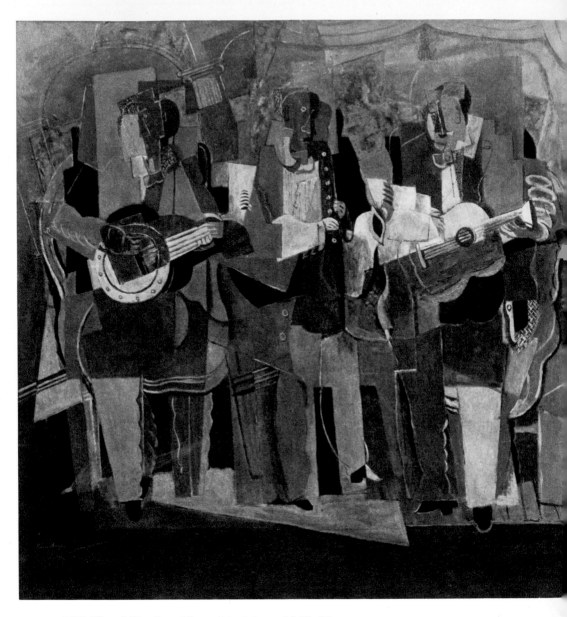

123. Henri Hayden. *Three Musicians*. 1919–20

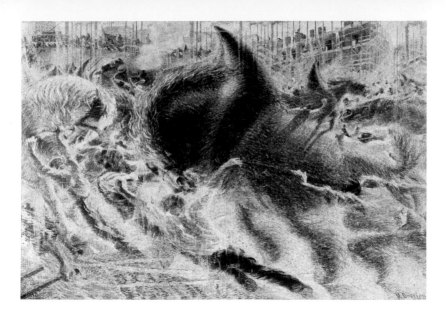

124. Umberto Boccioni. *The City Rises*. 1910–11

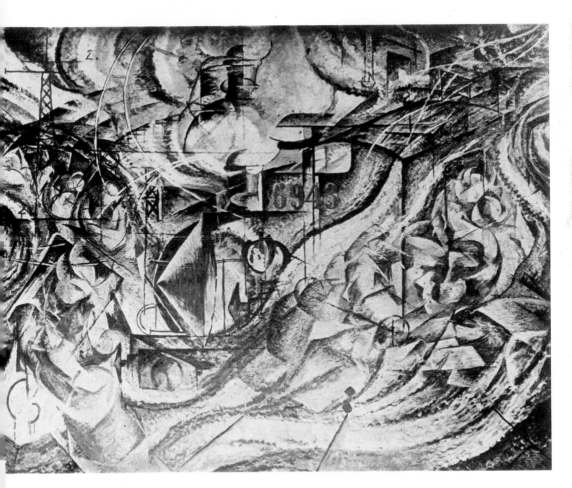

125. Umberto Boccioni. *States of Mind I: The Farewells*. 1911

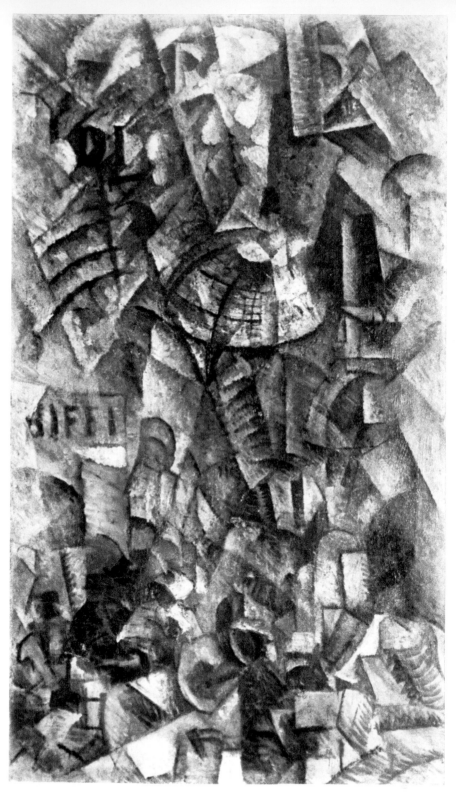

126. Carlo Carrà. *The Milan Galleria*. 1912

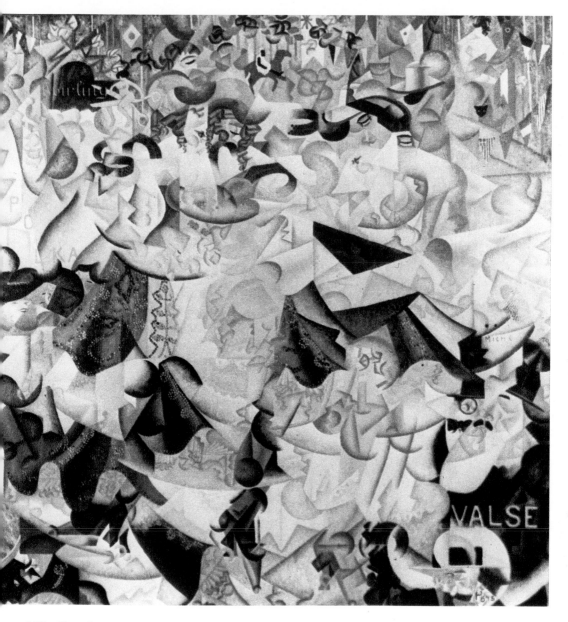

127. Gino Severini. *Dynamic Hieroglyphic of the Bal Tabarin*. 1912

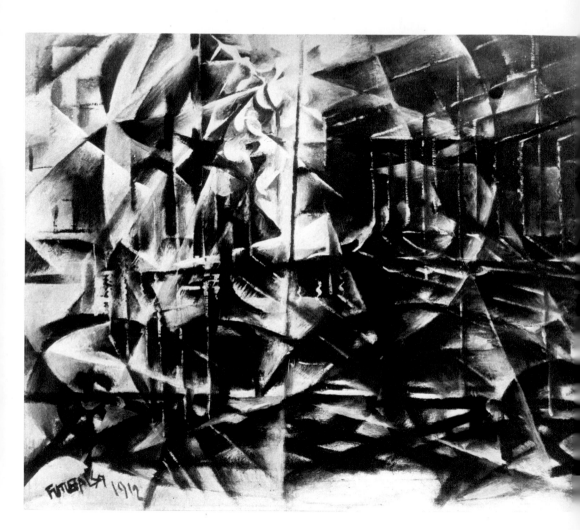

128. Giacomo Balla. *Speeding Automobile*. 1912

Part Three

CUBISM and TWENTIETH-CENTURY ART

7 *Cubism and the Italian Futurists*

As the major innovation of early twentieth-century art, Cubism acted as a revolutionary stimulus that spread internationally from Paris much as Caravaggio's radical innovations of the late sixteenth century quickly spread from Rome throughout Europe. So powerful was this new language of discontinuous planes and fractured masses that its impact could be felt all over the Western world, whether one turned to Russia or Mexico, England or Italy, Germany or the United States. Wherever it was seen by artists and spectators alert to contemporary phenomena, Cubism carried with it the conviction of a vital, authentically modern style that could articulate the complex, fragmentary experiences of a new era.

Yet, like all major artistic viewpoints, Cubism permitted a number of reinterpretations that could extend far beyond the boundaries defined by its first masters. Even within the Parisian milieu, Duchamp and Delaunay had pursued Cubism to such unexpected ends as fantasy and abstraction, and Picasso himself trespassed further and further upon territories foreign to pure Cubism. Outside Paris, Cubism was subject to an even greater variety of transformations. Re-created in the context of the national tradition of Germany, for example, it could stand in distinct opposition to the values upheld by the School of Paris; and, absorbed by such individual geniuses as Klee or Mondrian, Cubism could attain extraordinary results that disclosed pictorial worlds unimagined by Picasso and Braque. Just as Impressionism was first assimilated by Van Gogh, Seurat, Cézanne, and Gauguin, and then altered almost beyond recognition by the same four masters, so, too, was Cubism ultimately transformed into modes that controverted its original character.

Nevertheless, Cubism was the matrix for most of the major pictorial and even sculptural expression of the first half of our century. Even such artists as Diego Rivera and André Masson, whose mature viewpoints were remote from Cubism, at one point paused to examine the Cubist world; and, with the possible exception of De Chirico, almost every major contemporary artist whose style matured soon after the high years of Cubism in 1911 and 1912 was profoundly affected by the Cubist revolution. Significantly, those early twentieth-century masters who stand apart from Cubism—Matisse, Rouault, Kandinsky—had defined the fundamentals of their art before this crucial historical moment. For those masters who followed it, however, the assimilation of Cubism was the critical point at which they began to participate in the mainstream of contemporary art. As will be seen, Cubism provided the pictorial techniques as well as the imaginative freedom to generate the rich diversity of artistic expression that characterizes the art of our time.

In no country was the language of Cubism applied to so concerted a program of modernity as in Italy. Unlike the peaceful invention and assimilation of Cubism within the circumscribed pictorial environment of Paris, Italy's reception of the new style was vociferously associated with a world that lay far outside the confines of the picture frame. With the revolutionary urgency of the many "isms" that erupted around 1910, the movement known as Futurism exploded in 1909 and 1910 with a series of manifestoes. The well-known creed of Futurism was a vigorous avowal of the new phenomena of our century involving those experiences of speed, force, and energy particularly related to the machine and to modern urban life.

If Futurism embraced the present, it also rejected the past. Whereas De Chirico looked back nostalgically to the remote Mediterranean tradition of art and humanism that had transformed nineteenth-century Italy into a moribund museum, the Futurists iconoclastically attacked this same tradition with verbal and pictorial proclamations. By affirming so emphatically, in the words of their literary leader, Marinetti, that "a roaring motor car, hurtling like a machine gun, is more beautiful than the Winged Victory of Samothrace," the Futurists hoped to wrench Italy from her languid, retrospective dream of an antique and Renaissance past into the shrill, dynamic realities of the industrial present. To accomplish this aim, they needed to develop a style as aggressive and contemporary as their new urban environment. For this, Cubism was essential.

If, by 1910, Futurism had already written and shouted its dogma in words, its pictures still lacked an appropriately modern language to articulate their new subjects. *The City Rises* by Umberto Boccioni (1882–1916) is a case in point. Against the Milanese urban background of smoking chimneys, scaffolding, a streetcar, and a locomotive, enormous draft horses tug at their harnesses, while street workers attempt to direct the animals' explosive strength. Yet the pictorial means of realizing this veneration of titanic energies and industrial activity are, in 1910, as anachronistic as the prominent role given to horse power. Basically, Boccioni still works here within a modified Impressionist technique whose atomizing

124

effect on mass permits the forceful, churning symbols of horse and man-power to slip out of their skins in an Impressionist blur of moving light.

By the end of 1911, however, Boccioni, like his fellow Futurists, had visited Paris in order to become acquainted with the *avant-garde* center of Europe and to prepare for the Futurist exhibition to be held in Paris in 1912. The impact of Cubism on the Futurists was immediate, as may be suggested by Boccioni's scene of railroad-station farewells, the first in his 1911 series, States of Mind. A twentieth-century reinterpreta-tion of Turner's *Rain, Steam and Speed* or Monet's Gare St.-Lazare series, it plunges the spectator into a raucous, near-hysterical turmoil of ma-chines and people. Yet now, Cubist planes dominate Impressionist dots and yield a metallic harshness far more relevant to the machine world ad-mired by the Futurists. If Monet and Turner interpret the railroad theme as a dazzling luminary spectacle, Boccioni, with his newly acquired Cubist vocabulary, sees it as a collisive confusion in which mass emotions are harshly contrasted with the impersonal automatism of the machine. In the center, the glistening metal engine, with bumpers and headlights, presides over the human scene in which embracing figures flow irregularly around the mechanical sentinel in pulsating waves of emotion reminiscent of the Symbolists' use of line around 1890. By employing the Cubist interlocking of angular, fragmented planes, Boccioni creates, not the homogeneous glitter of Impressionism, but a dissonant joining and separation of forms almost audible in their clangorous reverberations. The silent, cerebral dissection of form in Analytic Cubism is converted here into the noisy, as-saulting ambiance of acoustic, optical, and kinetic sensations of a modern railroad terminus. Even the engine number, 6943, has a dramatic qual-ity that portends the emotional cleavage of imminent departure rather than suggesting the intellectual quality of metaphysical wit that such num-bers have in the works of Picasso and Braque.

The hustle of the modern urban scene was as familiar a subject for the Futurists as for the Impressionists, but, characteristically, the Ital-ians' use of a Cubist vocabulary renders such scenes more syncopated and hectic. For example, a 1912 view of the Milan Galleria by Carlo Carrà (1881–1966) presents, like Boccioni's railroad station, an explicitly mod-ern situation in Milan, the most industrialized of Italian cities and, ap-propriately, the center of Futurist activity. Here the kaleidoscopic struc-ture and luminous planes of the Analytic Cubist paintings that Carrà had just seen in Paris in 1911 are eminently suited to the subject, for they elicit the shifting, nervous spectacle of urban groups milling about under the great cruciform vaults and dome of the Galleria, whose architectural fusion of linear structural ribs of metal with the shimmer and seeming weightlessness of glass parallels Analytic Cubist scaffolding. As in Boccioni's railroad station, the use of letters establishes a relation between the artist and subject far more particularized than in Cubism. The letters BIFFI, for instance, refer to the famous café in the Milan Galleria and, as such, localize the scene as precisely as a photographic document or, for that matter, an Impressionist painting.

The same commitment to the frenzy and hubbub of city life is seen

in the 1912 *Dynamic Hieroglyphic of the Bal Tabarin* by Gino Severini 127
(1883–1966), a work whose very title expresses, on the one hand, the specific locale that stimulated the work and, on the other, the abstractly worded intention of the artist to render the scene in hieroglyphics, as it were, of the kinetic excitement of the Parisian cabaret. In such a painting, Severini, who worked in Paris rather than in Italy, continues the late nineteenth-century French tradition of cabaret scenes, recalling Degas and Seurat even in a detail like the scroll and pegs of the bass viol that projects above the bottom edge of the canvas. Once more, however, Cubist fragmentation is used to evoke a far more agitated world than that of the later nineteenth century or the world of Cubism itself; for everything, from the shiny black top hat of the monocled gentleman at the lower right to the splintered particles of wineglass and petticoat at the lower left, sharply collides in this continuum of nervous, jagged movement. And, characteristically, such other Cubist devices as letters (VALSE, BOWLING, POLKA) and collage (the sequins on the dancer's dress) are used in a Futurist way to present the cabaret scene with journalistic insistence on contemporary fact.

The kinetic emphasis in these works was often singled out by the Futurists for closer scrutiny. Boccioni's *Elasticity* of 1912 now begins to xxx
focus more exclusively on a study of vigorous, sequential movement, as foreign to the intellectual dynamics of Analytic Cubism as the aggressively harsh and sour colors. A literal demonstration of horsepower, Boccioni's machinelike horse, with its virile, black-booted rider, thunders across an appropriately mechanized landscape of high-tension poles and factory chimneys. If the splintered planes of such a work depend on the Cubist analysis of solid and void, the reasons for this dismemberment are very different. Here mass has been shattered by the dynamic energies of horse and rider, with their up-and-down as well as forward motion, rather than by the quiet spatial investigations of Cubism. If in Cubism the spectator, by implication, moves around static objects, in a Futurist canvas like this the spectator remains static while moving objects rush across his field of vision. Again, vestiges of an Impressionist viewpoint may be sensed here, especially in the way the extremities of horse and rider lie beyond the picture's edge. By using this Impressionist compositional technique, Boccioni implies not only that his tightly compressed subject is so dynamic that it must burst its four-sided confines, but that it is a fragment of a constantly changing visual experience.

The straining muscular elasticities of Boccioni's painting were often replaced by more mechanized diagrams of sequential motion. The 1912 *Speeding Automobile* by Giacomo Balla (1871–1958) seizes upon 128
a more contemporary subject than Boccioni's, but similarly transforms it into a boundless web of overlapping, transparent planes dependent on the vocabulary of Analytic Cubism. Yet again, unlike Cubism, planar dissolution is the result of kinetic, not intellectual, activity. The metal specter of wheels, motor, and body that speeds across the panel from right to left is decomposed into multiple and partial views, not because it is observed from multiple and partial vantage points but because its great velocity has

made it impossible to locate in a single, static position. The disintegration of mass achieved here is an attempt to capture the perception of a swiftly moving object, with results that resemble, in the regular sequence of superimposed images, a stroboscopic photograph. The light, too, while depending on the translucent facets of Analytic Cubism, is essentially realistic in its intention; for the intersecting beams and arcs evoke the sudden, dazzling illumination of headlights on metal. And the subject, as well, clearly distinguishes itself from the Cubist world by virtue of its commitment to a specifically contemporary phenomenon rather than to the tradition-bound subject matter of Picasso or Braque. Even those French masters who recorded the world of machinery and aeronautics—Léger, La Fresnaye, Delaunay—hardly displayed so vehement an enthusiasm for new inventions. For the Futurists, the Cubist vocabulary was primarily a means of recording those new urban experiences of increasing speed and energy which seemed to render a speeding automobile as insubstantial as the dissected object in a 1911 Picasso. In this sense, Futurism became, in part, a final extension of the Impressionist viewpoint that would commit to canvas only the objective visual data of the urban scene.

The Futurists' worship of force and movement was often directed to the more abstract energies of war and revolution. Already in 1911, Luigi Russolo (1885–1947) had attempted to convey the power of human masses in the *Revolt*. In this ingenious work, Cubist fragmentation is translated into a sequence of chevrons energized by the dark, seething triangle of people whose machinelike violence provides a path of destruction that shatters the rows of urban buildings above and below. However, the implications of this work, in which, in a most contemporary way, humanity is conceived not as individuals but as social groups, were not fulfilled until the outbreak of the First World War on July 28, 1914, after which the Futurists often recorded their enthusiasm for this monumental collision of human and mechanical forces. Like Léger, the Futurists were stimulated by the spectacle of planes, tanks, guns, and soldiers, but unlike the Frenchman, the Italians reacted to the war with a violence and exhilaration that went far beyond Léger's more aesthetic approach to combat and war machinery. Even Severini, in Paris, quickly moved from the milieu of the café to the actualities of the First World War. His painting, *War,* of 1915, is an immediate reflection of French militarization, with its posterlike slogans locked into the grinding wheels and smoking chimneys of a mechanized world at war.

In Italy, however, the Futurists' reaction to contemporary events was far more emphatic. In a collage of 1914, Carrà, like Severini, uses Cubist means for the very non-Cubist ends of propaganda. Here an explosive array of labels, newspaper clippings, music, and paint bursts before the spectator with all the assaulting urgency of a newsboy screaming a war headline. Far from the hermetic world of Cubist collage, Carrà's work is a shrill torrent of noise and spectacle whose connection with nonaesthetic realities is as vivid and immediate as the military exclamations (EVVIVAAA L'ESERCITO—Long live the Army!), the fragments of health advertisements, or the jolting sound of sirens whose wails (HUHU-

129

130

131

HUHUHUHUHUH) rise across the collage and reverberate outward in printed echoes (ECHI). The sputtering, cacophonous excitement of this collage is made explicit by the title, *Manifesto for Intervention,* that is, the intervention of Italy on the side of the Allies.

If the propagandist intention of this work is affirmed by the inclusion of words as vital to contemporary events as "Tokio," "Parigi," "Trieste," it was even more vigorously upheld by the Futurists' public demonstrations for intervention and their own subsequent participation in the war. Boccioni, for one, joined the artillery and, like the other Futurists, executed a number of war paintings. One of these, the 1915 *Charge of* 132 *Lancers,* vividly summarizes the Futurist translation of Cubism. The palette of grays and blacks transcribes Cubist monochromes into a deadly world of gun metal and lances; and the dissected planes of Cubism now rush forward with the deafening sound of mass destruction. And, as a final irony in this Italian interpretation of Cubism, the newspaper, with its blaring headlines of German strongholds taken by the French *(Punti d'appoggio tedeschi presi dai francesi),* wrenches us into that grim world of actuality that could be observed only by the closest reader of the newspaper clippings that hovered over the table tops of Braque, Gris, and Picasso.

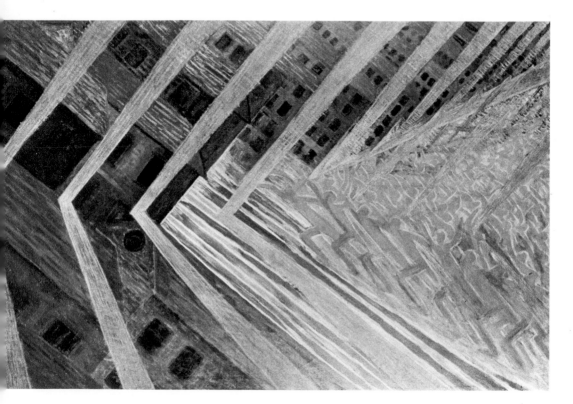

129. Luigi Russolo. *The Revolt*. 1911

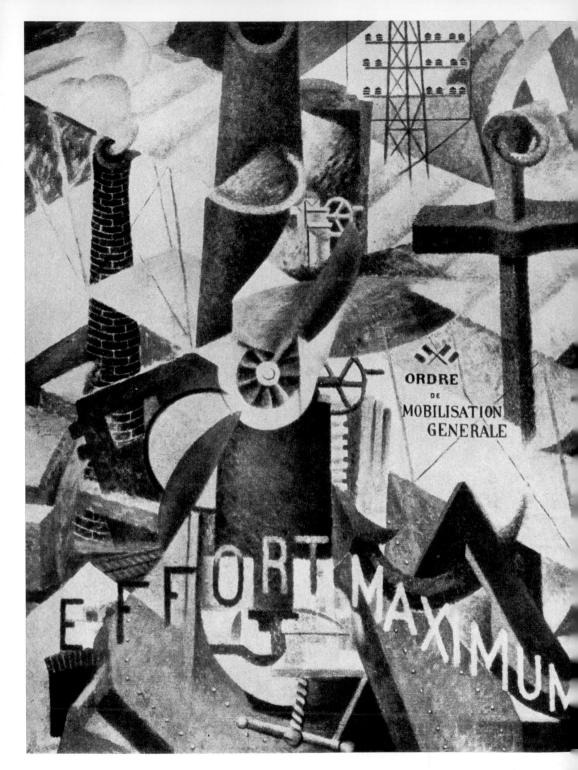

130. Gino Severini. *War*. 1915

131. Carlo Carrà. *Manifesto for Intervention.* 1914

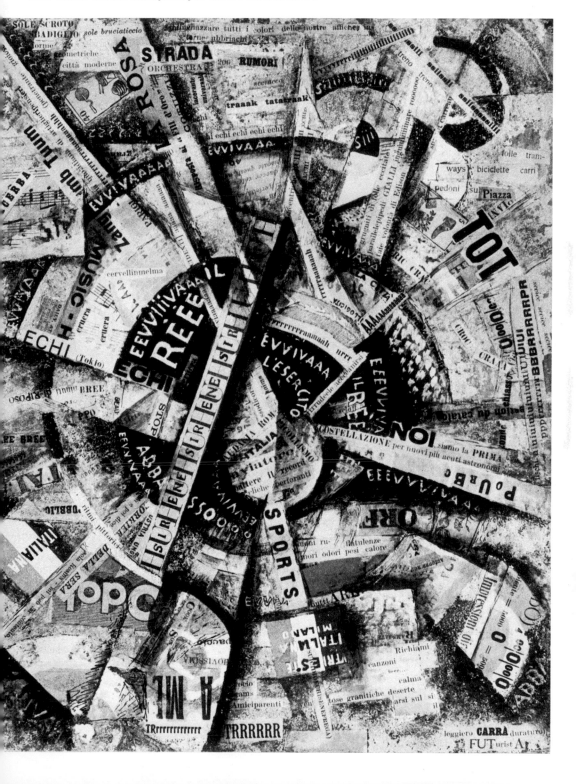

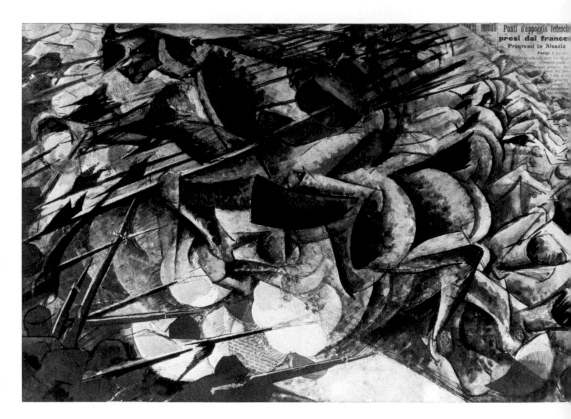

132. Umberto Boccioni. *Charge of Lancers*. 1915

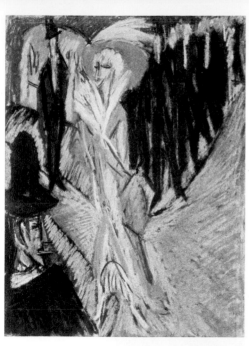

133. Ernst Ludwig Kirchner.
Street with Red Woman. 1914

134. August Macke.
Figures by the Blue Sea. 1913.

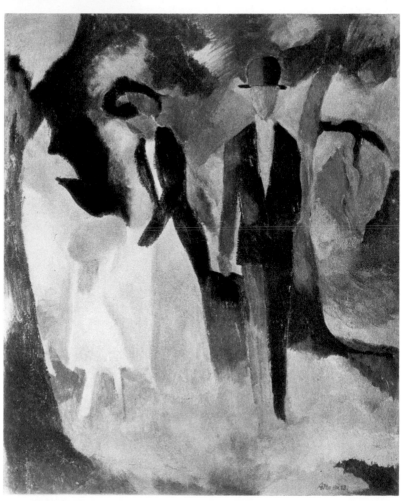

135. August Macke. *Kairouan I*. 1914

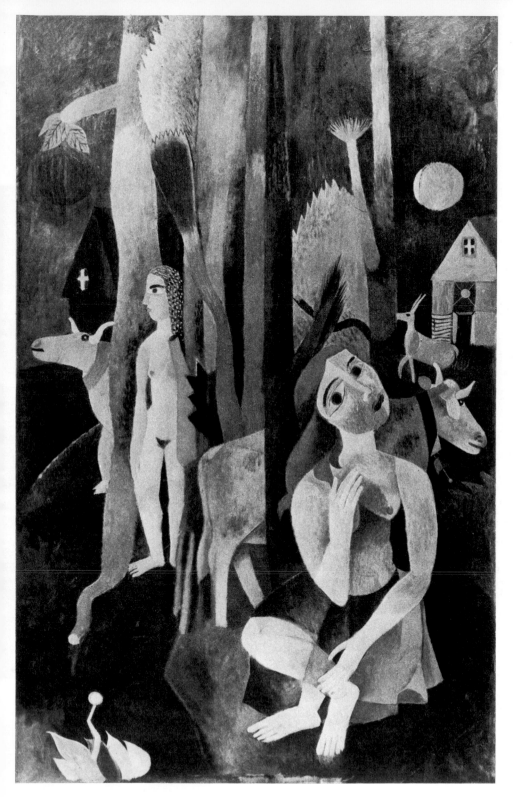

136. Heinrich Campendonk. *Pastoral Scene*. About 1920

137. Franz Marc. *Animal Destinies*. 1913

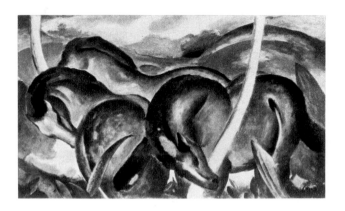

138. Franz Marc. *Blue Horses*. 1911

139. Caspar David Friedrich.
Mountain Gorge. About 1812

8 *Cubism and the German Romantic Tradition*

Hardly any pictorial tradition could seem so remote from Cubism as Germany's. The familiar generalizations about German painting—its emphasis of emotion at the expense of structure, its penchant for the spiritual and the mystical, its assertion of individual genius rather than the collective discipline of group style—suggest the problems that would attend the German assimilation of the new world of Cubism. In particular, the first major movement in twentieth-century German art, Die Brücke (The Bridge), appeared especially antithetical to the Cubist viewpoint, insisting as it did upon the most raw and immediate expression of primal emotions. Yet, after 1910 even some of the masters of Die Brücke moved from the urgency of their early Expressionist style to something that suggested a certain contact with Cubist vocabulary. A pastel of 1914 by Ernst Ludwig

133 Kirchner (1880–1938), *Street with Red Woman,* is such a work, for its nervous, herringbone patterns recall the interlocking facets of Cubism as well as the spiky, agitated line of those late medieval German prints so admired by the masters of Die Brücke. But, characteristically, Kirchner used these modified Cubist means for Expressionist ends that reflect the emotional anxieties of Germany on the eve of the First World War. Here the web of acute angles is painfully, almost hysterically taut, visually underlining the lurid psychological tensions in this scene of a streetwalker confronted with her prospective clientele.

In general, however, the artists of Die Brücke only adapted Cubist mannerisms without absorbing the more radical implications of this foreign viewpoint. It was left rather to certain masters first associated with

Der Blaue Reiter (The Blue Rider) group (active between 1911 and 1913) to achieve a fuller comprehension of those Parisian Cubist canvases and drawings exhibited at the German art centers of Munich, Berlin, and Cologne. The *oeuvre* of the short-lived August Macke (1887–1914) is a case in point, rejecting as it does the fury and excitement of the early style of Die Brücke and substituting for it the subtle disciplines of Cubism and an equally subdued lyricism. Stimulated by the art of Delaunay, whom he had met in 1912, Macke transformed the Frenchman's chromatic Cubism into a personal, if minor, viewpoint. In *Figures by the Blue Sea* of 1913, 134 Macke chooses a theme familiar to French Impressionism—Sunday strollers casually enjoying the pleasures of nature—but his particular sensibility turns this mundane subject into something far less palpable and hedonistic than, say, a comparable work by Renoir. In Macke's hands, Delaunay's rainbow webs are loosened in structure and softened in color so that the scene appears to dissolve quietly in a gentle Arcadian atmosphere that completely transcends the everyday character of the theme.

In 1914, together with Paul Klee and Louis Moilliet, Macke actually left this prosaic world of parks and pedestrians to visit the exotic world of Tunis. His reaction to this intoxicating environment was characteristic, for he avoided precisely those overtly sensuous and dramatic aspects of North Africa which had appealed to such French visitors as Delacroix and Matisse. Macke's typical understatement is made in a watercolor of the period, *Kairouan I.* Here the geometry of Cubism is translat- 135 ed into an almost childlike stylization of the Tunisian scene, from the arcs and rectangles that represent the domes and towers of the skyline to the triangles of the middleground that depict the desert caravan of wagon, dromedaries, and horses. Furthermore, the interlocking planes of Cubism weave these exotic elements into a delicate narrative fabric that conjures up a mood of miniature fantasy comparable to that of Klee.

The same evocation of a dreamlike whole that is more than the sum of its Cubist parts is evident in the work of Heinrich Campendonk (1889– 1957). A work like *Pastoral Scene* of about 1920 creates a similar fairy- 136 tale atmosphere, with its strange juxtaposition of nudes and farm animals in a dense forest. Again, Campendonk's Cubism contributes to this naïve expression, for his geometric stylizations correspond to the genuinely unsophisticated simplifications of form that he and other members of Der Blaue Reiter had studied in children's art and in Bavarian folk art. As in the analogies between Rousseau and Picasso, the reduction of the world to elementary shapes often produces results that approach the true innocence and technical limitations of the so-called primitive artist.

The romantic sensibility to nature implicit in these quiet reveries of Macke and Campendonk is even more pronounced in the two most important German masters of Cubism, Franz Marc (1880–1916) and Lyonel Feininger (1871–1956). Indeed, these two figures may almost be interpreted as contemporary re-creations, in a Cubist vocabulary, of the mystical viewpoint toward nature articulated in words and in paint by the two great German Romantic artists, Philipp Otto Runge and Caspar David Friedrich. The work of Marc, in particular, virtually reasserts the German

Romantic doctrine that the painting of nature is a religious experience providing artist and spectator with a means of approaching the divine spirit behind literal appearances. The special symbol Marc used to evoke this Romantic pantheism was the animal, for in the subhuman world of beast and landscape, Marc felt the closest contact with an intimate harmony between God and living beings, remote from the corruption of man.

138 In the *Blue Horses* of 1911, Marc attempts to represent this pure bond between animals and a natural environment with a pre-Cubist vocabulary. Still preserving the integrity of individual forms, Marc expresses the symbiotic relationship between animals and nature by the analogous contours that unite the rounded rhythms of the horses' backs with the landscape in which these animals graze so peacefully. And just as these visual rhymes produce a gentle consonance that transcends the disorder of literal fact in favor of an internal harmony, so, too, do Marc's colors conform to what is seen by the spiritual rather than the physical eye, moving from the colors of perception to an unseen realm where horses can be blue or red.

XXXI However, it was only after 1912, when Marc met Delaunay in Paris, that his growing freedom from literal appearances was completely realized, and, for this, Cubism was essential. In his *Deer in a Forest, II* of 1913–14, there is again a group of three docile beasts, but, with his new Cubist means, Marc now achieves a merging of animal and landscape more profound than was possible with his pre-Cubist vocabulary. Ironically, the language that had been invented in Paris to redefine the independent aesthetic reality of art is now used in the milieu of Munich to affirm the spiritual realities also potential to art. Here the interlocking planar and linear fragments of Cubism are intended to evoke the ultimate unity of all the diverse phenomena of nature. The three deer, deprived by Cubism of their material substance, become only spiritual presences that blend mysteriously into the similarly insubstantial patterns of earth and tree. The emphatically unreal colors again oppose the French viewpoint of Delaunay, from whom they are partially derived, for these colors are intended not so much as demonstrations of the artist's theoretical independence from nature as of his desire to unveil an unseen world of divinity that could not be represented according to empirical observation.

137 The spiritual fusion of all of God's world, which Marc attained through Cubism, was not always so silent and lyrical. In *Animal Destinies* of 1913, Marc experiences nature in a moment of violence and catastrophe that strangely prophesies the human destinies of the imminent World War. Here a shattering, elemental force commands the individual deer, horses, foxes, and boars so powerfully that their distinct forms are almost wholly disintegrated. If the sweeping impact of the splintering rays almost suggests the velocity of a Futurist painting, these lightning bolts of energy are not to be read as paths of speeding machines but rather as spiritual symbols of the moment of sacrifice and death that culminates the underlying life cycle of nature. Indeed, the inscription on the reverse of the painting makes this intention more explicit: *Und alles Sein ist flammend Leid* (And all being is flaming suffering).

140 In *Tirol,* begun in 1913, Marc again uses Cubist and perhaps even

Futurist means to express an experience that could hardly be more foreign to the French tradition. Here Marc stands in awe before the overwhelming spectacle of cosmic energy and upheaval, and in this he allies himself with such other Northern landscape masters as Van Gogh or Friedrich who experienced a comparable ecstasy before the drama of nature. Like Friedrich's *Mountain Gorge*, Marc's canvas indicates the fearsome powers of God's world by the precariously balanced diagonal tree of the foreground, which appears to have been uprooted by the same superhuman cataclysm evident in the unstable equilibrium of mountain rocks in the distance. Again, like Friedrich, Marc experiences the infinite smallness of man before the gigantic forces of nature. The tiny Alpine houses dwindle to insignificance beneath the radiant explosion that unites sun, mountain, and sky in an apocalyptic torrent of shattered Cubist planes. And for Marc, as for Friedrich and Runge, this natural power was a reflection of the supernatural. One year later, in 1914, he repainted the central mountain peak, transforming it into a mystical double image. The mountain becomes one with the body of the Virgin, who holds the Christ Child at her breast; and the summit is metamorphosed into the head of the Virgin, whose bursting nimbus of light radiates throughout the world. 139

Like Marc, Lyonel Feininger succeeded in making the Paris-born language of Cubism articulate experiences that stem from the countertradition of German Romanticism. Although his life began and ended in the United States, Feininger belongs clearly within the orbit of German painting. Indeed, his formative and mature years were spent in Germany in close connection with the masters of Der Blaue Reiter and then the Bauhaus.

Feininger's early Cubist work, like Marc's, often betrays a Futurist inflection. In the *Bicycle Riders* of 1912 there can be found a counterpart to the kinetic and mechanical themes of the Italians, as five cyclists speed across our field of vision like Balla's automobile. Yet already one senses in Feininger a delicacy remote from the brash, metallic world of the Italians. The Cubist faceting now has a jeweled elegance that, as in Villon's *Marching Soldiers,* lends the mundane theme it describes an unexpected refinement and fragility. One senses, too, in the acute and spiky angles of Feininger's Cubist planes those Gothic tendencies which will become more explicit in his later work. 141

128

XXVIII

By the 1920s, Feininger had achieved a fuller definition of his personal vision. In a painting of the Barfüsserkirche in Erfurt of 1924 (1927?), the overt dynamism of mechanical and human activity in the cyclists is replaced by a very different kind of movement. Now Feininger chooses to depict the soundless, ghostly motion of people, light, and architecture in the narrow, angular streets of Erfurt, a medieval German city. The translucent planes of Analytic Cubism acquire, in Feininger's hands, a mysterious, filtered luminosity that approaches the quality of light passing through stained glass. Appropriately enough to the late medieval building that dominates the view, the Barfüsserkirche, Feininger's painting almost re-creates the hushed religious atmosphere of a Gothic church. The figures are minuscule, dwarfed by the narrow, vertical proportions of the late medieval 142

architecture of the North; and the broken, crystalline angles of the gabled roofs and windows similarly contribute to the quiet drama of the scene. But above all, it is the light, with its interpenetrating beams, that serves to deprive matter of its substance. As in Gothic architecture seen through luminous stained-glass veils, the Cubist merging of glowing light with the wall planes of church and houses transforms everything into a vaporous, evanescent world that pertains more to spirit and feeling than to body and intellect.

94 The mystic interpretation of Gothic architecture implied by this work is as different from Delaunay's *Saint-Séverin* as Goethe's veneration of Strasbourg Cathedral is from Viollet-le-Duc's rationalistic analysis of French Gothic structure. Elsewhere, too, Feininger revives those German Romantic attitudes which would seek out a mystic experience through the contemplation of nature's infinities. His fascination with the emotive potentialities of a Cubist dissection of light and atmosphere inevitably led him to what was probably his greatest theme, the sea. In the *Glorious*

143 *Victory of the Sloop Maria* of 1926, Feininger offers a reprise of Friedrich's romantic theme of tiny figures by the seashore watching boats sail into the distant horizon—a familiar Romantic symbol of longing for the unknown. Now the canvas is filled with the most insubstantial aspects of nature—fog, water, light—and, by means of Cubist merging of planes, even the sails dissolve into this spectral vision of nature's mysteries.

144 Feininger's involvement with the sea continued throughout his career, witness a painting executed in America in 1944, *Dunes with Ray of Light*. Once more Feininger recalls a theme of Friedrich. As in the older

145 master's *Monk by the Sea,* Feininger's two figures stand on the bleak dunes before the hazy infinitudes of the northern sea. The all-penetrating glow of the light-drenched fog is now so strong that even the linear scaffolding of Feininger's Cubism is almost completely absorbed by its emanations, just as the tiny figures almost dissolve into the mystic totality

67, 168, 169 of nature's spectacle. Like Mondrian in his earlier sea meditations, Feininger re-creates, in Cubist terms, a Romantic reverie upon the impalpable spiritual forces of nature; and, like Marc, Feininger relegates the ostensibly impersonal and supranational discipline of Cubism to the expression of a viewpoint that is both intensely personal and national. Pursuing their own emotive needs, Marc and Feininger transformed Cubism into a vehicle for newly articulating the German Romantic sense of intangible mystery that lies behind the material surface of nature.

9 *Cubism in England and America*

In both England and America, the assimilation of Cubism had to be accomplished in two stages. The first stage involved a sudden exposure of the Cubist viewpoint to artists and a public who were, for the most part, unaware of the innovations that had revolutionized the making and experiencing of art on the Continent; the second stage required a less ardent, more sustained consideration of the new problems posed by the Cubist world. In both countries, the introduction of Cubism was made at about the same time and with a comparably shocking abruptness—in England through the Vorticist movement of 1914, in America through the Armory Show of 1913, which exhibited to an unprepared public the extreme *avant-garde* art of Europe and America.

The Vorticist movement, led by the writer-artist Wyndham Lewis (1884–1957), exploded upon the English public in 1914 with the vociferous modernity that characterized the outburst of Futurism in Italy some four years earlier. Vorticism, as shouted through the manifestoes of its literary vehicle, *Blast,* was belligerently in favor of that energy and mechanization which the Futurists venerated; but, in order to assert its independence from the Italians, it criticized them for offering only a new form of Impressionism, for showing machines as moving blurs rather than as lucidly angular, cold, and impersonal objects. The Vorticists' means of exalting the machine world depended, like the Futurists', upon Cubism, the style that appeared to obliterate completely the many vestiges of nineteenth-century realism that survived the year 1900.

Like most of the "isms" that erupted around 1910, Vorticism was as intense as it was short-lived, producing its most radical verbal and pictorial statements within a few years. A typical example of this heated moment of English modernism can be seen in one of Lewis' illustrations to a 1914 folio edition of Shakespeare's *Timon of Athens*. Ironically perpetuating the traditional penchant of English artists for literary illustration, Lewis attacks his theme with an antitraditional torrent of spiky Cubist planes whose clashing, metallic edges culminate in the so-called "vortex" of the upper left-hand corner. And often, in the same series of illustrations, Lewis even moved from Cubism to totally abstract patterns of jagged, dynamic planes.

The aggressive iconoclasm and rather callow flavor of the Vorticist movement could hardly be more alien to England's most distinguished Cubist, Ben Nicholson (b. 1894), who was born a decade too late to participate in the first fervors of modernism. Working at a less crucial historical moment, Nicholson slowly and patiently considered the premises of Cubism. Like Villon and Feininger, he offers a cautious, subtle art of refinement within a narrow and perfected range rather than an impetuous art that risks adventure and heresy; and, like these Continental masters, he remained loyal to the self-imposed restrictions of a Cubist viewpoint.

Unlike Villon and Feininger, however, Nicholson did not begin to mature artistically until the late 1920s. A drawing of about 1928, *Banks Head—Castagnola,* already illuminates something of the distinctive qualities of Nicholson's work. As the very title implies, Nicholson reveals a familiarly English commitment to observed fact, for the array of breakfast objects presented here is not the generalized grouping of table top and china that we might expect in a French still life but a specific document of data observed at a particular time and in a particular place that even includes the window view of a Swiss lake. With an almost Pre-Raphaelite instinct for literal fact, Nicholson scrupulously records the details of a coffee pot, a flowered plate, the cracked edge of an opened boiled egg, and even the words on a box of Kellogg's Corn Flakes; but at the same time, a contradictory instinct toward simplification renders these forms in delicate, hairbreadth outlines whose chasteness recalls the earlier English line drawings of Blake and Flaxman and whose weightlessness and transparent intersections approach the floating, incorporeal world of Cubism.

In a casual drawing like this, Nicholson feels no need to achieve a coherent degree of stylization and, as a result, he vacillates between an inherent dependence upon precisely observed fact and a desire to transform this fact into more generalized statement. In his finished paintings, however, such contradictions are often eliminated or, at times, surprisingly reconciled. In a canvas of 1932, *Au Chat Botté,* Nicholson's dependence on particularized fact is far less pronounced, though still evident. As in Braque's *Café-Bar* of 1919, a still life is disclosed through what appears to be the window of a café whose name and location are identified by the letters that float upon the picture surface. With familiar Cubist irony, these three-dimensional table objects are far more immaterial than the two-dimensional words in their midst. So fragile, in fact, are the threadlike

146

147

148

64

223

outlines that define the eyes and mouth of the head at the left, the lip and handle of the jug in the center, and the bodiless mandolin at the right, that they appear to vanish, even after being discerned, into the quiet but vibrant surface that represents both a transparent pane of glass and an opaque tilted table top.

If such passages as the curtain at the left or the relatively detailed description of the mandolin at the right suggest vestiges of Nicholson's respect for concrete fact, other of his still lifes arrive at a more consistent level of generalization in which the intrusion of particular objects is no longer felt. This is the case in a still life of 1929–35, where the array of table-top objects has been purified to a degree of exquisite precision that reminds one of the most rarefied Purist drawing of Ozenfant. Mug, bowl, bottle, and table are transformed into frail phantoms of objects whose abstemious geometries are defined only by razor-thin outlines. The spatial organization, too, is exacting in its refinement, for the sequence of planes created by these overlappings of transparent and opaque forms occurs within a space so shallow that its calibration transcends the capacities of all but the most sensitive eye. And if these extreme discretions of line and plane evoke the hyper-aestheticism of the Whistlerian tradition, so, too, does Nicholson's color. By comparison with these muted variations of beige, white, and gray, alleviated only by the most quiet of reds, even Picasso's and Braque's palettes of 1911 seem rich and sensuous. Indeed, in such a work Nicholson achieves a degree of attenuated sensibility that is almost puritanical beside its Continental Cubist counterparts.

Pressed one step further, this pursuit of a lean and perfect harmony could annihilate the object entirely, and often, in his transformation of empirical fact into an abstract geometry, Nicholson presents the latter alone. In the *White Relief* of 1938, for example, he moves from the illusion of still-life objects in a shallow pictorial space to the actual construction of pure circles and rectangles in a shallow relief. Yet, unlike Mondrian, whose experience of Cubism led to a complete rejection of any specific objects in his work, Nicholson never remained consistently within this austere realm of pure geometric relations but moved back and forth, like Villon, to the tangible realities of observed nature.

In the 1940s, Nicholson, in a most English way, arrived at a compromise solution that would peacefully combine the most particularized data of perception with the ostensibly contradictory viewpoint of complete nonobjectivity. This may be seen in *Mousehole* of 1947, which moves Picasso's and Matisse's Mediterranean window views with foreground still lifes to a vista of the Cornish coast near the English artists' colony of St. Ives. For here there are passages of a geometric purity that could almost be excerpts from a nonobjective canvas (such as the overlapping curved and straight-edged planes that offer so generalized a description of the bottle, bowl, and mug in the right foreground), whereas, at the same time, Nicholson leads our eye to an expanse of sailboats, coastal hills, and rural houses whose topographical exactitude evokes the most detailed visual observations of such early nineteenth-century English landscape artists as Constable, Cotman, and Girtin.

XXXII

87

149

150

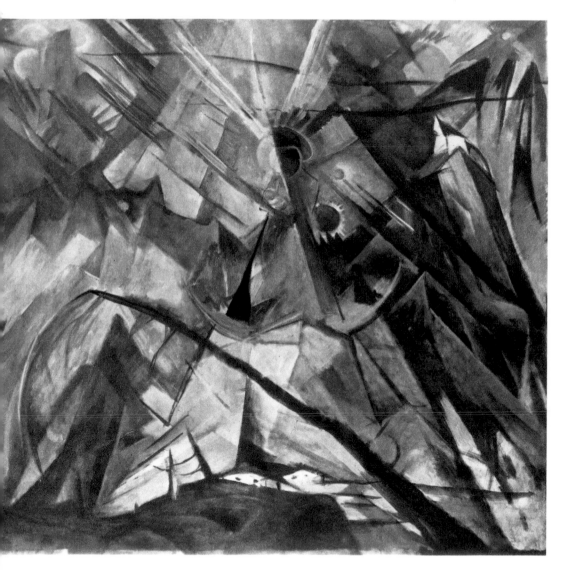

140. Franz Marc. *Tirol*. 1913–14

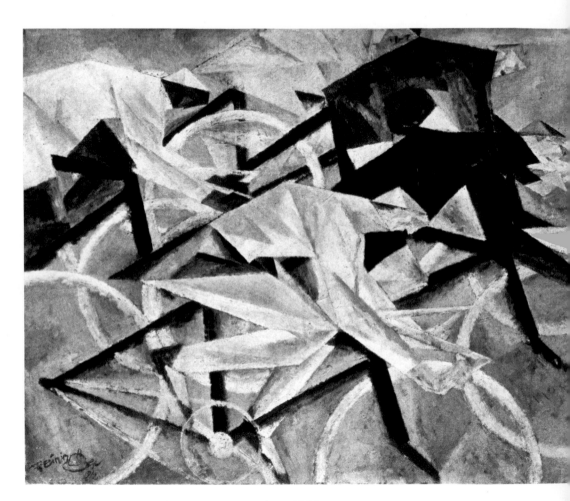

141. Lyonel Feininger. *Bicycle Riders.* 1912

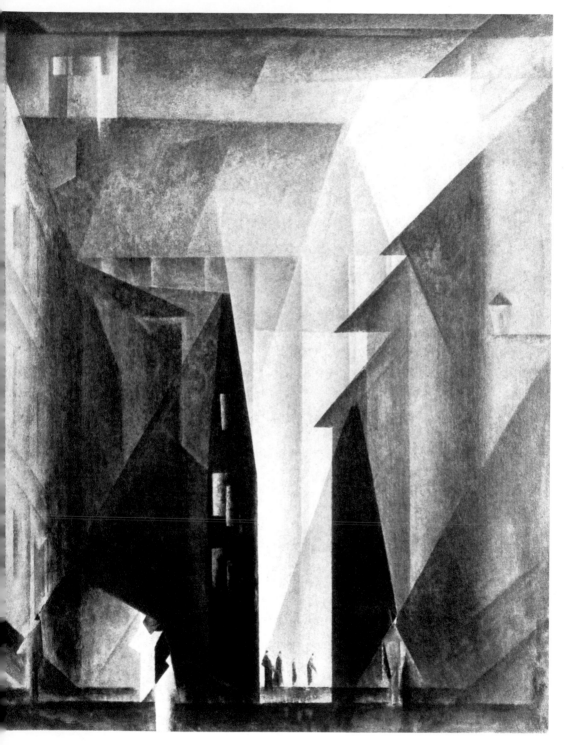

142. Lyonel Feininger. *Barfüsserkirche in Erfurt*. 1924 (1927?)

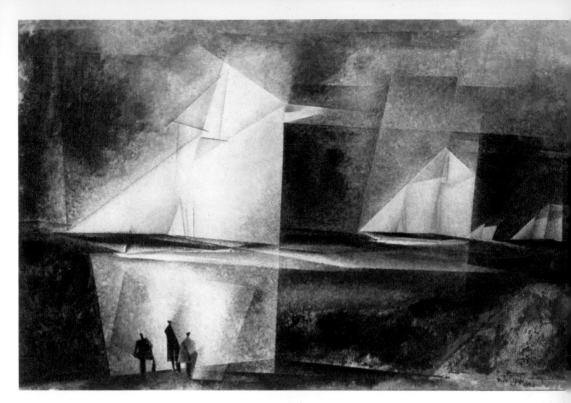

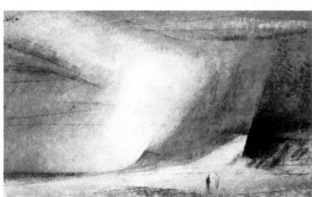

143. Lyonel Feininger. *The Glor
Victory of the Sloop Maria.* 192

144. Lyonel Feininger.
Dunes with Ray of Light, II. 1944

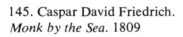

145. Caspar David Friedrich.
Monk by the Sea. 1809

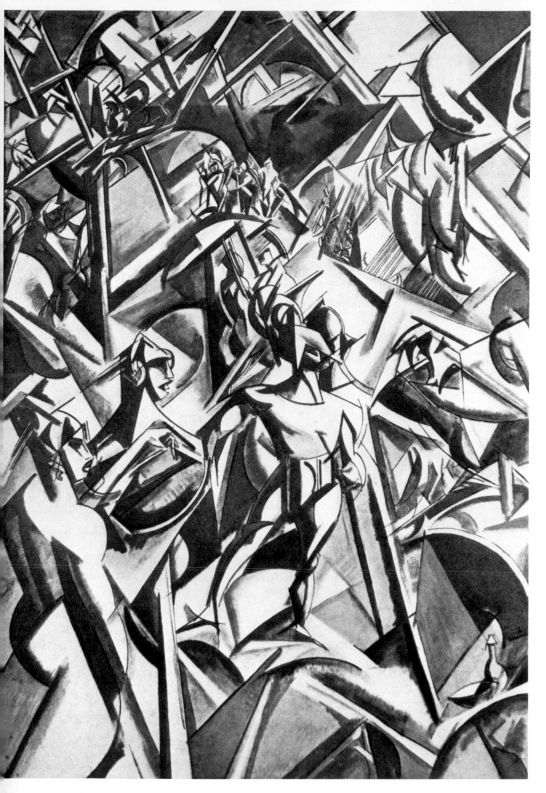

146. Wyndham Lewis. Illustration to Shakespeare's *Timon of Athens*. 1913 or 1914

147. Ben Nicholson. *Banks Head-Castagnola.* About 1928–29

148. Ben Nicholson. *Au Chat Botté.* 1932

149. Ben Nicholson. *White Relief.* 1938

150. Ben Nicholson. *Mousehole.* 1947

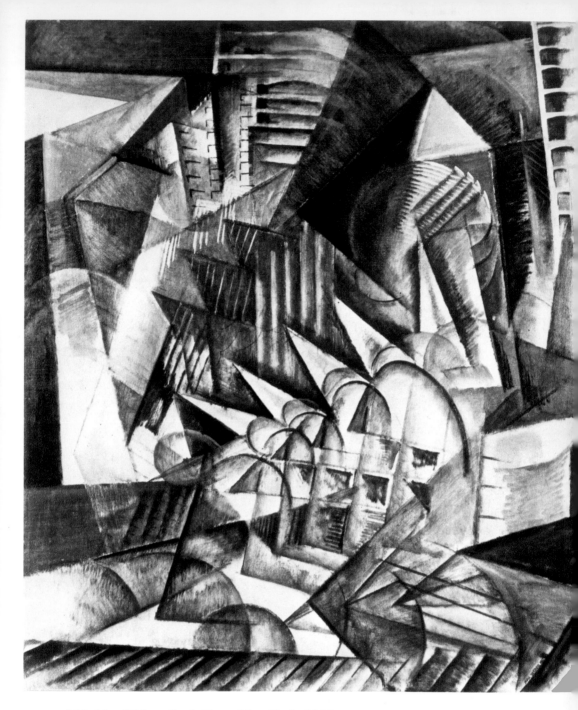

151. Max Weber. *Rush Hour, New York*. 1915

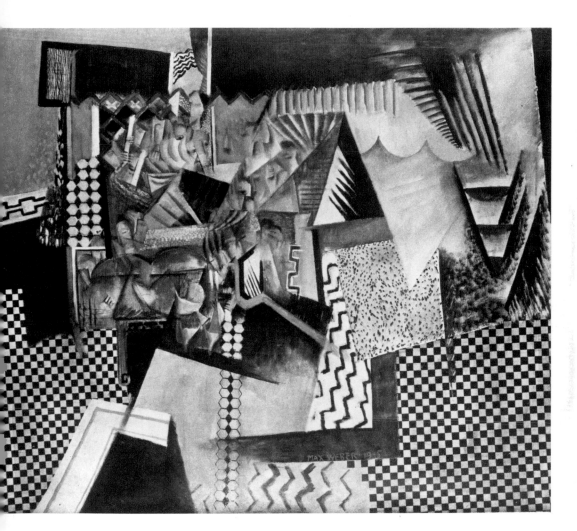

152. Max Weber. *Chinese Restaurant*. 1915

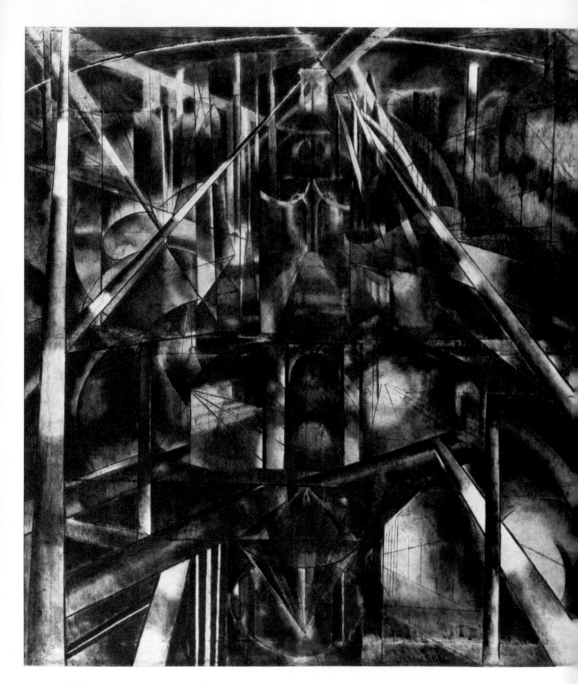

153. Joseph Stella. *Brooklyn Bridge*. 1917–18

154. John Marin. *Woolworth Building, No. 31.* 1912

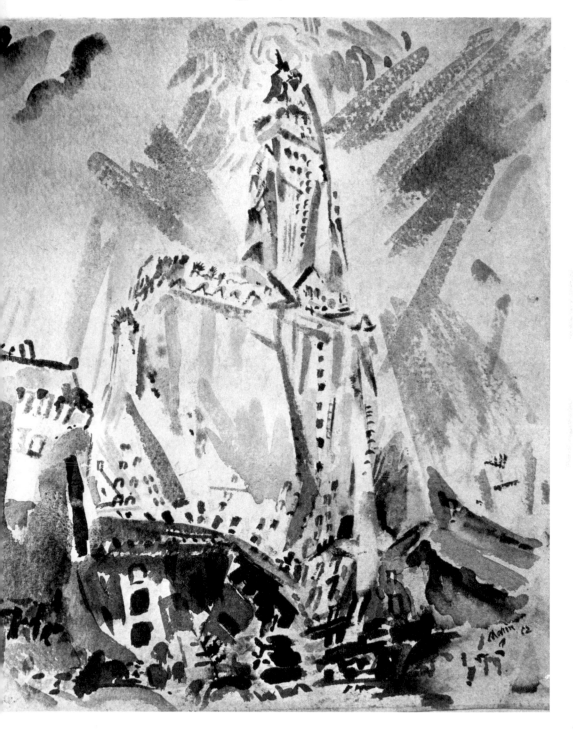

155. John Marin. *Lower Manhattan*. 1922

156. John Marin. *Maine Islands*. 1922

157. Winslow Homer. *Maine Coast*. 1895

158. Charles Sheeler. *Barn Abstraction*. 1917

159. Charles Demuth. *Stairs, Provincetown*. 1920

160. Charles Demuth.
"*. . . and the Home of the Brave.*" 1931

161. Stuart Davis. *Salt Shaker*. 1931

162. Stuart Davis. *Report from Rockport*. 1940

It is not surprising that the closest parallels to the inflections that England gave to Cubism should be found in America, the country whose pre-Cubist tradition had been most closely related to England's. The course of Cubism in America began after 1910, as in England, with a sudden and unprepared explosion of modernity, and was then followed by a quieter assimilation that often combined both the ascetic refinement and the ultimate commitment to a particularized reality so conspicuous in Nicholson. The Armory Show of 1913 provided perhaps an even more traumatic introduction to the *avant-garde* than did the Vorticists in England, for this show, which traveled from New York to Chicago and Boston, abruptly disclosed the strange new world of masters like Matisse, Picasso, Duchamp, and Picabia. The difficult task of the American artist was to digest these foreign innovations.

Again it was Cubism that carried the greatest impact in the awakening of American art to contemporary European developments, though, as might be expected in the most mechanized environment of the contemporary world, it was a Cubism strongly tinged with a Futurist flavor. The early work of Max Weber (1881–1961), who had had firsthand experience of the Parisian *avant-garde* between 1905 and 1909, exemplifies this hybrid viewpoint, for his paintings use fundamentally Cubist means to evoke the dynamic experience of the New York milieu. In his *Rush Hour, New York* of 1915, the spectator is thrust into the most frenetic confusion of the city's daily peaks of mechanical and human activity. Rolling wheels, skyscrapers, station platforms are fragmented and recomposed as the whirring, metallic engine of a vast urban machine; and, in particular, the sensation of rushing motion in all directions is suggested by the repetitive sequences of spiky, angular patterns that appear to roar past the viewer like an express train. Even within the context of a more static situation, as in the *Chinese Restaurant* of the same year, 1915, Weber conveys the hectic velocity of the great metropolis. By comparison with Picasso's contemporary Rococo Cubism, whose patterned enrichments parallel this work, Weber's scene is jarring and harsh in its movement, and the blurred sequence of faces woven into the brilliant fabric similarly conveys kinetic sensations. Like Carrà's *Milan Galleria,* Weber's painting is almost documentary, for the milieu of the Chinese restaurant that he re-creates has a particularity of setting that clearly distinguishes it from Parisian Cubism. Here all the gaudy décor of the restaurant is specifically recorded, from the checkered tiles of the floor to the scalloped eaves that decorate the upper right-hand corner.

The very idea of painting a Chinese restaurant in New York speaks for the close commitment to reality that characterized not only most American painting in general but American Cubism in particular. Like Weber, most American Cubists depend on a visual stimulus that is much more particularized than the Parisian world of still-life objects or even the urban world of Léger, which is never one city but all cities. The New York scene provided an especially rich opportunity to convey the drama of new urban experience with the comparably new vocabulary of Cubism, and the most assertively modern monuments of the city were often recorded.

Joseph Stella (1877–1946), like Weber, devoted most of his energies to just such subjects; and his *Brooklyn Bridge* of 1917–18 may exemplify 153 this outlook. By contrast with the earlier view of Brooklyn Bridge by Gleizes, Stella's bridge is a record of a particularized experience. If the 121 French Cubist generalizes the bridge to a point almost beyond identification, Stella remains within the realm of the specific, for the Gothic towers and the sweeping pattern of straight and curved cables readily permit recognition of this great feat of nineteenth-century engineering. Even more, Stella's interpretation is less detached, for he experiences the bridge subjectively in terms of the violent sensation of a motorist who speeds across the blinding network of interpenetrating beams and arches, roads, and traffic lights. In this way, the deep perspective of the diminishing ribbons of roads and cables is contracted with a vertiginous speed that assails the spectator even more dramatically than Weber's *Rush Hour, New York.*

The same combination of Cubist fragmentation and urban movement is apparent in John Marin (1870–1953), whose early work in particular stressed the dynamic potentialities of Cubism as applied to the New York scene. A watercolor view of the Woolworth Building of 1912 is an 154 American counterpart of such French icons of modernity as Delaunay's *Eiffel Tower,* especially since the Gothic skyscraper, then nearing comple- 95 tion, was at the time the tallest building in the world. With directness and vigor, Marin's lunging brushstroke shatters the mass of this gravity-defying tower of steel so that the building almost dissolves into the teeming street life below and the agitated sweep of wind and clouds above. Here the Cubist merger of mass and void conveys the dynamic urban interplay of speeding automobiles and soaring skyscrapers.

In a later watercolor view of 1922, Marin ascends to the top of the Woolworth Building and looks down upon the skyscrapers of Lower Manhattan. Once more, as in La Fresnaye's *Conquest of the Air,* the 155, XXIX language of Cubism, with its freedom from the laws of gravity, is particularly suited to the aerial experience of our century. From Marin's dizzy vantage point the familiar relations of up and down are controverted and the spectator is confronted rather with a seething eruption of kinetic forces that burst outward like an exploding planet. In keeping with the American tradition, Marin's record of Manhattan is topographically more exact than one might first expect from its ostensibly abstract translation of streets and buildings into plunging and colliding axes of movement; the sewed-on paper sunburst of the foreground refers to the golden dome of the Pulitzer Building (now destroyed) and, to the right, even the colonnaded facade of the United States Customs House can be located next to the great traffic artery of Broadway.

The dynamism of Marin's style, with its linear distillations of paths of energy, was not limited to the Futurist experience of an urban world. The larger part of his *oeuvre,* in fact, was stimulated by the energies inherent in nature and not in the work of man. In a watercolor like *Maine Islands,* also of 1922, he turns from the impersonal crowds of Manhattan 156 to a lonely subjective response to nature as experienced off the north-

eastern Atlantic coast. There, tensely contracted into a curtained window view, Marin's vigorous Cubist shorthand seizes upon the essential oppositions of island and sea, sky and cloud, rock and tree, crystallizing the whole into a nucleus that seems to pinpoint the boundless energies of nature. In this, Marin reasserts, in a contemporary vocabulary, the experience of the nineteenth-century American painter Winslow Homer, who, like Marin, confronted himself with the savage powers of sea and rock off the coast of Maine. Despite the difference of pictorial style, both these artists share an American penchant for realist observation. In Marin's watercolor, for all its apparent abstraction, one can almost sense the forceful breezes and the pungent tang of the salt air that are evoked more literally in the seacapes of Homer.

157

The dependence on topographical fact evident in Weber, Stella, Marin would appear to characterize American Cubism as a whole. Charles Sheeler (1883–1965), in his 1917 *Barn Abstraction,* re-creates a Pennsylvania barn as an ascetic Cubist drawing whose right-angled purity and vertical striations refer specifically to the clean planes and wooden planking of the rural building. The work of Charles Demuth (1883–1935) similarly exemplifies this American wedding of an abstract style with a viewpoint whose particularity of observation is fundamentally realistic. His *Stairs, Provincetown* of 1920 depicts, like Sheeler's barn, a characteristic fragment of American architecture, in this case a wooden staircase of a New England house whose irregular scaffolding is eminently suitable to a Cubist vocabulary. Or in a later work, " . . . *and the Home of the Brave"* of 1931, Demuth again clings to a specific aspect of the American scene, here an industrial plant. In this painting the style vacillates suddenly between the absolute geometry of rectangular planes that compose the foreground and the literal description above that enumerates the luminary variations of every square pane of glass in the factory windows, a contrast that parallels the similar juxtaposition of the very abstract and the very concrete in certain works of Ben Nicholson. And to speak of Nicholson is to be reminded, too, of still further analogies between English and American Cubism. Demuth's lean style, in particular, recalls the English master's elegant, hairbreadth precision of line and plane; but in general, both Nicholson and the American Cubists share a kind of Anglo-Saxon puritanism whose antisensuousness and economy are reflected in sharp, dry edges and spare, cold colors.

158

159

160

This generalization touches even the most visually brilliant American Cubist, Stuart Davis (1894–1964). Like his exact contemporary Nicholson, Davis was too young to absorb Cubism until a decade after its initial impact, but perhaps for this very reason his assimilation of Cubism was more patient and penetrating than that of his elder compatriots. Like Nicholson, Davis learned Cubism by painting still-life objects, a circumstance that temporarily related him more closely to the abstract and analytical approach of the Parisian Cubists, whom he visited in 1928–29, than to the American commitment to the peculiarities of topographical fact. But, characteristically, Davis' still lifes revealed, from the start, his fas-

cination with the contemporary world, for he chose not the traditional objects of the Paris ateliers, but rather such a humble machine-made product as an eggbeater or a salt shaker.

The closeness of his scrutiny is apparent in a painting of 1931, *Salt Shaker,* which recalls the Léger of the 1920s in its veneration of clean, geometrically exact machine forms. Yet unlike the French master, Davis studies such an object with a highly particularized viewpoint, exploring not only its symbolism (the identifying letter S) and structure (the perforated metal and glass planes), but even its function. For in this inventive diagram, Davis demonstrates how a static table object, suggested by the secure vertical at the left, becomes a dynamic mechanism whose moving parts and upside-down position are indicated by the rising diagonals at the right and the changing directional arrows that follow the movement of the salt in the shaker when it is being used. 161

Like the *Salt Shaker,* the later work of Davis demonstrates not only a close observation of particular things, but the ability to re-create such observations into startlingly new shapes and relationships. In the 1940 *Report from Rockport,* whose very title parallels verbally Davis' fondness for brash visual puns and rhymes, he allies himself with other American Cubists by evoking a precise description of a specific New England fishing town, yet he far transcends Marin or Demuth in the liberties that he takes with both subject and style. Here Davis begins with the concrete images of the Massachusetts coast town—the garages, the gasoline pump, the clouds, the word "Seine" (with perhaps purposeful Cubist ambiguity, for the word in both French and English means a fish net as well as the Parisian river to which Davis often alludes in his American canvases)—and creates from these particular fragments a dazzlingly animated canvas whose swarming activity of glaring, flat colors and jagged, bobbing shapes is almost a metaphor for the succession of brilliant discontinuities so rapidly offered to the modern, and especially the modern American, eye and ear by flashing neon signs, billboards seen from a speeding automobile, and the nervous syncopations of jazz. 162

The freedom from literal appearances that Davis achieves in these jigsaw-puzzle rearrangements of the most literal observations grew steadily, so that by the 1950s his external references are more to be intuited than identified precisely. In *Colonial Cubism* of 1954, the visual experience of the New England environment is vividly scrambled in colors that suggest, but do not describe, the sharp-edged and freshly painted white planes of Colonial wooden houses as seen under the crystal-clear orange sun, blue sky, and white clouds of the North Atlantic region. And, in such a work, Davis provides a brilliant résumé of American Cubism, re-creating the most concrete data of his native American experience in terms of the most abstract disciplines of a foreign pictorial language. XXXIII

10 Cubism and Abstract Art: Malevich and Mondrian

In its initial development, Cubism described the world with a language that continued to increase in geometric regularity. In a drawing like Picasso's *Nude* of 1910, even the complex and irregular shapes of the human form are distilled into a vocabulary that admits only the straight line and the arc. But if the major Cubists soon veered away from this austere direction, which threatened to obscure completely their pictures' essential contact with external reality, there were other artists who could draw very different conclusions from Cubism's radically unreal metaphor of reality. Some of the Cubist masters themselves—Delaunay, Villon, Nicholson—occasionally eradicated entirely their pictures' references to reality, arranging as independent forms those geometries which Cubism had so carefully extracted from the world of appearance; but their pursuit of so purified an art constantly alternated with the creation of works whose roots depended on the close observation of concrete objects.

A few masters, however, were to be more consistent in their commitment to the world of pure geometry that Cubism had momentarily adumbrated in 1910–11 and then rejected—the Russian Kasimir Malevich (1878–1935) and the Dutchman Piet Mondrian (1872–1944).

In the years around 1910, a country's artistic radicalism often seemed to correspond inversely to the closeness of its contact with progressive currents before these years. By comparison with the quiet and, at times, relatively conservative development of Cubism in Paris, Italian Futurism and English Vorticism displayed an obstreperous modernism whose radical flavor was largely intended to resurrect a moribund tradition.

In Russia, the enthusiastic interest in the *avant-garde* displayed by artists and collectors around 1910 was also a partial means of thrusting a nation that had been on the artistic periphery of the Western world into the fore-front of contemporary experience. Here, as elsewhere, Cubism was the style that first appeared to convey the most vigorous acceptance of the modern world, though an even more radical fracturing of mass may have preceded it in the form of Rayonism, a movement begun by Michael Larionov and his wife Natalia Gontcharova but whose exact dates are still uncertain. But apart from such questions of historical priority, Cubist paintings were well known in Moscow around 1910, not only through periodicals and the great collection of Sergei Shchukhin (which contained fifty Picassos), but through such exhibitions as those held by the Jack of Diamonds group, which in 1912 showed works by Picasso, Léger, Gleizes, and Le Fauconnier.

The rapidity and originality with which Cubism was assimilated in Russia are suggested in a painting of 1911 by Malevich, the *Woodcutter*. 163
Like Léger, Malevich often interpreted Cubism in terms of forceful phys-ical activity, paralleling the vigorous movement the Frenchman had elabo-rated in his 1910 *Nudes in the Forest*. In style, too, Malevich reduces the XXII
world to clean-edged, chunky shapes whose brilliant contrasts of light and shadow transform the sturdy, bearded peasant into a gleaming metal robot.

The energetic functioning of these mass-produced Cubist parts is even more explicit in another work, the *Scissors Grinder* of 1912, whose 164
dynamism is almost Futurist. Again, as in Léger, the human figure is like a machine, so that the scissors grinder as a man is nearly indistinguishable from the pedal that he presses, the metal blade that he holds, or the whirl-ing grindstone that he sits by. If these mechanized exemplars of impersonal labor evoke the constructive dreams of a new industrial society, they also demonstrate the backwardness of Russia in the pre-Revolutionary years. Ironically, Malevich's woodcutter and scissors grinder, for all their machine implications, are essentially nineteenth-century genre figures taken from the very nonindustrialized peasant community of a czarist society.

Yet the extreme purifications of a mechanized Cubist style could not sustain Malevich's radical impulses. In the following year, 1913, he wiped from his canvases even those vestiges of traditional realism dis-cernible in his Cubist work, as if the construction of a new world demanded a complete destruction of the past. With the revolutionary zeal and idealism that prophesied the political revolution soon to come, Malevich proclaimed the new art of Suprematism, which denuded the still impure geometries of his Cubist work into perfect circles and squares and presented these abso-lutes as the virgin alphabet of a pictorial language that would never again be tainted by contact with any realities beyond itself.

For Malevich, the transition from Cubism to the Utopian purity of a nonobjective world was an abrupt jump that seemed more the product of a sudden intellectual revelation than of a sustained pictorial develop-ment. Even the structure of his Suprematist compositions, with their dis- 165
crete, bounded shapes unambiguously located on top of a continuous, flat background, completely rejects the complexities of Cubist syntax. But for

another master of nonobjective painting, the adventurous change from Cubism to an art of pure geometric relations was achieved by evolution and not revolution.

Like the other great master of nonobjective painting, the Russian Wassily Kandinsky (1866–1944), Mondrian belonged to an older generation than the Cubists and had already begun his career as a painter in the 1890s. Like Kandinsky, too, his art did not receive its mature inflection until the years around 1910, as if history had obliged him to reserve the full statement of his powers until the moment of a profound transformation of Western art. But, unlike Kandinsky, whose turbulent shapes and colors crystallized into a geometric language without passing through the structural disciplines of Cubism, Mondrian studiously assimilated the rigorous lessons of Picasso and Braque.

In comparing two paintings of trees, one of 1908–09 and one of 1912, the significance of Cubism in Mondrian's development may be
166
approached. In the earlier painting, Mondrian still works within the confines of an essentially realist viewpoint, though he strains these boundaries to a degree that goes even beyond the expressive distortions of his Dutch pictorial ancestor, Vincent van Gogh. Like Van Gogh's attitude toward nature, Mondrian's was mystical, sensing an underlying divinity in the spectacle of landscape; and like Van Gogh's late cypresses, Mondrian's heroic tree writhes and quivers with an organic energy that would guide the spectator from the world of objective perception to an experience that is cosmic in its implications. Wishing to transcend the earthbound particularities of visual data, Mondrian attempts to wed trunk, branches, earth, and sky into one animistic whole. Just as the trembling, skeletal branches are woven directly into the fabric of the sky, like the spiraling contours of Van Gogh's cypresses, so, too, do the tree's vertical roots blend imperceptibly with the earth that nourishes them. Furthermore, the unspiritual realm of palpable matter is assaulted by the nervous, electric movement of Impressionist brushstrokes, which almost dissolve the material substance of the tree into a pulsating sea of feeling.

The expressive intensity of such a painting suggests how passionate was Mondrian's desire to find a pictorial means that could convey his spiritual experience of the fundamental oneness and vitality of nature. When he came to Paris from Holland early in 1912, he finally discovered
XXXIV
such a means in the Cubism of Braque and Picasso. In the 1912 tree study, Mondrian provides a testament to his patient examination of Analytic Cubism as well as to his extremely personal interpretation of it. Here the severities of 1911 Cubism are quickly absorbed. With a puritanical denial of sensuousness, Mondrian seizes the austere palette of beiges and grays, though he renders it even more Spartan with the bone-dry chill of his own bluish whites. In structure, too, he easily grasps the economical vocabulary of straight lines and arcs, but converts it into something still more rigid by emphasizing throughout the stern junctions of right angles. But, above all, it is the difference of expressive intention that distinguishes such a work from a mere Cubist school piece. For Mondrian, as for Marc, the Cubists' destruction of corporeal matter, their fusion of solid and void, their re-

moteness from visible reality were all vehicles to articulate a mystic conception of cosmic harmony that lay behind the surfaces of reality. Now the earlier tree has merged almost unrecognizably into adjacent earth and sky, leaving behind only a few remnants of its literal appearance in the greater density of brownish planes that suggest the vertical trunk or the broad arcs that suggest the expansive spread of the horizontal branches. This search for the unity beneath the variety of appearances extends as well to the insistent extraction of horizontal and vertical networks of form. Profoundly inspired by Theosophy, Mondrian's thinking tended to reduce all experience to two opposing forces—positive and negative, masculine and feminine, dynamic and static—and it was precisely through the assertion of horizontal and vertical axes that he felt he could articulate this philosophy in visual terms. For him, the intellectual and sensuous geometry of Cubism was a means of unveiling the spiritual geometry of the universe.

So deeply was Mondrian immersed in the mystic experience of nature that his Cubist work, with few exceptions, avoided the Parisian repertory of still-life objects and the human figure. Instead, he continued his earlier devotion to the study of trees, earth, sky, and water. A most remarkable painting of 1912, *Seascape,* recalls his pre-Cubist fascination 167
with the bleak sand dunes of Holland and, beyond that, the whole Northern Romantic tradition, from Friedrich to Feininger, of man's lonely contemplation of the infinities of nature and God. Here the minimal vocabulary and multiple spaces of Cubism are dedicated to expressing the awesome oneness and immensity of the sea. The duality of straight lines and arcs re-creates the endless interplay of the static calm of the horizon with the dynamic swelling of waves, just as the ambiguous interlocking of these broad, horizontal planes, so like the vast expanses of the ocean itself, evokes the sense of a continuous, fluid substance in both surface and depth.

Mondrian's Cubist meditation upon the sea was not unique in his *oeuvre.* Again, in 1914, he translated the Parisian Cubist's world of studio objects into a Northern mystic's world of immaterial nature and spirit. This was the famous Pier and Ocean series, in which he continued to pursue, with the same quiet fervor, his search for a pictorial equivalent of the overwhelming unity that he felt in the diverse appearances of nature. In a preliminary study of the theme, the topographical essentials of shore, 168
jutting pier, and ocean are still discernible, but, in the studies that followed, these diverse elements are wedded into an all-embracing oneness. Without 169
the clue of the early study, the references to reality would here be indecipherable, for Mondrian has reduced all experience to the opposition of verticals and horizontals. Yet, paradoxically, this minimal vocabulary yields a maximum of complexity, in a way that parallels both the simple oneness and the infinite change of the sea itself. Within this increasingly rigid context of right-angle relationships and the total elimination of the transient element of color, the mazelike variations of interwoven line and plane are as rich and ambiguous as in an Analytic Cubist painting. Furthermore, the enframing oval, which Braque and Picasso also used at this time, not only acts as a supple foil to these rectilinear patterns but

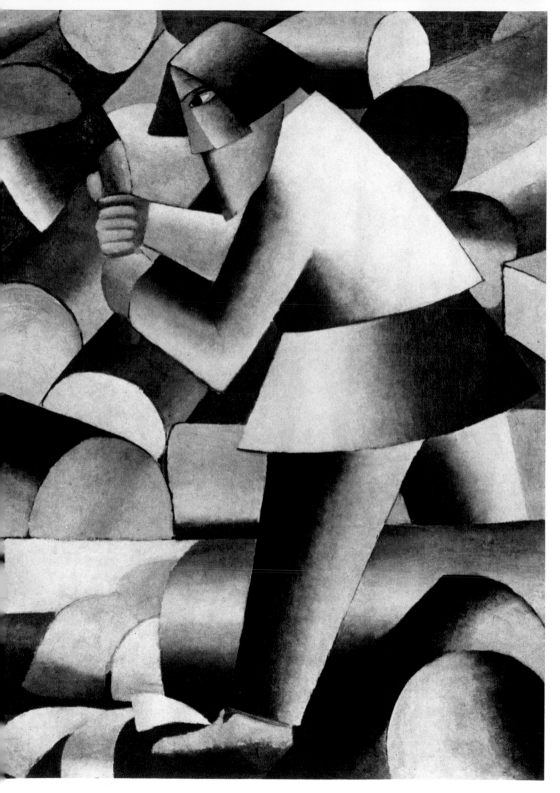

163. Kasimir Malevich. *The Woodcutter*. 1911

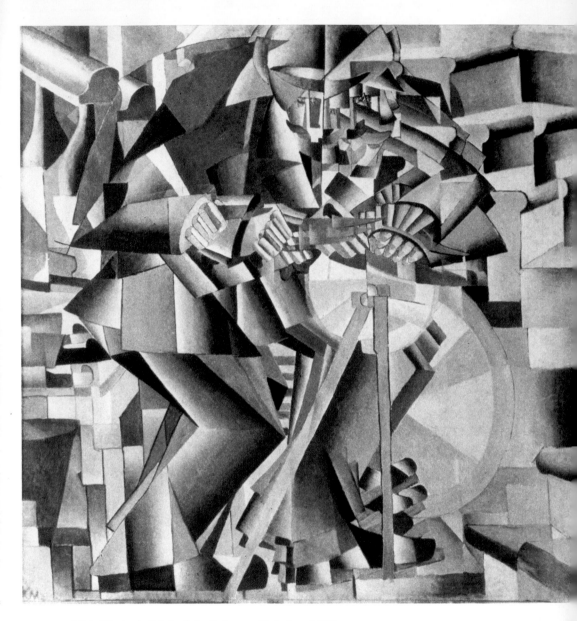

164. Kasimir Malevich. *Scissors Grinder*. 1912

165. Kasimir Malevich. *Suprematist Composition:*
Red Square and Black Square. 1914–16

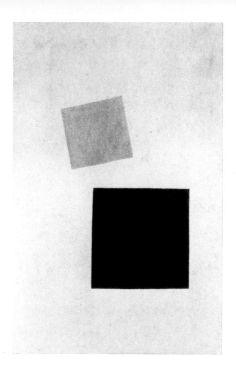

166. Piet Mondrian. *The Red Tree.* 1908–9

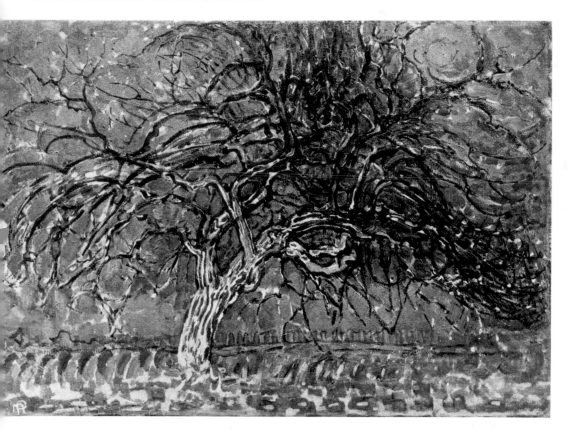

167. Piet Mondrian. *Seascape*. 1912

168. Piet Mondrian. *Pier and Ocean*. 1914

169. Piet Mondrian. *Pier and Ocean*. 1914

170. Piet Mondrian. *Church at Domburg*. About 1914

171. Piet Mondrian. *Church Façade*. 1914 (misdated 1912 by the artist)

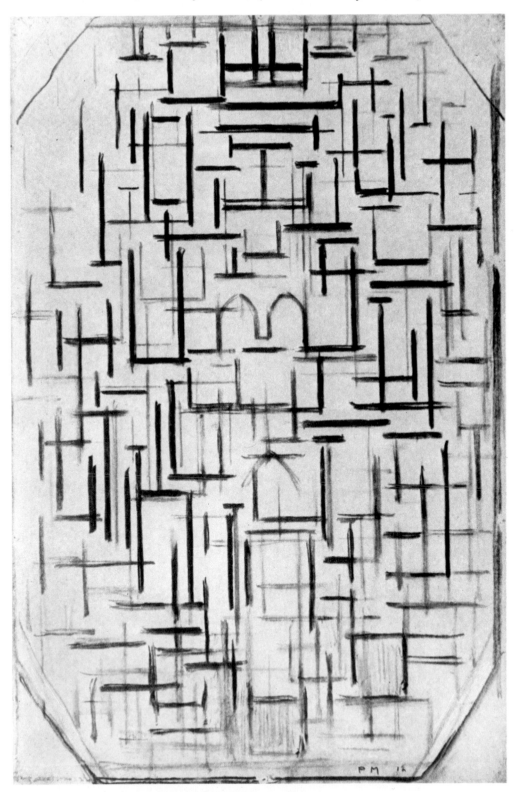

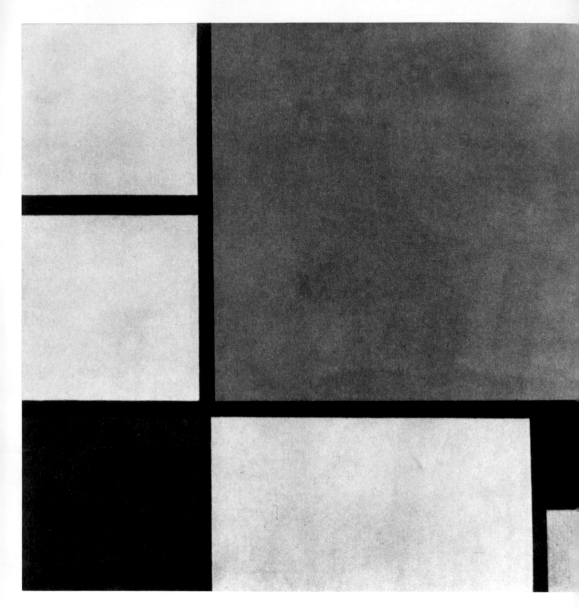

172. Piet Mondrian. *Composition No. 2 with Red, Blue, and Yellow*. 1929

also constricts the picture to a dynamic, egglike nucleus suggesting, like all of Mondrian's later work, that what is presented on canvas or paper is only an infinitesimally small part of something that extends infinitely in all directions. Confronted with such visual complexity, one realizes only on second glance that the picture is virtually symmetrical, except for the most subtle variations of width, length, and texture in the application of the crayoned lines. And, in concentrating on the unity rather than the diversity of the work, one realizes further that the restless, interlocking rhythms of line and plane are ultimately resolved into a large cross that seems to emanate serenely and quietly from beneath the agitated surface.

In another series of studies from the same year, 1914, Mondrian's dedicated search for fundamentals replaces the horizontal mysteries of the sea with the vertical mysteries of a church. But for Mondrian, the heavy masonry walls and buttresses of the late Gothic church at Domburg are no more palpable than sea or sky. In one study, vestiges of the building are still visible in the pointed arch of the central doorway, the paired arches of the windows above, and the diagonal buttresses at the left; but by and large the imposing mass is dissolved into an impalpable network of component horizontals and verticals that stresses, above all, the skyward movement of this Gothic building. The religious implications of the cross in the Pier and Ocean studies are here more explicit, not only in terms of the subject itself but again in terms of the central cross that emerges above the doorway, which, we know from Mondrian's earlier, more realistic studies of the church, was not actually on the building.

In another drawing of the same Dutch church, Mondrian purges his forms to an even stricter order, so that not only have those vestiges of reality which, in other studies, permit architectural identification almost totally disappeared, but even the oval frame has become rectilinear. In a sense, a drawing like this can almost be considered a more rigorous analysis of an Analytic Cubist painting, for it continues to pursue Picasso's and Braque's direction of 1911 to a logical extreme in which a stringently monadic vocabulary finally obliterates any recognizable reference to reality. Yet, ultimately, such a reference underlies this study (still barely perceptible, in fact, in the softly drawn single and paired arches of the center), and it is this remote but essential contact with the structure of the visible world that distinguishes Mondrian from Malevich or Kandinsky and asserts his fundamental origins in Cubism.

But Mondrian's relentless destruction of the particular did not stop even at this great distance from reality. Soon the stimuli of tree, sea, and church were to vanish in his persistent search for the irreducible structure of the seen world, although their horizontal and vertical ghosts were always to hover behind his late work. By the 1920s, in fact, Mondrian had finally disclosed the indivisible components of the fugitive surfaces of nature—a dynamic grid of perfectly parallel and perpendicular lines, the absolute lightness and darkness of white and black, and the three primary colors: red, yellow, and blue.

If the mystical annihilation of any explicit reference to the material

world places these later works in a realm that is foreign to Picasso or Braque, it should not be forgotten that their vocabulary and structure were carefully distilled from Analytic Cubism. In Mondrian, as distinct from Malevich and Kandinsky, there is no sense of separate forms resting upon a ground plane, but rather an ambiguous interlocking of shapes and spatial relations. As in Cubism, no area is complete in itself, no plane absolute in its location. And again, as in the most severe Analytic Cubist canvases, an infinitely simple and predictable vocabulary creates a structure that is infinitely complex and unpredictable.

For Mondrian, Cubism was essentially a means of furthering the purification of the senses and the spirit, yet, unsupported by the Cubist experience, his arrangements of straight lines and flat colors would be arid and lifeless exercises instead of the taut and radiant organisms that they are. With the irony of a great master rejected by an equally great pupil, Cubism gave Mondrian the strength to create canvases whose remote, pristine intensity could stand in firm and beautiful opposition to Picasso's and Braque's commitment to the material world.

11 *Cubism and Fantastic Art: Chagall, Klee, Miró*

If Cubism provided one of the most rigorously disciplined pictorial structures in the history of art, it simultaneously released, for certain artists, an unparalleled freedom of imaginative structure. Duchamp's work has shown how the logical analyses of Cubism could be transformed into fantasy. The same surprising metamorphosis occurred in the work of three other masters—the Russian Marc Chagall, the Swiss Paul Klee, and the Spaniard Joan Miró.

Marc Chagall (b. 1887 [1889?]) moved to Paris from Russia in 1910, and thus repeated the biographical pattern of the many twentieth-century artists who gravitated to Europe's artistic capital from countries whose nineteenth-century tradition was relatively remote from the most progressive artistic currents. Nevertheless, when Chagall arrived in Paris, he already had behind him a small but markedly individual *oeuvre,* which was distinguished by its fanciful narrative descriptions of the major events —birth, marriage, death—connected with the simple life cycle he had experienced around him in the Jewish quarter of his native town, Vitebsk.

174 In *Candles in the Street* of 1908, he takes a fundamentally traditional perspective space and an essentially literal description of the village figures and their humble architecture and strains them wildly in order to re-create the strange, disjointed memories of his grandfather fiddling on a village rooftop, of a woman shrieking down the street one night to bring help to her dying husband, and of the dead man himself, lying on the ground and surrounded by six candles. Yet the relatively traditional style of this painting hardly seems capable of articulating fully the ex-

traordinary fluidity of imagination suggested by this juxtaposition of separate memory images, and Chagall himself quickly explored a new pictorial means to make his fantastic ends visible. Within one year after arriving in Paris he had learned the language of Cubism thoroughly, and could already use it to translate his own feelings, memories, and symbols into paint.

Chagall's astonishingly rapid absorption of Cubism is apparent in *I and the Village* of 1911. The plunging perspective space, the discrete and opaque forms, the relative respect for scale and gravity in the early work are suddenly replaced by a flattened space, fragmented and transparent objects, and an exuberant disregard for matters of size or of up and down. Now the images of Vitebsk, which had been naïvely, if vigorously, described with the continuous space and integral objects of *Candles in the Street,* float in a discontinuous space composed of fragmented memories. The startlingly large head of a fantastic creature—part cow, part donkey, part goat (and in the empathic intensity of the eye, one feels, part Chagall)—confronts the equally large head of a peasant, while the dreamlike spaces around them are filled with a fantastic village landscape in which peasants are as free as houses to challenge the laws of gravity and in which the memory of a cow being milked can suddenly materialize in the phantom jowl of the festively decorated farm animal. In short, the physical restrictions of the seen world give way to the psychological release of an imagined world, but this new-found liberty is balanced by the new-found discipline of Cubism. As such, Chagall's seemingly random associations of holiday, farm, peasants, and a Christian society outside the crowded Jewish quarter where he was raised are tightly fused in a centrifugal fabric of interlocking Cubist planes. If the vocabulary of Analytic Cubism, with its hovering, dismembered forms, could help Chagall to realize in paint the fluid and evanescent memories of his youth, its syntax could also serve him as a means of joining these fragments into a coherent pictorial whole.

The same combination of firm Cubist structure and exhilarating imaginative freedom is apparent in another work of 1911, *Half-Past Three (The Poet),* a canvas whose somewhat cryptic title was given it by Chagall's close friend, the poet Blaise Cendrars. Here the painter evokes the ecstatic moment of artistic creation by pursuing to a more astonishing extreme Cubism's disregard of gravity. In contrast with the green cat, who sits like a muse at the left, the poet and his world exultantly soar through the air, borne by the fanciful winds of creativity. The poet's green head, paralleling in color the cat of inspiration, is lopped off and inverted and, like the magically weightless still-life objects at the right, seems to circulate through these imaginary spaces with the freedom of the balloonlike shapes that rise above it. So intoxicating is the newly discovered liberty of this topsy-turvy world that even Chagall's rainbow-colored signature at the lower left defies gravity and floats on its side.

If these extremes of fantastic dismemberment of objects go far beyond the more sober fragmentations of Picasso's and Braque's work of the same year, so, too, does the range of Chagall's color. In vivid con-

173

XXXV

trast with the cautious monochromes of his Cubist contemporaries, Chagall uses color uninhibitedly to verify, as it were, the fact that his imagery pertains to the world of imagination and not to the world of perception. Accordingly, his chromatic freedom is much closer in intention to Marc's work than to the analytic investigations of abstract color that characterized the work of his friend Delaunay, whose palette of 1911 superficially resembles Chagall's.

175 How complete a release of feeling Chagall could obtain under the liberating impetus of Cubism is suggested by the *Drunkard,* a work of 1911–12. Now the lofty vertigo of an inspired poet in his studio is replaced by the vulgar dizziness of a drunken diner before a repast of fish and fowl. With even greater freedom than in *Half-Past Three,* Chagall conveys the sensation of alcoholic imbalance by completely separating the drunkard's head from his body, while the bottle itself floats irrationally before his strange eyes, unlike the carving knife which, obeying gravity, drops from his hand. Again, Cubism creates the possibility of dispersing these objects as well as providing the ligatures to join them. Throughout, this loose-jointed world is united by the prismatic interlockings of Cubism, and even the air-borne bottle is firmly locked in place by the interpenetrating edge of the table top.

The extraordinarily imaginative use to which Chagall could put a Cubist vocabulary is once more exemplified in a work of 1913, the *Pregnant Woman.* The scene conjures up the familiar memories of Chagall's Russian background, the wooden cottages, the peasants, farm animals, and colorful textiles; and in particular, the theme of pregnancy confirms Chagall's fascination with elemental human experience, a feature so evident in his early work. Most remarkable is the pregnant woman herself, who is represented in terms of a symbolism as startling as it is simple. The unborn child visibly resides in his mother's womb, re-creating through a Cubist superimposition of images the type of traditional Russian icon of the Virgin holding an enframed image of the Christ Child. Chagall's treatment of the mother's head is even more inventive. Here he seizes upon the imaginative potentialities of the simultaneous viewpoints investigated by Cubism, and imposes a female face seen frontally on a bearded male face seen in profile. Although Picasso had used such multiple views earlier, he had been motivated primarily by pictorial intuition. Chagall, by contrast, transforms this Cubist simultaneity into a symbol of the sexual duality, male and female, that lies behind the miracle of genesis. In this, Chagall is the first contemporary artist to examine the psychological implications of the multiple view discovered by Cubism, prefiguring by more than a decade Picasso's explorations of the dual aspects of human personality—external and internal, conscious and subconscious—evoked by the full face imposed upon a profile. And, once more, Cubism provides the warp and the woof of Chagall's dream fabric, weaving the disparate angles and arcs of moon and cloud, roof and sky into a secure visual structure without violating the air-borne freedom of his fantasy.

177
80 In *Paris Through the Window,* also of 1913, Chagall repeats a theme that Léger had painted in the previous year. Like Léger, Chagall

demonstrates the Cubists' acute awareness of the flat reality of the picture surface by making the plane of the window frame and window sill synonymous with the picture plane itself; but, needless to say, the view that lies in front of and behind this magical screen shares none of Léger's respect for palpable fact. Chagall introduces his Parisian fantasy with the Janus-headed figure, half-masked and half-unmasked, at the right—the child, as it were, of the double-faced pregnant woman—and the sphinxlike creature on the window sill, half cat and half human. Beyond, the filmy Eiffel Tower, so loved by Chagall's friends Cendrars and Delaunay, becomes almost the only earthbound object in a vertiginous world of prismatic Cubist rays illuminating a puffing train that runs its daily course upside down, a pair of pedestrians who stroll sideways along the Champ-de-Mars, and a man with a parachute who seems just to have jumped from the invisible summit of the Eiffel Tower.

With such indifference to gravity, Chagall's art goes far beyond even the most air-borne canvases of Delaunay or La Fresnaye and into the unbounded spaces of fantasy. Yet, even among these unfamiliar altitudes, which Chagall has sustained throughout his career, it should not be forgotten that it was the Cubist world that provided him with the essential release from the prosaic realm of earthbound reality as well as with the disciplined method of mapping out his strange new geography of memory and imagination.

The pre-Cubist work of Paul Klee (1879–1940), like that of Chagall, attempted to pursue fantastic extremes within the confines of a fundamentally realist style inherited from the previous century. But Klee's prolific imagination, like Chagall's, could hardly function with sufficient freedom in a pictorial world that still paid close homage to objective appearance. By 1912, the unrealistic potentialities of Cubism had become available to him, not only in Munich, through the milieu of Der Blaue Reiter, but in Paris, where, during a brief visit, he saw works by Picasso and Braque at the galleries, including those run by the German dealers Kahnweiler and Uhde.

It was not until 1914, however, that Klee produced works that fully assimilated Cubism. Of those, the *Hommage à Picasso* of that year 178 could hardly be more explicit in its title or style. Here Klee pays willing respect to the Spaniard's innovations, composing a delicate fabric of richly textured planes within the oval frame so frequently used by the Parisian Cubists. Yet Klee's personality is already evident.

The very idea of the painting is unusual, and is characteristic of Klee's inventiveness. This is neither a Cubist painting in the ordinary sense, for no object is analyzed here; nor is it a nonobjective painting in the ordinary sense, for it is not conceived as a self-sufficient entity free of reference to external reality. Rather, it is a painting about other paintings, a very personal commentary, as the title states, on the aesthetic realities of Picasso's Cubist work.

In style, too, the *Hommage à Picasso* already suggests the distinctive flavor of Klee's mature art. Unlike a Picasso or a Braque, it has a quality almost of preciosity, of hyperrefinement, in the delicate manip-

ulation of planes and textures, a quality apparent not only in the relatively small size of the work but in the extraordinarily subtle deviations from geometric regularity in the shape of the frame.

The private, miniaturist character of this painting, which demands that the spectator explore its creator's sensibilities at close range, is apparent in another Cubist-oriented work of the same year, *Red and White Domes*. A reflection of Klee's trip to Tunis with Macke and Moilliet in 1914, this watercolor, in its fragile fantasy, goes even beyond Macke's view of Kairouan. Here the chromatic freedom and checkerboard structure of Delaunay (whom Klee, like Macke, knew and admired) transform the exotic color and simple geometries of North African architecture into an enchanted recollection as remote from everyday experience as an illustration in a children's book. As in *Hommage à Picasso,* the relatively more impersonal and earthbound world of Cubism has been rendered intimate and magical. The floating, impalpable planes of Picasso have now become a vibrant, fantastic mesh into which Klee has delicately woven memory images of strange and distant lands.

In a later work, the *Villa R* of 1919, Klee explores still further the imaginative potentialities of Cubism's conceptual language. Here the Cubist use of fragmented letters stimulates an excursion into a mysterious, fairy-tale realm. With a freedom from prosaic fact that far transcends Picasso or Braque, Klee identifies his Cubist villa by a large, disembodied R that floats like a phantom signpost under the night sky, with its half and full moon. The solution of the enigma is then left to the spectator's imagination, which is obliged to reconstruct the unnamed, perhaps terrifying events that singled out this villa for so special and so cryptic a symbol.

If the Cubists' use of disembodied letters could provoke Klee to such an extraordinary adventure with a haunted house, their planar decomposition of mass could stimulate comparable flights of fancy. In *Uncomposed Components in Space,* a work of 1929, Klee wittily transforms Cubist spatial analysis into a whimsical world that almost mocks the hyperseriousness of intellectual artists. Here the disjointed, transparent planes of Cubism float ambiguously in a cerebral diagram of reality that also parallels the perspective drawing of architectural elevations, yet the product of this rational analysis is utterly irrational and childlike. In Klee's hands, the methodical spatial network of both Cubism and linear perspective is used to conjure up a doll house whose component parts of walls, doors, windows, and human and animal tenants could only be reassembled by an imagination as great as Klee's.

The scope of this imagination can be suggested by another Cubist work of the same year, 1929, which again uses Cubist means for Klee's fantastic ends. In *Clown* he offers a reprise of a theme that had fascinated him in his pre-Cubist years, that of duality of personality, as revealed in masks and actors. In an etching of 1904, the *Comedian,* Klee expresses this duality in the literal terms of an essentially realist vocabulary; in the later work, he expresses it more evocatively through the Cubist device of multiple viewpoints. Like Chagall in the *Pregnant Woman* and Picasso in his works of the late 1920s and early 1930s, Klee grasped the symbolic

implications of the Cubist discovery of a profile view imposed upon a full face—first made, however tentatively, in *Les Demoiselles d'Avignon*. Here the pink profile on the brown face suggests so elusive an interplay between the clown's mask and the human face beneath it that a true psychological identity of either clown or mask must always remain uncertain. And to render this fugitive personality even more unpredictable, Klee offers the unstable elements of the peaked green cap, which perches precariously on the corner of the clown's forehead, and the green ball, which rests on his shoulder and might vanish in the twinkling of one red eye.

If Klee's relationship to Cubism almost appears to be more that of a magician than of an artist, it should not be overlooked that Cubism gave him, as it gave Mondrian or Chagall, the necessary pictorial discipline to emerge as a major artist of this century. The *Clown,* apart from its psychological wit, achieves from the leanest ingredients as rich and taut an organization of flat colored planes as any of Picasso's Synthetic Cubist collages; and the *Uncomposed Components in Space* can approach the best of Analytic Cubism in its subtle modulations of light and its restless dialectic of flatness and depth, construction and dissolution. For Klee, Cubism not only unveiled a conceptual world of freedom to articulate the most unexpected ideas and experiences in a language of symbols, but it also provided the visual skeleton that could give substance to these fragile fantasies.

Born in 1893, some fourteen years after Klee, Joan Miró belonged to a generation too young to assimilate Cubism when it was first invented. About 1918, however, Miró began to examine more closely the Cubist viewpoint that he knew in Barcelona through the gallery of his friend José Dalmau; and in 1919, he made his first trip from Catalonia to Paris.

In two canvases of this year, *Landscape with Olive Trees* and 183, 184 *Nude with Mirror,* Miró's initial contact with Cubism is apparent. Unlike Chagall or Klee, however, he approaches it slowly and with a considerable reluctance to threaten the integrity of individual objects. In the painting of the nude, for example, Miró explores the clean, angular patterns of Cubism in his crystalline anatomical stylizations, yet he hesitates about investigating too fully the Cubist transparencies so cautiously suggested by the overlapping of the curtain and the shoulder or the intersection of a floating plane with the arm and the torso. Rather, Miró seems to use Cubism here to define more incisively the exact contours of an object and, with this, to create even more freely those repetitive abstract patterns that are already so evident in his vivid contrast of the decorative diagonal stripes of the rug against the vertical stripes of the cushion. This attraction to precise, sharp-edged shapes is also evident in the landscape, where the geometric patterns of Cubism are analogous to the neat striations of the cultivated earth, which move from the parallel tiers of the foreground to the saw-toothed patterns of the middleground, and finally, to the less disciplined shapes of the orchard and hills in the background.

In both the nude and the landscape, however, these decorative Cubist stylizations tell only half the story, creating, as it were, an abstract environment for the presentation of those organic forms which were ulti-

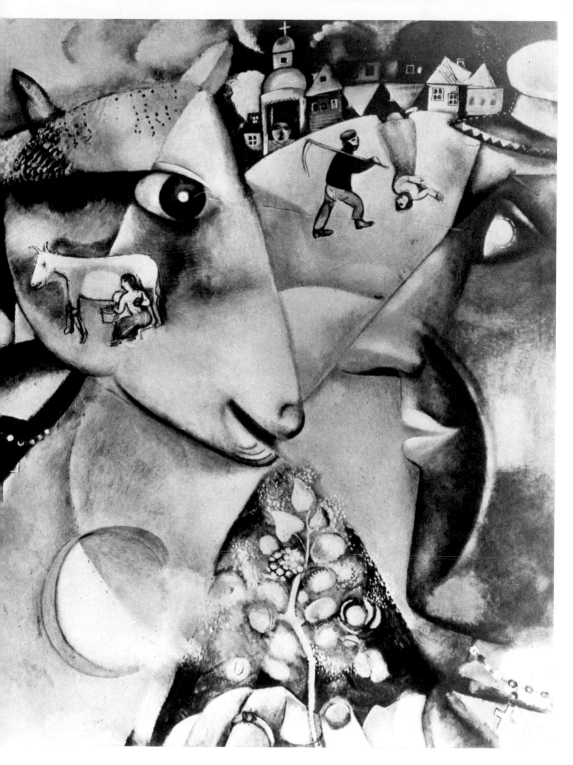

173. Marc Chagall. *I and the Village*. 1911

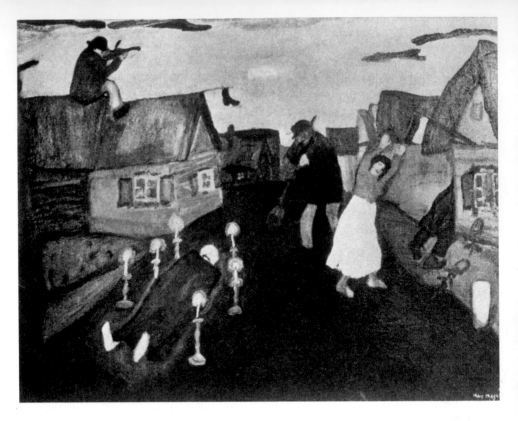

174. Marc Chagall. *Candles in the Street*. 1908

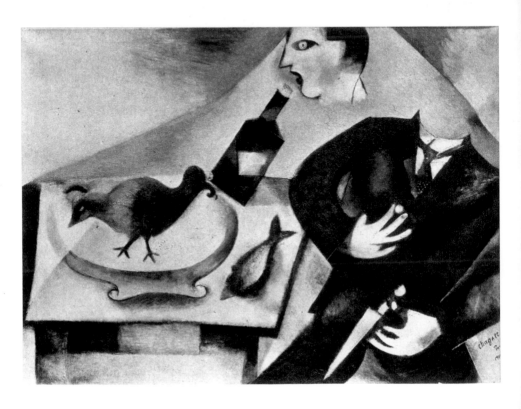

175. Marc Chagall. *The Drunkard*. 1911–12

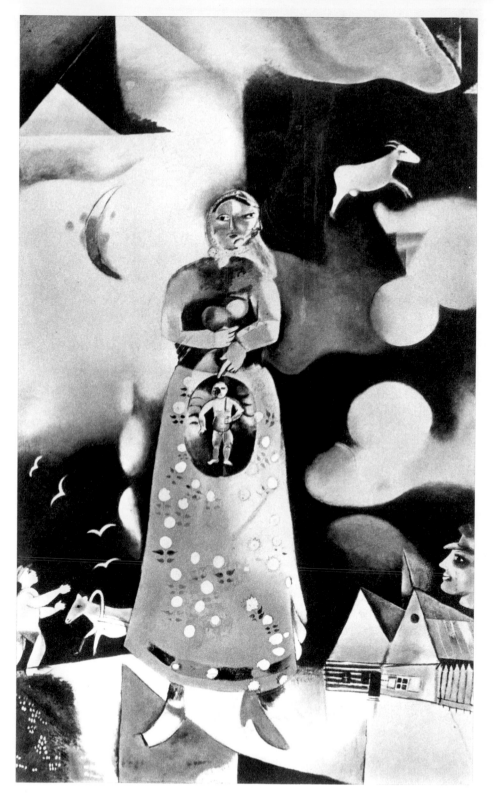

,176. Marc Chagall. *The Pregnant Woman*. 1913

177. Marc Chagall. *Paris Through the Window.* 1913

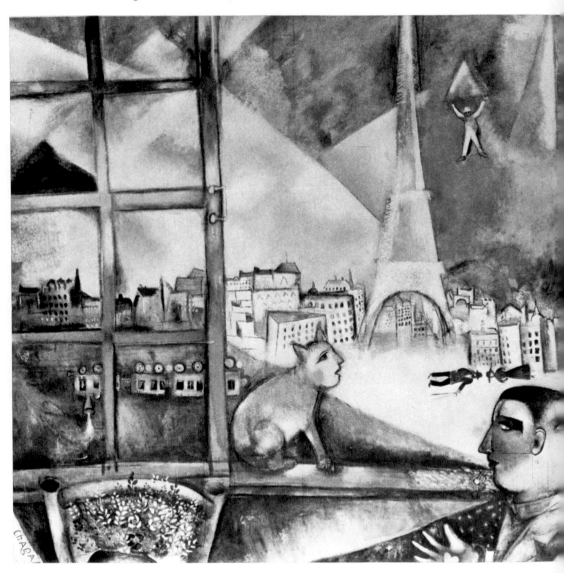

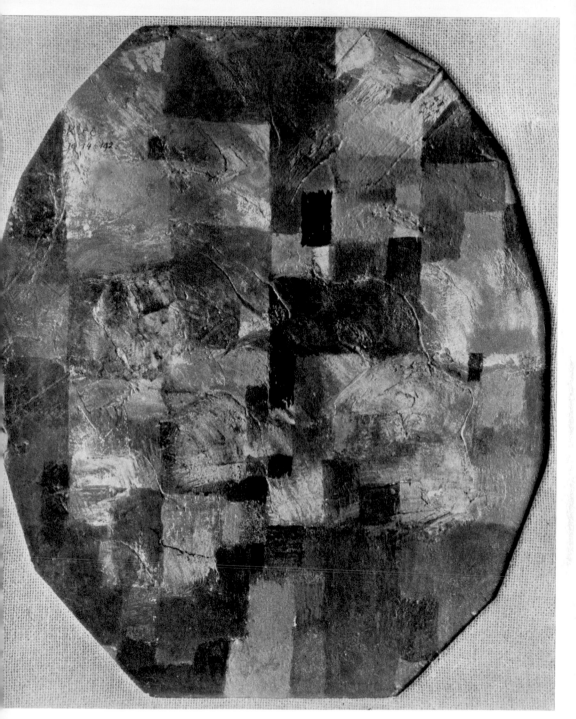

178. Paul Klee. *Hommage à Picasso*. 1914

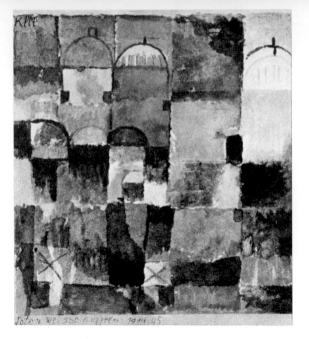

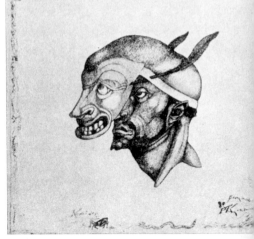

179. Paul Klee.
Red and White Domes. 1914.

181. Paul Klee. *Comedian, I.* 1904

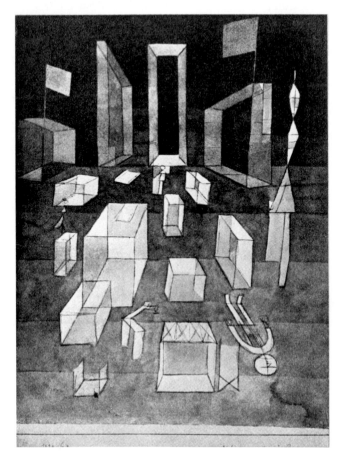

180. Paul Klee. *Uncomposed
Components in Space*. 1929

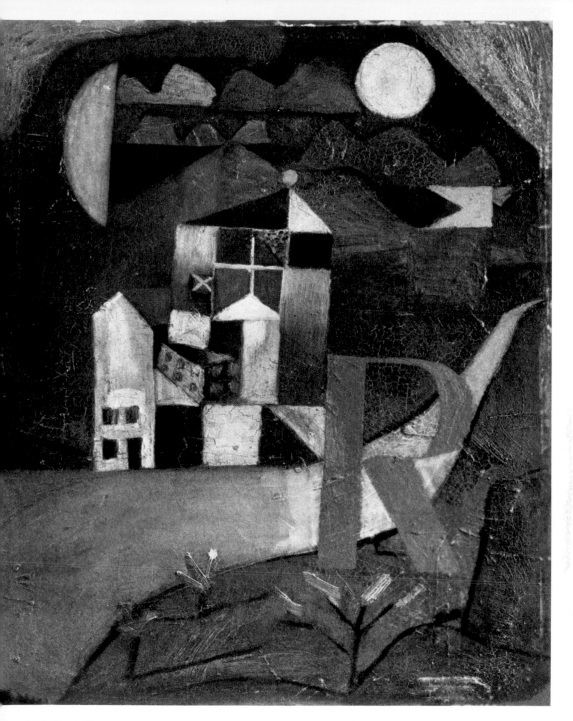

182. Paul Klee. *Villa R.* 1919

183. Joan Miró. *Landscape with Olive Trees.* 1919

184. Joan Miró. *Nude with Mirror.* 1919

186. Joan Miró. *Spanish Dancer*. 1924

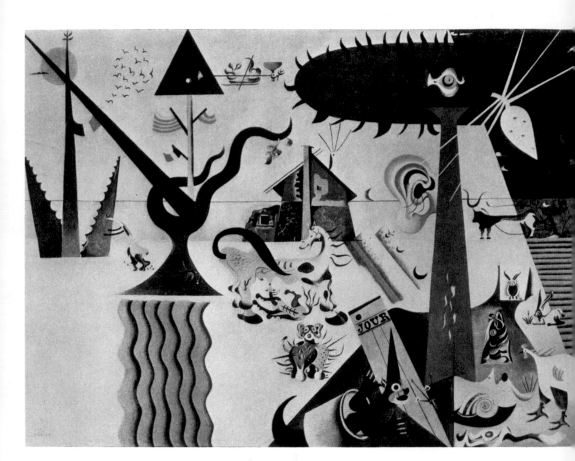

187. Joan Miró. *The Tilled Field*. 1923–24

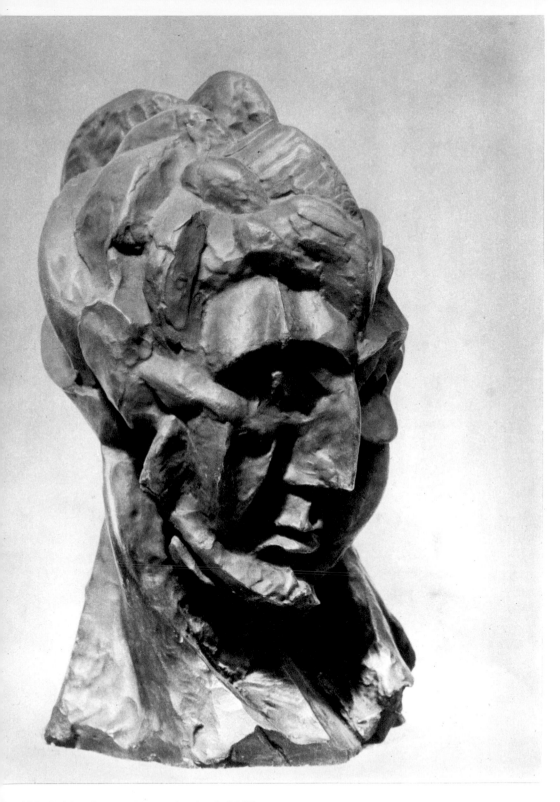

188. Pablo Picasso. *Woman's Head*. 1909

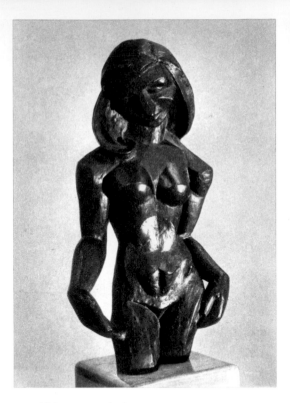

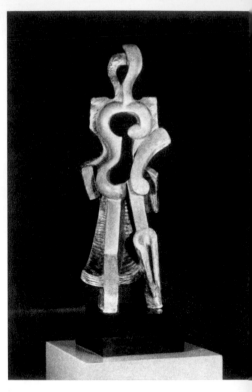

189. Roger de La Fresnaye.
Italian Woman. 1912

190. Alexander Archipenko.
Walking Woman. 1912

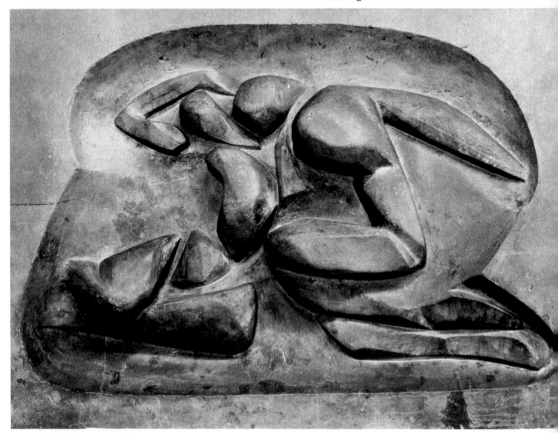

191. Raymond Duchamp-Villon. *The Lovers*. 1913

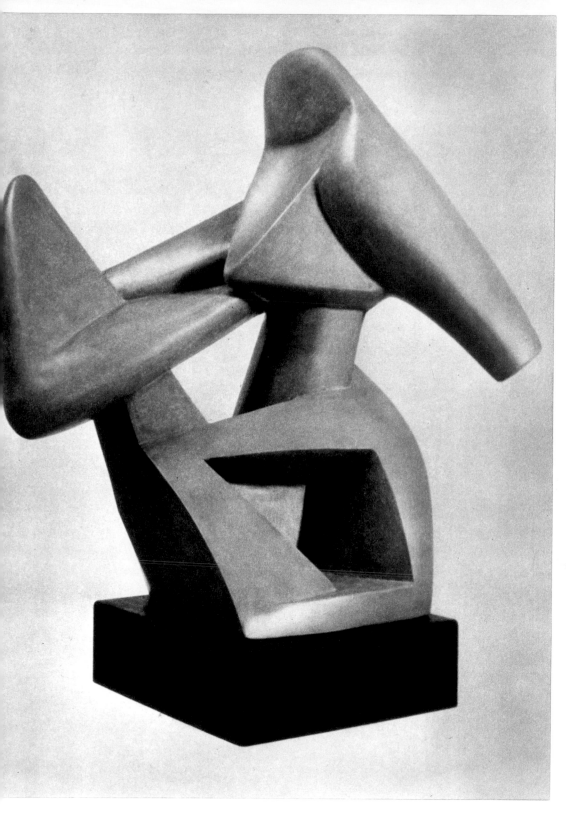

192. Alexander Archipenko. *Boxing*. 1913–14

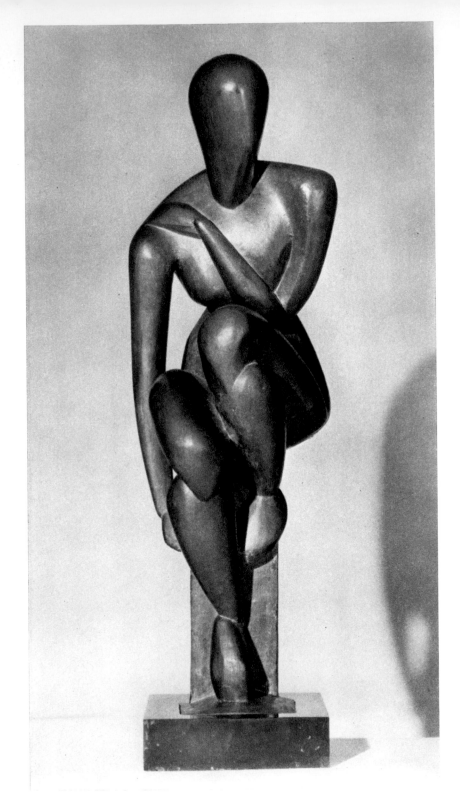

193. Raymond Duchamp-Villon. *Seated Woman*. 1914

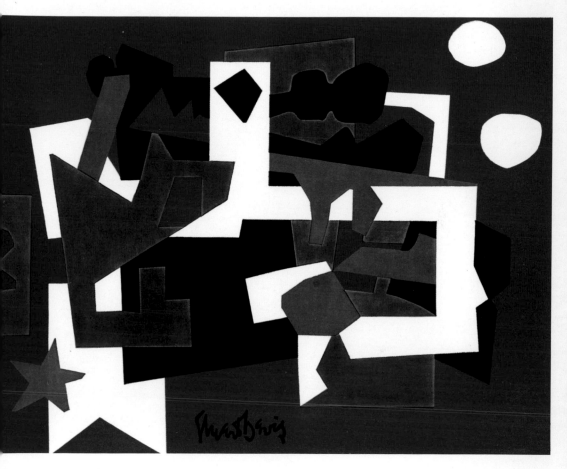

XXXIII. Stuart Davis. *Colonial Cubism*. 1954

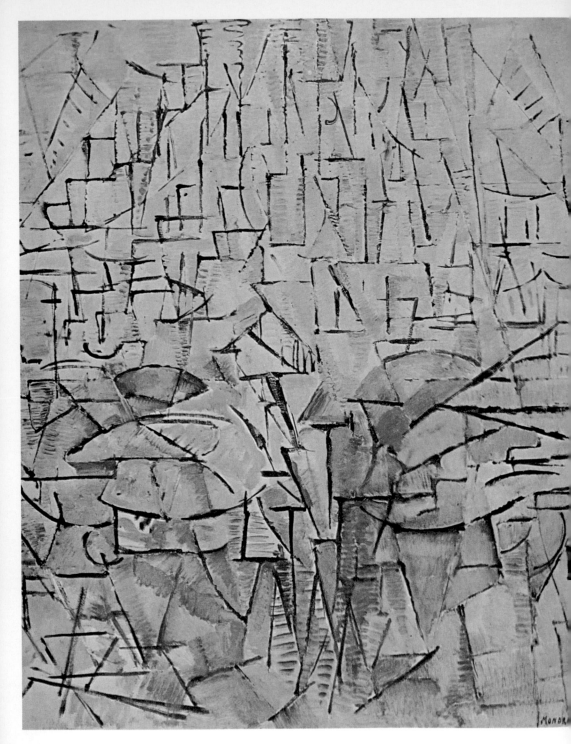

XXXIV. Piet Mondrian. *Composition No. 3 (Trees)*. About 1912

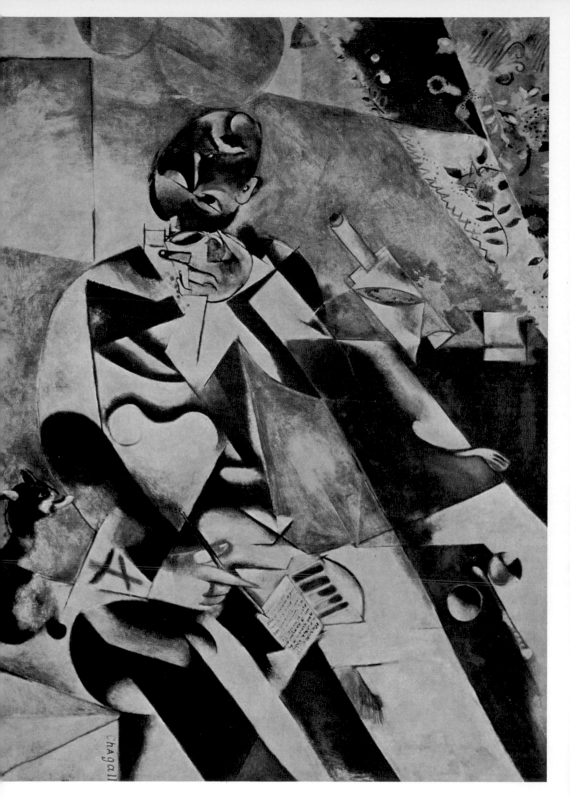

XXXV. Marc Chagall. *Half-Past Three (The Poet)*. 1911

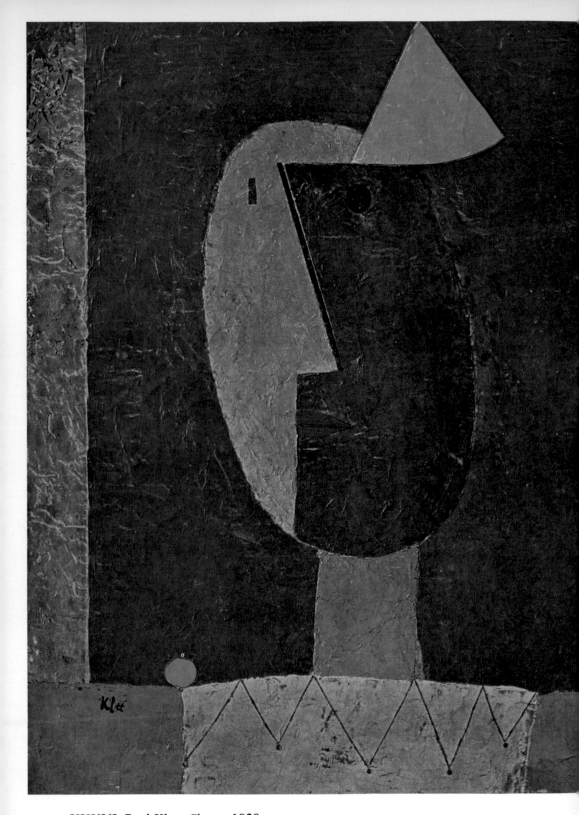

XXXVI. Paul Klee. *Clown*. 1929

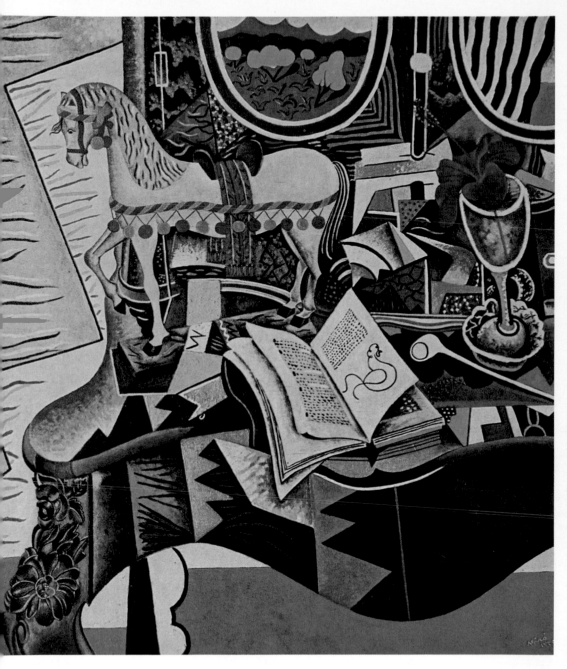

XXXVII. Joan Miró. *Still Life with Toy Horse.* 1920

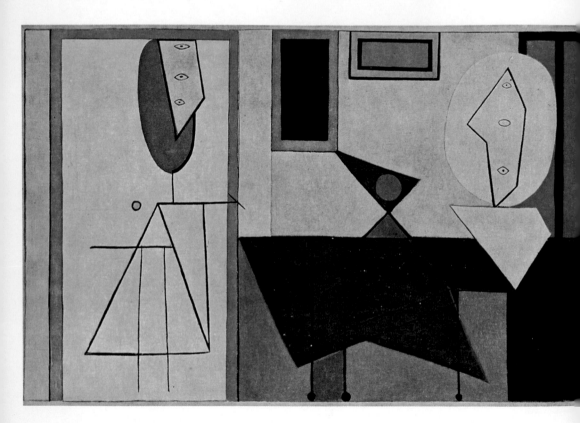

XXXVIII. Pablo Picasso. *The Studio*. 1927–28

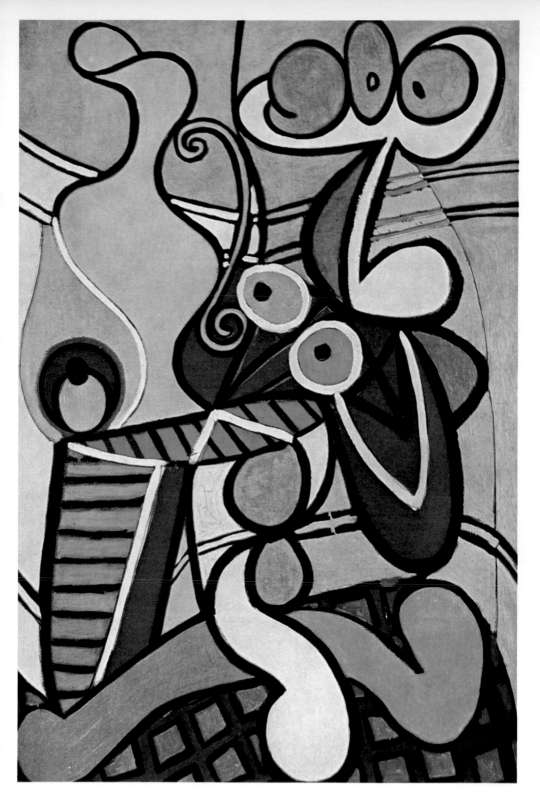

XXXIX. Pablo Picasso. *Still Life on a Table*. 1931

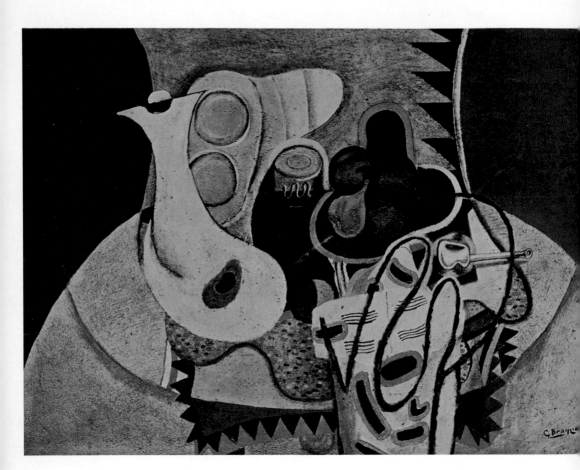

XL. Georges Braque. *The Pink Tablecloth*. 1933

mately to dominate Miró's mature work. With a Spaniard's sense of the distinctness and individuality of particular forms, Miró contrasts these angular Cubist facets with such irregular, anti-Cubist shapes as the braid of hair that falls across the nude's breast or the butterfly and floral decorations that are so clearly embroidered upon her cushion; or, in the case of the landscape, with the wriggling, curvilinear animation of the individual roots, leaves, and branches that grow from the Cubist earth.

185

The same curious contrast between an abstract Cubist environment and the intensely real creatures that inhabit it is even more pronounced in Miró's work of the early 1920s. Consider the *Still Life with Rabbit,* a work of 1920, the year after he settled in Paris. Here the Cubist facets of 1919 are used with an increasing freedom, so that the planes of wall and floor no longer pertain to the realm of literal description but offer, rather, an unreal spatial milieu of angular patterns whose extreme shallowness departs radically from the vestiges of illusionistic depth still present in the works of 1919. Within the context of this Cubist decorative fantasy, the still-life objects are invested with a startling reality. Beginning with the serpentine curves of the table legs and their leaflike carvings and continuing with the octopuslike onion that hangs upside-down from the table's edge, Miró carries us into a fantastic world of organic vitality whose bizarre whole seems to be much more than the sum of its prosaic parts. Recalling the almost mystical realism of the Spanish Baroque still life, the so-called *bodegón,* each of Miró's table objects takes on a magical intensity and lifelikeness, whether we turn to the nervous, twitching rabbit and rooster, the undulant shape of the limp, dead fish, or the crisp, bristling leaves and shining pepper.

XV
XXXVII

The dense and disquieting vitality of this painting, so like Picasso's *Dog and Cock* of the following year, is as evident in another work of 1920, the *Still Life with Toy Horse.* Once more, Miró's adaptation of Cubism does not extend to the dissection of individual objects, but serves rather to create an increasingly unreal milieu that lends the precisely described objects within it an ever more uncanny reality. Against a background of geometric stylizations that echo from the spiky patterns of the table to the wall plane at the left, this assemblage of the most palpable table objects has a strange presence that goes far beyond ordinary realism. Yet here this quality is more complex than in the *Still Life with Rabbit,* for Miró has begun to investigate that interplay of reality and illusion which was so conspicuous in Cubist collages. Paralleling the wit of his compatriots, Picasso and Gris, Miró presents natural forms—a horse, a rooster, flowers, a landscape—whose reality is as doubtful as the imitation wood grain of a Picasso collage. Thus, the white horse is only a child's wooden toy and the rooster is a Picasso line illustration from Cocteau's *Le Coq et l'Arlequin* (1918); and even the reality of the red hibiscus in the glass is not free from suspicion, judging from the *trompe-l'oeil* flower carved on the table leg. To enrich still further this essentially Cubist dialectic of fact and illusion, the half-landscape view seen through the oval frame might be, in this ambiguous context, either a real view seen through a window or a very Miróesque painting of a landscape.

The growing imaginative freedom suggested not only by this questioning of literal fact but also by the brilliantly unreal color was indeed borne out by Miró's work of the following years. In the *Spanish Dancer* 186 of 1924, the year of André Breton's first Surrealist manifesto, Miró suddenly abandons his intense respect for observed fact and experiments with the imaginative potentialities of Cubist dismemberment. Here reality is completely metamorphosed in a Cubist world that, as in the earlier works, acts as a rigid foil to the twisting movement of the subject, who waves her tentacular arms in rhythm with the sprightly leaves of the flower in her hair. The rest of her body follows the Surrealist implications of Picasso's most inventive Cubist anatomies, offering even a Picassoid pun in its equation of the bulbous head, kidney-shaped ear, straight-edged torso, and two lower orifices with the scroll, peg, fingerboard, and sound holes of the stringed instrument that accompanies her dance. The more consistently planar dissection of the *Spanish Dancer* was exceptional in Miró's *oeuvre*, but it nevertheless suggests how crucial Cubist means were in making the transition from the literal-minded fantasies of his early paintings to the grotesque and pixillated creatures who people the fluid spaces of his mature work.

This transition was even more explicit in the *Tilled Field,* a canvas 187 of 1923–24. Painting in Paris, Miró here re-creates in memory one of his favorite early subjects, the farm in his native Catalan village of Montroig, much as Chagall, in Paris, had painted memory images of his native Vitebsk. Now the realities of the perceived world are juxtaposed with the equally vivid realities of the imagination, so that the precisely delineated farm images of cat, snail, ox, chicken, rabbit, and nursing mare are mixed with such fragments of Parisian experience as the JOUR of a Cubist newspaper collage and the French flag that waves beside the flags of Spain and Catalonia. Furthermore, the independence from literal reality afforded by the space relations of Cubism could also provide the license for the invention of such strange treelike creatures as the one-eyed, one-eared being that surveys the cultivated farmland like a dream symbol of visual and aural attentiveness. Pictorially, too, Cubism lies behind Miró's interrelationship of disjointed forms on a flat surface. By such devices as the diagonal at the right that cuts through the transparent body of the ox or the repetitive patterns of tendrillike contours that echo through the ox's horns, the ear, the mare's tail, and the tree's branches, Miró weds together in one pictorial whole the disparate experiences of the imagination, just as Gris or Braque might unite and confound separate objects on a table top.

With this new-found freedom from the restrictions of reality and his special fascination with a vocabulary of throbbing, vermicular shapes that evoke the primitive, biological experiences associated with the subconscious and with the lower orders of life, Miró was soon to become one of the leading masters of Surrealism. Yet, as with two other masters of the imagination, Chagall and Klee, Cubism was the crucial experience in the formation of his art. On the one hand, it enabled him to escape from the demands of realism; on the other, it provided a pictorial control with which to transform extravagant flights of fantasy into major painting.

12 Cubism and Twentieth-Century Sculpture

As artists who dealt with real, rather than illusory, solids and voids, the younger Parisian sculptors could hardly ignore the spatial revolutions of Cubism. Yet the task of translating the new pictorial concepts of Cubist painting into three dimensions presented these sculptors with a unique problem that was not to be solved easily. How could an Analytic Cubist painting, with its subtle paradoxes of solid and void, opaqueness and transparency, *trompe-l'oeil* and symbol, be realized through the medium of sculpture? Could the tangible facts of bronze, stone, or terra cotta ever be carved or molded into so intangible and ambiguous an image?

In some ways it is far more difficult to outline the evolution of Cubist sculpture than of Cubist painting. For one thing, a definition of the scope of Cubist sculpture is elusive, since such sculpture often invades the territory of collage. Furthermore, the problem is complicated by the fact that none of the sculptors who investigated the Cubist aesthetic was an artist of the stature of Picasso or Braque, so that questions of leadership are more conjectural. And, not least, an assessment of the historical role of the diverse masters of Cubist sculpture is confused by a lack of reliable dates, without which many issues of priority must temporarily remain unanswered.

One thing, however, is clear—that the history of Cubist sculpture properly begins in 1909 with a work by no less a Cubist than Picasso himself. His bristling, energetic *Woman's Head* is clearly related to such a contemporary painting as the *Seated Woman,* transcribing into the actual substance of bronze what is still left of illusory substance in an early, less

188
25

291

radical stage of Cubist painting. Like the painting, the sculpture assaults the surface of a mass by splintering it into irregular, jagged facets; yet, beneath this almost Rodinesque shimmer of light, the solid core of the head, as in the painting, is still unthreatened. The course of Cubist painting, however, soon went far beyond this literally superficial faceting, and the more profound dissolution of mass that followed the works of 1909 demanded that Picasso temporarily withdraw his energies from the problem of Cubist sculpture.

This very problem, however, was soon approached in various ways by a group of Parisian sculptors whose backgrounds were as diverse as those of the Parisian Cubist painters themselves. These very painters, in fact, occasionally ventured into three-dimensional territory, as did Roger de la Fresnaye, whose *Italian Woman* of 1912 is an attempt, like Picasso's 189 bronze head of 1909, to render some of the preliminary surface agitation of Analytic Cubism in sculptural terms. Recalling the angularity of Picasso's far less civilized nudes of 1907–8, La Fresnaye's bronze tentatively suggests, in the modeling of the torso, some of the elisions of solid and void, concave and convex, that initiated the Cubist adventure; but, in general, its integrity of mass really precedes—in evolutionary, if not chronological, terms—Picasso's earlier bronze.

A more probing sculptural approach to the unstable facetings of Analytic Cubism was taken by Raymond Duchamp-Villon (1876–1918), who, like his two famous brothers, Marcel Duchamp and Jacques Villon, participated in the many Cubist exhibitions of 1910–14, including the Section d'Or. In the *Lovers* of 1913, Duchamp-Villon met Cubist painting 191 on more equal terms—those of relief sculpture. Here a most traditional sculptural theme—a pair of enraptured, nude lovers who recall Maillol and Rodin—is treated almost as an Analytic Cubist painting. Within the shallow space of sculptural relief, Duchamp-Villon fractures his solids into irregular fragments whose homogeneous texture and elusive fusion with the surrounding concavities offer an original, if somewhat elementary, parallel with the structural ambiguities of Analytic Cubist painting.

Yet such a work is clearly more pictorial than sculptural, avoiding, as it does, the problem of a truly three-dimensional equivalent of the Cubist confounding of solid and void. This problem, in fact, appears to have been most vigorously attacked by a foreigner in the Parisian milieu, the Russian-born Alexander Archipenko (1887–1964), who came to Paris in 1908 and allied himself with the Cubist movement. In the *Walking* 190 *Woman* of 1912, Archipenko inverts solid and void in a manner almost as radical as that of Analytic Cubism itself. The points of maximum density—the head and the torso—are transformed into gaping holes; and even the legs are splintered lengthwise into unexpected concavities, so that, as in Cubist painting, a fluid interaction between mass and space can be suggested. In *Boxing,* of 1913–14, the dynamic implications of 192 the *Walking Woman* produce another threat to the solidity and continuity of mass. Here a pair of boxers is metamorphosed into a straining, richly spatial network of thrusts and counterthrusts that recalls not only the kinetic aggressiveness of Futurism but also its forceful shattering of solids.

The slippery, unstable junctions of Archipenko's *Boxing* were soon repeated by Duchamp-Villon, this time in a sculpture in the round. If the

193 1914 *Seated Woman* is less bold in its dismemberments than Archipenko's boxing match, it is also more elegant and secure in style. As in the depersonalized figures of the *Lovers,* Duchamp-Villon here transforms all the body components (including the faceless De Chirico-like head) into a glistening, machinelike figure whose joints seem on the verge of unhinging.

The potential movement felt in the *Seated Woman* was brilliantly

194 realized in Duchamp-Villon's most imaginative work. In the *Horse* of the same year, 1914, the Futurist flavor of Archipenko's *Boxing* is still stronger; for here, Duchamp-Villon has created an extraordinary equation of the organic and the mechanical that has affinities with his brother Marcel's machine men. Even more than Boccioni's *Elasticity,* this is both literally

xxx and figuratively an image of horsepower, in which the sculptor has confounded the locomotive energy of the horse with a churning equine engine of muscular wheels and taut cranks.

The great promise of such a work was not to be fulfilled, for Duchamp-Villon's short life came to an end just before the Armistice. One wonders how he might have continued, since the *Horse,* in its almost baroque movement and in its organic fantasy of mechanized forms, takes us so far from the realm of a Cubist sculpture dependent on Cubist painting that one might even question whether it should properly be called Cubist at all. Be that as it may, by 1914 sculpture in Paris had virtually abandoned its initial and somewhat erratic attempts to cope with the discoveries of Analytic Cubism, and soon followed the new example of collage and Synthetic Cubism, whose flatter, larger, and more opaque shapes were far more easily realized in the medium of sculpture.

The new spatial concept of Analytic Cubism, however, was not completely fruitless in three-dimensional terms. One might even maintain that the new architectural aesthetic of Gropius, Mies van der Rohe, Le Corbusier, or the De Stijl masters, with its intricate structures of fragmented, seemingly weightless planes, interpenetrating solids and voids, and geometrically lucid parts, was essentially an extension of—or a parallel with—Picasso's and Braque's innovations of 1910–11. And outside Paris, there were sculptors who considered the problems of Analytic Cubism and who, in many examples, arrived at more inventive conclusions than their Parisian contemporaries. The Futurist Umberto Boccioni, for example, was perhaps an even finer sculptor than a painter. In the *Abstract*

196 *Voids and Solids of a Head* of 1912, he goes far beyond the contemporary work of Archipenko or Duchamp-Villon (both of whose studios he had visited in Paris in 1912) in his ruthless disintegration of sculptural mass. By comparison with Archipenko's *Walking Woman* of 1912 or Duchamp-Villon's *Lovers* of 1913, Boccioni's plaster head offers almost a total inversion of traditional sculptural concepts by transforming the surrounding spatial milieu into a solid and the enclosed solid into a hollow afterimage of an impalpable head.

The torsion and movement suggested by the twisted, sweeping arcs of this head are borne out in Boccioni's most famous work, the

Unique Forms of Continuity in Space of 1913, which may even surpass 195
Duchamp-Villon's *Horse* in its eruptive vigor and spatial innovation. With
typically Futurist iconoclasm, it offers a modern reprise of the winged
Victory of Samothrace, in which the overpowering energy of the striding
figure dissects the flesh and muscles into straining organic fragments that
fuse dynamically with the lacerated space around it.

 Although no more radical merger of solid and void was achieved
by any of the Parisian sculptors, a solution perhaps still closer to the
aesthetic of Analytic Cubism was arrived at in the following decades by
the two Russian Constructivist sculptors (and brothers), Naum Gabo
(b. 1890) and Antoine Pevsner (1887–1962). If the figures by Boccioni,
Duchamp-Villon, and Archipenko often rely on strident movement to
rupture the continuity of the skin enclosing them, Gabo and Pevsner
destroy their solids in a more penetrating and static way. Gabo's iron
Head of 1916 may resemble Boccioni's plaster head of 1912, but it 197
replaces the organic torsions with a more measured, stable vocabulary of
weblike planes whose simple geometries closely recall those of Analytic
Cubist painting. Moreover, the thinness of these metal components sug-
gests analogies with the disembodied quality of Analytic Cubist planes,
which, like these, float in an ambiguous relation with an adjacent void
whose boundaries are suggested but never completely defined.

 Unlike the more conservative Parisian sculptors or even Boccioni
(despite the Futurists' written assault on such old-fashioned materials as
bronze and marble), Gabo and Pevsner explored such heretical sculptural
materials as plastic, glass, industrial metals, and celluloid; and, in so doing,
they were able to offer what may be the truest three-dimensional equiva-
lent of Analytic Cubist painting. For example, in Pevsner's *Torso* of 1924– 198
26 the use of plastics produces a close analogy with the equivocal substance
of paintings like the *Portuguese* and *Ma Jolie.* According to the light and X, XI
the vantage point of the spectator, the plastic planes of Pevsner's *Torso*
alternate between transparency and opacity, creating, even in the tangible
realm of sculpture, an illusion of spatial positions that shift constantly in
a strangely unstable luminary milieu. The dissolution of mass, too, is
effectively realized in this translucent skeleton whose core seems no more
corporeal than its extremities.

 If Picasso's bronze head of 1909 and paintings of 1910–11 initiated
these scattered attempts to solve the problem of Analytic Cubist sculpture,
his collages and Synthetic Cubist paintings introduced the second and
more fruitful phase of Cubist sculpture. The very nature of collage, with its
piecing together of materials conceived as physical realities, was almost
more closely related to the palpable constructive processes of the sculptor
than to the illusory techniques of the painter; and, indeed, it would hardly
be less proper to categorize a collage as a bas-relief than as a painting. In
1912, in fact, Picasso actually made metal and paper cutouts, such as a
Guitar, which, in a logical but heretical way, paralleled the technique of 199
pasting papers in the world of real space by liberating Cubist planes from
the confines of a flat rectangular background. The implications were no
less logical and no less disconcerting; Picasso realized he could create

objects in relief or in the round just as he could create them with paste or paint on an opaque paper or canvas. The extraordinary *Still Life* of 1914 is a case in point. Here an assemblage of joined and painted wooden fragments and an actual bit of upholstery fringe becomes a three-dimensional collage still life of a molding, a table cloth, a goblet, a knife, some cheese, and some sliced sausage. By comparison with a collage or a painting, this work presents a still more disturbing relation to reality, for its carpentry makes these ostensibly unreal forms far more real and tangible facts. Furthermore, the unassertive innovations of such a construction extend even to the subject matter. Such trivial commonplaces as a knife and sausage are not exceptional in the domain of painting—witness an earlier Picasso still life of 1912—but these bits of an inanimate and even coarse reality are most unexpected in the domain of traditional sculpture, which generally adhered to the human figure. After the Cubist revolution, whose emphasis on aesthetic means deflated the values of representational ends, sculpture no longer concentrated so exclusively on portraits and lofty allegories, but was free to explore new realms of still life, fantasy, and even landscape.

No less modest in subject and no less compelling in result is the *Glass of Absinthe,* also of 1914. Again, the consistently deceptive illusion of traditional sculpture is disrupted by the intrusion of a very real object between a most unreal Rococo Cubist glass and a more plausible, but nevertheless unreal, lump of sugar. Like the bits of reality in contemporary collages, an actual silver strainer in this painted bronze sculpture confounds the relationship of the true and the false, of a real object and a work of art. At one stage in its extraordinary career, this strainer may have been used to strain real drinks through real sugar into real glasses. Now, however, this once prosaic object must function between a lump of sugar that is not sweet and a gaily speckled glass that can hold no liquid, for one of its sides is open to suggest both the transparency of glass and the Cubist fusion of solid and void.

The constructive techniques of collage were soon to be put to use by the other sculptors then working in Paris. Archipenko's *Médrano* of 1914 constructs a puppetlike toe dancer from wood, metal, and glass brilliantly painted to evoke the milieu of the Cirque Médrano, from which the work derives its title. But closer to Picasso's work are the constructions of Henri Laurens (1885–1954), a born Parisian. In a still life of 1918 (1916?), he constructs and paints a Synthetic Cubist wine glass and bottle of Beaune against an unstable cluster of tilted, floating planes that create, in a real world governed by gravity, something of the weightlessness and impalpability of Laurens' own collages. His drawn and pasted *Bottle of Beaune* of 1917, for example, is a fine, if somewhat lean, counterpart in two dimensions of the construction in three, which, however, even surpasses the collage in its complex interplay between solid and void, transparent and opaque, especially in its multiple intersections of planes and its disembodiment of the circles defining the extremities of the cylindrical bottle. And a still more imaginative dislocation of forms occurs in Laurens' constructed and painted *Head* of 1918 in which eyes, nose, hair-

201

200

202

203

204

205

206

line, and neck are scrambled with something of the bizarre results that inform many of Picasso's geometricized but loose-jointed countenances.

 At the same time, the Parisian Cubist sculptors worked in such conventional media as stone and bronze. Notable among these was Jacques Lipchitz (1891–1973), who came to Paris from his native Lithuania in 1909. Younger than Archipenko, Duchamp-Villon, and Laurens, Lipchitz may have begun his career as a Cubist sculptor a trifle later than his Parisian contemporaries, yet his work maintained a higher quality over a longer period of time. In the 1914 *Sailor with Guitar,* he parallels 207
Duchamp-Villon's *Seated Woman* of the same year in the bold, if more 193
angular, description of separate bodily components and in the loose articulation of such joints as the knee and hipbone. By the following year, however, Lipchitz discarded not only the relatively literal descriptiveness of such details as the sailor's cap and blouse and the adherence to approximately normal human proportions, but also the somewhat mannered decorative grace of the patterned arcs and angles that define this music-making figure. The 1915 *Bather* is an extraordinary jump in the direction 208
of formal freedom to compose a metaphor of the human body rather than a facsimile. Avoiding the problems of Analytic Cubism, Lipchitz plunges immediately into the Synthetic Cubist vocabulary of broad, flat planes, whose angular austerity recalls Picasso's *Harlequin* of the same year. The 57
surprisingly stark and elongated vertical of the torso, with its tiny circular breast, is countered by the geometric intricacy of the arms, head, and legs, which now avoids the more facile repetition of motifs characteristic of Lipchitz' earlier work.

 Something of the boldness involved in this extraordinary re-creation of the female nude may be measured by comparing it with Archipenko's treatment of the same theme, *Woman Combing Her Hair,* also of 209
1915. Here, despite the startling intrusion of a void where we would expect a solid core, Archipenko clings to a more traditional, if clearly more sensuous and elegant, interpretation of the female sculptured nude that already suggests a relaxation from the more audacious anatomies of his early work. Lipchitz, however, was to move on to still more inventive figure studies. The *Standing Personage* of 1916, for instance, is more 210
astonishing than the 1915 *Bather* in the remoteness of its human metaphor. Now even the sex of the figure has been obscured by the severe, architectonic vocabulary of sharp-edged verticals, some of which terminate in truncated curves in order to suggest the forms of head and torso. So compelling is this work in its spare, hieratic dignity that it fully rivals the majestic geometries of Léger's pristine compositions of the mid-1920s. 86

 Paralleling the evolution of Cubist painting, Cubist sculpture toward 1920 seemed to consolidate its earlier gains into a more secure, if less inventive, style. Lipchitz' bronze of 1918, the *Seated Guitar Player,* 211
is a case in point, for it moves from the imaginative daring of the earlier figure studies to a more regularized Cubist vocabulary of predictable patterns and a more normative system of human proportions. As in Gris's 1919 *Harlequin,* the diagonal axes are here clearly calculated in a vertical 76
and horizontal grid, just as the sequence of concave and convex seems to

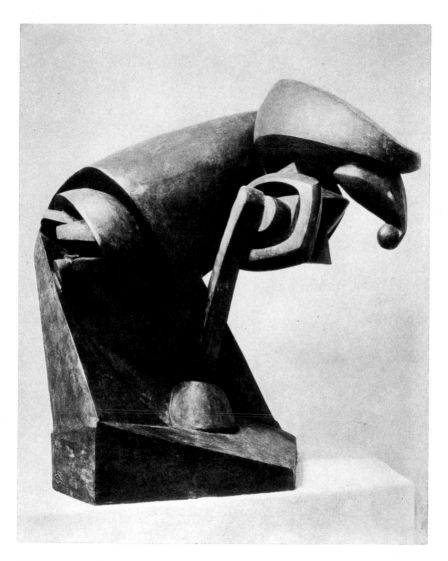

194. Raymond Duchamp-Villon. *The Horse*. 1914

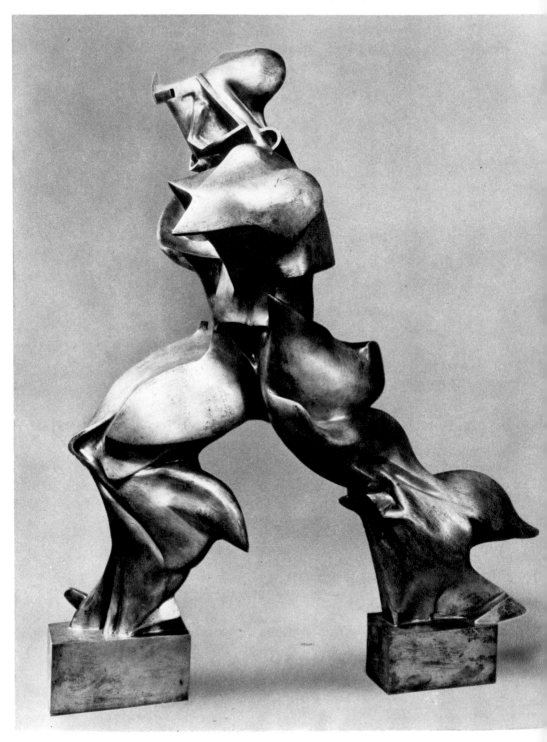

196. Umberto Boccioni.
*Abstract Voids
and Solids of a Head*. 1912

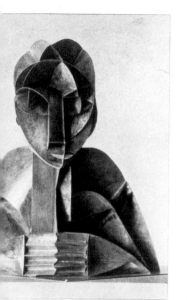

197. Naum Gabo. *Head*. 1916

198. Antoine Pevsner. *Torso*. 1924–26

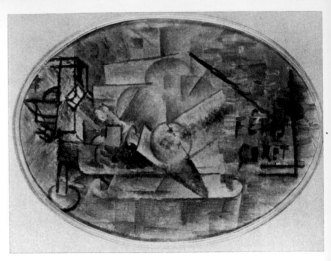

199. Pablo Picasso.
Guitar. 1912

200. Pablo Picasso. *The Sausage*. 1912

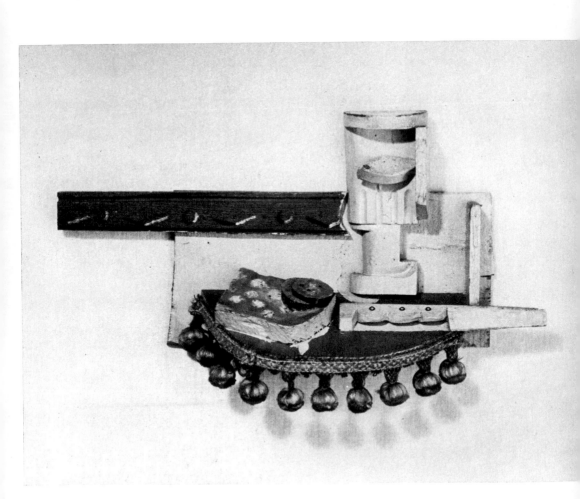

201. Pablo Picasso. *Still Life*. 1914

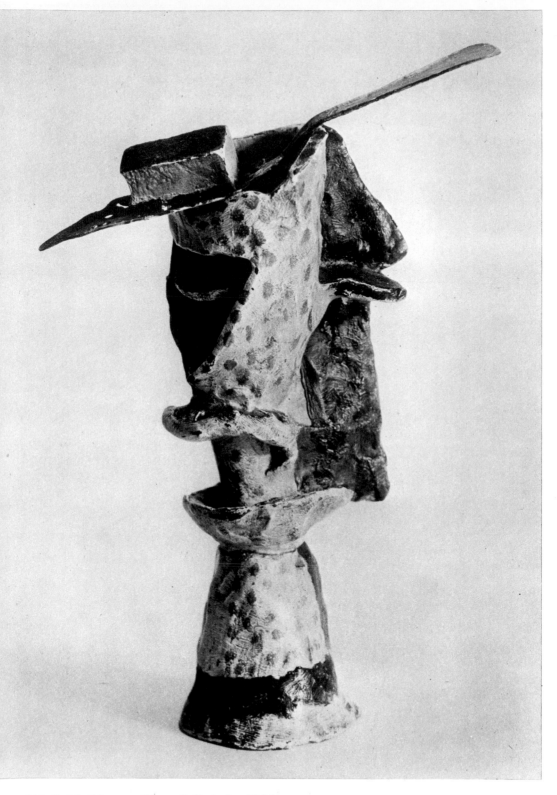

202. Pablo Picasso. *Glass of Absinthe*. 1914

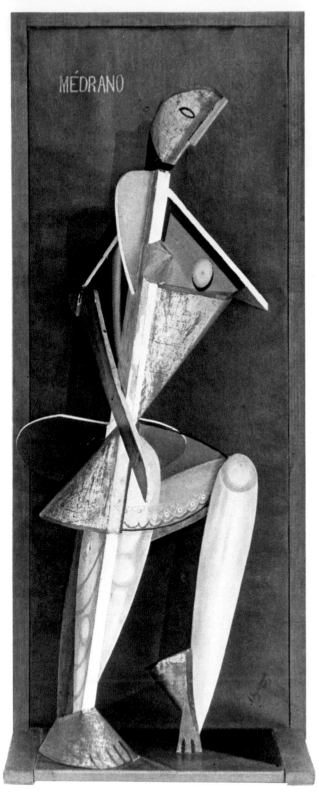

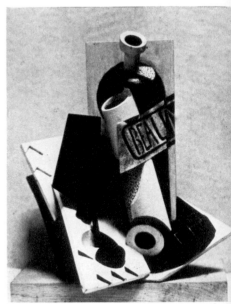

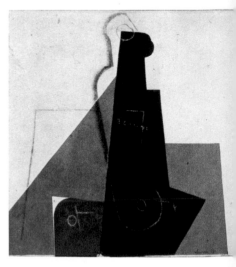

203. Alexander Archipenko.
Médrano. 1914

204. Henri Laurens.
Still Life. 1918 (1916?)

205. Henri Laurens.
Bottle of Beaune. 1917

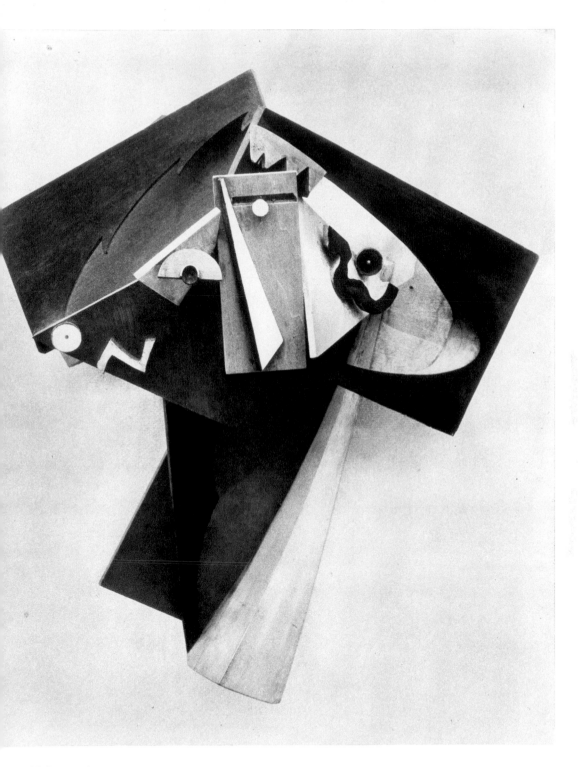

206. Henri Laurens. *Head*. 1918

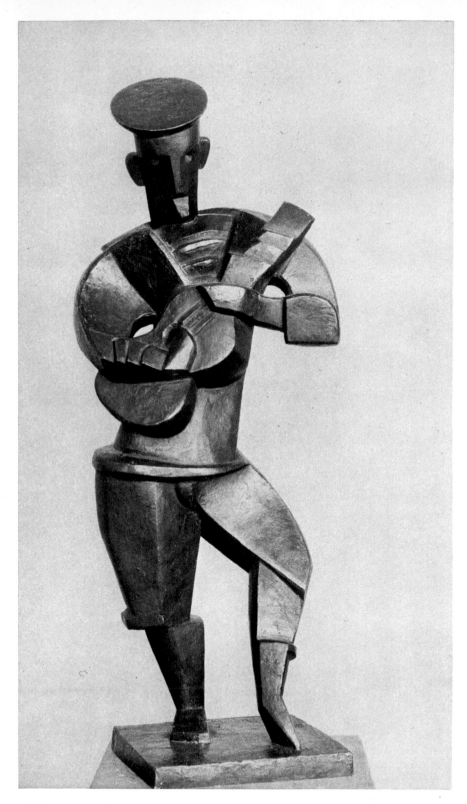

207. Jacques Lipchitz. *Sailor with Guitar*. 1914

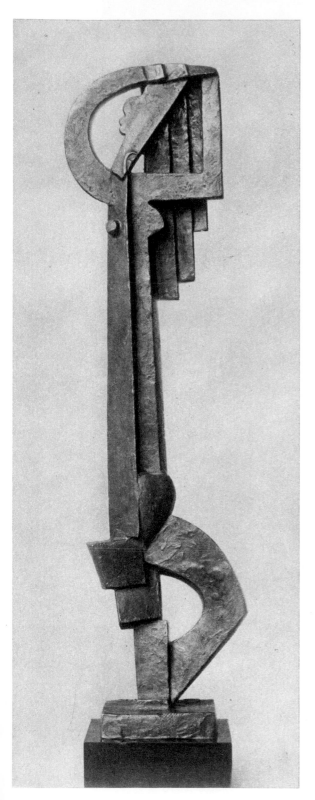

208. Jacques Lipchitz. *Bather*. 1915

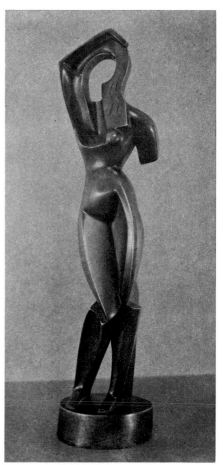

209. Alexander Archipenko.
Woman Combing Her Hair. 1915.

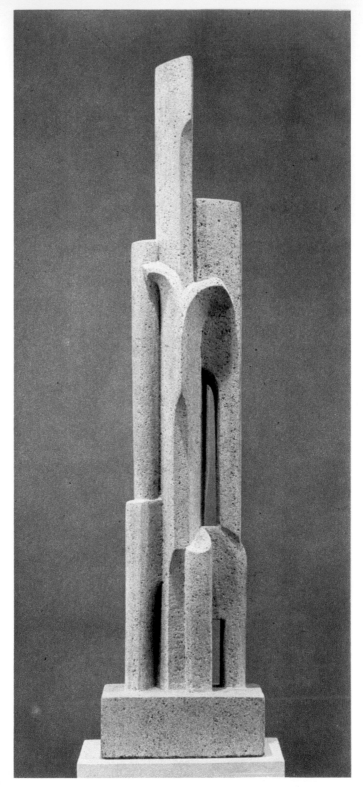

210. Jacques Lipchitz. *Standing Personage*. 1916

211. Jacques Lipchitz. *Seated Guitar Player*. 1918

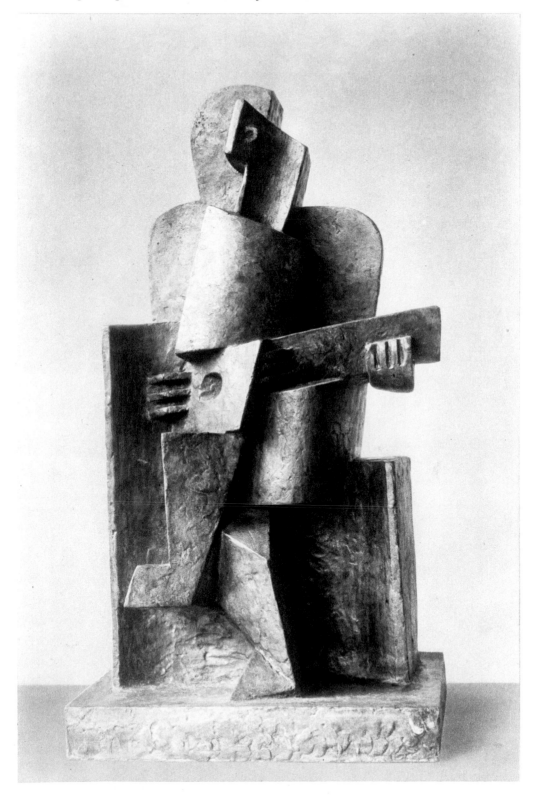

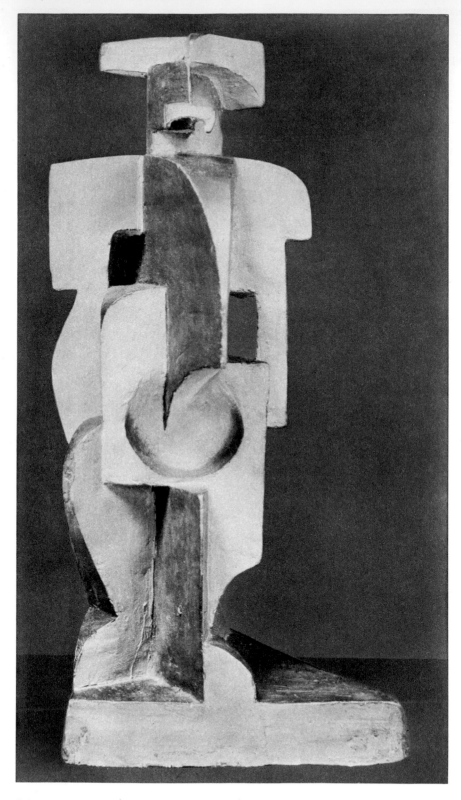

212. Juan Gris. *Torero (Harlequin)*. 1917

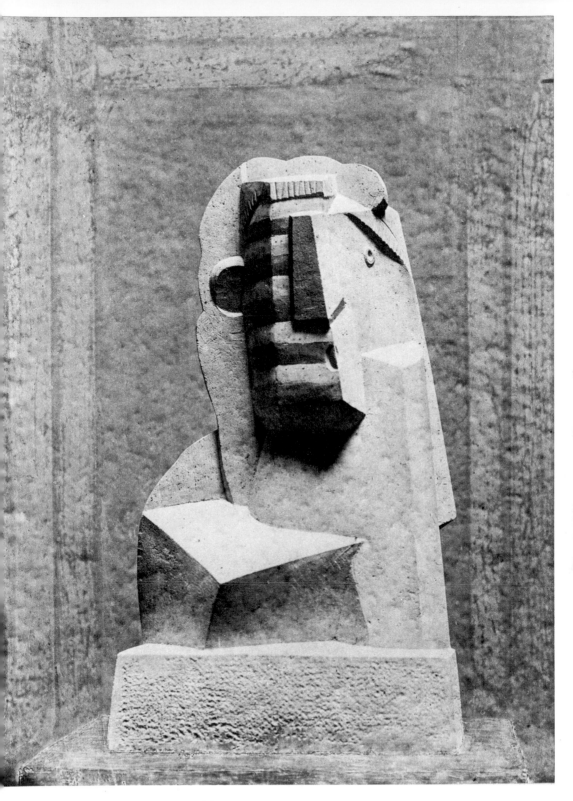

213. Henri Laurens. *Boxer*. 1920

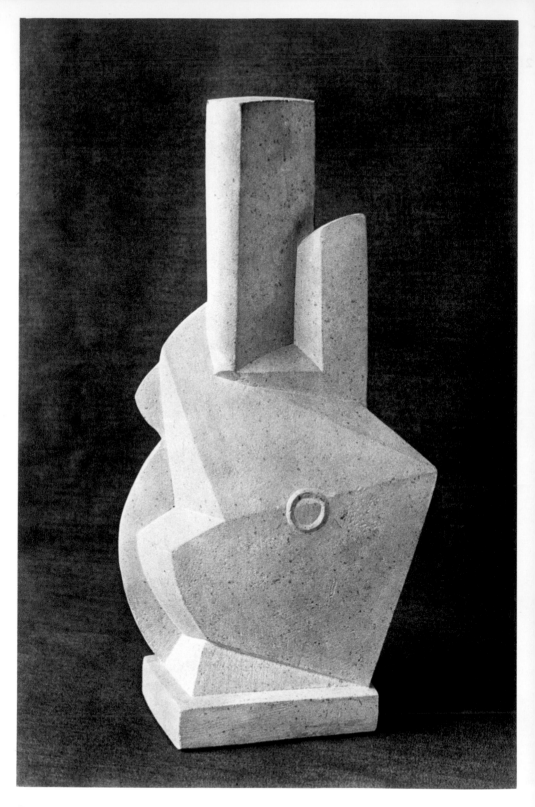

214. Henri Laurens. *Guitar*. 1920

215. Jacques Lipchitz. *Pierrot with Clarinet*. 1926

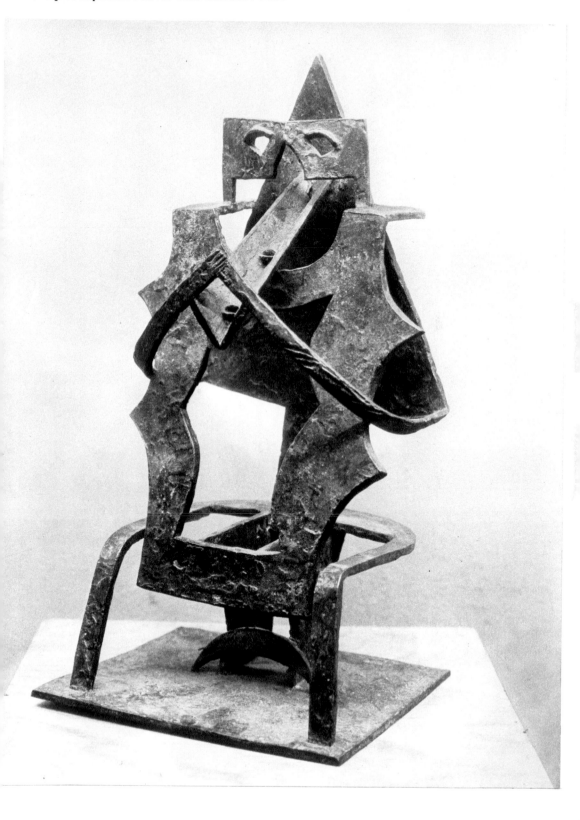

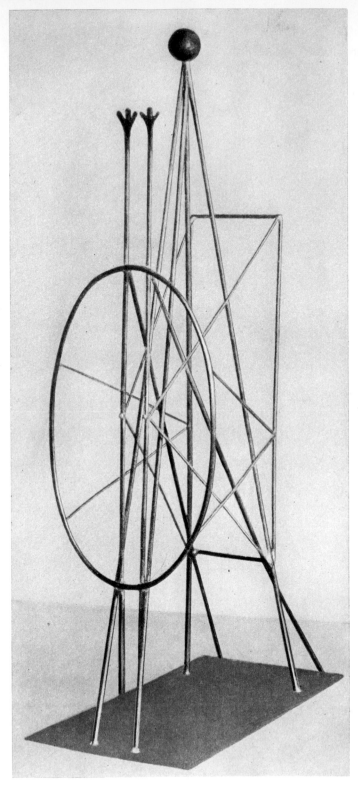

216. Pablo Picasso. *Design for a Construction in Iron Wire.* 1928

follow a predetermined order. Recalling Gris's pictorial puns, Lipchitz wittily confounds the four parallels of the hand at the right with the three strings of the guitar in the center and the three strings (or fingers) at the left.

212 To mention Gris here is to be reminded of his unique venture into sculpture, the painted plaster *Torero* of 1917 (often identified as a Harlequin, despite what would clearly seem to be a torero's hat), a work whose very existence is doubtless the result of Gris's close friendship with Lipchitz. If the sculptor Lipchitz' 1918 *Seated Guitar Player* is almost pictorial in its rather flattened structure and implicit singleness of vantage point, the painter Gris's 1917 *Torero* is paradoxically far more sculptural in its insistence that the spectator move around it to experience its complex structure from multiple vantage points. A three-dimensional translation of the lucid order and generally restricted palette (here browns, blacks, and blues) of Gris's own painting, the stately *Torero* seems to rotate around a rigid vertical core in a sequential interlocking of planar fragments whose spatial intricacy is as masterly as that in any of Lipchitz' own sculpture in the round.

The tendency around 1920 to discipline Cubism into a more lucid and sober geometry was echoed as well in the work of Laurens, who turned from his extraordinary constructions to a somewhat less challenging viewpoint that also involved a return to more traditional sculptural materials.
213 In the case of the stone *Boxer* of 1920, something of the grotesque wit of
206 the earlier constructed *Head* is maintained, especially in the caricatural coarseness of the blocky head, broad nose, and tiny eye; but even here the forms seem to settle, as in Lipchitz' 1918 *Seated Guitar Player,* into
214 more obviously measured patterns. At times, as in the stone *Guitar,* also of 1920, this geometric clarity achieves a spare and perfect elegance. Here the somewhat chilly, neutral surfaces are countered by such subtle, if austere, geometric variations as the angle and point at which the diagonal of the guitar's body intersects the sound hole, or the unpredictable contours at the left of the guitar. In general, however, most Cubist sculpture after 1920 showed either a slackening in intensity and quality or a structural rejuvenation that radically altered its original appearance.

Happily, a profound change occurred in the work of Lipchitz himself, thereby saving him from the somewhat sleek and mannered monotony that overcame much of Archipenko's and Laurens' later work. In a bronze
215 like the 1926 *Pierrot with Clarinet,* Lipchitz inaugurates a new sculptural adventure in which he severs completely his earlier dependence upon the dense solidity of stone and bronze masses. Now the eerie little figure—
62 a rather close quotation from Picasso's 1921 *Three Musicians*—becomes an open metal construction of lines and planes whose hollow core is as free from traditional conceptions of mass as is the weightless bronze costume that partially encloses this phantom shape. If this new kind of interplay between mass and space looks different from the Cubist sculpture of the previous decade, its ambiguities of void and substance, line and plane nevertheless pertain as fully to the original structural innovations of Cubism as do the later paintings of Picasso and Braque. Even after the

many transformations his art underwent in later years, Lipchitz could say, with good reason, "I am always a Cubist."

The same combination of creative innovation and a fundamentally Cubist aesthetic is exemplified in Picasso's own sculpture of the 1920s. In the *Design for a Construction in Iron Wire* of 1928, he moves into the realm of open, linear sculpture that had been suggested not only by Lipchitz, but before him (and more emphatically) by the Russian Constructivists, who, in turn, were indebted to the earlier innovations of Cubism. But here again, in this strange metal cage so foreign to his earlier work, Picasso creates what is essentially a Cubist interplay between the outlined, interpenetrating voids and the suggested, but intangible, solids of the bizarre pinpoint of a head, the still more curious arms which sprout three-fingered hands, or the skeletal torso, oval in front and rectangular in back. Cubist, too, is the tension between this austerely geometric vocabulary and the human anatomy that it describes.

216

In the following decades, sculpture, like painting, moved in a direction that explored both a vocabulary of more fluid, antigeometric shapes as well as themes of more explicitly biological fantasy. Yet, just as the discoveries of Cubism underlay the pictorial structure of masters like Klee, Chagall, and Miró, so, too, can much of the world of Gonzalez, Giacometti, Moore, Calder, and Smith trace its ultimate sources to the innovations of Cubism and Cubist sculpture. In three dimensions, as in two, Picasso's and Braque's revolution articulated the fundamental language from which most of the major art of the first half of our century was to evolve.

13 The Later Work of Picasso and Braque, 1925–1939

If Picasso and Braque began as very different artists, their common invention of Cubism temporarily involved them in an artistic union whose extraordinary closeness tended to suppress the many contradictory aspects of their personalities. By the 1920s, however, those differences of temperament and interest which had been concealed in the years around 1910 again became pronounced, and their careers diverged almost as sharply as they had in their pre-Cubist years.

217 A startling example is a Picasso still life of 1925, the *Ram's Head*, a gruesome display of table objects which would be unimaginable on the pleasurably ordered table tops of a French painter but which stands fully in the macabre still-life tradition of Picasso's Spanish pictorial ancestors.

218 Like Goya's late *Still Life with a Slaughtered Sheep*, Picasso's *Ram's Head* controverts both the hedonistic and the rational tenor of the French still-life tradition. Most prominent in this grisly array are the blank, dead eyes of the severed ram's head, which have the disquieting intensity familiar in Picasso. The ram's head, however, is no more repellent than the entourage of prickly and slimy sea life, which includes two scallops, a squid with two staring eyes, a bristling scorpion fish whose savage mouth seems to gasp for breath, and an equally untouchable sea urchin.

To what extent can such a painting still be considered Cubist? As in the Goya, the subject is so repugnant, its emotional and physical presence so immediate (here, even in tactile terms), that Picasso appears to have abandoned completely the measured and cerebral world of earlier Cubism in favor of something flavored with the morbidity and irrationality

of Surrealism, whose first manifesto had been proclaimed in the previous year. Yet, for all its insistent ugliness, such a work bears the indelible stamp of Cubism. In structure alone, the flattened space, the elisions of contour, the complex planar intersections of the tablecloth and the still-life objects all depend on Cubist innovations; and even the metaphysical confounding of identities so prominent in collage is used here to relate the fanlike shape of the scallops to the tail and fin of the scorpion fish or, still more imaginatively, to effect a biological and pictorial transition between the ram's head and the submarine creatures by emphasizing the snail-like character of the ram's horns and tough curls of hair.

The persistence of the Cubist aesthetic may be seen throughout Picasso's later work, though it is often combined with a thematic complexity that seems foreign to the original character of Cubism. A case in point is a magnificent pair of pictorial meditations on the creative process of the artist. In the earlier of the two, the *Studio* of 1927–28, Picasso XXXVIII again asserts his Spanish heritage by alluding, as he was later to do more explicitly, to Velázquez' *Las Meninas (The Maids of Honor)*. Like the 219 seventeenth-century painting, Picasso's may be interpreted as an allegory of the relationship between the artist and reality. In both pictures, the painter stands at the left before his easel, his paintbrush delicately poised in his hand. To the right are the realities that he must translate into art—in the Velázquez, the mirror image of the King and Queen, whose portraits he is painting, as well as the Infanta and her attendants; in the Picasso, a table with a bowl of green fruit and a white sculptured head. And both works include framed images that evoke varying degrees of reality and illusion—pictures, mirrors, doors, windows.

If Velázquez' painting contemplates the transformation of nature into art through the realist aesthetic of the Spanish Baroque, Picasso interprets his theme through the aesthetic of Cubism. The image of the artist himself is a complex Cubist pun in which human anatomy is confounded not only with a spare, abstract geometry but with the actual geometry of the rectilinear supports on the back of the painter's canvas and easel (which closely resemble the Velázquez) as well as with the thumb hole of the painter's palette. The intense and mysterious communion between the artist and his subject is underlined by the brilliant and imaginative color that Picasso had begun to use in such early Synthetic Cubist works as the *Violin* XII of 1913. Amid the vivid yellows, reds, and blacks so typical of Picasso's Spanish palette, a dazzling white is used to isolate the artist's head, the vertical strip of virgin canvas, and the bust on the table, which is illuminated by a magical white radiance analogous to the gray halo that surrounds the artist's own head. Furthermore, the inventive potentialities of Cubism permit Picasso to describe the artist's superior visual perception by the addition of a third eye, which becomes, with similar physiognomical fantasy, a mouth in the sculptured head at the right, thereby producing, with familiar Cubist paradox, a work of art anatomically more real than the real artist who copies it. And, as a comparable ambiguity in a painting whose imaginative richness is inexhaustible, Picasso encloses the entire painting within a narrow white margin which, like the use of *trompe-*

l'oeil or collage, further complicates the interplay of art and reality by suggesting that this is a picture within a picture.

220 In the painting that follows, the *Painter and Model* of 1928, Picasso demonstrates the Cubist aesthetic with even greater explicitness as well as with a certain humor that is absent from the lean and magical intensity of the preceding work. By way of explaining the Cubist lesson that pictorial styles are relative and not absolute, Picasso now shows the reality of the artist and his model as two quixotically unreal creatures, whereas the unreality of the work of art is shown as a prosaic profile that becomes, in this topsy-turvy context, far more lifelike than its living creator. As in the earlier *Studio,* this Cubist juggling of artistic and natural vision is continued in the strange environment, which again includes a mirror and offers such puns as the confusion of wall molding and picture frame—elements that are further confounded with the body of the model.

If such paintings exhibit a continued allegiance to Cubism, not only in the ambiguities of their pictorial language but in their very choice of subject, it is nevertheless apparent that their character is different from that of Cubist work of the previous decade. As already suggested by the 62 *Three Musicians* of 1921, the work of the 1920s usually implies a far wider range of vision than in earlier Cubism, which tended to concentrate on a few objects in a restricted space. This new spatial breadth, which is found as well in Gris's and Léger's later work, frequently encompasses many more objects than before; indeed, such complex groupings as two or three figures with a still life were almost unknown in the work of Picasso and Braque around 1910. Often, too, one senses in the work of the 1920s that the spatial environment is pre-existent to the forms within it. Now the still-life objects or figures have a more discrete quality and are far more clearly distinguished from the background than they had been in earlier Cubism. Furthermore, the vocabulary has now become more elaborate, especially in the increasing intrusion of more curvilinear shapes, and the structural relations far more intricate in their rich integration of multiple and diverse compositional elements. By comparison with earlier Cubist work, even the angular austerity and hairbreadth exactness of the *Studio* provide a richer range of form in the variety of large and small shapes, rational and irrational geometries, as well as a more emphatic (and ultimately, more traditional) sense of major and minor compositional accents.

Although Braque's later work never ventured into the new emotive realms that Picasso was to explore, it nevertheless demonstrated, within the confines of a Cubist iconography, a comparably new inflection in the 221 use of a Cubist vocabulary. A painting of 1929, *Still Life: Le Jour,* exemplifies the new spatial amplitude of the 1920s, in which horizontality gradually replaces the more characteristic verticality of earlier Cubism. Now the still-life objects seem to have more space to breathe in, as it were, existing comfortably against the broad, decorative extension of wallpaper and dado; and they emerge more clearly as protagonists set off by the minor embellishments of the background. Moreover, the variety of shapes, with their many sinuous, unpredictable contours, is increased considerably, whereas the fragmentation of individual forms is decreased. The fractur-

ing of the guitar and the pitcher, for example, provides simple divisions of lighted and shadowed areas, and many objects, such as the pipe, the apples, and the knife, preserve their integrity completely. By comparison with a Braque still life of 1910, the *Table,* which treats a similar theme (including even the foreground knife that overlaps the table drawer), the 1929 *Still Life* resembles a sumptuous orchestration of a work written originally for a string quartet. In place of the creative intensity and purified statement of the 1910 painting, it offers a greater relaxation and facility, and a more obvious, hedonistic profusion of alluring shapes, colors, and textures. 222

The growing curvilinearity of the 1920s became even more apparent in the early 1930s, as may be indicated by Picasso's *Still Life on a Table* of 1931 and Braque's *Pink Tablecloth* of 1933. Almost totally eliminating straight lines, both these still lifes present serpents' nests of form that writhe and twist with an uncanny vitality. Yet, even in the case of such an occasional convergence of style and subject, Braque and Picasso remain far more unlike than in the years around 1910. Braque's forms are ultimately contained within the rational, almost symmetrical framework of the red background and pink tablecloth, and even the ostensibly impulsive contours that surge across the sheet of music in the foreground are harmoniously tamed to conform to the comparable fluencies of shape that describe the decorative patterns of the tablecloth or the strange, flaccid form at the left, which suggests both a carafe and a mandolin. By contrast with these well-mannered undulations, Picasso's still life has an explosive agitation that far transcends the proprieties of a domestic interior. The colors, next to the delicate variations of pink, red, and purple in the Braque, are intense and powerful in their sudden juxtapositions of complementary reds and greens, yellows and purples, blues and oranges, and the thick black contours have an aggressive vigor that is remote from the delicate linear boundaries of Braque's forms. XXXIX, XL

For Braque such a proliferation of curves meant only a sensuous enrichment of his vocabulary; for Picasso these shapes conveyed a mysterious biological vitality that resembles a virile reinterpretation of the Art Nouveau. With an almost convulsive activity, these organic forms seem to pulsate with life, as in the swollen, intertwining table legs or the throbbing contours of the cobra-headed pitcher. Moreover, the themes of fertilization and birth, which become explicit in Picasso's cardinal masterpiece of the early 1930s, the *Girl Before a Mirror* of 1932, are already evoked here, whether in the black seedlike dots of the fruit, the protective eggshell contours that enclose the two green apples in the center, or the general preponderance of sexual symbolism. 227

If the dense and multileveled imagery of such a still life could not exist without the Cubist exploration of multiple and interrelated identities, neither could Picasso's contemporary investigations of the complex aspects of human personality. Like Chagall and Klee, Picasso realized the psychological potentialities implicit in the Cubist dissection of the human face, and by the late 1920s he began to focus on such problems with a prodigious inventiveness. The *Seated Woman* of 1927 is a creature of the 223

blackest magic, related to such sinister, primitive figures as the 1907 *Dancer* or, more generally speaking, to the monstrous witches who haunt the world of Goya or the comparably frightening heads in many Catalan Romanesque frescoes. Like the tautly knit hands and fingers, the head is a tense composite of flat intersecting planes, whose ritualistic power is in part achieved by the white, man-in-the-moon profile against an irregular black shadow and, even more emphatically, by the two masklike eyes— one tiny and menacing in its ambiguous position as both a frontal and profile eye, the other, at the right, less malevolent but equally mysterious in the way it animates the bladelike shape that seems to be borrowed, together with the sound-hole eye, from the 1924 *Still Life with Guitar*. Furthermore, the iconic intensity of this figure is underlined, as in the *Studio* of 1927–28, by the use of an enframing margin, which here isolated the image even more than the customary frame, and thereby lends it a still greater magic and remoteness from everyday experience.

The same Cubist vocabulary that could create such monsters and oracles could also express more subtle areas of psychology, particularly those associated with the twentieth century's keen awareness of the ambivalent and often contradictory nature of the human mind. In the *Red Armchair* of 1931, Picasso, like Klee in his 1929 *Clown,* combines frontal and profile views to create a strange and elusive psychological aura. The frontal view appears rigid and strained, in keeping with the austere rectilinearity of the belt, the molding, the stripes of the chair, and the vertical of the nose; whereas the profile view, which again recalls a crescent moon, seems concealed and distant and, in keeping with the organic shapes of the chair contours and the enclosed breasts and arms, far more relaxed and voluptuous.

A comparable polarity between conscious and subconscious forces is poetically realized in the *Dream* of 1932. Here the Cubist imposition of another lunar profile upon what is almost a frontal view of the head conjures up a domesticated daydream rather than the primitive terror of the 1927 *Seated Woman*. A jeweled and elegantly dressed woman, not unlike Ingres' contemplative female sitters, seems to have fallen into a gentle and languorous sleep within the comfortable confines of her armchair. Magically, the bisecting horizontal of the molding releases her from the restricting demands of her civilized environment and introduces the more sensuous freedom of the dream world. So evocative is Picasso's imagery that this Cubist simultaneity almost suggests the mysterious transition from a moment of drowsiness above to the more profound slumber of the fully supine, nocturnal profile below.

Following Picasso's cue, Braque in the 1930s examined the Cubist double image of the human form as well as themes that occasionally involved more complex human activity. As in Picasso's *Painter and Model* of 1928, Braque's *Painter and Model* of 1939 is divided into three areas— the seated, bearded painter at the right, the nude model at the left, and, in the center, the easel and canvas on which perceived reality is transformed into art. The model, too, depends on Picasso in its imposition of a profile upon a frontal view, although the double silhouette of the artist recalls

9

XVII

XXXVIII

224
XXXVI

225

220
226

319

more closely the bisection of still-life objects into contrasting shadowed and lighted areas so familiar in Braque's work of the 1920s. Characteristically, however, neither the theme of this painting nor its treatment of the human form conveys the magic and irrationality of comparable images by Picasso. For Braque, the human double image functions primarily as a passage of pictorial drama in which a black silhouette acts as a visual foil to the patterned complexities of its environment rather than as a poetic equivalent of some secretive, internal aspect of the human mind; and even the potential mystery of the subject tends to be subordinated by the sheer opulence of this tapestrylike canvas.

In a consideration of Braque's and Picasso's work of the 1930s, the problem of its very relevance to a discussion of Cubism must be raised, and with it, the problem of the proper terminus of the Cubist viewpoint. In Picasso, it is apparent that the experience of Cubism has cast its shadow across all his later works and that, like Lipchitz, he could say, "I am always a Cubist." Yet it is equally clear that the major issues involved in these later works have less and less to do with the intellectualized examination of pictorial means and ends that was essential to the invention of Cubism and collage. Already in the 1920s, themes of violence, mystery, and magic disrupt the measured, rational Cubist world of the previous decade; and by the 1930s, the many new psychological, political, and even moral factors introduced in Picasso's work far transcend the original boundaries of Cubism.

To be sure, the two major masterpieces of the 1930s could not have been painted without the foundations of Cubism. In the case of the *Girl Before a Mirror* of 1932, the miraculous evocation of the dualities of 227 human existence—whether the opposition of ego and id, individual and race, outer and inner self, womb and tomb—depends on the capacity of a Cubist vocabulary to express multiple and even contradictory experiences, but now within new psychological terms. Similarly, in *Guernica* 228 of 1937, the Cubist language of fragmentation is directed to new expressive ends—the grim documentation of the bombing of a Spanish town, whose holocaust of splintered and shattered human lives and moral values wrenches Cubism from the sensuous and intellectual confines of the artist's world to the agonizing actualities of Europe on the eve of the Second World War. Yet, if these two masterpieces remain fundamentally Cubist in their formal means, their new subject matter is so demanding that the continued relevance of the Cubist heritage becomes a peripheral issue.

With Braque, the question is much simpler in that his art continues to be faithful to the relatively restricted emotional and iconographic range of early Cubism that could no longer contain Picasso. Yet, formally speaking, Braque, like Picasso, takes the conventions of Cubism for granted in his later work, and does not attempt any profound reorientation of pictorial structure. Given the premises of Cubism's early decades, the later works can be understood readily, for they offer, primarily, luxurious variations on earlier themes.

In some ways, the later years of Cubism may be likened to the aftermath of Impressionism. If it is clear that the most pure and intense

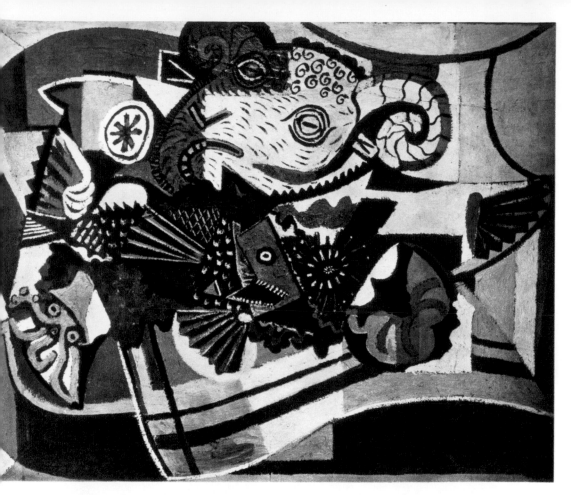

217. Pablo Picasso. *Ram's Head*. 1925

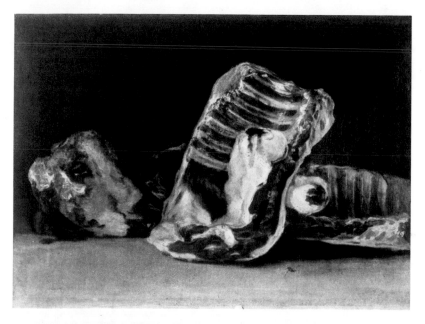

218. Francisco Goya. *Still Life with a Slaughtered Sheep*. About 1816

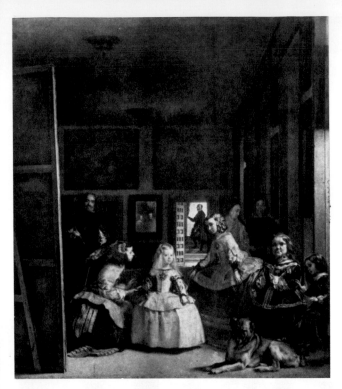

219. Diego Velázquez. *Las Meninas
(The Maids of Honor).* 1656

220. Pablo Picasso.
Painter and Model. 1928.

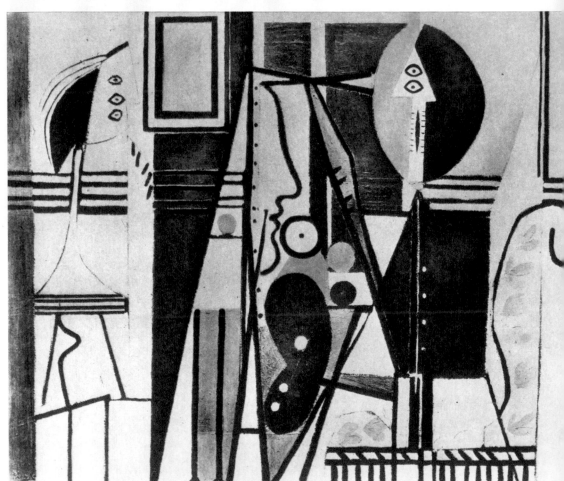

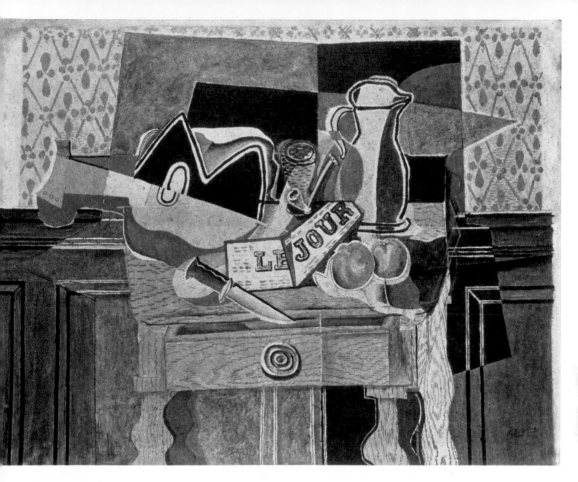

221. Georges Braque. *Still Life: Le Jour*. 1929

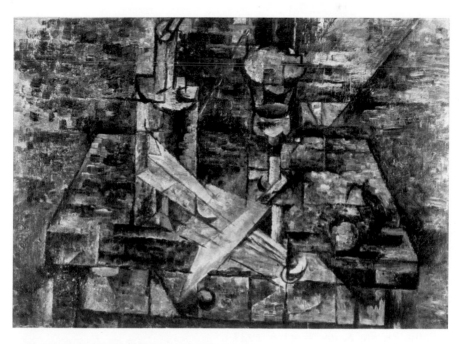

222. Georges Braque. *The Table*. 1910

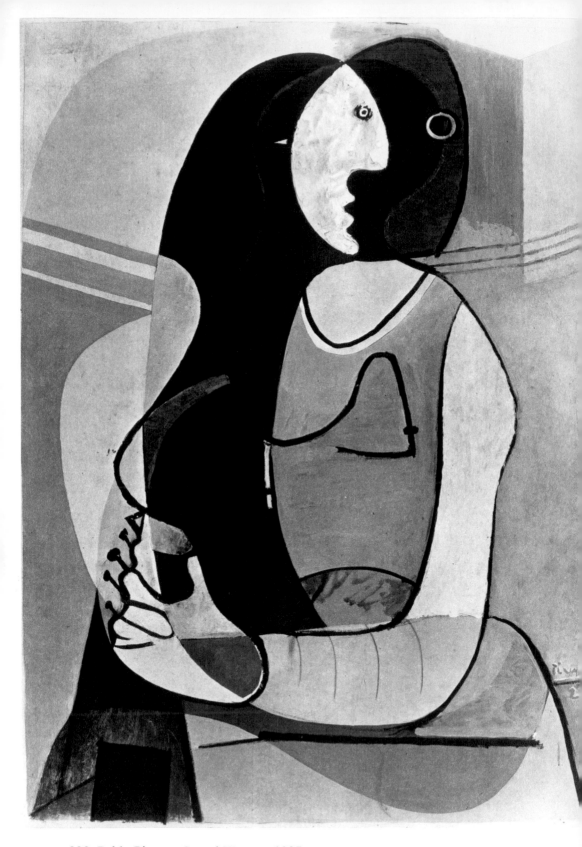

223. Pablo Picasso. *Seated Woman*. 1927

224. Pablo Picasso.
The Red Armchair. 1931.

225. Pablo Picasso. *The Dream*. 1932

226. Georges Braque. *Painter and Model*. 1939

227. Pablo Picasso. *Girl Before a Mirror*. 1932

228. Pablo Picasso. *Guernica*. 1937

creative moment of Impressionism occurred around 1870, as that of Cubism occurred around 1910, who could establish a meaningful death date for either viewpoint? In the 1890s, a master like Pissarro remained within the Impressionist orbit defined in the 1870s, whereas the late style of Monet and Renoir introduced many new elements that altered the character of their art without, however, obscuring the fact that the early experience of Impressionism was always to remain, even after 1910, an integral part of their work. Similarly, the broader historical consequences of Impressionism are no more easily delimited than those of Cubism. Van Gogh, Cézanne, Seurat, and Gauguin ended by largely contradicting the premises of Impressionism, yet they had first to absorb its discipline; and, in our century, Fauvism and Futurism, not to mention Cubism itself, pay homage in various ways to the premises of Impressionism.

In retrospect, it is apparent that the relevance of Cubism to the artistic experience of the twentieth century gradually diminished in the decades following 1920. Although Cubism continued to determine the pictorial conventions that dominated most major art of the 1930s and 1940s, the vitality of such new art usually depended on the very degree to which the original qualities of Cubism had been adulterated. Indeed, the later work of the most faithful masters of Cubism—Braque, Gris, Léger, Villon—often shows a weakening in intensity, as if the artists had slowly fallen out of phase with the rapid tempo of modern historical change.

By 1950, in fact, the structural conventions of Cubism that had dominated Western art since 1910 had finally been undermined by the vigorous new style whose most generally accepted label, "Abstract Expressionism," is almost as inaccurate as "Cubism" itself. Be that as it may, the innovators of this viewpoint rebelled against the Cubist tradition of the previous generation in favor of such opposing pictorial ancestors as the vaporous panoramas of the late Turner and Monet or the molten calligraphy of the early Kandinsky. Before the eruptive paint skeins of Mathieu or Pollock, or the vast and awesomely simple paint expanses of Rothko, Still, and Newman, the intricate, intellectualized world of Cubism may seem as alien and irrelevant as the work of the late Monet must have appeared to the Cubists. Yet, if the generative power of Cubism has waned, the authority of its major statements has not. The cardinal works of Picasso and Braque not only take their places beside the masterpieces of the Western pictorial tradition, but offer standards of twentieth-century achievement by which the art of today and tomorrow will be measured.

Chronology 1906–1925

	1906
Picasso	October 22: death of Cézanne at Aix-en-Provence summer: at Gosol fall: meets Matisse first studies for *Les Demoiselles d'Avignon*
Braque	spring: exhibits at Salon des Indépendants summer: first Fauve works October: goes to L'Estaque
Gris	arrives in Paris, moves into the *bateau-lavoir*

	1907
	Cézanne retrospective at the Salon d'Automne Kahnweiler opens gallery at 28 Rue Vignon
Picasso	spring: completes *Les Demoiselles d'Avignon* influence of Negro sculpture: *Dancer* contract with Kahnweiler meets Braque through Apollinaire
Braque	February: returns to Paris spring: exhibits at the Salon des Indépendants May: at La Ciotat September: at L'Estaque October: returns to Paris contract with Kahnweiler December: begins *Nude*

	1908
	banquet in honor of Rousseau in Picasso's studio Matisse speaks of "les petits cubes" apropos of Braque's *Houses at L'Estaque* Louis Vauxcelles refers to Braque's paintings as being reduced "à des cubes" (*Gil Blas*, November 14)
Picasso	August: at La Rue-des-Bois new attention to still life and landscape
Braque	summer: at L'Estaque October: rejected at the Salon d'Automne November: first one-man show at Kahnweiler Gallery
Gris	meets Kahnweiler

	1909
	Vauxcelles writes of "bizarreries cubiques" apropos of Braque's paintings at the Salon des Indépendants (*Gil Blas*, May 25)

Picasso	summer: at Horta de Ebro with Fernande Olivier fall: returns to Paris, moves to 11 Boulevard de Clichy exhibitions in Paris (Vollard) and Munich (Thannhauser Gallery) studies of Fernande Olivier
Braque	spring: two paintings at the Salon des Indépendants summer: at La Roche-Guyon and Carrières-St.-Denis close friendship with Picasso winter 1909–10: *Still Life with Violin and Pitcher*, includes *trompe-l'oeil* nail
Léger	meets Delaunay
Delaunay	Saint-Séverin series
Sculpture	Lipchitz arrives in Paris Picasso: *Woman's Head* (bronze)
New York	Weber returns to New York from Paris
Italy	Milan: first Futurist manifesto by Marinetti (published in Paris, *Le Figaro*, February 20)

	1910
	March 18–May 1: large representation of Cubists at the Salon des Indépendant XXVI, including Archipenko, Delaunay, Duchamp, Duchamp-Villon, Gleizes, Le Fauconnier, Léger, Lhote, Metzinger October 1–November 8: large representation of Cubists at the Salon d'Automne VIII, including Duchamp, Duchamp-Villon, Gleizes, La Fresnaye, Le Fauconnier, Léger, Metzinger, Picabia
Picasso	summer: at Cadaqués with Fernande Olivier and Derain portraits of Kahnweiler, Uhde, Vollard *Girl with Mandolin*
Braque	summer: at L'Estaque winter: exhibition in Munich (Neue Künstler-Vereinigung) *View of Sacré-Coeur*
Léger	contact with Picasso and Braque through Kahnweiler
Delaunay	Eiffel Tower series
Chagall	arrives in Paris

Italy	February 11: Milan, *Manifesto of the Futurist Painters*
Germany	first meeting of Marc and Macke

	1911
	April 21—June 13: prominent exhibition of Cubist group at the Salon des Indépendants XXVII, in Room 41, including Archipenko, Duchamp, Gleizes, Laurencin, La Fresnaye, Léger, Metzinger, Picabia, Reth; critical attacks June 13: first performance of Stravinsky's *Petrouchka* October 1—November 8: prominent exhibition of Cubist group at the Salon d'Automne IX, including Archipenko, Csaky, Duchamp, Duchamp-Villon, Gleizes, Le Fauconnier, Lhote, Metzinger, Picabia, Villon; further critical attacks
Picasso	summer: at Céret with Braque, Fernande, and Manolo; *The Accordionist* winter 1911–12: *Ma Jolie* exhibitions in New York (Photo-Secession Gallery) and Munich (Thannhauser Gallery)
Braque	spring: *The Portuguese* summer: at Céret with Picasso; *Man with a Guitar* October: returns to Paris
Gris	begins to paint in oils
Léger	spring: exhibits *Nudes in the Forest* at Salon des Indépendants
La Fresnaye	begins the *Artillery*
Duchamp	*Portrait of Chess Players*; first version of *Nude Descending a Staircase*
Boccioni	*States of Mind* October and November: trip to Paris with Carrà and Severini
Feininger	trip to Paris, meets Delaunay
Chagall	*I and the Village, Half-Past Three*
Sculpture	Laurens meets Braque Pevsner visits Paris
New York	Marin returns to New York from Europe Picasso exhibition (Photo-Secession Gallery)
Munich	December–January: first Blaue Reiter exhibition, including Delaunay

330

1912

February: Futurist exhibition in Paris at Galerie Bernheim-Jeune

March 20—May 16: another large exhibition of Cubists at the Salon des Indépendants XXVIII, including Archipenko, Delaunay, Duchamp, Gleizes, La Fresnaye, Laurencin, Le Fauconnier, Léger, Lhote, Mondrian, Reth, Diego Rivera

October 1–November 8: another large exhibition of Cubists at the Salon d'Automne X, including Archipenko, Csaky, Duchamp, Duchamp-Villon, Gleizes, La Fresnaye, Laurencin, Le Fauconnier, Léger, Marcoussis, Metzinger, Picabia, Rivera, Villon

October 10–October 30: exhibition of La Section d'Or at the Galerie La Boétie, including Archipenko, Duchamp-Villon, Gleizes, Gris, La Fresnaye, Laurencin, Léger, Lhote, Marcoussis, Metzinger, Picabia, Villon

Rouen: Cubist exhibition of Société Normande de Peinture Moderne

publication of Gleizes and Metzinger, *Du Cubisme,* and of the periodical, *La Section d'Or*

Picasso transformation from Analytic to Synthetic Cubism
May: first collage, *Still Life with Chair Caning*
May–October: at Avignon, Céret, and at Sorgues with Braque
October: moves to 242 Boulevard Raspail
December: new contract with Kahnweiler

Braque July: at Sorgues with Picasso
September: first *papier collé, The Fruit Dish*

Gris spring: exhibits at the Salon des Indépendants
October: exhibits with La Section d'Or
October: contract with Kahnweiler
Portrait of Picasso: The Watch (The Sherry Bottle)
exhibition at Kahnweiler Gallery

Léger *City of Paris* at the Salon des Indépendants

Delaunay

Duchamp second version of *Nude Descending a Staircase; The Bride*

La Fresnaye Meulan series
Marcoussis *Still Life with Chessboard*
Picabia *Procession in Seville*
Boccioni *Elasticity*
Carrà *Milan Galleria*
Severini *Dynamic Hieroglyphic of the Bal Tabarin*
Marin *Woolworth Building, No. 31*
Mondrian *Seascape* arrives in Paris
Sculpture Picasso's paper and metal constructions
Archipenko: *Walking Woman*
Boccioni: *Abstract Voids and Solids of a Head*
La Fresnaye: *Italian Woman*
Germany Munich: second Blaue Reiter exhibition (March), again including Delaunay
Klee, Marc, and Macke visit Delaunay in Paris
Feininger: *Bicycle Riders*
Cologne: Sonderbund exhibition includes Picasso and Braque
London winter: Picasso, Braque, and Lhote are exhibited at the Grafton Galleries
Barcelona spring: Cubist exhibition at Dalmau Gallery
Moscow Jack of Diamonds group exhibits Gleizes, Léger, Le Fauconnier, Picasso
Malevich's Cubist paintings

1913

Cubist groups at the Salon des Indépendants and the Salon d'Automne

Apollinaire publishes *Les Peintres cubistes: méditations esthetiques*

May 29: first performance of Stravinsky's *Sacre du printemps*

Picasso summer: at Céret, leaves in mid-August
fall: moves to 5 bis Rue Schoelcher
exhibitions in Munich, Prague, Berlin, Cologne

Braque summer: at Sorgues
The Clarinet

Léger contract with Kahnweiler begins Contrast of Forms series

Gris August–November: at Céret
November: returns to Paris
Smoker

La Fresnaye *Conquest of the Air* at the Salon d'Automne
Villon *Marching Soldiers*
Gleizes *Eugène Figuière*
Macke *Figures by the Blue Sea*
Marc *Animal Destinies; Deer in a Forest, II;* begins *Tirol*
Chagall *The Pregnant Woman; Paris Through the Window*
Sculpture Lipchitz meets Picasso
Gabo visits Paris, meets Archipenko
Pevsner returns to Paris
Duchamp-Villon: *The Lovers*
Archipenko begins *Boxing*
Boccioni: *Unique Forms of Continuity in Space*
Germany Picasso exhibitions in Munich, Cologne, Berlin
Berlin: first German "Salon d'Automne," including Archipenko, Delaunay, Gleizes, Léger, Marcoussis, Metzinger, Picabia
London beginnings of the Vorticist movement
New York February 17–March 15: Armory Show, including Braque, Picasso, Duchamp, Gleizes, Picabia; also exhibited in Boston and Chicago

1914

outbreak of World War I disperses Parisian Cubist group

James Joyce begins *Ulysses*

Picasso summer: at Avignon with Derain
exhibition at New York (Photo-Secession Gallery)
Rococo Cubism
beginning of realist drawings: *Plate with Wafers*

Braque spring: large exhibition at Dresden and Berlin
summer: at Sorgues, interrupted by war service
exhibition at New York (Photo-Secession Gallery)
Music

Léger enters army

Gris June–October: at Collioure
October: return to Paris concentrates on collages

Delaunay *Homage to Blériot*
Carrà *Manifesto for Intervention*
Mondrian returns to Holland; Pier and Ocean series
Chagall returns to Russia via Berlin, where he is given one-man exhibition (Der Sturm)
Sculpture Picasso: Cubist construction, *Glass of Absinthe*
Duchamp-Villon: *The Horse*
Lipchitz: *Sailor with Guitar*
Archipenko: *Médrano*
Germany Klee, Macke, Moilliet visit Kairouan

Berlin: Der Sturm Gallery exhibits Gleizes, Metzinger, Duchamp-Villon, Villon

Klee: *Hommage à Picasso*

New York December 9–January 15: Picasso and Braque exhibition (Photo-Secession Gallery)

London Wyndham Lewis publishes *Blast*

1915

Picasso portrait drawings; *Harlequin*

Braque May 11: wounded at Carency

Gris suspends contract with Kahnweiler
Still Life Before an Open Window: Place Ravignan

Gleizes visits New York; *Brooklyn Bridge*

Boccioni *Charge of Lancers*

Weber *Rush Hour, New York*

Sculpture Lipchitz: *Bather*
Archipenko: *Woman Combing Her Hair*
Laurens begins his Cubist constructions

1916

February 8: Zurich, official christening of the Dada movement

Braque summer: demobilized

Gris summer: at Beaulieu

Boccioni August 17: killed in riding accident

Marc March 4: killed at Verdun

Sculpture Lipchitz: contract with Léonce Rosenberg
Gabo: *Head* (iron)

1917

Picasso travels with the Ballets Russes in Italy
moves to 22 Rue Victor Hugo, Montrouge

Braque summer: resumes painting, begins *Musician*
Léonce Rosenberg becomes his dealer

Léger *The Cardplayers*

Gris friendship with Lipchitz
contract with Léonce Rosenberg

Lhote *Rugby*

Stella begins *Brooklyn Bridge*

Sculpture Gris: *Torero (Harlequin)*

1918

death of Apollinaire as a result of war injuries
Léonce Rosenberg opens the Galerie de l'Effort Moderne
Ozenfant and Jeanneret (Le Corbusier) publish *Après le cubisme* and hold Purist exhibition at Galerie Thomas

Picasso July: marries Olga Koklova
Paul Rosenberg becomes his dealer

Braque completes *Musician; Musical Forms*

Gris begins to work in realist as well as Cubist style

Mondrian returns to Paris

Miró Barcelona: first exhibition

Sculpture October 7: death of Duchamp-Villon
Lipchitz: *Seated Guitar Player*

1919

Picasso exhibitions at Galerie de l'Effort Moderne and at Paul Rosenberg's

Braque March: exhibition at Galerie de l'Effort Moderne
Café-Bar

Gris April: exhibition at Galerie de l'Effort Moderne

Léger exhibition at Galerie de l'Effort Moderne
The City

Miró first visit to Paris; Cubist landscapes and figures

1920

Kahnweiler publishes *Der Weg zum Kubismus*
Ozenfant and Jeanneret (Le Corbusier) found *L'Esprit Nouveau* (1920–25)
last Cubist group exhibition at the Salon des Indépendants
Stravinsky's *Pulcinella* begins his Neoclassic period

Picasso Neoclassic period begins

Braque returns to Kahnweiler

Gris exhibits at La Section d'Or and at the Salon des Indépendants

Miró Cubist still lifes

Hayden completes *Three Musicians*

Sculpture Lipchitz: first one-man exhibition at Galerie de l'Effort Moderne
Laurens: *Guitar*

1921

Severini publishes *Du Cubisme au classicisme*

Picasso *Dog and Cock;* two versions of *Three Musicians* (painted during the summer at Fontainebleau)

Gris *Le Canigou*

Léger *Three Women (Le Grand déjeuner); Animated Landscape*

Villon *Color Perspective*

1922

James Joyce's *Ulysses* published in Paris

Picasso exhibition in Munich (Thannhauser Gallery)

Braque exhibits eighteen works at the Salon d'Automne

Marin *Lower Manhattan; Maine Islands*

1923

Picasso & Braque growth of curvilinear elements in Cubist style

1924

Breton publishes Manifesto of Surrealism
Gleizes publishes *La Peinture et ses lois: ce qui devait sortir du cubisme*

Picasso *Still Life with a Cake*

Braque *Still Life with Guitar and Fruit*

Gris gives lecture at the Sorbonne, *Des Possibilités de la peinture*

Léger *The Siphon;* film, *Ballet mécanique*

Villon *The Jockey*

1925

Le Corbusier designs Pavillon de l'Esprit Nouveau at the Exposition Internationale des Arts Décoratifs
last exhibition of La Section d'Or
Ozenfant and Jeanneret (Le Corbusier) publish *La Peinture moderne*

A Note on the Bibliography

This annotated bibliography comes in three parts. The first is the original bibliography, compiled in 1959 for the book's first edition and organized in terms of a preliminary section on general studies of Cubism followed by comments relevant to the material discussed in each chapter. The second bibliography is a short supplement compiled for the revised edition of 1966. The third is a long supplement compiled for the newest edition of 1976. Although these three bibliographies might have been combined, there seemed an advantage in leaving them in this form; for they represent, historiographically speaking, two very different periods in the state of our knowledge and interpretation of Cubism. The first bibliography and its brief supplement of 1966 provide, in effect, a full account of what might be considered the first broad phase in the literature of Cubism, from the earliest theoretical explanations of 1912 to the more detailed, historical surveys of the mid-century, when Cubism still seemed a living artistic force. The new supplement of 1976, however, represents a decade of what appears to be a revisionist wave of research and interpretation that began in the 1960s, at a time when Cubism had clearly taken its place as a great, but buried historical style and when art historians of a younger generation could look at it without the often distorting preconceptions of their seniors. Most of the pseudo-scientific language that had originally been used to justify Cubism has been happily replaced by a far more exact description of what Cubist art actually looks like. In this light, much more attention has been paid to the precise identification of what is represented in Cubist art, including not only figures, landscapes, and still-life objects which were once ignored or illegible, but also the literal and metaphorical meaning of the many painted, drawn, and pasted words so conspicuous in Cubist art after 1910. This interweaving of precise formal and iconographic analysis has been a salutary antidote to the evasive language characteristic of most discussions of Cubism cited in the original bibliography. Moreover, the last decade has marked a surge in scholarly research that has, among other things, expanded our geographical knowledge of the Cubist movement (especially in Eastern Europe) and refined and clarified many questions of dating that were left unexamined in the first half-century of Cubist studies. In short, the reader who wishes to consult the most up-to-date contributions in the vast bibliography on Cubism need consider only the most recent supplement; whereas the scholar who wishes to explore the entire body of literature on Cubism will have access to it through the reprinting of the original bibliography and its first supplement.

New York, 1976 R. R.

Bibliography

GENERAL STUDIES

The fullest and most up-to-date study of Cubism is John Golding, *Cubism: A History and Analysis, 1907–1914*, New York, 1959, which provides a closely documented history of the movement during its first seven years, as well as a bibliography rich in early newspaper and periodical references to the movement. For a more general study of Cubism in its broader historical and chronological ramifications, the best work remains, despite its early date, Alfred H. Barr, Jr., *Cubism and Abstract Art*, New York, 1936. The same combination of balanced historical interpretation, critical insight, and scholarly accuracy is found in Barr's equally fundamental study, *Picasso: Fifty Years of His Art*, New York, 1946, which, while focusing on Picasso, nevertheless provides an extremely lucid commentary on the evolution of Cubism.

In addition to the bibliographies included in these books, the most useful recent bibliographies of general works on Cubism are in Guy Habasque, *Cubism*, Geneva, 1959, and in Guillaume Apollinaire, *The Cubist Painters*, New York, 1949 (bibl. by Bernard Karpel), the English translation of Apollinaire's *Les Peintres cubistes*, Paris, 1913. An older, more detailed bibliography is found in *L'Amour de l'art*, No. 9 (November, 1933), reprinted in René Huyghe and Germain Bazin (eds.), *Histoire de l'art contemporain: la peinture*, Paris, 1935, Chaps. VIII–IX. A more recent bibliography of general studies as well as of individual artists is to be found in Maurice Raynal et al., *From Picasso to Surrealism*, Vol. III, *The History of Modern Painting*, Geneva, 1950. For bibliographies of individual artists, see the volumes already published in Hans Vollmer (ed.), *Allgemeines Lexikon der bildenden Künstler des XX. Jahrhunderts*, 5 vols., Leipzig, 1953–196?. Useful, too, are the bibliographies in the catalogue, *Collection of the Société Anonyme*, Yale University Art Gallery, 1950.

The most important early studies of Cubism are: Albert Gleizes and Jean Metzinger, *Du Cubisme*, Paris, 1912 (Eng. trans., London, 1913); Guillaume Apollinaire, *Les Peintres cubistes: méditations esthétiques*, Paris, 1913 (Eng. trans., New York, 1944, 1949); Arthur Jerome Eddy, *Cubists and Post-Impressionism*, Chicago, 1914, rev. ed., 1919; Gustave Coquiot, *Cubistes, futuristes, passéistes*, Paris, 1914; Ardengo Soffici, *Cubismo e futurismo*, 2nd ed., Florence, 1914; Daniel Henry [Kahnweiler], *Der Weg zum Kubismus*, Munich, 1920 (Eng. trans., New York, 1949); Paul Küppers, *Der Kubismus*, Leipzig, 1920; Rudolf Blümner, *Der Geist des Kubismus und die Künste*, Berlin, 1921.

Later studies of Cubism are surprisingly few in number and generally unsubstantial. The fullest general account is Guillaume Janneau, *L'Art cubiste*, Paris, 1929. Two most erratic and polemic studies, interesting primarily as eccentricities, are: Antonio Fornari,

Quarant'anni di cubismo, Rome, 1948; and François Fosca, Bilan du cubisme, Paris, 1956. Other texts that deal exclusively with Cubist art are, by and large, picture books with brief introductions of varying quality. These include: Egidio Bonfante, Arte cubista, Venice, 1945; Enrique Azcoaga, El Cubismo, Barcelona, 1949; Daniel Henry Kahnweiler, Les Années héro-ïques du cubisme, Paris, 1950; a special issue of Art d'aujourd'hui, IV, Nos. 3–4 (May-June, 1953), dedicated wholly to Cubism; and Alfred Schmeller, Cubism, London, 1956. In addition to John Golding's study, the most recent, detailed account, again dealing only with the years 1907–14, is Guy Habasque, Cubism, Geneva, 1959. For a study of Cubism from the theoretical viewpoint, see Christopher Gray, Cubist Aesthetic Theories, Baltimore, 1953 (bibl.).

By and large, several catalogues of Cubist exhibitions offer more accurate information and more intelligent interpretation than many of the studies cited above. These would include Les Créateurs du cubisme, Paris, Les Expositions de "Beaux-Arts," 1933; Le Cubisme, 1911–1918, Paris, Galerie de France, 1945, with an excellent essay by Bernard Dorival; The Cubist Spirit in Its Time, London, The London Gallery, 1947, with refreshingly spirited remarks by E.L.T. Mesens and Robert Melville; and the extremely well-documented Le Cubisme (1907–1914), Paris, Musée National d'Art Moderne, 1953, which includes excellent chronologies of the movement.

Several articles may also be cited in connection with general considerations of Cubism: Winthrop Judkins, "Toward a Reinterpretation of Cubism," Art Bulletin, XXX (December, 1948), pp. 270–78, a clear-sighted and clear-minded pictorial analysis of Cubism that offers a needed antidote to the many vague and speculative approaches to Cubist art; André Chastel, "Cubism: Discovery to Décor," Art News, LII (April, 1953), pp. 26–29, written on the occasion of the Paris exhibition; and Daniel Henry Kahnweiler, "Cubism: the Creative Years," Art News Annual, XXIV (1955), pp. 107–16, a new account of the high years of Cubism by one of the earliest and most perceptive critics of the movement.

In general, the treatment of Cubism in broader studies of contemporary art has often been superior to the relatively few serious studies of Cubism itself. Among these may be cited: Carl Einstein, Die Kunst des 20. Jahrhunderts, Berlin, 1926; James Johnson Sweeney, Plastic Redirections in 20th Century Painting, Chicago, 1934; Christian Zervos, Histoire de l'art contemporain, Paris, 1938; Bernard Dorival, Le Fauvisme et le cubisme, 1905–1911, Vol.

II, Les Étapes de la peinture française contemporaine, Paris, 1944 (an especially clear and detailed account); Reginald Wilenski, Modern French Painters, rev. ed., New York, 1954; Michel Seuphor, L'Art abstrait, Paris, 1949; Werner Haftmann, Malerei im 20. Jahrhundert, 2 vols., Munich, 1954–55; as well as the general studies by René Huyghe and Germain Bazin, and Maurice Raynal et al. cited above.

Chapters 1, 2, 3, 13
PICASSO AND BRAQUE

The finest monograph on Picasso, and one unlikely to be surpassed, is Alfred H. Barr, Jr., Picasso: Fifty Years of His Art, New York, 1946, already cited. It includes a thorough bibliography to 1945. This book and Christian Zervos's illustrated catalogue, Pablo Picasso, Vols. I [works from 1895 to 1906]–XI [works from 1940 to 1941], Paris, 1932–1960, are the two basic works for Picasso studies today. For interpretive insights into Picasso's art, Gertrude Stein's biography, Pablo Picasso, London, 1939, is still unchallenged. For a more orthodox biography, see Roland Penrose, Picasso; His Life and Work, New York, 1959. For an anthology of Picasso documents, see Jaime Sabartés, Picasso: documents iconographiques, Geneva, 1954. Of the many books on Picasso, the following, which vary in quality, are the largest in format and bulk: Joan Merli, Picasso, rev. ed., Buenos Aires, 1948; Maurice Raynal, Picasso, New York, 1953 (bibl.); Wilhelm Boeck and Jaime Sabartés, Picasso, New York, 1955, which brings Barr's bibliography up to date; Frank Elgar and Robert Maillard, Picasso, New York, 1956 (bibl.); and José Camón Aznar, Picasso y el cubismo, Madrid, 1956, which is oriented primarily toward Spanish Cubist painters and sculptors rather than toward Cubism in general. Particularly useful in Picasso studies are three exhibition catalogues: Pablo Picasso (text by F. Russoli), Milan, Palazzo Reale, 1953; the exemplary Picasso, 1900–1955 (ed. by M. Jardot), Paris, Musée des Arts Décoratifs, 1955, with excellent chronology and bibliography; and Picasso (ed. by Douglas Cooper), Marseilles, Musée Cantini, 1959.

Braque studies are far scanter. The most extensive are: Carl Einstein, Georges Braque, Paris, 1934; Henry Hope, Georges Braque, New York, 1949, with a thorough bibliography; and Maurice Gieure, G. Braque, Paris, 1956 (Eng. trans., New York, 1956), which brings the 1949 Hope bibliography up to date. For an excellent short essay and picture book, see John Richardson, Georges Braque (Penguin Modern Painters), 1959. Essential to Braque studies is the catalogue, G. Braque (ed. by Douglas Cooper), The

Arts Council of Great Britain, 1956, with chronology, bibliography, and detailed comments on individual pictures. A catalogue of Braque's oeuvre is now in preparation by the Éditions de la Galerie Maeght, Paris.

The following bibliographical notations refer to studies of particular problems discussed in Part One of this book, which deals with the early careers of Picasso and Braque. For a detailed consideration of the history and significance of Les Demoiselles d'Avignon, see John Golding, "The Demoiselles d'Avignon," Burlington Magazine, C (May, 1958), pp. 155–63. The definitive and most illuminating study of the general relation of primitive art to Cubism (as well as to other twentieth-century movements) is Robert Goldwater, Primitivism in Modern Painting, New York, 1938, with an excellent bibliography. More specific studies of this problem are found in James Johnson Sweeney, "Picasso and Iberian Sculpture," Art Bulletin, XXIII (September, 1941), pp. 191–98; and Daniel Henry Kahnweiler, "Negro Art and Cubism," Horizon, XVIII (December, 1948), pp. 412–20. A fervent but unreliable account of the importance of Céret in the creation of Cubism is Victor Crastre, La Naissance du cubisme (Céret 1910), Geneva, 1948. For an exemplary analysis of a single Analytic Cubist painting, see Ellen Johnson, "On the Role of the Object in Analytic Cubism: Picasso's Glass of Absinthe," Bulletin of the Allen Memorial Art Museum (Oberlin), XIII, No. 1 (1955), pp. 11–25. For a more general consideration of the Cubists' ultimate dependence on reality, see Clement Greenberg, "The Role of Nature in Modern Painting," Partisan Review, XVI (January, 1949), pp. 78–81. An earlier essay involving a comparable question is Léonce Rosenberg, Cubisme et tradition, Paris, 1920. The relation of contemporary science to Cubism, especially in terms of popularized concepts of space-time and four-dimensionality, is explored in Paul Laporte, "Cubism and Science," Journal of Aesthetics and Art Criticism, VII (March, 1949), pp. 243–56; and most influentially (and with reference to contemporary architecture) in S. Giedion, Space, Time, and Architecture, 3rd ed., Cambridge, Massachusetts, 1954. For a brilliant application of Cubist aesthetics to the study of literature, see Wylie Sypher, "Gide's Cubist Novel: Les Faux-Monnayeurs," Kenyon Review, XI, No. 2 (1949), pp. 291–309. The two standard general studies of modern French literature in relation to modern art are Georges Lemaître, From Cubism to Surrealism in French Literature, rev. ed., Cambridge, Massachussetts, 1947; and Marcel Raymond, De Baudelaire au surréalisme, rev. ed., Paris,

1947 (Eng. trans., New York, 1949, with excellent bibliography). On the problem of Picasso's multiple styles, see Robert Rosenblum, "The Unity of Picasso," *Partisan Review*, XXIV (Fall, 1957), pp. 592–96. On collage, see "Le Papier collé du cubisme à nos jours," special issue of *XXᵉ siècle*, VI (January, 1956); and Clement Greenberg, "Pasted-Paper Revolution," *Art News*, LVII (September, 1958), pp. 46–49.

Chapter 4
JUAN GRIS

The standard monograph on Gris is that written by his dealer: Daniel Henry Kahnweiler, *Juan Gris, sa vie, son oeuvre, ses écrits*, Paris, 1946 (rev. Eng. trans., New York, 1947, with thorough bibliography). For a more up-to-date bibliography, see James Thrall Soby, *Juan Gris*, New York, 1958. For Gris's letters, see *Letters of Juan Gris, 1913–1927*, collected by Daniel Henry Kahnweiler, trans. and ed. by Douglas Cooper, London, 1956. For a brief and particularly illuminating account of Gris's art and of Cubism in general, see Georg Schmidt, *Juan Gris und die Geschichte des Kubismus*, Baden-Baden, 1957. Extremely useful, too, is the exhibition catalogue, *Juan Gris* (ed. by Douglas Cooper), Bern, Kunstmuseum, 1956 (bibl.).

Chapter 5
LÉGER AND PURISM

In terms of bibliography and documentation, the most up to-date reference work is the exhibition catalogue, *Fernand Léger 1881–1955* (ed. by F. Mathey), Paris, Musée des Arts Décoratifs, 1956. The most useful monographs, all with bibliographies, are: Douglas Cooper, *Fernand Léger et le nouvel espace*, London, 1949; Katharine Kuh, *Léger*, Urbana, Illinois, 1953; and Pierre Descargues, *Fernand Léger*, Paris, 1955. For further pictorial documentation, see E. Tériade, *Fernand Léger*, Paris, 1928; and Christian Zervos, *Fernand Léger: oeuvres de 1905 à 1952*, Paris, 1952 (text in French and English). See also Daniel Henry Kahnweiler, "Fernand Léger," *Burlington Magazine*, XCII (March, 1950), pp. 63–69, for a consideration of Léger's position in the history of Cubism. The best early bibliography on Purism is found in Raymond Cogniat, "Le Purisme," *L'Amour de l'art*, No. 9 (November, 1933), pp. 238–39. For the viewpoint of the founders of the movement, see their periodical *L'Esprit nouveau*, 1920–25; Amédée Ozenfant, *Après le cubisme*, Paris, 1918; and Amédée Ozenfant and Charles Jeanneret [Le Corbusier], *La Peinture moderne*, Paris, 1925. On Ozenfant,

see Karl Nierendorf, *Amédée Ozenfant*, Berlin [n. d.]. On Le Corbusier as a painter, see the essay by James Thrall Soby in Stamo Papadaki (ed.), *Le Corbusier: Architect, Painter, Writer*, New York, 1948; and the exhibition catalogue, *Le Corbusier*, Musée de Lyon, 1956.

Chapter 6
THE PARISIAN SATELLITES

The fullest general account of the minor Parisian Cubists is in Bernard Dorival, *Le Fauvisme et le cubisme, 1905–1911*, Vol, II, *Les Étapes de la peinture française contemporaine*, Paris, 1944 (including a discussion of Purism). For Delaunay, the most thorough and up-to-date documentation and bibliography is found in Robert Delaunay, *Du cubisme à l'art abstrait* (ed. by Pierre Francastel, with a catalogue by Guy Habasque), Paris, 1957. See also François Gilles de la Tourette, *Robert Delaunay*, Paris, 1950; and the exhibition catalogue, *Robert Delaunay, 1885–1941*, Paris, Musée National d'Art Moderne, 1957. The most handy bibliographies for Duchamp and Picabia are in Robert Motherwell (ed.), *The Dada Painters and Poets: An Anthology*, New York, 1951. On Duchamp, see Robert Lebel, *Marcel Duchamp*, New York, 1959; *View*, V (March, 1945), an entire issue devoted to Duchamp; Katharine Kuh, "Marcel Duchamp," in the exhibition catalogue *20th Century Art from the Louise and Walter Arensberg Collection*, Art Institute of Chicago, 1949; and the exhibition catalogue, *Jacques Villon, Raymond Duchamp-Villon, Marcel Duchamp*, New York, The Solomon R. Guggenheim Museum, 1957 (bibl.). On Picabia, see Phillp Pearlstein, "The Symbolic Language of Francis Picabia," *Arts*, XXX (January, 1956), pp. 37–43. On Villon, see Jacques Lassaigne, *Jacques Villon*, Paris, 1950 (bibl.). Two particularly useful exhibition catalogues, both with bibliographies, are: *Jacques Villon, Lyonel Feininger*, Boston, Institute of Contemporary Art, 1949; and *Jacques Villon*, Albi, Musée Toulouse-Lautrec, 1955. For an excellent analysis of Villon's creative methods and the general problem of the relation of later Cubism to nature, see George Heard Hamilton, "The Dialectic of Later Cubism: Villon's *Jockey*," *Magazine of Art*, XLI (November, 1948), pp. 268–72. On La Fresnaye, see Raymond Cogniat and Waldemar George, *Oeuvre complète de Roger de La Fresnaye*, Paris, 1950 (bibl.); Germain Seligman, *Roger de La Fresnaye*, New York, 1945; and the exhibition catalogue, *Roger de La Fresnaye*, Paris, Musée National d'Art Moderne, 1950. On Metzinger, see Waldemar George, "Jean Metzinger," *L'Esprit*

nouveau, Vol. II, No. 15 (March, 1922), pp. 1781–88. On Gleizes, see the exhibition catalogue, *Albert Gleizes: le cubisme et son dénouement dans la tradition*, Lyon, Chapelle du Lycée Ampère, 1947. A succinct discussion of Gleizes and Metzinger's Cubist theory is in Charles Gauss, *The Aesthetic Theories of French Artists, 1855 to the Present*, Baltimore, 1949, Chap. VI. For characteristic later theoretical studies by Gleizes, see *Du Cubisme et des moyens de le comprendre*, Paris, 1920; *La Peinture et ses lois: ce qui devait sortir du cubisme*, Paris, 1924; and *Tradition et cubisme: vers une conscience plastique*, Paris, 1927. On Lhote, see Pierre Courthion, *André Lhote*, Paris, 1926; Roger Brielle, *André Lhote*, Paris, 1931; and Anatole Jakovsky, *André Lhote*, Paris, 1947.

On Marcoussis, see Jean Cassou, *Marcoussis*, Paris, 1930; and *Sélection* (Antwerp), VIII, No. 7 (1929), issue devoted to Marcoussis, with bibl. On Hayden, see Édouard Roditi, "Henry Hayden and the Return from Cubism," *Arts*, XXXI (December, 1956), pp. 34–39.

Chapter 7
CUBISM AND THE ITALIAN FUTURISTS

For thorough documentation and bibliography on Futurism, see Maria Drudi Gambillo and Teresa Fiori (eds.), *Archivi del Futurismo*, Vol. I, *Archivi dell'arte contemporanea*, Rome, 1958. For more general considerations of the movement, see Rosa Clough, *Looking Back at Futurism*, New York, 1942; Alfred H. Barr, Jr. and James Thrall Soby, *Twentieth-Century Italian Art*, New York, 1949 (with the most convenient bibliography); Raffaele Carrieri, *Pittura, scultura, d'avanguardia (1890–1950) in Italia*, Milan, 1950; and Guido Balla, *Modern Italian Painting from Futurism to the Present Day*, New York, 1958. On Boccioni, see Giulio Carlo Argan, *Umberto Boccioni*, Rome, 1953 (bibl.); and Boccioni's own *Pittura, scultura futuriste*, Milan, 1914. On Carrà, see Roberto Longhi, *Carlo Carrà*, Milan, 1937 (bibl.); and Guglielmo Pacchioni, *Carlo Carrà*, 2nd ed., Milan, 1958 (bibl., text in Eng.). On Severini, see Pierre Courthion, *Gino Severini*, rev. ed., Milan, 1945 (bibl.); and Severini's own *Du Cubisme au classicisme*, Paris, 1921, a characteristic document of the anti-Cubist turn to classical order and tradition in the 1920s.

Chapter 8
CUBISM AND THE GERMAN ROMANTIC TRADITION

Two large recent studies offer the most exhaustive documentation and biblio-

graphy on modern German painting: Peter Selz, *German Expressionist Painting*, Berkeley and Los Angeles, 1957; and Bernard Myers, *The German Expressionists: A Generation in Revolt*, New York, 1957. For a briefer and more extensive study with bibliography, see Andrew Ritchie (ed.), *German Art of the Twentieth Century*, New York, 1957. On the Blaue Reiter in particular, see the exhibition catalogue, *Der Blaue Reiter: München und die Kunst des 20. Jahrhunderts, 1908–1914*, Munich, Haus der Kunst, 1949; and Lothar Günther Buchheim, *Der Blaue Reiter*, Feldafing, 1959. On Macke, see Gustav Vriesen, *August Macke*, Stuttgart, 1953 (bibl.). On Campendonk, see Georg Biermann, *Heinrich Campendonk*, Leipzig, 1921; and Mathias Engels, *Heinrich Campendonk*, Cologne, 1957. On Marc, see Alois Schardt, *Franz Marc*, Berlin, 1936 (bibl.); and Klaus Lankheit, *Franz Marc*, Berlin, 1950. On Feininger, see the exhibition catalogues, *Lyonel Feininger, Marsden Hartley*, New York, The Museum of Modern Art, 1944 (bibl.); and *Jacques Villon, Lyonel Feininger*, Boston, Institute of Contemporary Art, 1949 (bibl.); and Hans Hess, *Lyonel Feininger*, New York, 1961. On the problem of Feininger's relation to German Romanticism, see Alfred Werner, "Lyonel Feininger and German Romanticism," *Art in America*, XLIV (Fall, 1956), pp. 23–27.

Chapter 9
CUBISM IN ENGLAND AND AMERICA

On Vorticism and Lewis, see Charles Handley-Read (ed.), *The Art of Wyndham Lewis*, London, 1951; James Thrall Soby, "Wyndham Lewis' Vorticism," in his *Contemporary Painters*, New York, 1948; and the exhibition catalogue, *Wyndham Lewis and Vorticism*, London, The Tate Gallery, 1956. On Nicholson, see Herbert Read, *Ben Nicholson*, 2 vols., London, Vol. I, 1948, Vol. II, 1956 (bibl.); John Summerson, *Ben Nicholson* (Penguin Modern Painters), 1948; and J. P. Hodin, *Ben Nicholson; The Meaning of His Art*, London, 1957 (bibl.).
The most thorough study of American painting of this period is Milton Brown, *American Painting from the Armory Show to the Depression*, Princeton, 1955 (bibl.). See also Andrew Ritchie, *Abstract Painting and Sculpture in America*, New York, 1951 (bibl.); and

John Baur, *Revolution and Tradition in Modern American Art*, Cambridge, Massachusetts, 1951. On Weber, see Lloyd Goodrich, *Max Weber*, New York, 1949 (bibl.). On Marin, see the exhibition catalogue, *John Marin*, Boston, Institute of Modern Art, 1947 (bibl.); and William Carlos Williams, Duncan Phillips, and others, *John Marin*, Berkeley, 1956. On Sheeler, see the exhibition catalogue, *Charles Sheeler*, Los Angeles, University of California Art Galleries, 1955 (bibl.). On Demuth, see Andrew Ritchie, *Charles Demuth*, New York, 1950 (bibl.). On Davis, see James Johnson Sweeney, *Stuart Davis*, New York, 1945 (bibl.); and H. H. Arnason, "Stuart Davis," in the exhibition catalogue, *Stuart Davis*, Minneapolis, Walker Art Center, 1957.

Chapter 10
CUBISM AND ABSTRACT ART: MALEVICH AND MONDRIAN

A brief and useful survey of avant-garde art in Russia in the early twentieth century is Michel Seuphor, "Au temps de l'avant-garde," *L'Oeil*, No. 11 (November, 1955), pp. 24–39. On Malevich, see Margot Aschenbrenner, "Farben und Formen im Werk von Kasimir Malewitsch," *Quadrum*, IV (1957), pp. 99–110; and Ella Winter, "The Lost Leadership of Malevich," *Art News*, LVII (December, 1958), pp. 34–37. The most substantial monograph on Mondrian, including an extensive bibliography, is Michel Seuphor, *Piet Mondrian, Life and Work*, New York, 1956. See also Ottavio Morisani, *L'Astrattismo di Piet Mondrian*, Venice, 1956; and H. L. C. Jaffé, *De Stijl, 1917–1931*, Amsterdam, 1956, which discusses Mondrian in the context of the Dutch movement, De Stijl.

Chapter 11
CUBISM AND FANTASTIC ART: CHAGALL, KLEE, MIRÓ

On Chagall, see James Johnson Sweeney, *Marc Chagall*, New York, 1946 (bibl.); Lionello Venturi, *Chagall*, New York, 1956, which brings the Sweeney bibliography up to date; Walter Erben, *Marc Chagall*, New York, 1957; Jacques Lassaigne, *Chagall*, Paris, 1957; and the richly documented catalogue, *Marc Chagall* (ed. by F. Mathey), Paris, Musée des Arts Décoratifs, 1959. Of the many studies on Klee, the fullest bibliography and documentation

is contained in Will Grohmann, *Paul Klee*, New York, 1954. See also Carola Giedion-Welcker, *Paul Klee*, New York, 1952; and Werner Haftmann, *Paul Klee*, Munich, 1956. The most up-to-date Miró bibliography is in James Thrall Soby, *Joan Miró*, New York, 1959. See also James Johnson Sweeney, *Joan Miró*, New York, 1948; Clement Greenberg, *Joan Miró*, New York, 1948; and A. Cirici-Pellicer, *Miró y la imaginación*, Barcelona, 1949.

Chapter 12
CUBISM AND TWENTIETH-CENTURY SCULPTURE

The handiest general accounts of contemporary sculpture are: Carola Giedion-Welcker, *Contemporary Sculpture: An Evolution in Volume and Space*, rev. and enlarged ed., New York, 1960, which contains an extensive bibliography; Andrew Ritchie, *Sculpture of the Twentieth Century*, New York, 1953, with a more modest bibliography; and Michel Seuphor, *La Sculpture de ce siècle*, Neuchâtel, 1959 (Eng. trans., New York, 1960). On Picasso as a sculptor, see Daniel Henry Kahnweiler, *The Sculptures of Picasso*, London, 1949; and Giulio Carlo Argan, *Scultura di Picasso*, Venice, 1953. On La Fresnaye as a sculptor, see Jean Cassou, "Sculpture de La Fresnaye," *Derrière le miroir*, No. 32 (October, 1950), pp. 2–3. On Duchamp-Villon, see Walter Pach, *Raymond Duchamp-Villon, sculpteur*, Paris, 1924. On Archipenko, see Hans Hildebrandt, *Alexandre Archipenko, son oeuvre*, Berlin, 1923. On Boccioni, see bibliography for Chapter VII. On Gabo and Pevsner, see Ruth Olson and Abraham Chanin, *Naum Gabo, Antoine Pevsner*, New York, 1948 (bibl.); and Herbert Read and Leslie Martin, *Gabo*, Cambridge, Massachusetts, 1957 (bibl.). On Laurens, see Marthe Laurens (ed.), *Henri Laurens, sculpteur, 1885–1954*, Paris, 1955; Cécile Goldscheider, *Laurens*, Cologne and Berlin, 1956 (bibl.); and the exhibition catalogue, *Henri Laurens*, Paris, Musée National d'Art Moderne, 1951. On Lipchitz, see Henry Hope, *The Sculpture of Jacques Lipchitz*, New York, 1954 (bibl.); Robert Goldwater, *Lipchitz*, Amsterdam, 1954 (bibl.) (Eng. ed., New York, 1959); and A. M. Hammacher, *Jacques Lipchitz: His Sculpture*, New York, 1960 (bibl.).

Supplement to the First Revised Edition

Since 1959, when this bibliography was compiled, two general studies of Cubism have appeared that add little of historical or interpretive significance: Pierre Cabanne, *L'Epopée du Cubisme*, Paris, 1963, a popularized history; and Maurice Sérullaz, *Le Cubisme*, Paris, 1963, a brief textbook survey in the series, *"Que sais-je?"* However, an important anthology of Cubist documents, bibliography, and historiography by Edward F. Fry is scheduled for publication in 1966 in the multilingual series, *Dokumente*, and promises to play a major role in future studies of Cubism. A provocative interpretation of Cubism in the context of modern literature (Pirandello, Gide) and philosophy (Whitehead) can now be found in Wylie Sypher, *Rococo to Cubism in Art and Literature*, New York, 1960; and two new collections of essays by that venerable critic of Cubism, Daniel Henry Kahnweiler, have recently been published: *Entretiens avec Francis Crémieux*, Paris, 1961; and *Confessions esthétiques*, Paris, 1963. For a résumé and evaluation of the latest studies of Apollinaire, see Michel Décaudin, "Guillaume Apollinaire, Études et informations réunies," special number of *Revue des lettres modernes*, No. 69–70, Spring, 1962.

About the major Cubists, there have been relatively few publications. However, Picasso studies have benefited greatly from two fine exhibition catalogues, one by John Richardson (*Picasso, an American Tribute*, New York, Public Education Association, 1962), and one by Jean Sutherland Boggs (*Picasso and Man*, Art Gallery of Toronto, 1964). On Braque, see Jean Leymarie, *Braque*, Geneva, 1961 (bibl.), as well as two large exhibition catalogues by Douglas Cooper (*Braque*, Munich, Haus der Kunst, 1963) and John Richardson (*Georges Braque, 1882–1963*, New York, Public Education Association, 1964). A smaller exhibition, with catalogue, was held at the Louvre (*L'Atelier de Braque*, Paris, 1961). On Léger, see Robert Delevoy, *Léger*, Geneva, 1962 (bibl.). On Gris, see the exhibition catalogue by John Richardson, *Juan Gris*, Dortmund, Museum am Ostwall, 1965. On the mathematical basis of Gris's composition, see William A. Camfield, "Juan Gris and the Golden Section," *Art Bulletin*, XLVII, March, 1965, pp. 128–134. For an attractively illustrated exhibition catalogue of works by the four major Cubists, see *Le Cubisme*, Basel, Galerie Beyeler, 1962. For a scholarly presentation of a group of important Cubist works, see Bernard Dorival, "La Donation André Lefèvre," Musée National d'Art Moderne," *Revue du Louvre et des Musées de France*, No. 1, 1964, pp. 3–24.

Most recent publications on Cubism have tended to explore the historical roles and the character of the lesser-known Parisian Cubists, especially those associated with the Section d'Or. Albert Gleizes has been the object of particular attention, climaxed by the admirably documented exhibition catalogue by Daniel Robbins (*Albert Gleizes, 1881–1953*, New York, The Solomon R. Guggenheim Museum, 1964). Other exhibition catalogues include: *Albert Gleizes, 1881–1953*, Aix-en-Provence, Galerie Lucien Blanc, 1960; *Albert Gleizes, 1881–1953*, Avignon, Musée Calvet, 1962; *Albert Gleizes et Tempete dans les Salons, 1910–1914*, Musée de Grenoble, 1963; and *Albert Gleizes and the Section d'Or*, New York, Leonard Hutton Galleries, 1964 (introductions by William A. Camfield and Daniel Robbins). For further material on Gleizes, see also *Albert Gleizes et le Cubisme*, Basel, 1962 (introduction by Rudolf Indlekofer). Other important exhibition catalogues that have focused on Parisian Cubists of lesser reputation include: *Cubist Painters*, London, Kaplan Gallery, 1963; and *Autour du Cubisme*, Cologne, Kunstverein, 1964. Of these minor masters, Marcoussis has at last received a full-length study with *catalogue raisonné*: Jean Lafranchis, *Marcoussis, sa vie, son oeuvre*, Paris, 1961, followed by two exhibition catalogues (Paris, Galerie Kriegel, 1962; Paris, Musée National d'Art Moderne, 1964).

R. R.
New York, 1966

Supplement to the Present Edition

Since the above supplement was written, the growth of publications concerning Cubism has been enormous. In the broadest terms, those of an overall history of modern art, the most lucid, well-balanced, and reliable account of Cubism within a rich international context is now found in George Heard Hamilton, *Painting and Sculpture in Europe, 1880–1940* (Pelican History of Art), Baltimore and Harmondsworth, 1967. In the narrower terms of studies of Cubism *per se*, the most important contribution has been Edward F. Fry, *Cubism*, New York, 1966, which provides not only an essential compilation of early criticism of Cubist art and a thorough bibliography and exhibition list, but also a succinct and clear-minded history of the movement within the context of Parisian developments in the period 1907–25. From an international point of view, the first valuable new addition to our knowledge of non-Parisian ramifications of Cubism was the exhibition of Cubist art from Prague, which, beginning in Paris (*Paris–Prague, 1906–30 . . .* , Musée National d'Art Moderne, 1966), traveled to Brussels, London, and Rotterdam. It not only included unfamiliar works by Braque and Picasso, but a survey of such then barely known Czech Cubist painters as Emil Filla and Bohumil Kubišta and the internationally more significant Czech Cubist sculptor Otto Gutfreund. This Eastern European expansion of Cubism has continued to be explored in the last ten years.

The continuing growth of art publications has produced several useful pictorial anthologies of Cubist art which, if modest in text, often illustrate seldom seen works. Of these may be mentioned José Pierre, *Le Cubisme (Histoire générale de la peinture)*, Lausanne, 1966; and three Italian publications: François Mathey, *Le Manifestazioni cubiste (L'Arte Moderna)*; idem, *Léger e altre personalità cubiste (L'Arte Moderna)*; and Alberto Martini, *Picasso e il Cubismo (Mensili d'Arte)*, all Milan, 1967. In 1970, two more ambitious studies of Cubism were published: Nicholas Wadley, *Cubism (Movements of Modern Art)*, London, 1970; and Douglas Cooper, *The Cubist Epoch*, London, 1970. Wadley's study, which is full of fresh and imaginative observations, is an enlarged international view of Cubism, which includes

337

the Czech material and even suggests the impact of Cubism on such later developments as Surrealism and Abstract Expressionism. Cooper's study, which served as the catalogue for the major exhibition held in 1971 at the Los Angeles County Museum of Art and the Metropolitan Museum of Art in New York, offers a concise, if familiar, history of Cubism rather than detailed information about the works exhibited. With the exception of its neglect of Britain, it is fully as international as Wadley's study, again incorporating the Czech material, but far more traditional and restrictive in interpretation and in time span (1907–21). Wadley's and Cooper's international view was again reflected in a large exhibition, Les Cubistes, held in 1973 (Bordeaux, Galerie des Beaux-Arts, and Paris, Musée d'Art Moderne de la Ville de Paris). It presented works by little-known minor artists (Maria Blanchard, Emilio Pettoruti, Antonin Prochazka) as well as rarely seen works by major ones. Other general presentations of Cubism include Paul Waldo Schwartz, Cubism, New York, 1971, most original in its incorporation of literary parallels, and Max Kozloff, Cubism/Futurism, which offers many vivid descriptions of familiar works.

More detailed investigations of questions of documentation and interpretation have been abundant in the last decade, and were typified by the scholarly colloquium on Cubism held in 1971 and then published: Université de Saint-Étienne, Centre Interdisciplinaire d'Études et de Recherche sur l'Expression contemporaine, Le Cubisme (Travaux IV), Paris, 1973. Several articles have offered important revisions in the traditionally accepted dates of papiers collés by Braque and Picasso: Bernard Dorival, "Musée National d'Art Moderne; les préemptions de l'État à la seconde vente André Lefèvre," La Revue du Louvre et des musées de France, XVI (1966), pp. 27–36, 111–20; Robert Rosenblum, "Picasso and the Coronation of Alexander III: A Note on the Dating of Some Papiers Collés," Burlington Magazine, CXIII (October, 1971), pp. 604–7; Pierre Daix, "Des bouleversements chronologiques dans la Révolution des papiers collés (1912–1914)," Gazette des Beaux-Arts, LXXXII (October, 1973), pp. 217–27. More evidence for the study of early Cubism is offered in Edward F. Fry, "Cubism 1907–1908: An Early Eyewitness Account," Art Bulletin, XLVIII (March, 1966), pp. 70–73, which discusses the American painter Gelett Burgess's visits to the studios of Cubist artists, especially those of

Braque and Picasso. The question of the impact of African art on Picasso and on Cubism has been renewed in the detailed study by Jean Laude, La Peinture française (1905–1914) et "l'art nègre," Paris, 1968; and a contrary viewpoint is asserted in Pierre Daix, "Il n'y a pas d'art nègre das les 'Demoiselles d'Avignon,' " Gazette des Beaux-Arts, LXXVI (October, 1970), pp. 247–69. Other aspects of Cubism are treated in Robert Rosenblum, "Picasso and the Typography of Cubism," in Roland Penrose and John Golding, eds., Picasso in Retrospect, New York, 1973, pp. 49–75, which considers the multiple meanings of the choice of words in Cubist art; in Mortimer Guiney, Cubisme et littérature, Geneva, 1972, a solid study of the aesthetic of Cubism as applied to literature; and in L.D. Henderson, "A New Facet of Cubism: 'The Fourth Dimension' and 'Non-Euclidean Geometry' Reinterpreted," Art Quarterly, XXXIV (Winter 1971), pp. 410–33, a clarification of the mathematical analogies traditionally ascribed to Cubism.

Picasso studies in particular have been especially rich and innovative in recent years, not only in the context of many of the above-mentioned studies of Cubism, but in more monographic terms as well. Although the 85th-birthday Picasso exhibition in Paris yielded a catalogue with almost no information at all (Hommage à Pablo Picasso, Paris, Grand Palais and Musée du Petit Palais, 1966–67), this was happily an exception. A new catalogue raisonné of the Cubist works is soon to be published by Pierre Daix, a continuation of his and Georges Boudaille's Picasso: the Blue and Rose Periods; A Catalogue Raisonné of the Paintings, 1900–06, New York, 1967. The Picasso holdings of the Philadelphia Museum have now been discussed in Robert Rosenblum, "Picasso at the Philadelphia Museum of Art," Bulletin, Philadelphia Museum of Art, LXII (January–March, 1967), pp. 167–98; and those of the Museum of Modern Art, New York, have been catalogued and analyzed with exemplary precision in William Rubin, Picasso in the Collection of the Museum of Modern Art, New York, 1972. Individual works by Picasso have been getting closer scholarly attention than ever before, with Les Demoiselles d'Avignon appropriately receiving the lion's share: Günter Bandmann, Les Demoiselles d'Avignon (Werkmonographien zur bildenden Kunst in Reclams Universal-Bibliothek, no. 109), Stuttgart, 1965; Leo Steinberg, "The Philosophical Brothel," Art News, LXXI (September,

1972), pp. 20–29 and LXXI (October, 1972), pp. 38–47; Robert Rosenblum, "The 'Demoiselles d'Avignon' Revisited," Art News, LXXII (April, 1973), pp. 45–48; and Michel Hoog, "Les 'Demoiselles d'Avignon' et la peinture à Paris en 1907–08," Gazette des Beaux-Arts, LXXXII (October, 1973), pp. 209–16. Other useful contributions to the knowledge of specific works by Picasso are found in Christian Geelhaar, "Pablo Picassos Stilleben 'Pains et compotier aux fruits sur une table': Metamorphosen einer Bildidee," Pantheon, XXVIII/2 (1970), pp. 127–40; and Roland Penrose, "Picasso's Portrait of Kahnweiler," Burlington Magazine, CLXVI (March, 1974), pp. 124–31. An informative consideration of the impact of Catalonia on Picasso's Cubist work (i.e., the towns of Horta de Ebro, Cadaqués, and Céret) is found in Josep Palau i Fabre, Picasso en Cataluña, Barcelona, 1966. Knowledge of the cultural milieu around Picasso has been furthered by the exhibition Four Americans in Paris: The Collection of Gertrude Stein and Her Family, New York, Museum of Modern Art, 1970. Stein's writings about Picasso have also been anthologized and well-documented in Edward Burns, ed., Gertrude Stein on Picasso, New York, 1970. For a provocative reinterpretation of Picasso's Cubist space, see Leo Steinberg, "The Algerian Women and Picasso at Large," in Other Criteria, New York, 1972, pp. 125–234. For Picasso's sculpture, see Roland Penrose, The Sculpture of Picasso, New York, 1967; and Werner Spies, Picasso Sculpture, New York, 1972.

As for the other major Cubists, Braque has been the subject of a literate and sensible monograph: Edwin Mullins, The Art of Georges Braque, New York, 1968; and his Cubist work has now been fully catalogued in Marco Valsecchi, L'Opera completa di Braque, dalla scomposizione cubista al recupero dell'oggetto, 1908–1929, Milan, 1971. Gris has profited from a revised edition (New York, 1969) of the standard monograph by Daniel Henry Kahnweiler, an edition which brings the bibliography up to date and adds a catalogue of graphic work; as well as from a large exhibition (Juan Gris, Paris, Orangerie des Tuileries, 1974) and a copiously illustrated new monograph, Juan Antonio Gaya Nuño, Juan Gris, Barcelona, 1974. Of special consequence was the brilliant and original exhibition Léger and Purist Paris, London, Tate Gallery, 1970–71, whose catalogue by John Golding and Christopher Green offers innumerable new insights into the style, icono-

graphy, and milieu of Léger and of Parisian painting and sculpture in the decade 1918–28.

The past ten years have also seen an increase in knowledge about many lesser or more peripheral Cubist painters in the Parisian milieu, as well as about several Cubist sculptors. For two useful exhibition catalogues, see Richard V. West, *Painters of the Section d'Or; the Alternatives to Cubism*, Buffalo, Albright-Knox Art Gallery, 1967; and *The Cubist Circle*, Art Gallery, University of California, Riverside, 1971. For La Fresnaye there is now a definitive *catalogue raisonné*: Germain Seligman, *Roger de La Fresnaye*, Greenwich, Conn., 1969. Other important new monographs and exhibition catalogues include: Gustav Vriesen and Max Imdahl, *Robert Delaunay: Light and Color*, New York. 1969; *Hayden, soixante ans de la peinture, 1908–1968*, Paris, Musée National d'Art Moderne, 1968; George Heard Hamilton and William Agee, *Raymond Duchamp-Villon, 1876–1918*, New York, 1967; Werner Hofmann, *The Sculpture of Henri Laurens*, New York, 1970; Alexander Archipenko, University of California, Los Angeles, 1967. For an important new interpretation of Cubist sculpture within a general historical context, see Albert E. Elsen, *Origins of Modern Sculpture: Pioneers and Premises*, New York, 1974.

Knowledge about Cubism in the Anglo-Saxon world has been considerably expanded by two exhibition catalogues: *Cubism: Its Impact in the U.S.A., 1910–1930* (intro. by Clinton Adams), Albuquerque, University of New Mexico Art Museum, 1967; and *Abstract Art in England, 1913–1915*, London, d'Offay Couper Gallery, 1969. Other studies that refine considerably our information about the impact of Cubism on non-French or on primarily non-Cubist artists include: Marianne W. Martin, *Futurist Art and Theory, 1909–1915*, Oxford, 1968; Robert P. Welsh, *Piet Mondrian, 1872–1944*, The Art Gallery of Toronto, 1966; William A. Camfield, *Francis Picabia*, New York, The Solomon R. Guggenheim Museum, 1970; and Arturo Schwarz, *The Complete Works of Marcel Duchamp*, New York, 1969.

New York, 1976 R. R.

List of Illustrations

COLORPLATES

I. Pablo Picasso. *Les Demoiselles d'Avignon*. 1907. Oil on canvas, 96× 92″. The Museum of Modern Art, New York (Acquired through the Lillie P. Bliss Bequest)

II. Pablo Picasso. *Still Life with Skull*. 1907. Oil on canvas, 45¼×34⅝″. The Hermitage Museum, Leningrad

III. Pablo Picasso. *Nude in the Forest (La Grande dryade)*. 1908. Oil on canvas, 73¼×42⅛″. The Hermitage Museum, Leningrad

IV. Pablo Picasso. *Fruit and Wineglass*. 1908. Gouache on wood, 10⅝×8⅝″. The Museum of Modern Art, New York (Promised gift of Mr. and Mrs. John Hay Whitney)

V. Pablo Picasso. *Landscape*. 1908. Watercolor, 24¾×18⅝″. Kunstmuseum, Bern (The Hermann and Margrit Rupf Collection)

VI. Georges Braque. *Houses at L'Estaque*. 1908. Oil on canvas, 28¾× 23⅝″. Kunstmuseum Bern (The Hermann and Margrit Rupf Collection)

VII. Pablo Picasso. *Still Life with Gourd*. 1909. Oil on canvas, 28¾× 23⅝″. Collection Mr. and Mrs. John Hay Whitney, New York

VIII. Pablo Picasso. *Portrait of Ambroise Vollard*. 1909–10. Oil on canvas, 36¼×25⁹/₁₆″. Pushkin Museum, Moscow

IX. Georges Braque. *Still Life with Violin and Pitcher*. 1909–10. Oil on canvas, 46½×28¾″. Kunstmuseum, Basel

X. Georges Braque. *The Portuguese*. Spring 1911. Oil on canvas, 45⅞× 32⅛″. Kunstmuseum, Basel

XI. Pablo Picasso. *Ma Jolie (Woman with Guitar)*. Winter 1911–12. Oil on canvas, 39⅜×25¾″. The Museum of Modern Art, New York (Acquired through the Lillie P. Bliss Bequest)

XII. Pablo Picasso. *Violin*. 1913. Oil and sand on canvas, 25⁹/₁₆×18⅛″. Kunstmuseum, Bern (The Hermann and Margrit Rupf Collection)

XIII. Georges Braque. *The Clarinet*. 1913. Pasted paper, charcoal, chalk, and oil on canvas, 37½×47⅜″. Private collection, New York

XIV. Pablo Picasso. *Still Life in a Landscape*. 1915. Oil on canvas, 24⅜×29½″. Collection Heinz Berggruen, Paris

XV. Pablo Picasso. *Dog and Cock*. 1921. Oil on canvas, 61×30¼″. Yale University Art Gallery, New Haven (Gift of Stephen C. Clark)

XVI. Georges Braque. *Still Life with Guitar and Fruit*. 1924. Oil and sand on canvas, 45⅝×23⅝″. Private collection, France

XVII. Pablo Picasso. *Still Life with Guitar*. 1924. Oil on canvas, 38⅜×51⅛″. Stedelijk Museum, Amsterdam

XVIII. Juan Gris. *Still Life with Bottles*. 1912. Oil on canvas, 21½×18⅛″. Rijksmuseum Kröller-Müller, Otterlo, Holland

XIX. Juan Gris. *The Watch (The Sherry Bottle)*. 1912. Oil and pasted papers on canvas, 25¾×36¼″. Collection Hans Grether, Basel

XX. Juan Gris. *Still Life Before an Open Window: Place Ravignan*. 1915. Oil on canvas, 45⅞×35⅛″. Philadelphia Museum of Art (Louise and Walter Arensberg Collection)

XXI. Juan Gris. *Guitar with Sheet of Music*. 1926. Oil on canvas, 25⅝× 31⅞″. Collection Mr. and Mrs. Daniel Saidenberg, New York

XXII. Fernand Léger. *Nudes in the Forest*. 1909–10. Oil on canvas, 47¼×67″. Rijksmuseum Kröller-Müller, Otterlo, Holland

XXIII. Fernand Léger. *The Stairway*. 1913. Oil on canvas, 56¾×46½″. Kunsthaus, Zurich

XXIV. Fernand Léger. *The Cardplayers*. 1917. Oil on canvas, 50⅞×76″. Rijksmuseum Kröller-Müller, Otterlo, Holland

XXV. Fernand Léger. *Animated Landscape: Man and Dog*. 1921. Oil on canvas, 25⅝×36¼″. Private collection, Paris

XXVI. Robert Delaunay. *Homage to Blériot*. 1914. Watercolor on canvas, 98⁷/₁₆×98⁷/₁₆″. Kunstmuseum, Basel

XXVII. Marcel Duchamp. *Nude De-*

scending a Staircase, No. 1. 1911. Oil on cardboard, 37¾×23½". Philadelphia Museum of Art (Louise and Walter Arensberg Collection)

XXVIII. Jacques Villon. Marching Soldiers. 1913. Oil on canvas, 25⁹⁄₁₆× 36¼". Galerie Louis Carré, Paris

XXIX. Roger de La Fresnaye. The Conquest of the Air. 1913. Oil on canvas, 92⅞×77". The Museum of Modern Art, New York (Mrs. Simon Guggenheim Fund)

XXX. Umberto Boccioni. Elasticity. 1912. Oil on canvas, 39⅜×39⅜". Collection Dr. Riccardo Jucker, Milan

XXXI. Franz Marc. Deer in a Forest, II. 1913–14. Oil on canvas, 43¼×39⅜". Staatliche Kunsthalle, Karlsruhe

XXXII. Ben Nicholson. Still Life. 1929–35. Oil and pencil on canvas, 26×32". Collection C. S. Reddihough, Ilkley, England

XXXIII. Stuart Davis. Colonial Cubism. 1954. Oil on canvas, 45×60". Walker Art Center, Minneapolis (Courtesy the Downtown Gallery, New York)

XXXIV. Piet Mondrian. Composition No. 3 (Trees). About 1912. Oil on canvas, 37⁷⁄₁₆×31½". Gemeentemuseum, The Hague (S. B. Slijper Collection, Loan)

XXXV. Marc Chagall. Half-Past Three (The Poet). 1911. Oil on canvas, 77½× 57½". Philadelphia Museum of Art (Louise and Walter Arensberg Collection)

XXXVI. Paul Klee. Clown. 1929. Mixed medium, 26¾×19⅝". Collection Mr. and Mrs. William A. Bernoudy, Ladue, Missouri

XXXVII. Joan Miró. Still Life with Toy Horse. 1920. Oil on canvas, 32½×29⅝". Collection Mr. and Mrs. Earle Miller, Downingtown, Pennsylvania

XXXVIII. Pablo Picasso. The Studio. 1927–28. Oil on canvas, 59×91". The Museum of Modern Art, New York (Gift of Walter P. Chrysler, Jr.)

XXXIX. Pablo Picasso. Still Life on a Table. 1931. Oil on canvas, 76¾×51⅝". Estate of the artist

XL. Georges Braque. The Pink Tablecloth. 1933. Oil and sand on canvas, 38¼×51¼". Collection Walter P. Chrysler, Jr., New York

BLACK-AND-WHITE
ILLUSTRATIONS

1. Pablo Picasso. Girl on a Ball. 1905. Oil on canvas, 57½×37". Pushkin Museum, Moscow

2. Pablo Picasso. Self-Portrait. 1901. Oil on canvas, 31⅞×23⅝". Estate of the artist

3. Pablo Picasso. Self-Portrait. 1906. Oil on canvas, 36½×28¾". Philadelphia Museum of Art (A. E. Gallatin Collection)

4. Pablo Picasso. Two Nudes. 1906. Oil on canvas, 59⅞×39⅜". Private collection, Solothurn, Switzerland

5. Pablo Picasso. Two Nudes. 1906. Oil on canvas, 59⅝×36⅝". The Museum of Modern Art, New York (Gift of G. David Thompson in honor of Alfred H. Barr, Jr.)

6. Pablo Picasso. Family of Saltimbanques. 1905. Oil on canvas, 83¾× 90⅜". National Gallery of Art, Washington, D.C. (Chester Dale Collection)

7. Pablo Picasso. Study for "Les Demoiselles d'Avignon." 1907. Charcoal and pastel, 18⅞×25". Estate of the artist

8. Pablo Picasso. Woman (study for Les Demoiselles d'Avignon). 1906–7. Oil on canvas, 46⅞×36⅝". Private collection

9. Pablo Picasso. Dancer. 1907. Oil on canvas, 59×39¼". Collection Walter P. Chrysler, Jr., New York

10. African Sculpture (Bakota). Funerary Fetish. Brass sheeting over wood, 27¾" high. Reproduced by courtesy of the Smithsonian Institution, Washington, D. C. (Herbert Ward Collection)

11. Pablo Picasso. Dwarf Dancer. 1901. Oil on canvas, 41⅝×23¾". Museo de Arte Moderno, Barcelona

12. Georges Braque. Large Nude. 1907–8. Oil on canvas, 55¾×40". Galerie Alex Maguy, Paris

13. Paul Cézanne. Still Life: Jug of Milk and Fruit. 1888–90. Oil on canvas, 29⅞ ×38¼". Nasjonalgalleriet, Oslo

14. Paul Cézanne. Turning Road at Montgeroult. 1899. Oil on canvas, 31½ ×25⅝". Collection The Hon. and Mrs. John Hay Whitney, New York

15. Georges Braque. L'Estaque. 1906. Oil on canvas, 23¼×28⅜". Musée de l'Annonciade, Saint-Tropez, France

16. Georges Braque. Viaduct at L'Estaque. 1907. Oil on canvas, 25⅝ ×31⅞". Present owner unknown

17. Pablo Picasso. Flowers.1907. Oil on canvas, 36½×28½". The Museum of Modern Art, New York

18. Pablo Picasso. The Fishes. 1909. Gouache on panel, 8¼×10⅝". Private collection, France

19. Georges Braque. View of La Roche-Guyon. 1909. Oil on canvas, 25⁹⁄₁₆× 21¼". Collection Mr. and Mrs. George W. Staempfli, New York

20. Georges Braque. View of La Roche-Guyon. 1909. Oil on canvas, 36¼× 28½". Stedelijk van Abbemuseum, Eindhoven, Holland

21. Pablo Picasso. The Reservoir, Horta. Summer 1909. Oil on canvas, 23¾×19¾". Private collection, New York (formerly Collection Gertrude and Leo Stein)

22. Pablo Picasso. Sacré-Coeur. 1909. Oil on canvas, 36¼×25⅝". Estate of the artist

23. Georges Braque. View of Sacré-Coeur from the Artist's Studio. Summer 1910. Oil on canvas, 21⅝×16". Private collection, France

24. Georges Braque. Head of a Woman. 1909. Oil on canvas, 16⅛×13". Musée d'Art Moderne de la Ville de Paris

25. Pablo Picasso. Seated Woman (Woman in Green). 1909. Oil on canvas, 37¾×31½". Stedelijk van Abbemuseum, Eindhoven, Holland

26. Pablo Picasso. Gertrude Stein. 1906. Oil on canvas, 39¼×32". The Metropolitan Museum of Art, New York (Bequest of Gertrude Stein, 1946)

27. Pablo Picasso. Seated Woman. 1909. Oil on cardboard, 39×27⁹⁄₁₆". Collection Georges Salles, Paris

28. Pablo Picasso. Girl with Mandolin (Fanny Tellier). 1910. Oil on canvas, 39½×29". The Museum of Modern Art, New York (Promised gift of Nelson A. Rockefeller)

29. Pablo Picasso. Wilhelm Uhde. Spring 1910. Oil on canvas. 30¾×22¾". Collection Roland Penrose, London

30. Georges Braque. Violin and Palette. 1909–10. Oil on canvas, 36¼×16⅞". The Solomon R. Guggenheim Museum, New York

31. Georges Braque. Céret: The Rooftops. Summer 1911. Oil on canvas, 32⅜ ×23¼". Collection Mr. and Mrs. Ralph F. Colin, New York

32. Georges Braque. Man with a Guitar. Summer 1911. Oil on canvas, 45¾× 31⅞". The Museum of Modern Art, New York (Acquired through the Lillie P. Bliss Bequest)

33. Pablo Picasso. The Accordionist. Summer 1911. Oil on canvas, 51¼× 35¼". The Solomon R. Guggenheim Museum, New York

34. Pablo Picasso. Nude. 1910. Charcoal, 19 ×12¼". The Metropolitan Museum of Art, New York (Alfred Stieglitz Collection, 1949)

35. Georges Braque. Soda. 1911. Oil on canvas, 14¼" diameter. The Museum of Modern Art, New York (Acquired through the Lillie P. Bliss Bequest)

36. Pablo Picasso. Still Life with Chair Caning. May 1912. Oil and pasted oilcloth on canvas, 10⅝×13¾" (oval). Estate of the artist

37. Georges Braque. *The Fruit Dish.* 1912. Pasted paper and charcoal on paper, 24×17½″. Private collection, France

38. Pablo Picasso. *Bottle, Glass, Violin.* 1912–13. Charcoal with pasted papers, 18½×24⅝″. Moderna Museet, Stockholm

39. Pablo Picasso. *Spanish Still Life.* 1912. Oil on canvas, 18⅛×13″. Private collection, France

40. Pablo Picasso. *Dead Birds.* 1912. Oil on canvas, 18⅛×25⁹⁄₁₆″. Private collection, France

41. Pablo Picasso. *Bottle of Vieux Marc, Glass, Newspaper.* Spring 1913. Charcoal and pasted papers, 24⅝×18½″. Musée National d'Art Moderne, Paris

42. Pablo Picasso. *Violin.* 1912. Oil on canvas, 21⅝×18⅛″. Pushkin Museum, Moscow

43. Georges Braque. *Oval Still Life (Le Violon).* Spring 1914. Oil on canvas, 36⅜×25¾″. The Museum of Modern Art, New York (Gift of the Advisory Committee)

44. Georges Braque. *Le Guéridon.* Spring 1912. Oil on canvas, 45¾×31⅞″. Musée National d'Art Moderne, Paris

45. Pablo Picasso. *Man with a Hat.* December 1912. Charcoal, ink, pasted paper, 24½×18⅝″. The Museum of Modern Art, New York (Purchase)

46. Pablo Picasso. *Student with a Newspaper.* 1913–14. Oil and sand on canvas, 28⁵⁄₁₆×23⅝″. Private collection, Paris

47. Georges Braque. *Woman with Guitar.* 1913. Oil and charcoal on canvas, 51¼×29″. Musée National d'Art Moderne, Paris

48. Pablo Picasso. *Still Life with Calling Card.* 1914. Pasted papers and pencil, 5½×8¼″. Private collection

49. Georges Braque. *Bottle, Glass, and Pipe (Violette de Parme).* 1913. Pasted paper and charcoal on gesso on cardboard, 19½×25½″. Private collection

50. Pablo Picasso. *Plate with Wafers.* 1914. Pencil, 11¹³⁄₁₆×18⅞″. Estate of the artist

51. Pablo Picasso. *Still Life, "Ma Joie."* 1914. Oil on canvas, 17¾×16″. Collection H. Berggruen, Paris

52. Georges Braque. *Music.* 1914. Oil on canvas with gesso and sawdust, 36×23½″. The Phillips Collection, Washington, D. C. (Katherine S. Dreier Bequest)

53. Pablo Picasso. *Diaghilev and Selisburg.* 1919 (1917?). Pencil, 24⅞×18⅞″. Estate of the artist

54. Pablo Picasso. *Portrait of Olga in an Armchair.* 1919 (1917?). Oil on canvas, 51¹³⁄₁₆×35″. Estate of the artist

55. Pablo Picasso. *Max Jacob.* 1915. Pencil, 13×9⅞″. Private collection, Paris

56. Pablo Picasso. *Ambroise Vollard.* 1915. Pencil, 18⅜×12½″. The Metropolitan Museum of Art, New York (Whittelsey Fund)

57. Pablo Picasso. *Harlequin.* 1915. Oil on canvas, 72¼×41⅜″. The Museum of Modern Art, New York (Acquired through the Lillie P. Bliss Bequest)

58. Pablo Picasso. *The Window.* 1919. Gouache, 13¾×9¾″. Private collection, New York

59. Pablo Picasso. *Page of sketches.* 1919. Pencil, 12½×8⅝″. Private collection

60. Pablo Picasso. *Guitar, Bottle, and Fruit Dish.* 1921. Oil on canvas, 39⅜×35⁷⁄₁₆″. Landesmuseum, Hanover

61. Pablo Picasso. *The Pipes of Pan.* 1923. Oil on canvas, 80½×68⅝″. Estate of the artist

62. Pablo Picasso. *Three Musicians.* 1921. Oil on canvas, 79×87¾″. The Museum of Modern Art, New York (Mrs. Simon Guggenheim Fund)

63. Georges Braque. *Musician.* 1917–18. Oil on canvas, 86¾×44⅜″. Kunstmuseum, Basel

64. Georges Braque. *Café-Bar.* 1919. Oil on canvas, 45⅝×28¾″. Kunstmuseum, Basel

65. Georges Braque. *Musical Forms (Guitar and Clarinet).* 1918. Pasted paper, corrugated cardboard, charcoal, and gouache on cardboard, 30⅜×37⅜″. Philadelphia Museum of Art (Louise and Walter Arensberg Collection)

66. Pablo Picasso. *Still Life with a Cake.* 1924. Oil on canvas, 38½×51½″. The Museum of Modern Art, New York (Acquired through the Lillie P. Bliss Bequest)

67. Juan Gris. *Portrait of Picasso.* 1912. Oil on canvas, 37×29½″. Collection Mr. and Mrs. Leigh B. Block, Chicago

68. Francisco de Zurbarán. *Still Life with Oranges.* 1633. Oil on canvas, 23⅝×42⅛″. Collection Count Alessandro Contini-Bonacossi, Florence

69. Paul Cézanne. *The Black Clock.* About 1870. Oil on canvas, 21¾×29¼″. Collection Stavros S. Niarchos

70. Juan Gris. *Still Life.* 1911. Oil on canvas, 23½×19¾″. The Museum of Modern Art, New York (Acquired through the Lillie P. Bliss Bequest)

71. Juan Gris. *Violin and Engraving.* 1913. Oil and pasted papers on canvas, 25⅝×19⅝″. The Museum of Modern Art, New York (Bequest of Anna Erickson Levene in memory of her husband, Dr. Phoebus Levene)

72. Juan Gris. *Smoker.* 1913. Oil on canvas, 28⅞×21½″. Collection Mr. and Mrs. Armand P. Bartos, New York

73. Juan Gris. *The Table.* 1914. Colored papers, printed matter, charcoal, and gouache on canvas, 23½×17½″. Philadelphia Museum of Art (A. E. Gallatin Collection)

74. Pablo Picasso. *La Table de Toilette.* 1910. Oil on canvas, 24×18¼″. Collection Mr. and Mrs. Ralph F. Colin, New York

75. Juan Gris. *Portrait of Max Jacob.* 1919. Pencil, 14×10¼″. The Museum of Modern Art, New York (Gift of James Thrall Soby)

76. Juan Gris. *Harlequin.* 1919. Oil on canvas, 39⅝×25¾″. Collection Mr. and Mrs. Morton G. Neumann, Chicago

77. Juan Gris. *Le Canigou.* 1921. Oil on canvas, 25¾×39⅝″. Room of Contemporary Art, Albright-Knox Art Gallery, Buffalo

78. Juan Gris. *The Scissors.* 1926. Oil on canvas, 19½×24″. Private collection

79. Fernand Léger. *Woman Sewing.* 1909–10. Oil on canvas, 28⅜×21¼″. Private collection

80. Fernand Léger. *Paris Seen Through a Window.* 1912. Oil on canvas, 28×20⅞″. Collection Ingeborg Pudelko Eichmann, Florence

81. Fernand Léger. *The City.* 1919. Oil on canvas, 91×117½″. Philadelphia Museum of Art (A. E. Gallatin Collection)

82. Nicolas Poussin. *Holy Family.* 1651. Oil on canvas, 38½×51″. Fogg Art Museum, Harvard University, Cambridge, Massachusetts

83. Fernand Léger. *Three Women (Le Grand déjeuner).* 1921. Oil on canvas, 72¼×99″. The Museum of Modern Art, New York (Mrs. Simon Guggenheim Fund)

84. Fernand Léger. *The Siphon.* 1924. Oil on canvas, 25½×18″. Collection Mrs. Arthur C. Rosenberg, Chicago

85. Le Corbusier (Charles-Édouard Jeanneret). View of the Pavillon de l'Esprit Nouveau, Paris. 1925. With paintings on the wall by Léger (left) and Le Corbusier (right)

86. Fernand Léger. *Composition No. 7.* 1925. Oil on canvas, 51½×35¼″. Yale University Art Gallery, New Haven (Collection of the Société Anonyme)

87. Amédée Ozenfant. *Fugue.* 1925. Pencil, 18×22″. The Museum of Modern Art, New York (Gift of the artist)

88. Amédée Ozenfant. *Theme and Variations.* 1925. Oil on canvas, 39⅝ × 31⅞". Private collection, Paris

89. Le Corbusier (Charles-Édouard Jeanneret). *Still Life.* 1920. Oil on canvas, 31⅞ × 39¼". The Museum of Modern Art, New York (Van Gogh Purchase Fund)

90. Le Corbusier (Charles-Édouard Jeanneret). *Still Life with Many Objects.* 1923. Oil on canvas, 44⅞ × 57½". Musée National d'Art Moderne, Paris

91. Fernand Léger. *Landscape with Cows.* 1937. Oil on canvas, 36¼ × 23⅝". Present owner unknown

92. Fernand Léger. *Two Acrobats.* 1942–43. Oil on canvas, 49½ × 57". Sidney Janis Gallery, New York

93. Fernand Léger. *The Builders. 1950.* Oil on canvas, 118⅛ × 78¾". Collection Mme. F. Léger, Biot, France

94. Robert Delaunay. *Saint-Séverin.* 1909. Oil on canvas, 38 × 27¾". Philadelphia Museum of Art (Louise and Walter Arensberg Collection)

95. Robert Delaunay. *The Eiffel Tower.* 1910–11. Oil on canvas, 78½ × 50¾". Kunstmuseum, Basel (Emanuel Hoffmann Stiftung)

96. Robert Delaunay. *City of Paris.* 1912. Oil on canvas, 105⅛ × 159⅞". Musée National d'Art Moderne, Paris

97. Robert Delaunay. *Simultaneous Disk.* 1912. Oil on canvas, 53" diameter. Collection Mr. and Mrs. Burton Tremaine, Meriden, Connecticut

98. Marcel Duchamp. *The Chess Players.* 1910. Oil on canvas, 45 × 57⅞". Philadelphia Museum of Art (Louise and Walter Arensberg Collection)

99. Marcel Duchamp. *Portrait of Chess Players.* 1911. Oil on canvas, 39¾ × 39¾". Philadelphia Museum of Art (Louise and Walter Arensberg Collection)

100. Marcel Duchamp. *Yvonne and Magdeleine Torn in Tatters (The Sisters).* 1911. Oil on canvas, 23½ × 28¾". Philadelphia Museum of Art (Louise and Walter Arensberg Collection)

101. Marcel Duchamp. *Nude Descending a Staircase, No. 2.* 1912. Oil on canvas, 58 × 35". Philadelphia Museum of Art (Louise and Walter Arensberg Collection)

102. Marcel Duchamp. *The Bride.* 1912. Oil on canvas, 35⅛ × 21¾". Philadelphia Museum of Art (Louise and Walter Arensberg Collection)

103. Francis Picabia. *Dances at the Spring.* 1912. Oil on canvas, 47½ × 47½". Philadelphia Museum of Art (Louise and Walter Arensberg Collection)

104. Francis Picabia. *Procession in Seville.* 1912. Oil on canvas, 47¼ × 47¼". Herbert and Nannette Rothschild Collection, New York

105. Francis Picabia. *I See Again in Memory My Dear Udnie.* 1914. Oil on canvas, 98½ × 78¼". The Museum of Modern Art, New York (Hillman Periodicals Fund)

106. Jacques Villon. *Chessboard.* 1920. Etching, 7⅞ × 6¼". The Museum of Modern Art, New York (Gift of Ludwig Charell)

107. Jacques Villon. *Study for "The Jockey."* 1921. Pencil and watercolor on tracing paper, 15¼ × 21¾". Yale University Art Gallery, New Haven (Collection of the Société Anonyme)

108. Jacques Villon. *The Jockey.* 1924. Oil on canvas, 25⅜ × 50¼". Yale University Art Gallery, New Haven (Collection of the Société Anonyme)

109. Jacques Villon. *Color Perspective.* 1921. Oil on canvas, 21⅜ × 28⅝". The Solomon R. Guggenheim Museum, New York (Gift of Katherine S. Dreier Estate)

110. Jacques Villon. *Large Mowing Machine with Horses.* 1950. Oil on canvas, 38⅜ × 57¾". Collection Richard S. Zeisler, New York

111. Roger de La Fresnaye. *The Cuirassier.* 1910–11. Oil on canvas, 70⅞ × 70⅞". Musée National d'Art Moderne, Paris

112. Théodore Géricault. *Wounded Cuirassier.* 1814. Oil on canvas, 115 × 89⅝". The Louvre, Paris

113. Roger de La Fresnaye. *Artillery.* 1911. Oil on canvas, 51¼ × 62¾". Private collection, New York

114. Roger de La Fresnaye. *Landscape (The Village of Meulan).* 1912. Oil on canvas, 18¾ × 23¾". Philadelphia Museum of Art (Louise and Walter Arensberg Collection)

115. Jean Metzinger. *Tea Time (Le Goûter).* 1911. Oil on wood, 29¾ × 27⅜". Philadelphia Museum of Art (Louise and Walter Arensberg Collection)

116. Jean Metzinger. *Dancer.* 1912. Oil on canvas, 57½ × 45". Room of Contemporary Art, Albright-Knox Art Gallery, Buffalo

117. Albert Gleizes. *Eugène Figuière.* 1913. Oil on canvas, 56⅜ × 40⅛". Musée des Beaux-Arts, Lyon

118. Albert Gleizes. *Woman at the Piano.* 1914. Oil on canvas, 57⅝ × 44¾". Philadelphia Museum of Art (Louise and Walter Arensberg Collection)

119. André Lhote. *Rugby.* 1917. Oil on canvas, 50 × 52". Musée National d'Art Moderne, Paris

120. Louis Marcoussis. *Portrait of Guillaume Apollinaire.* 1912–20. Etching and drypoint, 19½ × 10⅞". The Museum of Modern Art, New York (Given anonymously)

121. Albert Gleizes. *Brooklyn Bridge.* 1915. Oil and mixed mediums on canvas, 40⅛ × 40⅛". The Solomon R. Guggenheim Museum, New York

122. Louis Marcoussis. *Still Life with Chessboard.* 1912. Oil on canvas, 54¾ × 36⅝". Musée National d'Art Moderne, Paris

123. Henri Hayden. *Three Musicians.* 1919–20. Oil on canvas, 69¼ × 69¼". Musée National d'Art Moderne, Paris

124. Umberto Boccioni. *The City Rises.* 1910–11. Oil on canvas, 78½ × 118½". The Museum of Modern Art, New York (Mrs. Simon Guggenheim Fund)

125. Umberto Boccioni. *States of Mind I: The Farewells.* 1911. Oil on canvas, 26¾ × 37⅜". Private collection, New York

126. Carlo Carrà. *The Milan Galleria.* 1912. Oil on canvas, 35⅞ × 20¼". Collection Gianni Mattioli, Milan

127. Gino Severini. *Dynamic Hieroglyphic of the Bal Tabarin.* 1912. Oil on canvas, with sequins, 63⅝ × 61½". The Museum of Modern Art, New York (Acquired through the Lillie P. Bliss Bequest)

128. Giacomo Balla. *Speeding Automobile.* 1912. Oil on wood, 21⅞ × 27⅛". The Museum of Modern Art, New York (Purchase)

129. Luigi Russolo. *The Revolt.* 1911. Oil on canvas, 59 × 90⅝". Gemeentemuseum, The Hague

130. Gino Severini. *War.* 1915. Oil on canvas, 36¼ × 28¾". Collection Mr. and Mrs. Joseph Slifka, New York

131. Carlo Carrà. *Manifesto for Intervention.* 1914. Tempera and pasted papers, 15 × 12". Collection Gianni Mattioli, Milan

132. Umberto Boccioni. *Charge of Lancers.* 1915. Tempera and pasted papers, 13½ × 20". Collection Dr. Riccardo Jucker, Milan

133. Ernst Ludwig Kirchner. *Street with Red Woman.* 1914. Pastel, 16⅛ × 12". Staatsgalerie, Stuttgart (Graphische Sammlung)

134. August Macke. *Figures by the Blue Sea.* 1913. Oil on canvas, 23⅝ × 19⅛". Staatliche Kunsthalle, Karlsruhe

135. August Macke. *Kairouan I.* 1914. Watercolor, 8 1/16 × 9⅝". Private collection

136. Heinrich Campendonk. *Pastoral*

Scene. About 1920. Oil on wood, 37½ × 23¼". Yale University Art Gallery, New Haven (Collection of the Société Anonyme)

137. Franz Marc. *Animal Destinies.* 1913. Oil on canvas, 76¾ × 105½". Kunstmuseum, Basel

138. Franz Marc. *Blue Horses.* 1911. Oil on canvas, 41½ × 71½". Walker Art Center, Minneapolis

139. Caspar David Friedrich. *Mountain Gorge.* About 1812. Oil on canvas, 36⅝ × 28¾". Kunsthistorisches Museum, Vienna

140. Franz Marc. *Tirol.* 1913–14. Oil on canvas, 57⅞ × 59½". Bavarian State Picture Collection, Munich

141. Lyonel Feininger. *Bicycle Riders.* 1912. Oil on canvas, 33½ × 39⅜". Leonard Hutton Galleries, New York

142. Lyonel Feininger. *Barfüsserkirche in Erfurt.* 1924 (1927?). Oil on canvas, 39 × 31¼". Private collection, Germany

143. Lyonel Feininger. *The Glorious Victory of the Sloop Maria.* 1926. Oil on canvas, 21½ × 33½". City Art Museum of St. Louis

144. Lyonel Feininger. *Dunes with Ray of Light, II.* 1944. Oil on canvas, 20 × 35". Room of Contemporary Art, Albright-Knox Art Gallery, Buffalo

145. Caspar David Friedrich. *Monk by the Sea.* 1809. Oil on canvas, 42½ × 66⅞". Courtesy the Verwaltung der ehemals Staatlichen Schlösser und Gärten, Berlin

146. Wyndham Lewis. Illustration to Shakespeare's *Timon of Athens.* 1913 or 1914. Pen and watercolor, original size unknown, probably about 16 × 10". (Destroyed)

147. Ben Nicholson. *Banks Head–Castagnola.* About 1928–29. Pencil, 13½ × 16¾". Collection Helen Sutherland, Penrith, England

148. Ben Nicholson. *Au Chat Botté.* 1932. Oil on canvas, 36⅞ × 48¾". Manchester City Art Galleries, England

149. Ben Nicholson. *White Relief.* 1938. Oil and pencil on carved board, about 7 × 11". Collection the late E. McKnight Kauffer, London

150. Ben Nicholson. *Mousehole.* 1947. Oil on canvas, 18 × 23". The British Council, London

151. Max Weber. *Rush Hour, New York.* 1915. Oil on canvas, 36 × 30". National Gallery of Art, Washington, D.C. (Gift of the Avalon Foundation, 1970)

152. Max Weber. *Chinese Restaurant.* 1915. Oil on canvas, 40 × 48". Whitney Museum of American Art, New York

153. Joseph Stella. *Brooklyn Bridge.* 1917–18. Oil on canvas, 84 × 76". Yale University Art Gallery, New Haven (Collection of the Société Anonyme)

154. John Marin. *Woolworth Building, No. 31.* 1912. Watercolor, 19½ × 16". Estate of Mrs. Eugene Meyer, Washington, D.C.

155. John Marin. *Lower Manhattan.* 1922. Watercolor, 21⅝ × 26⅞". The Museum of Modern Art, New York (Gift of Mrs. John D. Rockefeller, Jr.)

156. John Marin. *Maine Islands.* 1922. Watercolor, 16¾ × 20". The Phillips Collection, Washington, D. C.

157. Winslow Homer. *Maine Coast.* 1895. Oil on canvas, 30¼ × 44¼". The Metropolitan Museum of Art, New York (Gift of George A. Hearn in memory of Arthur Hoppock Hearn, 1911)

158. Charles Sheeler. *Barn Abstraction.* 1917. Black conté crayon on paper, 14⅛ × 19½". Philadelphia Museum of Art (Louise and Walter Arensberg Collection)

159. Charles Demuth. *Stairs, Provincetown.* 1920. Watercolor, 13 × 7⅞". The Museum of Modern Art, New York (Gift of Mrs. John D. Rockefeller, Jr.)

160. Charles Demuth. " . . . and the Home of the Brave." 1931. Oil on canvas, 30 × 24". The Art Institute of Chicago (Gift of Miss Georgia O'Keeffe)

161. Stuart Davis. *Salt Shaker.* 1931. Oil on canvas, 49⅞ × 32". The Museum of Modern Art, New York (Gift of Mrs. Edith Gregor Halpert)

162. Stuart Davis. *Report from Rockport.* 1940. Oil on canvas, 24 × 30". Collection Mr. and Mrs. Milton Lowenthal, New York

163. Kasimir Malevich. *The Woodcutter.* 1911. Oil on canvas, 37 × 28⅛". Stedelijk Museum, Amsterdam

164. Kasimir Malevich. *Scissors Grinder.* 1912. Oil on canvas, 31⅜ × 31⅜". Yale University Art Gallery, New Haven (Collection of the Société Anonyme)

165. Kasimir Malevich. *Suprematist Composition: Red Square and Black Square.* 1914–16. Oil on canvas, 28 × 17½". The Museum of Modern Art, New York

166. Piet Mondrian. *The Red Tree.* 1908–9. Oil on canvas, 27⁹⁄₁₆ × 39". Gemeentemuseum, The Hague (S. B. Slijper Collection, Loan)

167. Piet Mondrian. *Seascape.* 1912. Oil on canvas, 32 × 36". Private collection, Switzerland (Courtesy Sidney Janis Gallery, New York)

168. Piet Mondrian. *Pier and Ocean.* 1914. Charcoal and india ink, 19¾ ×

24⅜". Collection Harry Holtzman, Lyme, Connecticut

169. Piet Mondrian. *Pier and Ocean.* 1914. Crayon, pencil, and wash, 34⅝ × 44". The Museum of Modern Art, New York (Mrs. Simon Guggenheim Fund)

170. Piet Mondrian. *Church at Domburg.* About 1914. India ink, 24⅞ × 19¾". Gemeentemuseum, The Hague (S. B. Slijper Collection, Loan)

171. Piet Mondrian. *Church Façade.* 1914. (misdated 1912 by artist). Charcoal drawing, 38 × 25". Estate of Lester Avnet

172. Piet Mondrian. *Composition No. 2 with Red, Blue, and Yellow.* 1929. Oil on canvas, 17¾ × 17¾". National Museum, Belgrade

173. Marc Chagall. *I and the Village.* 1911. Oil on canvas, 75⅝ × 59⅝". The Museum of Modern Art, New York (Mrs. Simon Guggenheim Fund)

174. Marc Chagall. *Candles in the Street.* 1908. Oil on canvas, 27⅛ × 34¼". Private collection

175. Marc Chagall. *The Drunkard.* 1911–12. Oil on canvas, 33½ × 45¼". Collection Frau Milada Neumann, Caracas

176. Marc Chagall. *The Pregnant Woman.* 1913. Oil on canvas, 76⅜ × 45¼". Stedelijk Museum, Amsterdam

177. Marc Chagall. *Paris Through the Window.* 1913. Oil on canvas, 52⅝ × 54¾". The Solomon R. Guggenheim Museum, New York

178. Paul Klee. *Hommage à Picasso.* 1914. Oil on cardboard, 13¾ × 11⅝". Collection Mr. and Mrs. Peter A. Rübel, Cos Cobb, Connecticut

179. Paul Klee. *Red and White Domes.* 1914. Watercolor, 6⅛ × 5½". Collection unknown

180. Paul Klee. *Uncomposed Components in Space.* 1929. Watercolor, 12⅝ × 9⅞". Private collection

181. Paul Klee. *Comedian, I.* 1904. Etching, 5¾ × 6¼". (Plate destroyed)

182. Paul Klee. *Villa R.* 1919. Oil on cardboard, 10⅜ × 8⅝". Kunstmuseum, Basel

183. Joan Miró. *Landscape with Olive Trees.* 1919. Oil on canvas, 28½ × 35½". Collection Mr. and Mrs. Leigh B. Block, Chicago

184. Joan Miró. *Nude with Mirror.* 1919. Oil on canvas, 44 × 40". Kunstmuseum, Düsseldorf

185. Joan Miró. *Still Life with Rabbit.* 1920. Oil on canvas, 51⅛ × 43¼". Collection G. Zumsteg, Zurich

186. Joan Miró. *Spanish Dancer.* 1924. Colored pencils, charcoal, 93¾ × 58½".

Collection René Gaffé, Cagnes-sur-Mer, France

187. Joan Miró. *The Tilled Field*. 1923–24. Oil on canvas, $26 \times 36\frac{5}{8}''$. The Solomon R. Guggenheim Museum, New York

188. Pablo Picasso. *Woman's Head*. 1909. Bronze, $16\frac{1}{4}''$ high. The Museum of Modern Art, New York (Purchase)

189. Roger de La Fresnaye. *Italian Woman*. 1912. Bronze, $24\frac{3}{8}''$ high. Galerie Maeght, Paris

190. Alexander Archipenko. *Walking Woman*. 1912. Painted bronze, $26\frac{1}{2}''$ high. The Denver Art Museum (Purchased from "Collectors' Choice")

191. Raymond Duchamp-Villon. *The Lovers*. 1913. Original plaster, $27\frac{1}{2} \times 46''$. The Museum of Modern Art, New York (Purchase)

192. Alexander Archipenko. *Boxing*. 1913–14. Terracotta, 31" high. Collection Peggy Guggenheim, Venice

193. Raymond Duchamp-Villon. *Seated Woman*. 1914. Bronze, 27" high. Yale University Art Gallery, New Haven (Bequest of Katherine S. Dreier)

194. Raymond Duchamp-Villon. *The Horse*. 1914. Bronze, 40" high. The Museum of Modern Art, New York (Van Gogh Purchase Fund)

195. Umberto Boccioni. *Unique Forms of Continuity in Space*. 1913. Bronze, $43\frac{1}{2}''$ high. The Museum of Modern Art, New York (Acquired through the Lillie P. Bliss Bequest)

196. Umberto Boccioni. *Abstract Voids and Solids of a Head*. 1912. Plaster. (Destroyed)

197. Naum Gabo. *Head*. 1916. Galvanized iron, 18" high. Owned by the artist

198. Antoine Pevsner. *Torso*. 1924–26. Plastic and copper, $29\frac{1}{2}''$ high. The Museum of Modern Art, New York (Katherine S. Dreier Bequest)

199. Pablo Picasso. *Guitar*. 1912. Paper construction, $9\frac{1}{2} \times 5\frac{1}{2}''$. Estate of the artist

200. Pablo Picasso. *The Sausage*. 1912. Oil on canvas, $9\frac{1}{2} \times 13\frac{3}{4}''$. Collection

Mr. and Mrs. Harry N. Abrams, New York

201. Pablo Picasso. *Still Life*. 1914. Painted wood with upholstery fringe, $18\frac{7}{8}''$ wide. Tate Gallery, London

202. Pablo Picasso. *Glass of Absinthe*. 1914. Painted bronze, $8\frac{3}{4}''$ high. Philadelphia Museum of Art (A. E. Gallatin Collection)

203. Alexander Archipenko. *Médrano*. 1914. Painted tin, glass, wood, oilcloth, 50" high. The Solomon R. Guggenheim Museum, New York

204. Henri Laurens. *Still Life*. 1918 (1916?). Wood and plaster construction, painted, $9\frac{7}{8}''$ high. Present owner unknown

205. Henri Laurens. *Bottle of Beaune*. 1917. Collage, $20\frac{1}{2} \times 20\frac{1}{2}''$. Collection Christian Zervos, Paris

206. Henri Laurens. *Head*. 1918. Wood construction, painted, 20" high. The Museum of Modern Art, New York (Van Gogh Purchase Fund)

207. Jacques Lipchitz. *Sailor with Guitar*. 1914. Bronze, 30" high. Philadelphia Museum of Art

208. Jacques Lipchitz. *Bather*. 1915. Bronze, $31\frac{5}{8}''$ high. Private collection, New York

209. Alexander Archipenko. *Woman Combing Her Hair*. 1915. Bronze, $13\frac{3}{4}''$ high. The Museum of Modern Art, New York (Acquired through the Lillie P. Bliss Bequest)

210. Jacques Lipchitz. *Standing Personage*. 1916. Stone, $42\frac{1}{2}''$ high. The Solomon R. Guggenheim Museum, New York

211. Jacques Lipchitz. *Seated Guitar Player*. 1918. Bronze, $23\frac{5}{8}''$ high. Collection Mr. and Mrs. Alan Wurtzburger, Pikesville, Maryland

212. Juan Gris. *Torero (Harlequin)*. 1917. Painted plaster, $21\frac{1}{4}''$ high. Philadelphia Museum of Art (A. E. Gallatin Collection)

213. Henri Laurens. *Boxer*. 1920. Stone, $12\frac{1}{4}''$ high. Galerie Louise Leiris, Paris

214. Henri Laurens. *Guitar*. 1920.

Stone, $15\frac{1}{8}''$ high. Galerie Louise Leiris, Paris

215. Jacques Lipchitz. *Pierrot with Clarinet*. 1926. Bronze, $14\frac{3}{4}''$ high. Collection Mr. and Mrs. William D. Vogel, Milwaukee

216. Pablo Picasso. *Design for a Construction in Iron Wire*. 1928. 30" high. Estate of the artist

217. Pablo Picasso. *Ram's Head*. 1925. Oil on canvas, $32\frac{1}{8} \times 39\frac{1}{2}''$. Private collection

218. Francisco Goya. *Still Life with a Slaughtered Sheep*. About 1816. Oil on canvas, $18\frac{1}{8} \times 25\frac{1}{4}''$. The Louvre, Paris

219. Diego Velázquez. *Las Meninas (The Maids of Honor)*. 1656. Oil on canvas, $125\frac{1}{4} \times 108\frac{5}{8}''$. The Prado, Madrid

220. Pablo Picasso. *Painter and Model*. 1928. Oil on canvas, $51\frac{5}{8} \times 63\frac{7}{8}''$. The Museum of Modern Art, New York

221. Georges Braque. *Still Life: Le Jour*. 1929. Oil on canvas, $45\frac{1}{4} \times 57\frac{3}{4}''$. National Gallery of Art, Washington, D.C. (Chester Dale Collection)

222. Georges Braque. *The Table*. 1910. Oil on canvas, $15 \times 21\frac{1}{2}''$. Collection Mr. and Mrs. Ralph F. Colin, New York

223. Pablo Picasso. *Seated Woman*. 1927. Oil on wood, $51\frac{1}{8} \times 38\frac{1}{4}''$. Collection James Thrall Soby, New Canaan, Connecticut

224. Pablo Picasso. *The Red Armchair*. 1931. Oil and ripolin on plywood, $51\frac{1}{8} \times 38\frac{1}{8}''$. Estate of the artist

225. Pablo Picasso. *The Dream*. 1932. Oil on canvas, $51\frac{1}{2} \times 38\frac{1}{8}''$. Collection Mr. and Mrs. Victor W. Ganz, New York

226. Georges Braque. *Painter and Model*. 1939. Oil on canvas, $51 \times 69''$. Collection Walter P. Chrysler, Jr., New York

227. Pablo Picasso. *Girl Before a Mirror*. 1932. Oil on canvas, $63\frac{3}{4} \times 51\frac{1}{4}''$. The Museum of Modern Art, New York (Gift of Mrs. Simon Guggenheim)

228. Pablo Picasso. *Guernica*. 1937. Oil on canvas, $11'5\frac{1}{2}'' \times 25'5\frac{3}{4}''$. On loan to the Museum of Modern Art, New York, from the artist

Index of Names

Roman numerals refer to the colorplates; numbers in italics denote black-and-white illustrations.

Apollinaire, Guillaume, 26, 90, 158, 159, 181, 183; portrait of, *120*
Archipenko, Alexander, 292-93, 294, 295, 296, 313; *190, 192, 203, 209*

Balla, Giacomo, 206-7, 220; *128*
Barr, Alfred H., Jr., 91
Bartók, Béla, 16
Blake, William, 223
Blériot, Louis, 159
Boccioni, Umberto, 204-5, 206, 208, 293-94; XXX, *124, 125, 132, 195, 196*
Bramante, 13
Braque, Georges, 13-14, 26, 28-32, 41-48, 65-72, 89-94, 105-7, 111, 112, 129, 131, 133, 134, 135, 154, 155, 157, 158, 160, 178, 180, 181, 182, 203, 205, 207, 208, 223, 224, 247, 248, 257, 258, 260, 262, 263, 290, 291, 293, 313, 314, 315, 317-20, 329; VI, IX, X, XIII, XVI, XL, *12, 15, 16, 19, 20, 23, 24, 30, 31, 32, 35, 37, 43, 44, 47, 49, 52, 63, 64, 65, 221, 222, 226*
Breton, André, 290

Calder, Alexander, 314
Campendonk, Heinrich, 218; *136*
Caravaggio, 135
Carrà, Carlo, 205, 207-8, 241; *126, 131*
Cendrars, Blaise, 260, 262
Cézanne, Paul, 15, 26, 27, 28, 29-30, 31-32, 66, 129, 133, 134, 135, 179, 180, 203, 329; *13, 14, 69*
Chagall, Marc, 259-62, 263, 264, 290, 314, 318; XXXV, *173, 174, 175, 176, 177*
Chardin, Jean Baptiste, 106
Chirico, Giorgio de, 204, 293
Cimabue, 159
Claudel, Paul, 179
Cocteau, Jean, 289
Constable, John, 224
Cooper, Douglas, 67
Corot, Camille, 42
Cotman, John, 224
Crotti, Jean, 180
Cummings, E. E., 90

Dalí, Salvador, 111
Dalmau, José, 264
Dante, 94
David, Jacques-Louis, 111, 136, 153, 180
Davis, Stuart, 243-44; XXXIII, *161, 162*
Degas, Edgar, 206
Delacroix, Eugène, 218
Delaunay, Robert, 133, 158-59, 178, 180, 182, 203, 207, 218, 219, 221, 242, 245, 261, 262, 263; XXVI, *94, 95, 96, 97*
Demuth, Charles, 243, 244; *159, 160*
Derain, André, 14, 31, 134
Diaghilev, Sergei, 94; portrait of, *53*
Dickens, Charles, 94
Donatello, 46
Duchamp, Marcel, 92, 135, 158, 159-60, 177, 178, 203, 241, 259, 292, 293; XXVII, *98, 99, 100, 101, 102*
Duchamp-Villon, Raymond, 160, 292, 293, 294, 296; *191, 193, 194*
Dufy, Raoul, 31

Einstein, Albert, 13

Feininger, Lyonel, 178, 218, 220-21, 223, 248; *141, 142, 143, 144*
Figuière, Eugène, 181, 183; portrait of, *117*
Flaxman, John, 223
Freud, Sigmund, 13
Friedrich, Caspar David, 218, 220, 221, 248; *139, 145*

Gabo, Naum, 294; *197*
Gaudí, Antoni, 111
Gauguin, Paul, 16, 203, 329
Géricault, Théodore, 179; *112*
Giacometti, Alberto, 314
Gide, André, 45
Girtin, Thomas, 224
Gleizes, Albert, 158, 180-82, 183, 242, 246; *117, 118, 121*
Goethe, Johann Wolfgang von, 221
Gontcharova, Natalia, 246
Gonzalez, Julio, 314
Goya, Francisco, 41, 44, 315, 319; *218*
Gris, Juan, 111-12, 129-32, 133, 135, 154, 157, 178, 182, 208, 289, 290, 296, 313, 317, 329; XVIII, XIX, XX, XXI, *67, 70, 71, 72, 73, 75, 76, 77, 78, 212*
Gropius, Walter, 293

Hayden, Henri, 183-84; *123*
Herbin, Auguste, 180
Hofmannsthal, Hugo von, 70
Homer, 94
Homer, Winslow, 243; *157*
Humbert, Marcelle, 48, 65; portrait of, XI
Huxley, Aldous, 45

Ingres, Jean-Auguste-Dominique, 16, 92, 131, 136, 319

Jacob, Max, 93, 131; portraits of, *55, 75*
Jeanneret, Charles-Edouard, 154-55, 293; *85, 89, 90*
Joyce, James, 43, 47-48, 94

Kahnweiler, Daniel Henry, 26, 111, 133, 181, 183, 262
Kandinsky, Wassily, 159, 204, 247, 257, 258, 329
Kirchner, Ernst Ludwig, 217; *133*
Klee, Paul, 203, 218, 259, 262-64, 290, 314, 318, 319; XXXVI, *178, 179, 180, 181, 182*
Koklova, Olga, 94; portrait of, *54*
Kupka, Frank, 159

La Fresnaye, Henri de, 180
La Fresnaye, Roger de, 179-80, 182, 207, 242, 262, 292; XXIX, *111, 113, 114, 189*
Larionov, Michael, 246
Laurencin, Marie, 180
Laurens, Henri, 295-96, 313; *204, 205, 206, 213, 214*
Le Brun, Charles, 182
Le Corbusier, 154-55, 293; *85, 89, 90*
Le Fauconnier, Henri, 180, 246
Le Nain brothers, 153, 179
Léger, Fernand, 111, 133-36, 153-56, 157, 160, 177, 179, 207, 241, 244, 246, 261-62, 317, 329; XXII, XXIII, XXIV, XXV, *79, 80, 81, 83, 84, 86, 91, 92, 93*
Lewis, Wyndham, 222, 223; *146*

Lhote, André, 182, 183; *119*
Lipchitz, Jacques, 296, 313-14, 320; *207, 208, 210, 211, 215*

Machaut, Guillaume de, 94
Macke, August, 218, 263; *134, 135*
Maillol, Aristide, 292
Malevich, Kasimir, 245, 246-47, 257, 258; *163, 164, 165*
Manet, Edouard, 93, 134, 153
Marc, Franz, 218-20, 247, 261; XXXI, *137, 138, 140*
Marcoussis, Louis, 182-83; *120, 122*
Mare, André, 180
Marin, John, 242-43, 244; *154, 155, 156*
Marinetti, Filippo, 90, 204
Masaccio, 66
Masson, André, 204
Mathieu, Georges, 329
Matisse, Henri, 14, 16, 30, 134, 157, 204, 218, 224, 241
Metzinger, Jean, 158, 180-82; *115, 116*
Michelangelo, 13, 15
Mies van der Rohe, Ludwig, 293
Millet, Jean François, 179
Miró, Joan, 105, 111, 155, 259, 264, 289-90, 314; XXXVII, *183, 184, 185, 186, 187*
Moilliet, Louis, 218, 263
Mondrian, Piet, 159, 203, 221, 224, 245, 247-48, 257-58, 264; XXXIV, *166, 167, 168, 169, 170, 171, 172*
Monet, Claude, 13, 41, 47, 48, 180, 181, 205, 329
Moore, Henry, 155, 314

Newman, Barnett, 329
Nicholson, Ben, 178, 223, 241, 243, 245; XXXII, *147, 148, 149, 150*

Olivier, Fernande, 42; portrait of, *25*
Ozenfant, Amédée, 154, 224; *87, 88*

Pergolesi, Giovanni Battista, 94
Pevsner, Antoine, 294; *198*
Picabia, Francis, 177-78, 241; *103, 104, 105*
Picasso, Pablo, 13-16, 25-32, 41-48, 65-72, 89-96, 105-7, 111, 112, 129, 130, 131, 133, 134, 135, 153, 154, 155, 157, 158, 160, 178, 180, 181, 182, 183, 203, 205, 207, 208, 218, 224, 241, 245, 246, 247, 248, 257, 258, 260, 261, 262, 263, 264, 289, 291-92, 293, 294-95, 296, 313, 314, 315-20, 329; portraits of, *2, 3, 67;* I, II, III, IV, V, VII, VIII, XI, XII, XIV, XV, XVII, XXXVIII, XXXIX, *1, 2, 3, 4, 5, 6, 7, 8, 9, 11, 17, 18, 21, 22, 25, 26, 27, 28, 29, 33, 34, 36, 38, 39, 40, 41, 42, 45, 46, 48, 50, 51, 53, 54, 55, 56, 57, 58, 59, 60, 61, 62, 66, 74, 188, 199, 200, 201, 202, 216, 217, 220, 223, 224, 225, 227, 228*
Piero della Francesca, 46
Pirandello, Luigi, 70
Pissarro, Camille, 13, 48, 134, 329
Pollock, Jackson, 329
Poussin, Nicolas, 15, 111, 136, 153, 182; *82*
Prokofiev, Sergei, 16

Raphael, 13, 15

Rembrandt, 66
Renoir, Auguste, 13, 48, 106, 218, 329
Reth, Alfred, 180
Riemann, Georg, 181
Rivera, Diego, 204
Rodin, Auguste, 292
Rosenberg, Léonce, 183
Rothko, Mark, 329
Rouault, Georges, 204
Rousseau, Henri, 28, 218
Rubens, Peter Paul, 66
Runge, Philipp Otto, 218, 220
Russolo, Luigi, 207; *129*

Schwitters, Kurt, 91
Selisburg, 94; portrait of, *53*
Seurat, Georges, 111, 134, 153, 158, 203, 206, 329
Severini, Gino, 181, 206, 207; *127, 130*
Shakespeare, William, 223
Shchukin, Sergei, 246
Sheeler, Charles, 243; *158*
Smith, David, 314
Stein, Gertrude, 42, 48, 91, 112; portrait of, *26*
Stella, Joseph, 242, 243; *153*
Sterne, Laurence, 94
Still, Clyfford, 329
Strauss, Richard, 70
Stravinsky, Igor, 16, 43, 94
Survage, Léopold, 180

Tchaikovsky, Piotr, 94
Tellier, Fanny, 42; portrait of, *28*
Titian, 66
Toklas, Alice B., 91
Toulouse-Lautrec, Henri de, 181
Turner, Joseph Mallord William, 205, 329

Uccello, 46
Uhde, Wilhelm, 44, 181, 262; portrait of, *29*

Valmier, Georges, 180
Van Eyck, Jan, 93
Van Gogh, Vincent, 203, 220, 247, 329
Vauxcelles, Louis, 30, 182
Velázquez, Diego, 41, 44, 316; *219*
Vermeer, Jan, 134
Villon, Jacques, 160, 178-79, 182, 220, 223, 224, 245, 292, 329; XXVIII, *106, 107, 108, 109, 110*
Viollet-le-Duc, Eugène, 221
Vlaminck, Maurice, 14
Vollard, Ambroise, 44, 93, 181; portraits of, VIII, *56*

Weber, Karl Maria von, 94
Weber, Max, 241-42, 243; *151, 152*
Woolf, Virginia, 43
Wright, Wilbur, 180

Zurbarán, Francisco de, 41, 112, 130; *68*

Photographic Sources

The publisher and author wish to thank the museums, galleries, and private collectors for granting permission to reproduce the paintings, drawings, prints, and sculpture in their collections. Photographs have been supplied by the owners or custodians of the works of art reproduced, except in the instances listed below. For supplying these photographs, we gratefully acknowledge the courtesy of: A.F.I., Venice: *184*; Agraci, Paris: *218*; Archives Photographiques, Paris: *15, 44, 111, 122*; Paul Bijtebier, Brussels: *47*; F. Bruckmann AG, Munich: *139*; Bulloz, Paris: *79*; J. Camponogara, Lyons: *117*; Chatherineau, Lille: *39*; Clari, Milan: *131, 132*; Colten Photos, New York: *162*; Walter Dräger, Zurich: *185*; Fine Art Engravers, Ltd., London: *49*; Fleming & Co., Ltd., London: *29, 201*; James H. Flude, Irwin, Pennsylvania: *5*; Giraudon, Paris: *96, 112*; Hanover Gallery, London: *205*; Lucien Hervé, Paris: *90*; W. Carpenter Jacobs: *146*; Sidney Janis Gallery, New York: *167*; M. Knoedler & Co., Inc., New York: *175*; Galerie Louise Leiris, Paris: *4, 16, 21, 22, 23, 24, 38, 51, 67, 204, 212, 213, 214*; Penoptaz, Athens: *69*; Louis Pomerantz: *183*; Romanelli, Venice: *192*; Paul Rosenberg & Co., New York: *58, 217*; J. P. Rossignol, Paris: *12, 41*; Maurice Routhier, Paris: *119, 123*; John D. Schiff, New York: *19, 72, 110*; Schweizerisches Institut für Kunstwissenschaft, Zurich: *178*; The Museum of Modern Art, New York: *7, 17, 31, 53, 61, 74, 87, 89, 142, 151, 222, 223, 228*; Walter Steinkopf, Berlin: *145*; Adolph Studly, New York: *59, 76, 208, 211, 215*; Charles Uht, New York: *28*; Anna Wachsmann, New York: *9*; Wildenstein & Co., Inc., New York: *14*.